TOULOUSE-LAUTREC

GÖTZ ADRIANI

TOULOUSE-LAUTREC
THE COMPLETE GRAPHIC WORKS

A Catalogue Raisonné

THE GERSTENBERG COLLECTION

With 421 illustrations, 78 in colour

THAMES AND HUDSON

Contents

For Ev and Walther Scharf

Foreword

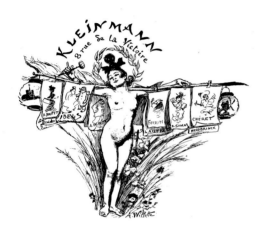

It is a hackneyed commonplace to say that Toulouse-Lautrec was one of the greatest exponents of graphic art. And yet one only becomes fully aware of how true this is when one has a chance to see the whole of his magnificent output in this medium brought together. In the period between Goya and Picasso, only the graphic works of Daumier and Degas even come close to matching his artistic achievement, and none of these artists produced a comparable output within a span of barely ten years; for in the brief period from 1891 to 1901, the year of his death, Lautrec produced 351 lithographs, 28 of which were posters that quickly secured him lasting fame. It was these works which put the name of the aristocrat from the South of France on everyone's lips and which continue to be reproduced today with undiminished popularity, no doubt finding a fitting place decorating ash-trays, T-shirts, tea towels and other useful objects. Two as yet unpublished contemporary photographs (Ills. pp.12 and 13) of places that figured large in the artist's life – the Moulin Rouge and Aristide Bruant's cabaret Le Mirliton – show Lautrec's posters (Nos. 1 and 57) on display outside the buildings; and as we can see, they are highly effective both as decoration and advertisement.

However, Lautrec's reputation as a graphic artist did not correspond with his success as a poster designer: the MOULIN ROUGE had made him famous overnight. This we can see from a significant advertisement by the print-dealer and publisher Edouard Kleinmann (Ill. above left), drawn by Adolphe Willette in the popular style of the time for the magazine *L'Escarmouche* (*cf.* Nos. 45–56). The banner with Lautrec's name held by the comely muse is literally overshadowed by those of the more popular and successful illustrators of the day, whose names are now largely forgotten.

Although Lautrec enjoyed the enthusiastic support of Edouard Kleinmann, the artist's lithographs were almost all priced at the lower end of the scale. His posters, on sale in Edmond Sagot's gallery from as early as 1892, fetched on average between 2 and 12 francs, depending on their condition. His colour lithographs in small editions, now among the most sought-after works on the prints market, then cost hardly more than 20 francs, and the unique ELLES series of ten sheets (Nos. 171–181) was a financial disaster for its publisher, Gustave Pellet, largely because of the high price of 300 francs. Pellet also published another of Lautrec's major works, the colour lithograph LA GRANDE LOGE (No. 202), of which only twelve impressions were made, and the artist wrote to him concerning the financial details of the transaction on 30 November 1898: 'On July 8, 1897, you took 25 impressions in black (INTÉRIEUR DE BRASSERIE) [probably No. 209] at a net price of 10 francs, and 12 impressions of FEMMES DANS LA LOGE [No. 202] at 20 francs net. You have

sold 2 imp. of BRASSERIE, making 20 francs, and one impression of LA LOGE at 20 francs. Making a total of 40 francs. You advanced me 200 francs on the lot, 160 now outstanding. Therefore I am leaving you 8 impressions of LA LOGE on deposit and taking back the rest' (Goldschmidt–Schimmel, No. 221). As a comparison we should mention that in 1892 the Moulin Rouge charged 1.50 francs for a cocktail and 12 francs for a bottle of champagne.

Clearly the time was not yet ripe for a full appreciation of the artistic and graphic qualities of Lautrec's lithographic work. His use of colour, for instance, now virtually taken for granted, seems to have been felt as a weakness, even as late as 1898, when a critic writing in the magazine *Le Temps* on 5 November said: 'These lithographers err, in my modest opinion, all too frequently in searching for effects that are not properly part of the field of lithography. Above all, they are almost all filled, indeed obsessed, with the desire to transpose their wild notions into colour. I find that obsession regrettable. It is impossible to achieve anything but very lurid colour effects in lithography; they are most effective on a poster, but in a careful print made for the amateur draughtsman's portfolio or an album they are confusing and distressing to the eye.'

Only a few connoisseurs with a sure eye for the new were not confused by the means of expression which Lautrec had adopted – and one of these was the Berlin collector Otto Gerstenberg (1848 Pyritz – 1935 Berlin). Gerstenberg had studied mathematics and was later director of the Victoria Insurance Company. Around 1900 he began collecting old and contemporary graphics, and after only a few decades he was the proud possessor of series by Schongauer, Dürer, Rembrandt, Lucas van Leyden and Ostade, then Goya, Klinger, Liebermann and Menzel, to be followed by Corot, Daumier, Manet, Degas and many others.

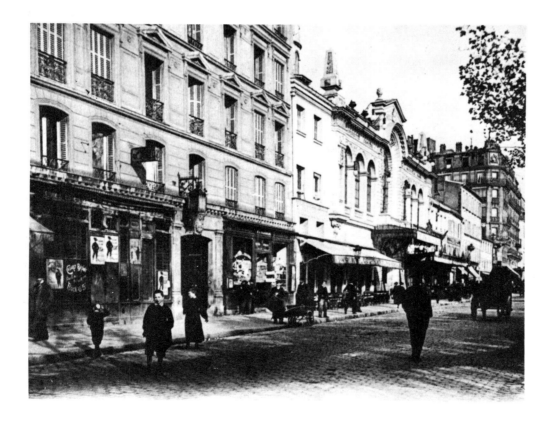

Le Mirliton,
84 Boulevard Rochechouart,
Paris, 1894
(Photo: Bibliothèque Nationale,
Paris)

Moulin Rouge,
90 Boulevard de Clichy,
Paris, 1891
(Photo: Bibliothèque
Nationale, Paris)

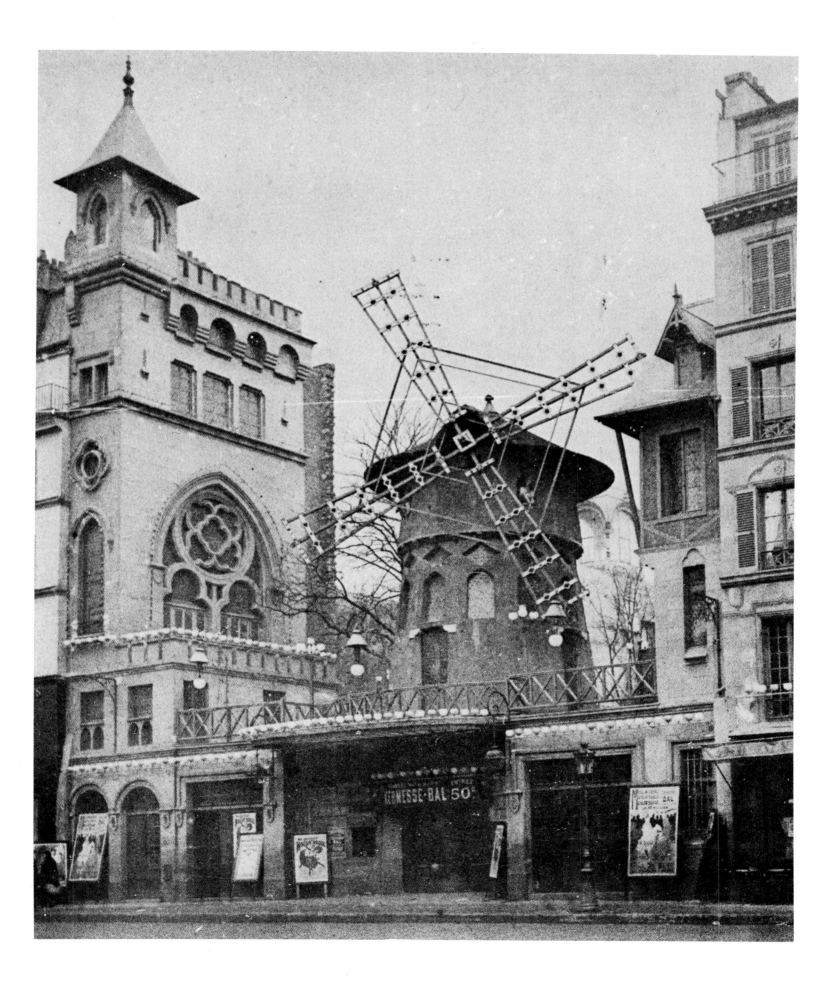

Toulouse-Lautrec occupied a special position in this collection, for it contains, with very few exceptions, his entire graphic output along with several of his paintings and drawings. One can truly say that Otto Gerstenberg succeeded in building up the most complete collection of Lautrec's original graphic works that has ever existed. The value of the collection in terms of quantity is far exceeded by its quality, for compared with the Toulouse-Lautrec collection in the Bibliothèque Nationale in Paris (which has held the graphic works from Lautrec's estate since 1902, thanks to a bequest from his mother), the Gerstenberg Collection is unique in having a large number of de luxe impressions, trial proofs and single states, as well as a large number of impressions bearing a dedication. Of the 360 prints made by Lautrec, only 6, of rather secondary quality, are not in the collection (Nos. 125, 190, 259, 277, 300 and 344), and they are more than compensated for by the fact that Otto Gerstenberg owned a large number of prints for which only a single impression exists. Outstanding sheets from the former collections of Guérin, Heymel, Mutiaux, Pochet, Ragault, Roger-Marx, Stinnes and others finally found their home in Berlin, and we are exceptionally fortunate in having been able to reassemble a collection of such outstanding importance and to provide a full documentation in the form of this publication, which is designed to be the complete catalogue of Toulouse-Lautrec's graphic output.

In lithography Lautrec found the graphic medium that best suited him. He came to the technique relatively late, and from the start regarded it as of equal rank with painting and drawing. From 1892/1893 he showed paintings, posters and lithographic editions in one or more colours side by side at the same exhibitions, while the nine drypoints (Nos. 241–249) were scarcely more than occasional work, and were not published. We have not included here either the illustrations reproduced mechanically from drawings, mostly for magazines, or the four well-known monotypes, two of which are in the Gerstenberg Collection (Ills. pp. 15 and 16), since these prints were not designed for editions; they can be found in the catalogue of Lautrec's paintings and drawings by M. G. Dortu.

Toulouse-Lautrec almost always drew directly onto the litho stone, and only in exceptional cases did he use specially prepared transfer paper. He drew mostly with greasy lithographic chalk or a paintbrush and ink, only occasionally using a pen. He also developed a particular fondness for a special technique in which inks were sprayed more or less evenly onto the stone with a brush and sieve. After highlights and lighter areas had been scratched out of the drawing on the stone with scrapers and needles, and the different stones had been prepared with colour in the case of colour lithographs, the printer could begin etching and colouring the drawing. Before the edition was printed, trial proofs and individual colour proofs were often taken, so that corrections could be made where necessary, and finally the work was released for printing with the appropriate comments. Large editions of the posters (between 1000 and 3000), sheet music title pages, programmes and so on were mostly printed mechanically, while a hand press was sufficient for smaller editions. Of the 360 graphic works, the Gerstenberg Collection has several examples that were unpublished and of which, therefore, only a single or very few trial proofs are known. Only a few copies have survived of many of the posters, despite the big editions, probably because they were printed on cheap, wood-pulp paper and were intended mainly for use on hoardings; only a few impressions were available for specialist collectors of posters and prints. Most of the lithographs were commissioned by newspaper editors or writers,

LE CLOWN (THE CLOWN), 1899
Monotype with oil paint
on white paper,
49.5 × 35.5 cm

dealers and publishers, for specific events or theatrical projects, and they were printed in various Parisian firms. The small Ancourt printing firm most frequently received the commission, and here Lautrec worked first with the lithographer Cotelle, and then with Henri Stern, who later opened his own business.

The following points will be of interest to the reader of this complete catalogue of Toulouse-Lautrec's graphic works. All the works reproduced (with the exception of Nos. 125, 190, 259, 277, 300 and 344) come from the Gerstenberg Collection. To achieve a particularly high quality of reproduction, all the illustrations were corrected from the originals, thus for the first time enabling optimal reproduction, as faithful as possible to the original. Contrary to usual practice, the illustrations are not of details, but of the whole sheet, and this has enabled us to show the relation between the size of the sheet and the size of the image, which plays such an important part in Lautrec's work. Where there was nothing to suggest otherwise, the information given in the basic catalogue by Loys Delteil has been used, especially for the titles to the works and the size of the editions of the published graphics. The chronological sequence of the numbering, established on the basis of external data or stylistic features, largely follows a chronology I produced in 1976, which differed in a few minor details from Delteil's and Adhémar's chronologies. In the case of lithographs for which several states are known, all are listed, but I have refrained from repeating the information already given for the previous state. Technical data on the monochrome (mostly olive green, black or reddish-brown) or coloured works (the list of colours is usually the same as the number of stones used) and on the method of working are followed by the dimensions of the work, given in millimetres, height before width. Any inscriptions on the stone and the type of paper are then described. Many of the sheets in the Gerstenberg Collection are signed by the artist, usually in pencil, and several have specific dedications. The sheets also bear Otto Gerstenberg's dark brown or black collector's stamp (Lugt 2785), usually on the back, showing Victoria, the goddess of victory, with the monogram O.G. (Ill. p. 19). In some cases the editions were numbered and stamped by the publishers. Many of the sheets in the artist's possession on his death were stamped with Lautrec's red monogram (Lugt 1338) by the dealer Maurice Joyant, a friend of Lautrec from his youth and later his biographer and executor; only in isolated cases did Lautrec use that stamp himself, in orange-red, and in rare cases, blue. For each of the works the number in Delteil's catalogue raisonné (1920) and those in the subsequent catalogues by Adhémar (1965), Adriani (1976) and Wittrock (1985) are also given. Finally, a brief text provides information on the motif, the persons depicted, the person or printer who commissioned the work, and discusses critical reaction in the press, questions of dating and preliminary studies in Dortu's catalogue of paintings and drawings. For a list of the abbreviated bibliographical references, see p. 430.

My grateful thanks go to all those who helped to make this major project and publication possible.

CONVERSATION, 1899
Monotype with oil paint
on white paper,
49.5 × 35.5 cm

Catalogue

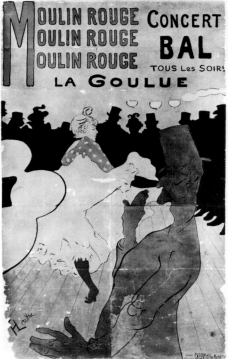

1·1

Colour lithograph, poster; of unusual size, consisting of three parts joined across the middle and at the top (two of 840 × 1220 mm, with a narrow strip of lettering).

First state. With lettering in red designed by Lautrec, the words 'MOULIN ROUGE' repeated three times, and in black: 'CONCERT/BAL/TOUS Les SOIRS/LA GOULUE'; the top rows were printed on a separate sheet of paper. Drawing in black with yellow, red and blue; ink with brush, and spraying technique, chalk.
1910 × 1150 mm.
Signed on the stone, lower left; lower right, the address of the printer: 'AFFICHES AMERICAINES CH LEVY. 10. Rue Martel. PARIS'.
Poster paper.
Size of edition not known (*c*. 1000–3000); only a few sheets have survived in the complete state, that is, with the strip of lettering attached at the top; three trial proofs are also known (without the strip of lettering attached at the top) from the key stone with the drawing in black and the blue colour stone.
Delteil 339 (state not described; instead he shows a reproduction of the poster which differs from the original in having a shorter text on the attached strip of lettering at the top); Adhémar 1; Adriani 1 II; Wittrock P 1 A.
Second state. Part of the edition has more text in red lettering, not designed by Lautrec, at the bottom of the sheet: 'TOUS LES SOIRS/MOULIN ROUGE/les Mercredis et Samedis/BAL MASQUÉ'. The typography is in the fashion of the time and differs markedly from the image and lettering as designed by the artist.
Delteil 339 II; Adhémar 1; Adriani 1 III; Wittrock P 1 B (under P 1 C and D incomplete posters without the strip of lettering are also included as states!).

Lautrec began producing graphics at a time when his mastery of drawing had reached its peak and he could experiment on the stone as he wished. In this first print he used both a brush and litho chalk (in the dancer's hair). But above all he made use of the spraying, or spattering, technique, by which, using a brush dipped in paint, minute particles of colour could be sprayed through a sieve onto the stone; several applications of paint enabled him to achieve subtle nuances and particularly rich mixtures of colour. For example, in the foreground figure black, red and blue are sprayed one over the other in such a way as to produce a dark violet. To prepare for the drawing on the stone, which was probably made by the artist himself with the help of the printer, a charcoal drawing was made, partly heightened in colour, and of roughly the same dimensions as the lithograph: Dortu P.402 (Musée d'Albi), and the portrait studies Dortu P.400, P.401.

The artist has portrayed the star dancers of the Moulin Rouge, Louise Weber, known as La Goulue (1870–1929), and Etienne Renaudin, known as Valentin le Désossé (1843–1907), against a background of spectators. He made the poster in the summer of 1891 for Charles Zidler, the impresario who had opened the entertainment establishment on the Boulevard de Clichy two years before, and he mentions it in letters to his mother at Albi, as in this one written in July (?) of that year: 'I am still waiting for my poster to come out – there is some delay in the printing. But it has been fun to do. I had a feeling of authority over the whole studio, a new feeling for me' (Ph. Huisman – M. G. Dortu, *Lautrec by Lautrec*, New York 1964, p. 90). In October he said: 'My poster is pasted today on the walls of Paris and I'm going to do another one'; and on 26 December 1891 he wrote: 'The newspapers have been very kind to your offspring. I'm sending you a clipping written in honey ground in incense. My poster has been a success on the walls, despite some mistakes by the printer which spoiled my product a little' (probably a reference to the fact that at least part of the drawing, some of which is a little unsure, was put onto the stone by the printer following the charcoal drawing mentioned above). The last mention of the MOULIN ROUGE poster is on 25 January 1892: 'I've just come back from the opening of the Cercle exposition [Lautrec sent works to the exhibitions of the Cercle Artistique et Littéraire in the Rue Volney in 1889, 1891 and 1892] where my daubs, although hung about as badly as possible, have had favourable mention in the press. Besides this, they are being very nice to me in the newspapers since my poster. "Le Paris", a very Republican paper (don't breathe a word to the family) has even seen fit to devote two columns to me [article by Arsène Alexandre on 8 January 1892], in which they tell all about me down to the last detail' (Goldschmidt-Schimmel, Nos. 126, 132, 133). The poster was shown as Lautrec's first graphic work, in two states, at the annual exhibition of Les XX in February 1892 in Brussels.

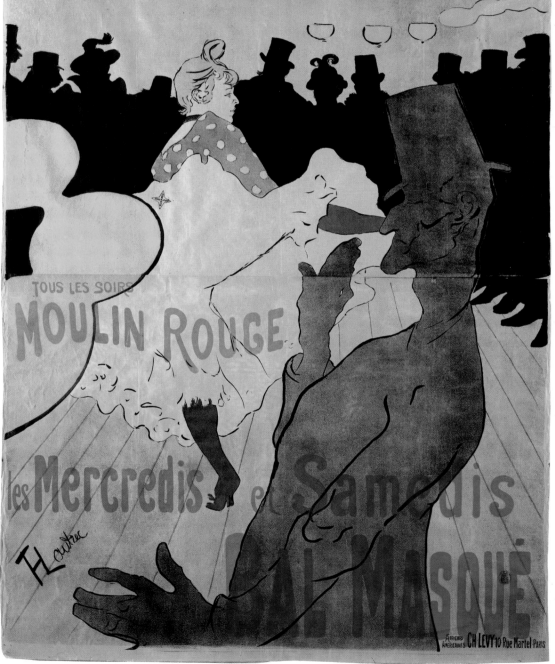

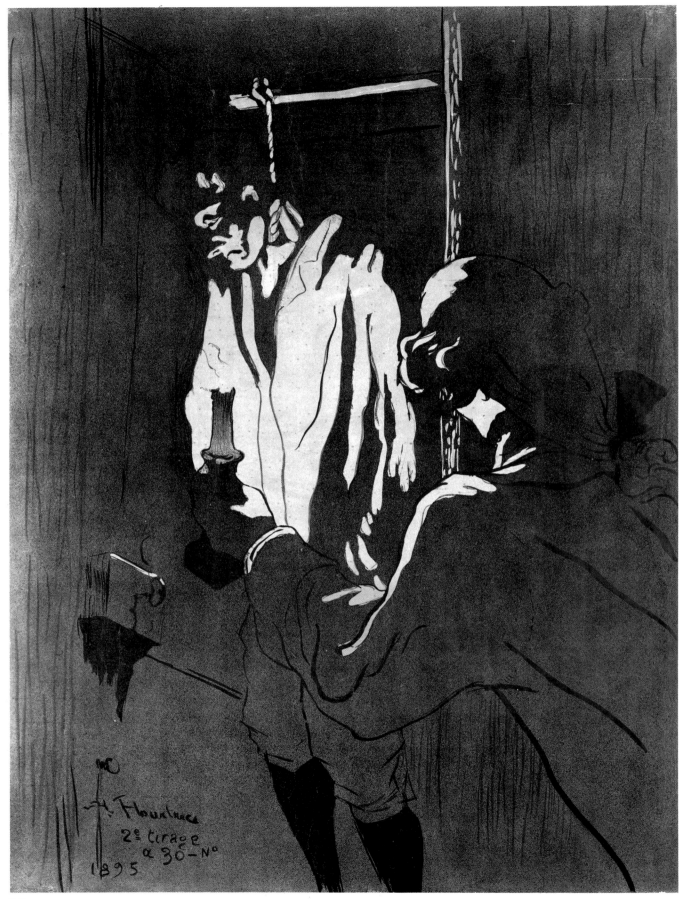

2 Le Pendu 1891/1892 and 1895
The Hanged Man

Colour lithograph, poster.
First state. Drawing in black, with dark
greyish-green; ink with brush, and
spraying technique, chalk.
753 × 553 mm.
Signed on the stone, lower left.
Beige vellum paper.
Size of edition not known (several
hundred). Only one example has
survived, where the lithograph has been
used as a pictorial motif stuck onto a
lettered poster (1258 × 923 mm) not
designed by Lautrec (Adriani, ill. p. 38);
but the drawing had to be cut down
somewhat on all four sides for the
purpose. Impressions intended to be used
on the lettered poster are known
(697 × 470 mm).
Delteil 340 I; Adhémar 4; Adriani 2 I;
Wittrock P 2 A B.
Second state. New version made in 1895.
Drawing in black (on a new stone) and
olive green; ink with brush, and spraying
technique, chalk.
800 × 603 mm.
Signed on the stone, lower left, and
inscribed: '2e tirage/ a 30 – No/1895'.
Vellum.
Edition of 30.
Delteil 340 II; Adhémar 4; Adriani 2 II;
Wittrock P 15.

Arthur Huc, art-lover and editor of the
magazine *La Dépêche de Toulouse*, used the
lithograph, which was printed by the firm
of Cassan Fils in Toulouse, together with
the lettered poster (in yellow ochre, red
and black, made by R. Thomas & Co.,
Toulouse) to advertise the serial novel *Les
Drames de Toulouse* by A. Siégel. The first
state of the lithograph probably dates
either from the autumn of 1891 – for
Lautrec says in a letter of October 1891 in
connection with the hanging of the
Moulin Rouge poster (No. 1) that he was
starting work on a new one
(Goldschmidt-Schimmel, No. 126) – or
the spring of 1892, before publication of
the novel on 16 April. The charcoal
drawing Dortu D.3227 (Musée d'Albi),
the dimensions of which are roughly the
same, was made as a study for the print.
The novel is set in the eighteenth century,
and to match the text the artist has used a
dramatic style of drawing, with rich
contrasts, that also occurs in some of his
later lithographs. The new version of
1895 was for an edition of only 30.
Following the success of the poster the
whole edition was probably intended for
sale to collectors.

3 Ambassadeurs,
 Aristide Bruant 1892

Colour lithograph, poster; consisting of
two parts joined across the middle of the
picture, with some impressions printed on
one, and some on two sheets of paper;
with light lettering designed by Lautrec,
edged in blue and olive green:
AMBASSADEURS/aristide/BRUANT/
dans/son cabaret'.
Drawing in olive green with yellow, red,
blue and black; ink with brush, and
spraying technique.
1338 × 917 mm.
Signed on the stone, lower left; address of
the printer on the left edge: 'IMP EDW
ANCOURT & Cie 83 Fg St DENIS'.
Poster paper.
Size of edition not known (*c*. 1000–3000);
one trial proof is also known.
Delteil 343; Adhémar 6; Adriani 5;
Wittrock P 4.

The poster was prepared down to the
finest details of the typographic design in
the gouache sketch Dortu A.200 (Stavros
Niarchos Collection, London) and several
studies Dortu D.3222, D.3445 and
D.3446. Aristide Bruant (1851–1923) was
a singer who created a sensation in his
cabaret Le Mirliton by abusing the
audience. He was one of the first to show
an interest in Lautrec's work, which he
did from 1886, doing his best to popular-
ize it. Lautrec made more posters for Bruant
than for anyone else: four altogether
(Nos. 3, 4, 12 and 57). There is also a
large-scale design for a poster that was not
printed, Dortu P.413 (Musée d'Albi).
 On 3 June 1892 the celebrated singer,
who had moved his activities from
Montmartre to the centre of Paris, had his
première in the Ambassadeurs, a *café
concert* at 3 Avenue Gabriel. Against the
wishes of the manager, Pierre Ducarre
(see No. 24), he had asked Lautrec to
design a poster; indeed, Bruant even went
so far as to force the finished poster on
Ducarre, who refused to pay for either the
design or the printing, calling the work 'a
revolting mess'. Bruant said he would not
appear unless the poster was displayed on
the stage and in the streets. The poster was
mentioned in the magazine *En Dehors* on
10 July 1892, and *La Vie Parisienne*
moaned: 'Who will rid us of this picture
of Aristide Bruant? You cannot move a
step without being confronted with it.
Bruant is supposed to be an artist; why,
then, does he put himself up on the walls
beside the gaslamps and other
advertisements? Doesn't he object to
neighbours like these?'

4 Eldorado,
 Aristide Bruant 1892

Colour lithograph, poster; consisting of
two parts joined across the middle of the
picture, with some impressions printed on
one, and some on two sheets of paper;
with light lettering designed by Lautrec,
edged in olive green and blue:
'ELDORADO/aristide/BRUANT/dans/
son cabaret'.
Drawing in olive green, with yellow, red,
blue and black; ink with brush, and
spraying technique.
1370 × 965 mm.
Monogram on the stone, lower right,
with the address of the printer: 'Imp
BOURGERIE & Cie 83,FgStDenis,
(AffichesANCOURT)'.
Poster paper.
Size of edition not known (*c*. 1000–3000);
one trial proof also known.
Delteil 344; Adhémar 7; Adriani 6;
Wittrock P 5.

Despite the fairly discouraging reactions
to his first attempt (see No. 3), Lautrec
also designed this poster, at Bruant's
request, for his appearances at the
Eldorado on the Boulevard de
Strasbourg. He used new stones for the
drawing, with the same dimensions and
the same colour arrangement as the
previous design, but reversed. The
management of the Eldorado was hardly
more amenable, as we see from a letter by
Lautrec which may refer to the
Eldorado poster: 'Bruant, my good
friend. Enclosed the states as requested. As
far as the poster ex edition is concerned,
there are no good impressions left. The
Eldorado management was very mean,
haggling over the price and giving me less
than the printing costs at Chaix. So I have
worked at cost price. I am sorry they
misused our good relations to exploit me.
It remains to be hoped we will be more
careful next time' (*Collection M.L. – Henri
de Toulouse-Lautrec*, Vente Galerie
Charpentier, Paris 1959, No. 260).

4

AMBASSADEURS...

aristide BRUANT dans son cabaret

HLautrec

3

Colour lithograph, poster; consisting of
two parts joined across the middle of the
picture, with some impressions printed on
one, and some on two sheets of paper;
with lettering designed by Lautrec in
olive green: 'Reine de Joie/par/Victor
Joze/chez/tous les/libraires'.
Drawing in olive green with yellow, red
and black; ink with brush, and spraying
technique, transfer screen.
1365 × 933 mm.
Signed on the stone, left; lower right,
address of the printer: 'Imp. Edw.
ANCOURT & Cie. PARIS'.
Poster paper.
Size of edition not known (*c.* 1000–3000);
four trial proofs also known.
Delteil 342; Adhémar 5; Adriani 7;
Wittrock P 3.

The poster advertising Victor Joze's book
Reine de Joie/Mœurs du Demi-Monde
(Queen of Joy/Customs of the *Demi-
Monde*), Paris 1892, must have appeared at
about the same time as the two BRUANT
posters (Nos. 3 and 4). Joze, a Polish
writer and a friend of Lautrec, who
designed two more lithographs for him in
later years (Nos. 58 and 232), had
commissioned a coloured poster. The
charcoal drawing Dortu D.3224 (Musée
d'Albi) and the detail studies Dortu
D.3225 and D.3226 were made in
preparation for the drawing on the stone.
On 4 June 1892 the periodical *Fin de
Siècle*, run by Joze (whose real name was
Victor Dobrsky), reported the appearance
of the highly individual composition,
which was also used at a reduced size as
the title page for the book. (Pierre
Bonnard designed the jacket.)
 The poster and the anti-Semitic leaflet
published by Henry Julien in the series *La
Ménagerie Sociale* caused a scandal. The
episode shown here is one in which the
heroine of the novel, Hélène Roland,
kisses the corpulent Olizac at a table laid
for a meal – Lautrec actually drew
Georges Lasserre for the figure on the left
(see No. 198), with Luzarche d'Azay on
the right. At the insistence of Baron
Rothschild, who believed the main
character in the novel, a Baron Rosenfeld,
to be modelled on himself, attempts were
made to suppress the entire edition. This
did not, however, prevent the publishers
of *Fin de Siècle* from selling part of it, and
the poster was also mentioned in *En
Dehors* on 10 July 1892.
 In February 1893 Thadée Natanson
commented on Lautrec's first posters in
No. 16 of his periodical *La Revue Blanche*:

'The posters that have recently decorated
the walls of Paris – or still are decorating
them – have surprised, disturbed and
delighted us. The black, bobbing crowd
around the dancer with her fluttering
skirts and her astonishing partner in the
foreground [No. 1], or the masterly
portrait of Aristide Bruant [Nos. 3 and 4]
are unforgettable. The last poster in
particular gave us a shiver of delight: this
delicious REINE DE JOIE, bright, attractive
and superbly perverse . . . Enchanted eyes
no doubt still linger outside shop
windows displaying the happy, carefree
colours of a Chéret, but we eagerly root
around in our memories for the select
excitements of art which have become
almost painfully tangible through
Toulouse-Lautrec's disturbing
inventions.'

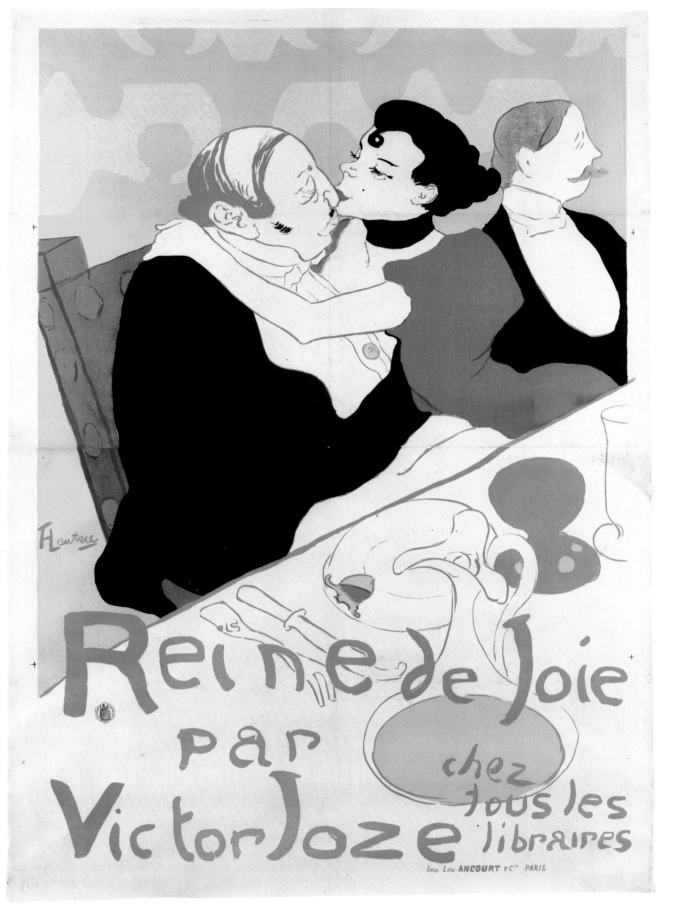

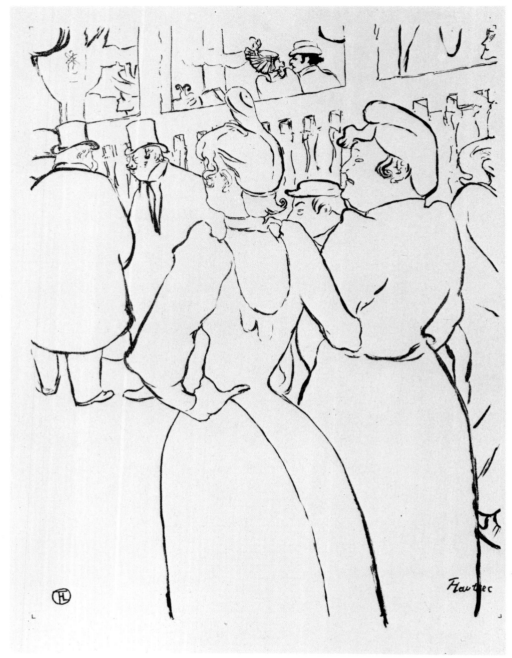

6·I Trial proof

6 AU MOULIN ROUGE, LA GOULUE ET SA
 SOEUR 1892
 *At the Moulin Rouge, La Goulue and her
 Sister*
Colour lithograph.
First state. Drawing mainly in La Goulue's
dress (low neckline at the back, left sleeve
and skirt) and in the upper left and the
balustrade area.
Drawing in black with olive green, blue,
red and yellow; ink with brush, and
spraying technique.
462 × 347 mm.
Signed on the stone, lower right, with
monogram, lower left.
Vellum.
One impression known; this is signed and
inscribed by the artist: '*état noir trait*'
(Kornfeld and Klipstein auction catalogue
90, Berne 1958, No. 1027); four trial
proofs from the black drawing stone are
also known.
Delteil 11 (state not described);
Adhémar 2 (state not described);
Adriani 3 II; Wittrock 1 I.
Second state. The drawing upper left and
in La Goulue's dress, together with the
balustrade and monogram lower left
erased, and replaced by a new monogram
and drawing of the balustrade in red.
Drawing in olive green with blue, light
green, red, yellow, beige and black.
461 × 348 mm.
Monogram in red on the stone, lower left.
Edition of 100 numbered impressions,
signed by the artist in pencil on the lower
left edge; lower right, the printer's stamp:
'Chromo – Lithographie EDW.
ANCOURT & Cie/PARIS/83
FAUBOURG St.DENIS'. Six trial
proofs are also known, including one in
watercolour Dortu A.199 (Bibliothèque
Nationale, Paris).
Delteil 11; Adhémar 2; Adriani 3 III;
Wittrock 1 II.

This was the first limited edition of a print
by Lautrec and it was published together
with the following sheet (No. 7) by the
art-dealers Boussod, Valadon et Cie.,
where Lautrec's old friend and later
biographer, Maurice Joyant, was
manager. The print was offered for sale in
October 1892 for 20 francs, and the
painting Dortu P.422 (Philadelphia
Museum of Art), which is almost the
same size, served as a model. As early as
July the artist claimed to be so far highly
satisfied with the results of his
experiments in the field of colour
lithography: 'My little efforts have turned
out perfectly and I've caught onto
something which can lead me quite far –
so I hope' (Goldschmidt-Schimmel, No.
145).

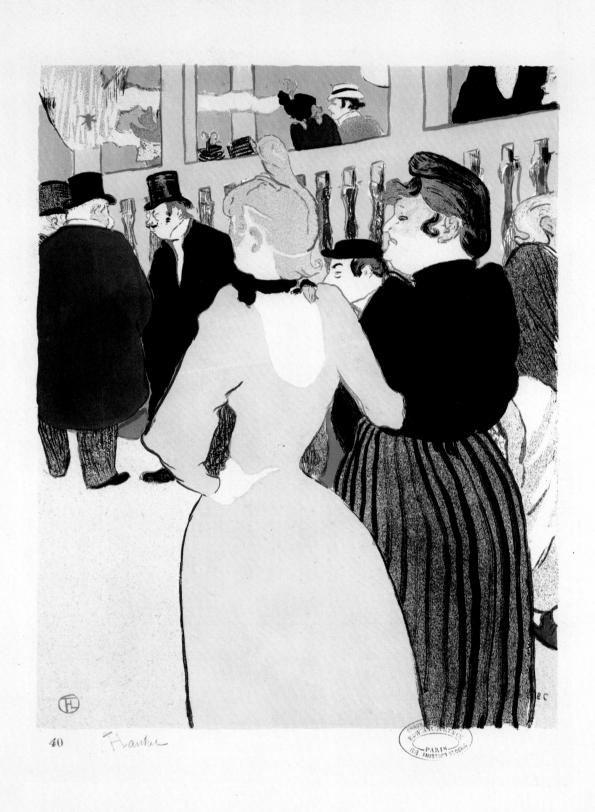

6·II

7 L'ANGLAIS AU MOULIN ROUGE 1892
The Englishman at the Moulin Rouge

Colour lithograph.
First state. Drawing in black; ink with
brush.
470 × 373 mm.
Signed on the stone, lower right;
monogram, lower left.
Vellum.
Two impressions known (Bibliothèque
Nationale, Paris), one in watercolour
Dortu A.198.
Delteil 12 (state not described);
Adhémar 3 (state not described);
Adriani 4 I; Wittrock 2 I.
Second state. New drawing of the back of
the chair in aubergine, new monogram in
red and new drawing of the right-hand
half of the picture and the background.
Drawing in olive green with aubergine
(some turquoise), blue, red, yellow and
black; the colours changed during the
edition (on some prints the dress and hat
of the girl in the background are light
blue instead of wine red); ink with brush,
and spraying technique.
534 × 375 mm.
Signed on the stone, lower right;
monogram, lower left, and on the edge of
the sheet lower right, the printer's
address: 'Imp.Edw. Ancourt à Paris'.
Hand-made paper.
Edition of 100 numbered impressions,
signed by the artist on the lower left edge
in pencil; three trial proofs from the
drawing stone and individual colour
stones are also known.
Delteil 12; Adhémar 3; Adriani 4 II;
Wittrock 2 II.

This colour lithograph was also published
by Boussod, Valadon et Cie. (see No. 6),
and it derives from a painting which used
to be in the collection of the character
depicted, a painter from Lincoln called
William Tom Warrener (1861–1934),
Dortu P.425 (Metropolitan Museum of
Art, New York); see the portrait studies
Dortu P.426 (Musée d'Albi), D.3229.
Warrener had been a pupil at the
Académie Julian and had lived in Paris
since the mid-1880s; he was a frequent
visitor to the Moulin Rouge.

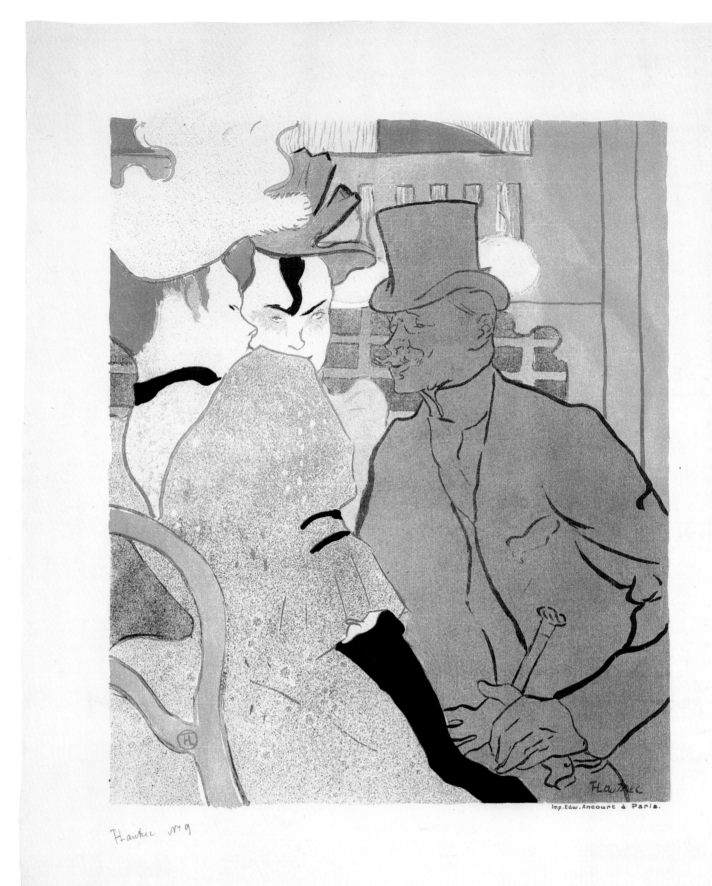

Lautrec Nº 9

L'anglais au Moulin rouge (12)

8 DIVAN JAPONAIS 1892/1893

Colour lithograph, poster, with light and dark lettering designed by Lautrec, outlined in black and olive green: 'Divan Japonais/75 rue des Martyrs/Ed Fournier/directeur'.
Drawing in olive green with black, yellow and red; ink with brush, and spraying technique, chalk, transfer screen.
808 × 608 mm.
Signed in black on the stone, lower right, with the address of the printer: 'IMP. EDW. ANCOURT, PARIS'.
Poster paper.
Size of edition not known (c. 1000–3000); seven trial proofs are also known, from colour stones printed individually and together.
Delteil 341; Adhémar 11; Adriani 9; Wittrock P 11.

The poster was prepared down to the typographic details in several sketches – Dortu P.420, P.459, A.201, D.3223. It was put up on 20 January 1893 as an advertisement for a small *café concert* at 75 Rue des Martyrs, started by Jehan Sarrazin and, since autumn 1892, run by Edouard Fournier. It was decorated in the so-called Japanese style with lanterns and mock bamboo. Unlike the MOULIN ROUGE poster (No. 1) it is not the star who draws the attention here – the singer Yvette Guilbert (1865–1944) who had her first stage successes here in 1892 is up in the top left-hand corner, with her head cut off by the edge of the sheet – but two spectators in a box, typical of the literary audience which filled the Divan Japonais: Jane Avril (1868–1943) and Edouard Dujardin (1861–1949), a critic of literature, music and art. The brilliant Jane Avril celebrated her greatest triumphs under the name of La Mélinite, doing wild dances in the style of Kate Vaugham at the Jardin de Paris, the Casino de Paris, the Moulin Rouge and the Folies Bergère.
 The critic Gustave Geffroy said in the liberal periodical *La Justice* on 15 February 1893 that Lautrec's posters for Bruant (Nos. 3 and 4), La Goulue (No. 1) and now the Divan Japonais had conquered the streets of Paris with invincible authority. Félix Fénéon himself, spokesman of the Neo-Impressionists, commented on these first posters with great enthusiasm on 30 April 1893 in the newspaper *Père Peinard*, which had anarchist leanings: 'By the devil, he is impudent, young Lautrec; he's not timid, either in his drawing or his colour. White, black and red in big patches with simple

shapes, that's him. There isn't another like him; no-one can show the grimaces of the bloated capitalists like he can, sitting at their tables with their little whores, licking their chops to sharpen them. LA GOULUE (No. 1), REINE DE JOIE (No. 5), the DIVAN JAPONAIS and two for a bar called BRUANT (Nos. 3 and 4), that is all he has done in the way of posters, but it is all exploding with will-power, impudence and wickedness, and those who want nothing but candy floss to eat stand quite speechless'.

9 COUVERTURE DE 'L'ESTAMPE ORIGINALE' 1893
Cover for 'L'Estampe Originale'

Colour lithograph, cover folded in the middle with lettering designed by Lautrec in black: 'l'estampe/originale/publiée/par/ le Journal des/artistes'.
Drawing in olive green with beige, old rose, red, yellow and black; ink with brush, and spraying technique.
565 × 652 mm.
Signed and dated on the stone, upper right; monogram, lower right; address of the printer, lower left: 'Imp. Edw. Ancourt Paris'.
Vellum.
Edition of 100 numbered impressions, signed in pencil on the left by the artist; some also have the blind stamp of the *L'Estampe Originale* edition (Lugt 819) on the lower left. Five trial proofs are also known, some of which bear the artist's note 'passe'.
Delteil 17; Adhémar 10; Adriani 10 II; Wittrock 3.

Much of Lautrec's work in 1893 was inspired by Jane Avril. She is depicted here on the cover of *L'Estampe Originale* at Ancourt & Cie., Paris, Lautrec's favourite lithography workshop, taking a critical look at an impression, while Père Cotelle, the experienced printer at the firm, works at a Brisset press. This lithograph was based on several detail studies – Dortu P.486, A.206, D.3434 – and it was the cover for an issue of the magazine that was first published on 30 March 1893 by the art-dealer and publisher André Marty. Marty intended to publish ten original graphics 'by the élite of today's young artists' every quarter with *L'Estampe Originale*, in an edition of 100, for an annual subscription price of 150 francs. By the beginning of 1895 he had published altogether 95 prints by 25 artists in this way. While etching was the most usual graphic technique, the first issue of *L'Estampe Originale* in 1893 stressed that all the different techniques were of equal importance, and acknowledged lithography as an independent artistic medium which ranked alongside woodcut and etching.
 As early as February 1893 the lithograph cover, together with the BRUANT and DIVAN JAPONAIS posters (Nos. 3 or 4 and 8) and the smaller colour lithographs AU MOULIN ROUGE (No. 6) and L'ANGLAIS AU MOULIN ROUGE (No. 7) were shown in Brussels at the annual exhibition of the artists' group Les XX.

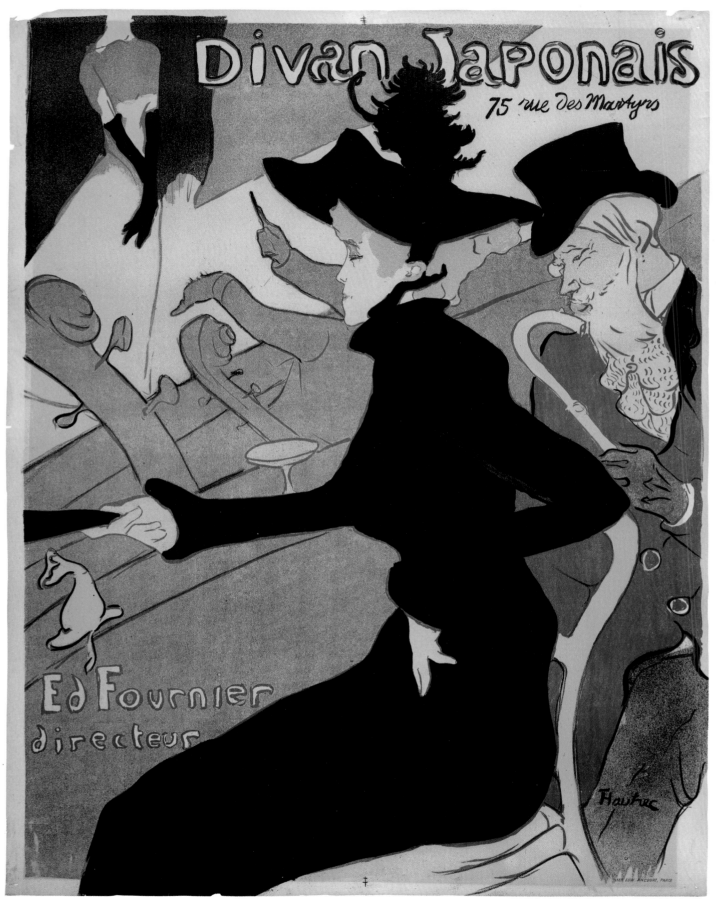

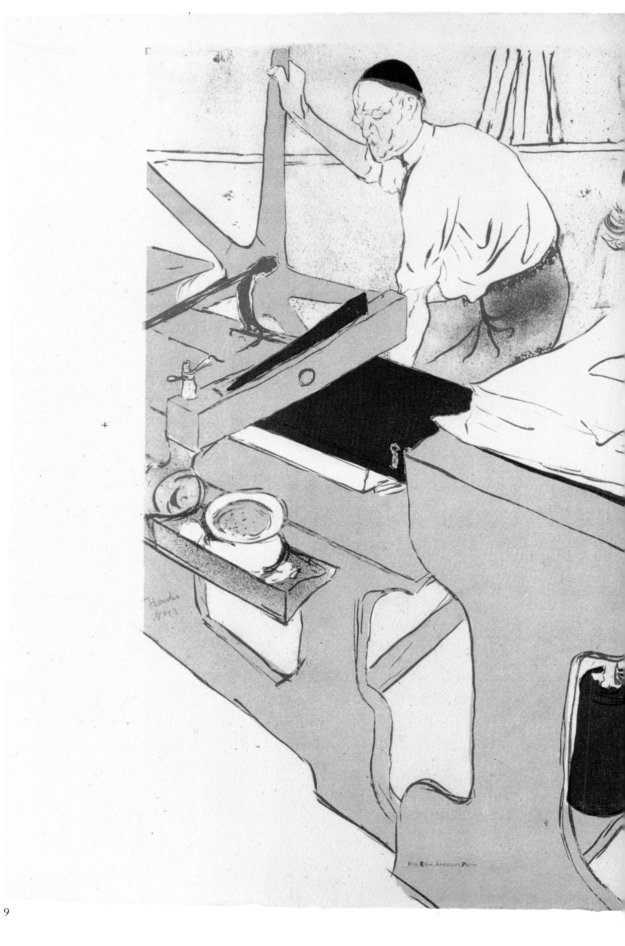

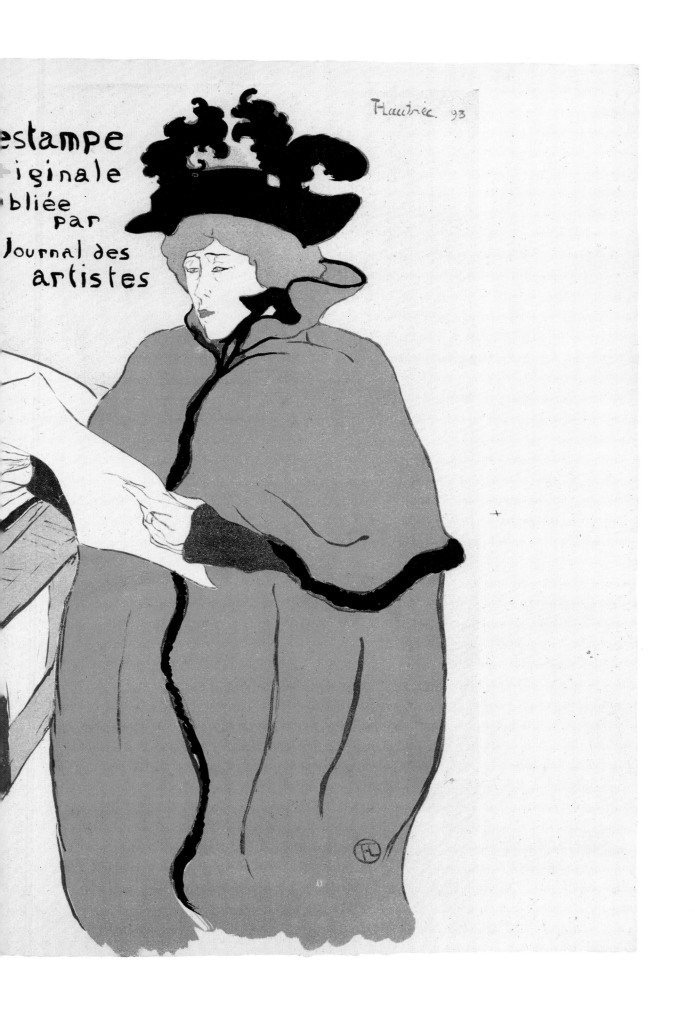

10 Trial proof with mount

10 MISS LOÏE FULLER 1893

Colour lithograph.
Drawing in olive green, blue or blue-grey
on a reddish-brown tinted plate; in
addition, yellowish-brown for the head
and legs of the dancer, while the robe is in
shimmering tones of red, violet, blue,
yellow and green; light blue and various
bronze tones in the robe and background;
ink with brush, and spraying technique,
dusted with gold and silver.
370 × 260 mm.
Vellum.
Edition of 50, a few signed by the artist
lower left in pencil and stamped with
Lautrec's red monogram (Lugt 1338). In
addition to two impressions dedicated 'à
Marty' and 'à Stern' (illustrated), six trial
proofs are known, mainly from the key
stone in black, olive green and blue. Some
of the impressions in this edition were
supplied in a dark grey mount
(417 × 270 mm), decorated with a clover-
leaf pattern of golden trails which covered
most of the surface. Ten impressions are
known which had to be trimmed slightly
on the left or right edge to fit the mount.
Delteil 39; Adhémar 8; Adriani 8 III;
Wittrock 17.

On the stage, which cuts diagonally across
the picture and is itself cut into on the
right by the shadow of a cello neck, Loïe
Fuller (1862–1928) is performing her
danse du feu. This was then world-famous,
and she actually patented it in 1894. Loïe
Fuller was an actress and dancer, born in
Chicago, who had been appearing at the
Folies Bergère since November 1892. She
wore wide, swirling voile skirts, and
would swing tulle veils high into the air
on long poles to achieve particular light
effects under the multi-coloured electric
spotlights that were installed especially for
her performances. See the studies for the
figure of the dancer Dortu P.468 (Musée
d'Albi), D.3420.
 André Marty had been promoting
Lautrec since 1893. As the publisher of the
edition printed by Ancourt, Paris, at 50
francs per impression, he later told Delteil
that each impression had been
individually coloured by the artist using a
wad of cotton wool and finally dusted
over with gold or silver powder. Delteil
assumed that this colouring had been
done after the impressions were printed,
but in fact the changing rainbow tones in
the dancer's skirts and in the background
could have been printed simultaneously
on a single stone using a special process
(iris printing). The stone would have to
be re-coloured after each printing, with
the roller soaked in different colours. The
gold and silver dust would then be
applied wet on wet to the stone, again
separately for each impression, and
printed. This would explain the different
colour effects achieved in the individual
impressions, while the stones used (the
drawing and the reddish-brown for the
background and the yellowish-brown for
the dancer's head and legs) would be
printed in the normal way and would not
need to be changed for each impression.
Directly after the print appeared in
February 1893 the work was discussed in
an article on 'Japonisme d'Art' in *Le
Figaro Illustré*, with reference to the ability
of Japanese artists to express movement
with the utmost economy. It should be
added that it was also a Japanese custom to
heighten the effect of colour prints by
using gold-dusted paper or different metal
powders.

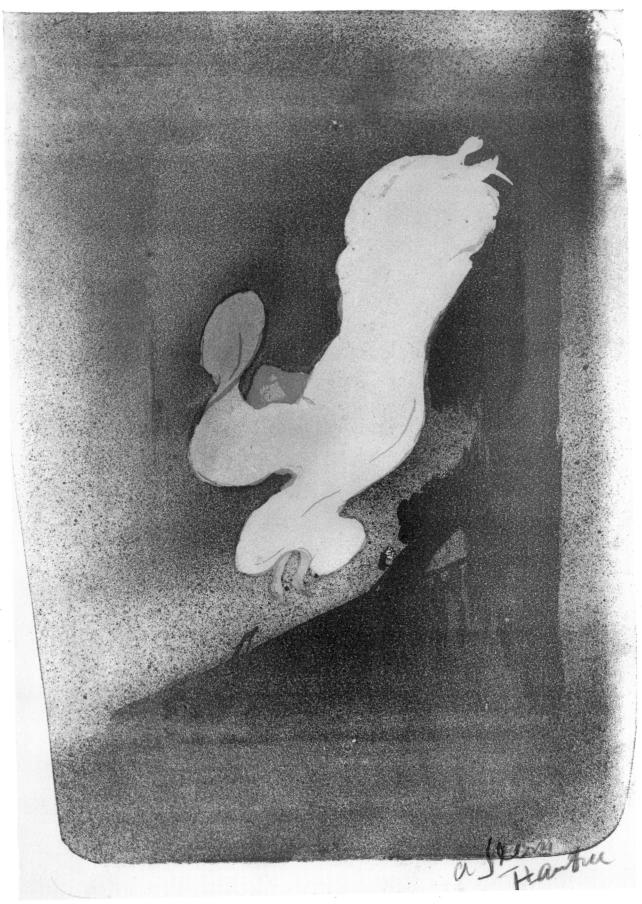

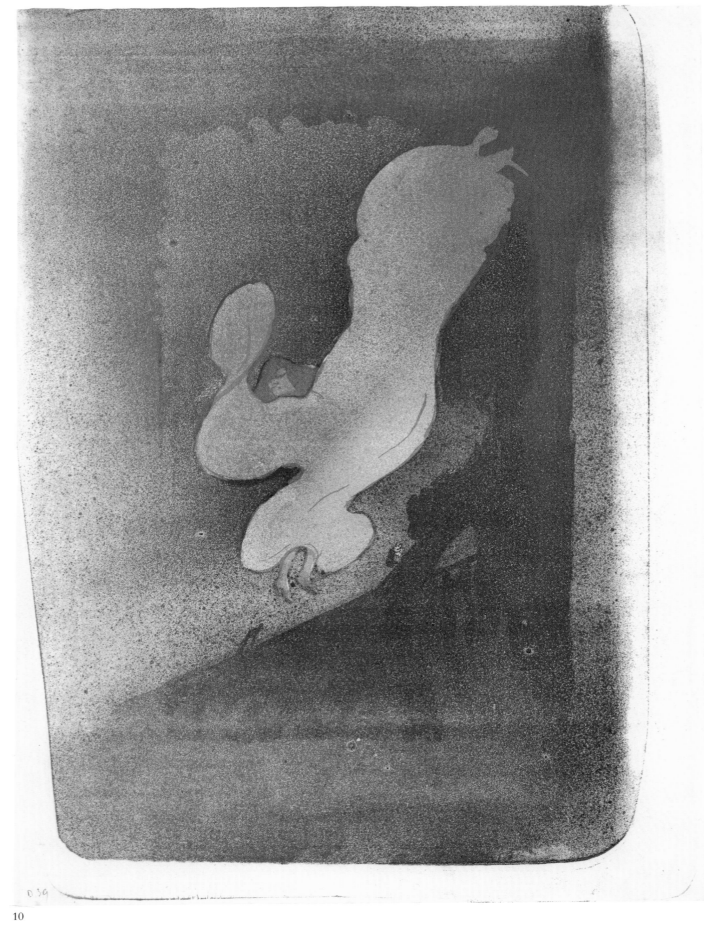

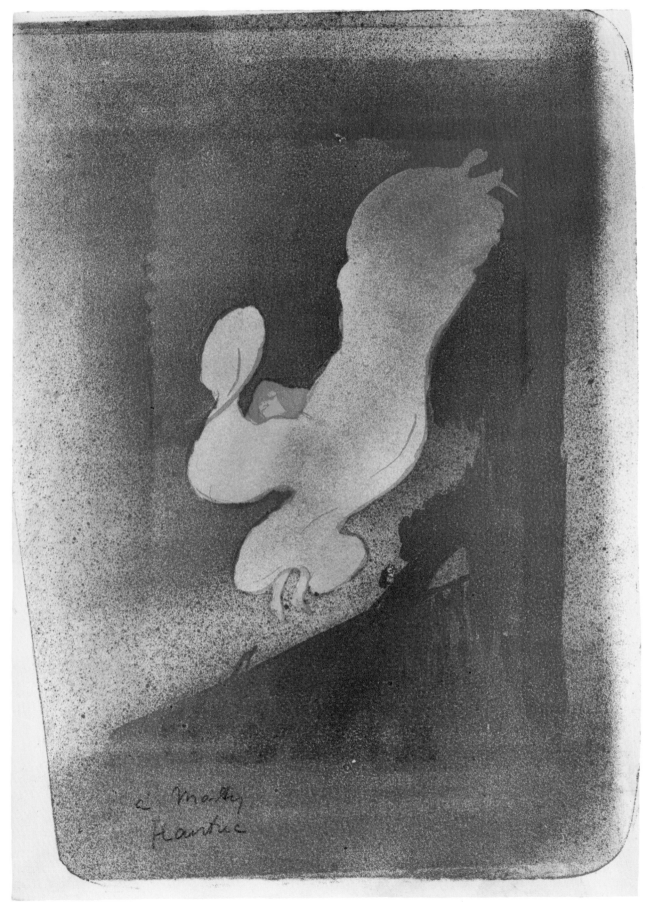

Colour lithograph, poster.
First state. With light lettering outlined in olive green designed by Lautrec: 'Jane Avril'.
Drawing in olive green with yellow, orange, red and black; ink with brush and spraying technique.
1240 × 915 mm.
Signed, dated and inscribed at the bottom on the stone: 'Depot Chez Kleinmann/8, Rue de la Victoire'; monogram lower left with the address of the printer: 'Imp. CHAIX 20, Rue Bergère PARIS ENCRES LORILLEUX'.
Poster paper.
Size of edition not known; two trial proofs from the drawing stone in olive green are also known. In addition, 20 numbered impressions were printed on thick vellum paper and signed by the artist in pencil. In his sales catalogue of November 1893 the publisher Edouard Kleinmann lists these impressions at 10 francs each.
Delteil 345 I; Adhémar 12 I; Adriani 11 II; Wittrock P 6 A B.
Second state. With additional lettering in black not designed by Lautrec, upper right: 'Jardin/de Paris'.
Size of edition not known (*c.* 1000–3000).
Delteil 345 II; Adhémar 12 II; Adriani 11 III; Wittrock P 6 C.

This colour poster, deposited in the Bibliothèque Nationale in Paris on 8 May, was used to advertise Jane Avril's appearance – much celebrated in the press – at the Jardin de Paris, a new *café concert* on the Champs Elysées; see the study for the figure of the dancer Dortu P.482 (Stavros Niarchos Collection, London). In a letter to André Marty of 2 June 1893 the artist remarked that his poster would appear next day (Goldschmidt-Schimmel, p. 159, Note 2). With the approval of the management Jane Avril had commissioned the poster from Lautrec, whose work she admired. Apart from Bruant, she was the only one with sufficient faith in his powers of invention to set him to work on her publicity. On 25 June 1893 Lautrec wrote to Firmin Javal, editor of the periodical *L'Art Français*: 'I received a request from M. Roques, editor of the *Courrier Français*, asking me for permission to reproduce my JANE AVRIL poster. As you are the first one I authorized to make this reproduction, I have let him know he should come to an agreement with you to the end that your copies will come out simultaneously, so as not to make the thing stale. This letter gives you full power so that if the *Courrier* should pull a fast one on you, we would be able to give the editor a rap on the knuckles, you, I and Kleinmann [Edouard Kleinmann, of 8 Rue de la Victoire, published and stored graphics by Lautrec from 1893 to 1896]' (Goldschmidt-Schimmel, No. 161; *cf.* also letter No. 175). In fact, the reproduction in the *Courrier Français* appeared on 2 July 1893, while *L'Art Français* did not publish its own version until 29 July.

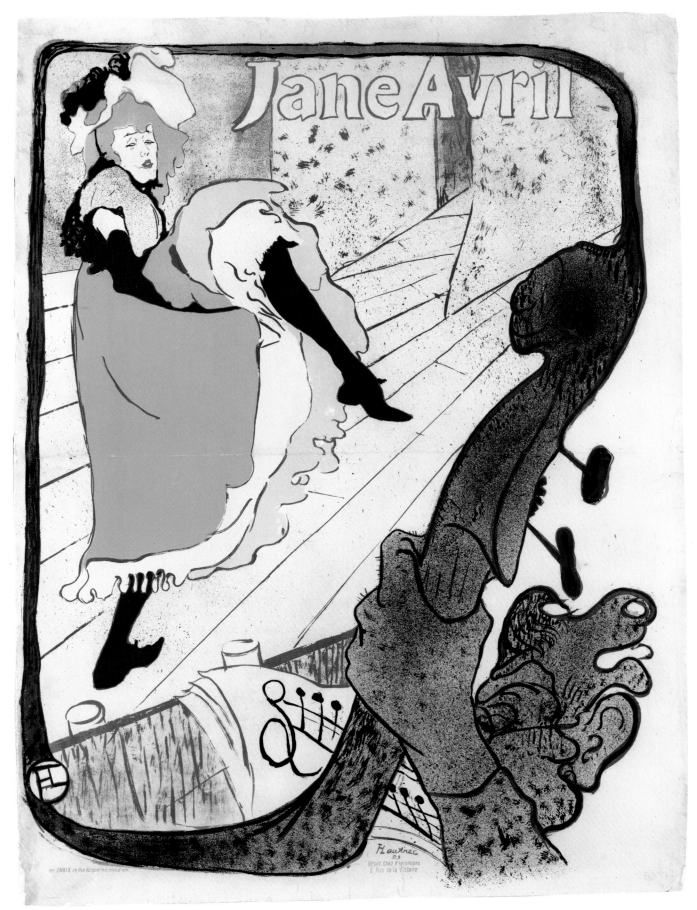

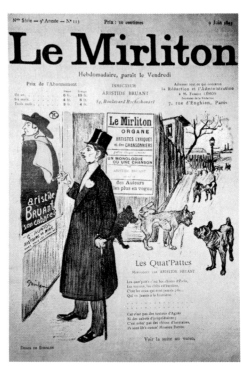

Title page of the periodical *Le Mirliton*,
9 June 1893

12 ARISTIDE BRUANT DANS SON
CABARET 1893
Aristide Bruant in his Cabaret

Colour lithograph, poster; consisting of
two parts joined in the middle of the
picture, some impressions printed on one
and some on two sheets of paper.
First state. No lettering, drawing in olive
green with black, red and curry brown;
ink with brush and spraying technique.
1273 × 950 mm.
Signed on the stone, lower left, with
monogram in red; address of the printer
on lower left edge of the picture: 'Sté
ANme IMPie & PUBté CHARLES
VERNEAU 114, Rue Oberkampf, Paris'.
Poster paper.
Size of edition not known.
Delteil 348 I; Adhémar 15 I; Adriani 14 I;
Wittrock P 9 A.
Part of the edition had the following text,
added on Bruant's instructions in 1912:
'BRUANT/Revient/à/Montmartre/dans/
COMÉDIE MONDAIN/75, rue des
Martyrs/Du Vendredi/22 Mars/au Jeudi/4
Avril [1912]'. Two of these are known.
Second state. The image was transferred to
new stones and the following lettering,
designed by Lautrec, was added in white
using the spraying technique: 'aristide/
BRUANT/dans son cabaret'.
A new printer's address appears on the
left-hand edge of the picture: 'Imp.
EDW. ANCOURT et Cie PARIS
(DÉPOSÉ)'.
Size of edition not known (*c.* 1000–3000).
Delteil 348 II; Adhémar 15 II;
Adriani 14 II; Wittrock P 9 C.
Part of the edition also had the following
text in black lettering, not designed by
Lautrec, added later on Bruant's
instructions, upper left: 'THEATRE
ROYAL/DES/Galeries Saint-Hubert/
SAMEDI 8 JUILLET [1899]' or: 'Alcazar
Lyrique'. One impression is known of
each.

The title page designed by Théophile
Alexandre Steinlen for the illustrated
magazine published by Bruant, *Le
Mirliton* (9, No. 113 of 9 June 1893),
shows a man looking at the Lautrec poster
on a wall (ill. above left). Bruant also had
a smaller version of the poster made
(505 × 385 mm), which was based on the
watercolour Dortu A.205, and sold this,
signed and numbered by himself, in his
bar Le Mirliton (*Cat. Toulouse-Lautrec*,
A 11).

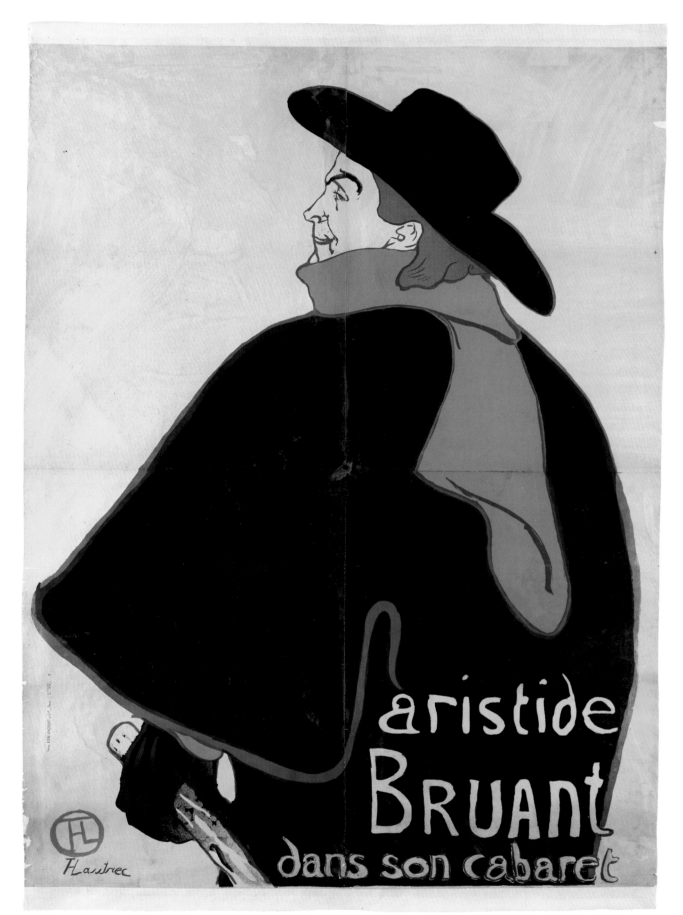

aristide
Bruant
dans son cabaret

12·II

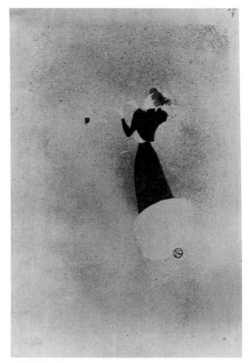

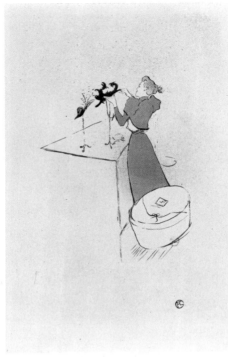

13·I Trial proof

13·II

13 La Modiste, Renée Vert 1893
The Milliner, Renée Vert

Colour lithograph, menu card.
First state. With menu text designed by
Lautrec: 'menu/Potages . . .'.
Drawing in olive green with grey-beige;
ink with brush and spraying technique.
460 × 290 mm.
Monogram on the stone, lower right.
Vellum.
Size of edition not known; 15 trial proofs
are also known, taken from the key stone
in olive green or black, and from the
colour stone in various tints – printed
singly and together.
Delteil 13 II; Adhémar 17 II; Adriani 16 II;
Wittrock 4 I.
The impression shown here, which is
unevenly printed, has Lautrec's note
'passe' lower right in pencil and his
monogram stamp in red (Lugt 1338).
Second state. Menu text removed.
455 × 305 mm.
Edition of 50, 25 numbered on Japan
paper and signed lower left by the artist in
pencil, and 25 on vellum, stamped lower
right with Lautrec's red monogram (Lugt
1338).
Delteil 13 I; Adhémar 17 I; Adriani 16 I;
Wittrock 4 II.

This menu card, showing the milliner
Renée Vert or one of her assistants, is one
of Lautrec's most delicate works in the
field of commercial graphics. The print
was made by Ancourt, Paris, and it was
based on a drawing made on transfer
paper Dortu D.3459 and the studies
Dortu D.3457 (note on left by the artist,
'Menu du 23') and D.3458. The edition
with the drawing and no text was
published by Edouard Kleinmann.
 Renée Vert had long been a member of
Lautrec's circle. In 1893 she married his
student friend, Adolphe Albert, who was
later secretary of the Société des Peintres-
Graveurs Français (see No. 304). Lautrec
had exhibited works in the Salon des
Indépendants in March 1893 (from 1889
to 1897 he regularly sent works to the
exhibitions held by this organization,
which was in opposition to the official
Salon). He was singled out for particular
praise in the *Chronique des Arts* on 1 April,
and it was perhaps for this reason that he
was asked to design the menu card for a
dinner given by the Société des
Indépendants on 23 June 1893.

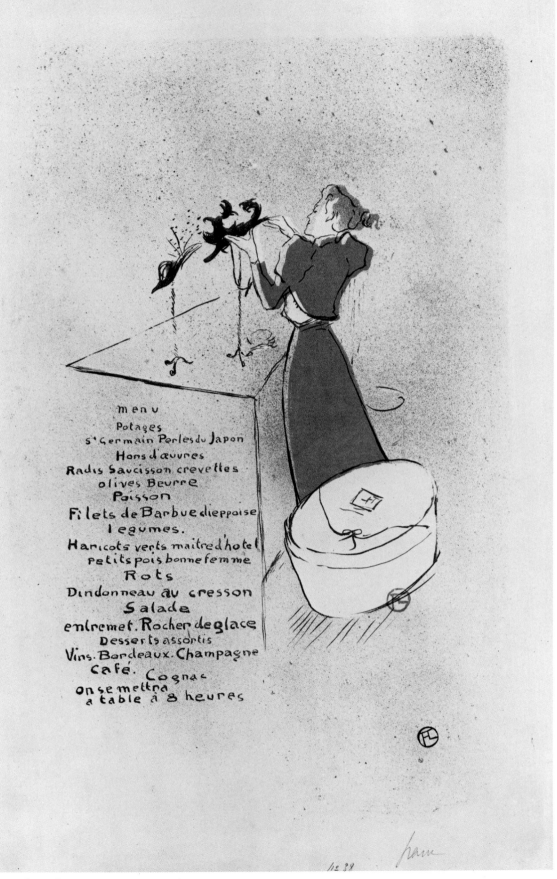

menu
Potages
St Germain Perles du Japon
Hors d'œuvres
Radis Saucisson crevettes
olives Beurre
Poisson
Filets de Barbue dieppoise
legumes.
Haricots verts maître d'hôtel
petits pois bonne femme
Rots
Dindonneau au cresson
Salade
entremet. Rocher de glace
Desserts assortis
Vins. Bordeaux. Champagne
Café. Cognac
On se mettra
à table à 8 heures

13·1 Trial proof

Colour lithograph, poster.
First state. With lettering not designed by
Lautrec, in black and red:
'LIRE/DANS/Le Matin'.
Drawing in black with olive-grey,
reddish-brown and red; ink with brush
and spraying technique, chalk, worked
with a scraper.
825 × 590 mm.
Monogram on the stone, lower left.
Poster paper.
One impression known (Musée d'Albi).
Delteil 347 I; Adhémar 14 I; Adriani 13 I;
Wittrock P 8 (state not described).
Second state. With additional text in
lettering not designed by Lautrec in dark
blue, bottom: 'au Pied /DE/
L'ÉCHAFAUD/MÉMOIRES DE/l'abbé
Faure'.
In addition to the above colours there is
dark blue on the lettering, the basket and
the ground.
On the stone lower left beside the
monogram, the address of the printer:
'CHAIX 20, Rue Bergère PARIS' and
'(ENCRES CH. LORILLEUX & Cie)'.
Size of edition not known (about 1000).
Delteil 347 II; Adhémar 14 II;
Adriani 13 II; Wittrock P 8.

The advertisement for the memoirs of
Abbé Faure (At the Foot of the Scaffold),
written in 1891, is somewhat lurid. This
account of the experiences of a prison
priest, who accompanied 38 delinquents
to the guillotine during his years of
service, was serialized by *Le Matin* in
autumn 1893. The colour lithograph was
based on the painted study Dortu P.511,
which was owned by Alfred Edwards, the
editor of *Le Matin*, who also
commissioned the poster. Lautrec wrote
to his mother on 17 or 24 July 1893 that
he had to design a poster for *Le Matin*
(Goldschmidt-Schimmel, No. 162). The
arrangement of the lettering, the line of
figures in silhouette across the middle of
the picture, and the main group cutting
across the foreground echo the main
features of the MOULIN ROUGE poster
(No. 1).

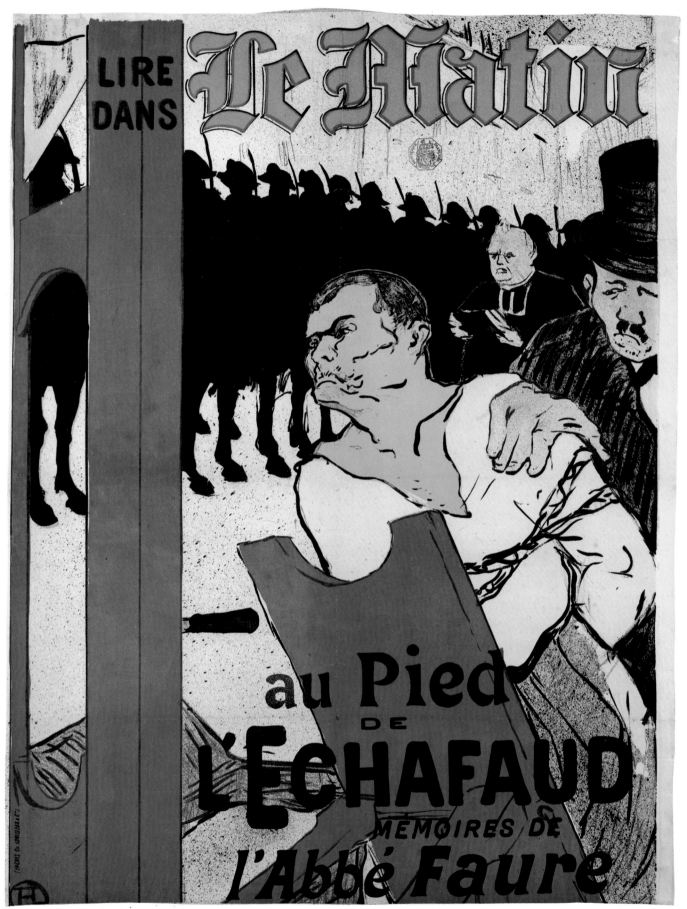

14·II

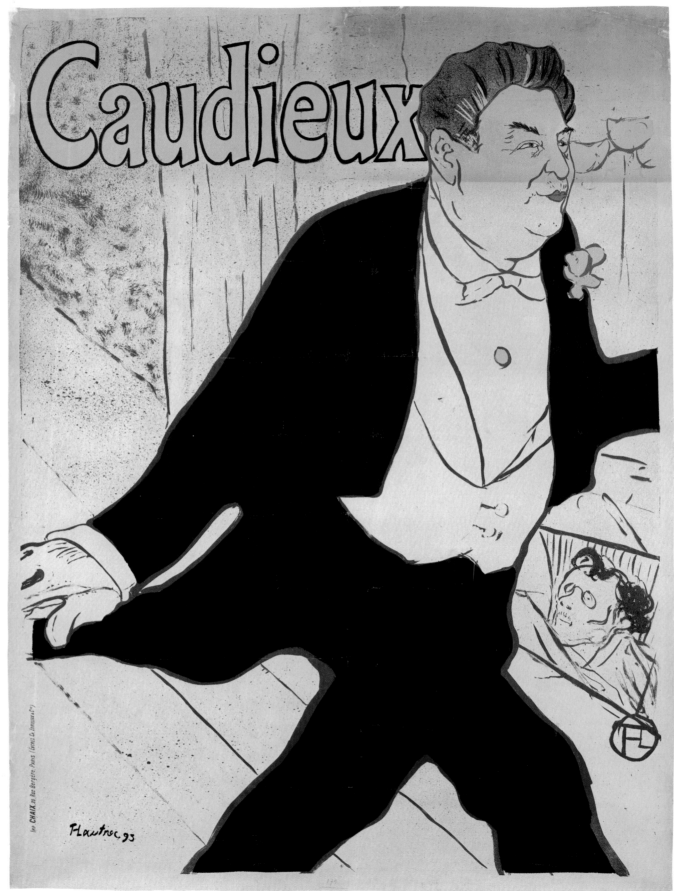

15

15 CAUDIEUX 1893

Colour lithograph, poster, with lettering designed by Lautrec in yellow and black: 'Caudieux'.
Drawing in olive green with yellow, red and black; ink with brush and spraying technique.
1246 × 895 mm.
Monogram on the stone, lower right; signed and dated lower left in black, with the address of the printer: 'IMP. CHAIX 20, Rue Bergère, PARIS (Encres CH. LORILLEUX & Cie)'.
Poster paper.
Size of edition not known (*c*. 1000–3000).
Delteil 346; Adhémar 13; Adriani 12; Wittrock P 7.

The compositional arrangement that had been so effective in the JANE AVRIL posters (Nos. 8, 11) and elsewhere, of a stage rising diagonally across the poster, is used with similar colouring in the poster for the comedian Caudieux, who appeared at the Petit Casino, the Eldorado and the Ambassadeurs (see No. 23); *cf.* the charcoal drawing Dortu D.3324 (Musée d'Albi), a colour study, also on a large scale Dortu P.474 (Musée d'Albi), and the rough sketches Dortu D.3369 and D.3453.

16–26 LE CAFÉ CONCERT 1893
The Café-Concert

Series of 22 lithographs in one folder, 11 by H. G. Ibels and 11 by H. de Toulouse-Lautrec. The complete series, which had a foreword by Georges Montorgueil, depicts matadors and scenes from the Paris *cafés concert*. It was commissioned by André Marty and published by *L'Estampe Originale*. Lautrec had to share the commission with Henri Gabriel Ibels, a cartoonist and political caricaturist who was then much more widely known than Lautrec. We can only deduce the sequence in which the prints were made, some of which are related to posters already mentioned, from the fact that the first, which shows JANE AVRIL dancing (No. 16), was reproduced in the issue for 29 July 1893 of the magazine *L'Art Français*; most of the others, designed during that year, were published on 9 December in the supplement to *L'Echo de Paris* (Nos. 16–20, 22, 23, 26). The album was printed by Edw. Ancourt & Cie, 83 Rue du Faubourg Saint-Denis, and sold by the publisher at 20 francs (standard edition of 500 impressions on vellum), and 50 francs (de luxe edition of 50 impressions on hand-made Japan paper). The album was deposited in the Bibliothèque Nationale in Paris on 13 December 1893. The cover of the standard edition (442 × 325 mm) has a *café-concert* scene designed by Ibels with the following text in red: 'Le Café-Concert/ LITHOGRAPHIES/DE/H.-G. Ibels/ET DE/H. de Toulouse-Lautrec/TEXTE DE GEORGES MONTORGUEIL/Edité par 'L'Estampe originale', 17, rue de Rome – Paris'. The cover of the de luxe edition (475 × 330 mm) has the following text in black: 'Le Café Concert/Prix: cinquante francs'; it is signed in blue ink, lower right, by Ibels, Montorgueil and Lautrec. The Gerstenberg Collection has both the de luxe and the standard editions.

16 JANE AVRIL 1893

Lithograph, plate 1 of the *Le Café Concert* series.
First state. Drawing in black; ink with brush, and spraying technique.
266 × 215 mm.
Monogram on the stone, lower left.
Vellum, hand-made Japan paper.
Edition of 550, 50 a de luxe edition on hand-made Japan paper.
Delteil 28; Adhémar 28 I; Adriani 17 I; Wittrock 18.
Second state. After the *Le Café Concert* series, the image was transferred to a new stone in 1894 and used for sheet music, with a text not designed by Lautrec: 'repertoire/de Jane Avril/1 Les petites Miss/2 Mon anglais . . .' (the page also bore the address of the publisher A. Bosc and the name of the printer Chaimbaud & Cie, Paris).
Drawing in olive green.
255 × 220 mm.
Signed in the stone lower right.
Vellum.
Size of edition not known.
Delteil 28 (state not described); Adhémar 28 II; Adriani 17 II; Wittrock 18.
New edition (after 1901). Bracket-shaped drawing in upper left-hand corner removed; no text added; drawing again in black.

17 YVETTE GUILBERT 1893

Lithograph, plate 2 of the *Le Café Concert* series.
Drawing in dark olive green; chalk, ink with brush.
253 × 223 mm.
Monogram on the stone, lower right.
Vellum, hand-made Japan paper.
Edition of 550, 50 a de luxe edition on hand-made Japan paper.
Delteil 29; Adhémar 29; Adriani 18; Wittrock 19.

Yvette Guilbert was engaged at the Scala at this time.

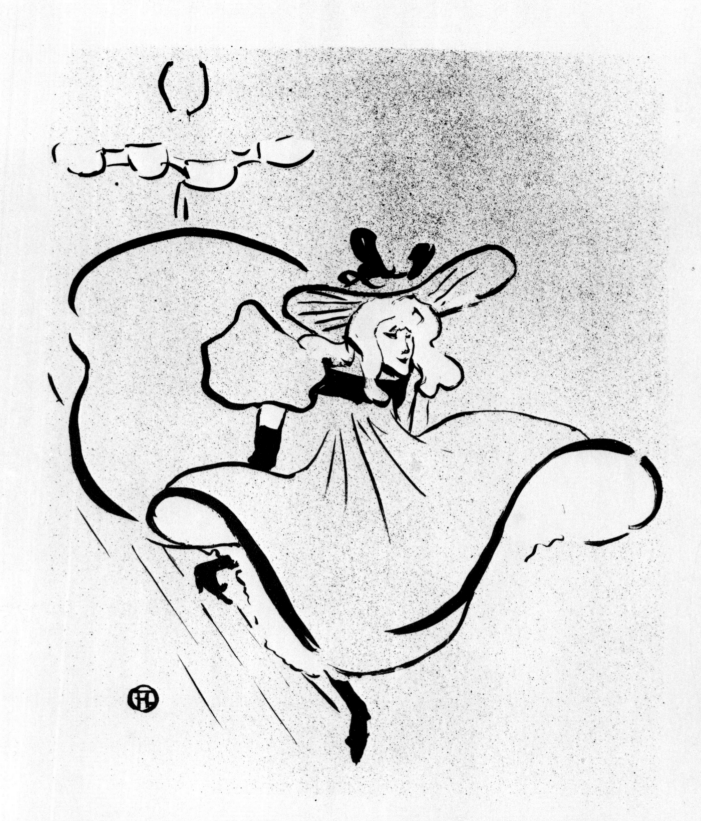

16·I

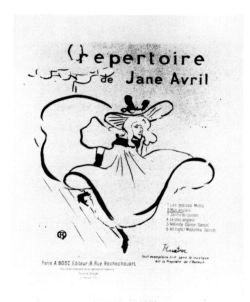

18 PAULA BRÉBION 1893

Lithograph, plate 3 of the *Le Café Concert* series.
Drawing in olive green; ink with brush.
262 × 197 mm.
Monogram on the stone, lower left.
Vellum, hand-made Japan paper.
Edition of 550, 50 a de luxe edition on hand-made Japan paper.
Delteil 30; Adhémar 30; Adriani 19; Wittrock 20.

Paula Brébion (born in 1860) was a singer who had enjoyed great success at the Eldorado, the Alcazar and the Scala; Georges Montorgueil described her as 'dark and powerful, with wide open eyes light as water, and the lisping voice of a little girl, when she wistfully stretches out her lovely arms, singing her constant refrain: 'Ah, how I love the soldier boys!' A preparatory drawing (325 × 250 mm), not listed by Dortu, is in the Boymans-van Beuningen Museum, Rotterdam (Inv. No. F II 202).

16·II 18

19 MARY HAMILTON 1893

Lithograph, plate 4 of the *Le Café Concert* series.
Drawing in olive green; ink with brush, chalk.
268 × 163 mm.
Monogram on the stone, lower edge.
Vellum, hand-made Japan paper.
Edition of 550, 50 a de luxe edition on hand-made Japan paper.
Delteil 31; Adhémar 31; Adriani 20; Wittrock 21.

The lithograph depicts the English *diseuse* Mary Hamilton, who appeared in male dress; *cf.* the later print, probably drawn from memory (No. 142).

17 19

20 EDMÉE LESCOT 1893

Lithograph, plate 5 of the *Le Café Concert*
series.
Drawing in black; ink with brush and
spraying technique, chalk, worked with
the scraper.
270 × 190 mm.
Monogram on the stone, lower edge.
Vellum, hand-made Japan paper.
Edition of 550, 50 a de luxe edition on
hand-made Japan paper.
Delteil 32; Adhémar 32; Adriani 21;
Wittrock 22.

Edmée Lescot appeared as a Spanish
dancer at the Ambassadeurs; *cf.* the detail
study Dortu D.3426.

21 MADAME ABDALA 1893

Lithograph, plate 6 of the *Le Café Concert*
series.
Drawing in black; ink with brush and
spraying technique, worked with the
scraper.
270 × 200 mm.
Monogram on the stone, lower right.
Vellum, hand-made Japan paper.
Edition of 550, 50 a de luxe edition on
hand-made Japan paper.
Delteil 33; Adhémar 35; Adriani 22;
Wittrock 23.

Madame Abdala was a singer who
appeared at the Ambassadeurs and the
Scala in 1893. Montorgueil wrote of her:
'She is extraordinarily thin and she does
all the things naughty little girls dream of,
like sticking out her tongue, squinting,
making faces and rolling her eyes . . .
Bony and angular, Abdala sometimes
looks like a Daumier in the play of the
lights and the shadows.'

22 ARISTIDE BRUANT 1893

Lithograph, plate 7 of the *Le Café Concert
Concert* series.
Drawing in black; chalk, ink with brush
and spraying technique.
268 × 215 mm.
Monogram on the stone, lower right.
Vellum, hand-made Japan paper.
Edition of 550, 50 a de luxe edition on
hand-made Japan paper.
Delteil 34; Adhémar 38; Adriani 23;
Wittrock 24.

The drawing Dortu D.3447 was a study
for the print. The litho stone is now in the
Musée d'Albi.

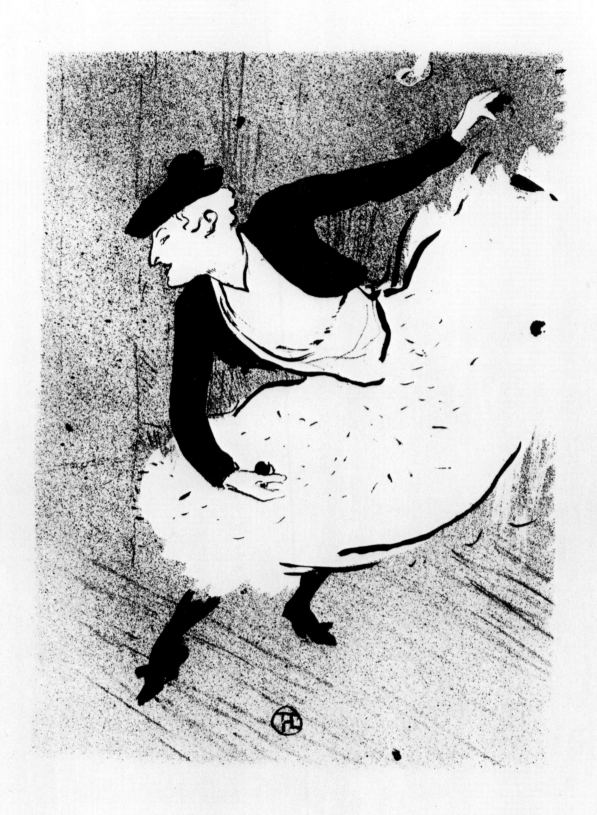

20

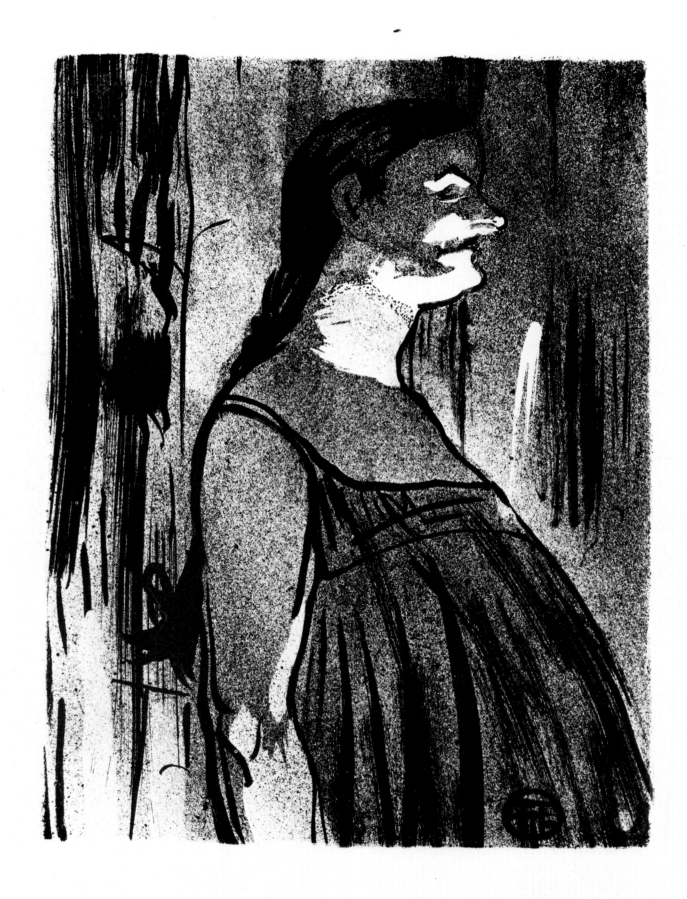

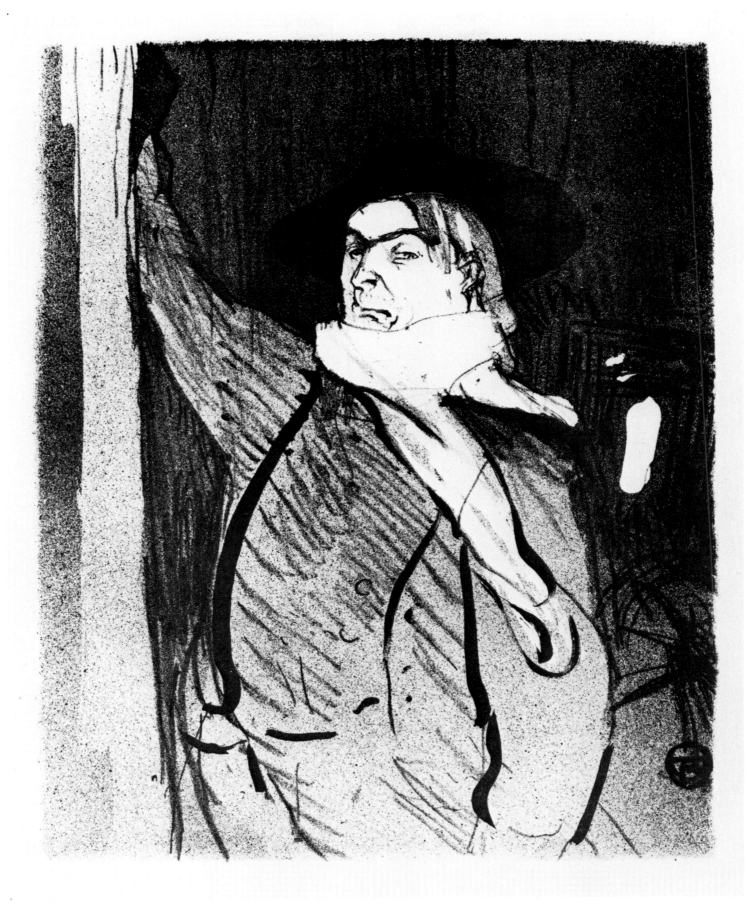

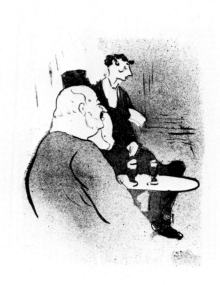

24

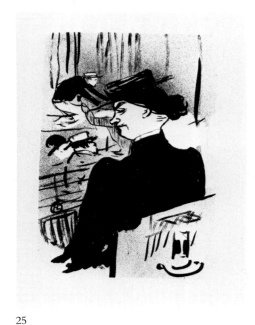

25

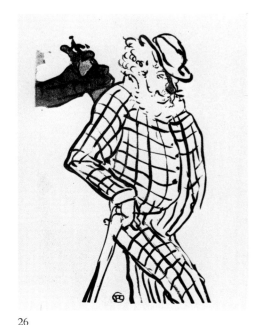

26

23 CAUDIEUX, PETIT CASINO 1893
Caudieux at the Petit Casino

Lithograph, plate 8 of the *Le Café Concert* series.
Drawing in black; chalk, sprayed ink, worked with the scraper.
275 × 218 mm.
Monogram on the stone, lower left.
Vellum, hand-made Japan paper.
Edition of 550, 50 a de luxe edition on hand-made Japan paper.
Delteil 35; Adhémar 36; Adriani 24; Wittrock 25.

The comedian Caudieux danced mainly at the Petit Casino (see No. 15).

24 DUCARRE AUX AMBASSADEURS 1893
Ducarre at the Ambassadeurs

Lithograph, plate 9 of the *Le Café Concert* series.
Drawing in black; ink with brush and spraying technique.
260 × 199 mm.
Monogram on the stone, lower right.
Vellum, hand-made Japan paper.
Edition of 550, 50 a de luxe edition on hand-made Japan paper.
Delteil 36; Adhémar 33; Adriani 25; Wittrock 26.

In the foreground is Pierre Ducarre, manager of the *cafés concert* Alcazar d'Eté and the Ambassadeurs, and who, according to Yvette Guilbert, always looked like a guest at a poor people's wedding; *cf.* the portrait study Dortu D.3738 (Jäggli-Hahnloser Collection, Winterthur).

25 UNE SPECTATRICE 1893
A Spectator

Lithograph, plate 10 of the *Le Café Concert* series.
Drawing in black; ink with brush and spraying technique, worked with the scraper.
269 × 185 mm.
Monogram on the stone, left.
Vellum, hand-made Japan paper.
Edition of 550, 50 a de luxe edition on hand-made Japan paper.
Delteil 37; Adhémar 37; Adriani 26; Wittrock 27.

On the stage behind the spectator is the comedian Pierre-Paul Marsalès, born in 1863 and known as Polin. Compare the portrait study of the spectator Dortu D.3372.

26 COMIQUE EXCENTRIQUE ANGLAIS 1893
Eccentric English Comedian

Lithograph, plate 11 of the *Le Café Concert* series.
Drawing in black; ink with brush and spraying technique.
278 × 205 mm.
Monogram on the stone, lower edge.
Vellum, hand-made Japan paper.
Edition of 550, 50 a de luxe edition on hand-made Japan paper.
Delteil 38; Adhémar 34; Adriani 27; Wittrock 28.

English comedians were all the rage in *fin-de-siècle* Paris.

23

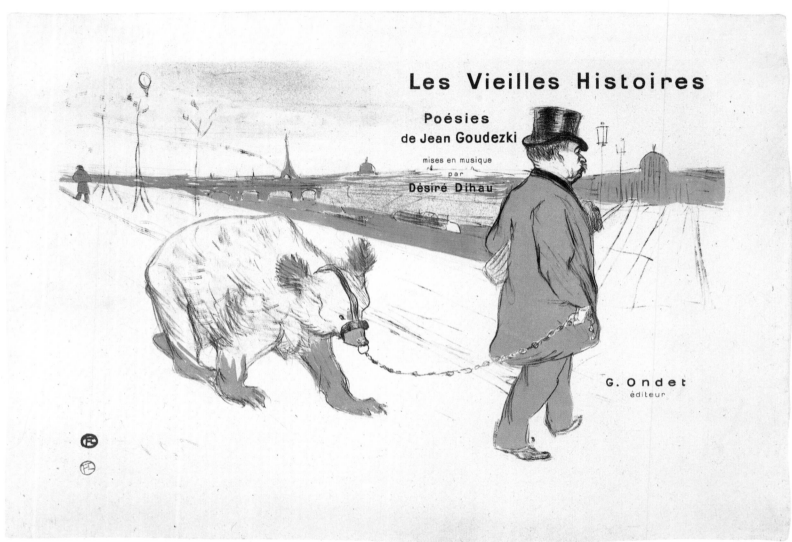

27·III

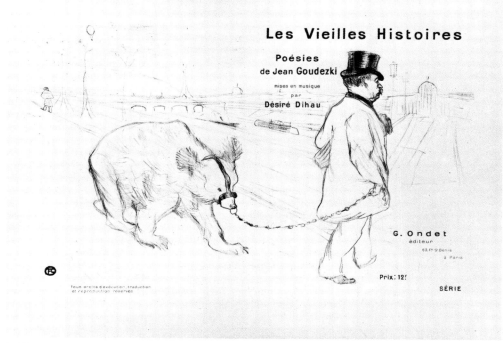

27·II

27–32 'LES VIEILLES HISTOIRES' 1893

A collection of song titles. Henri Gabriel
Ibels had persuaded the music publisher
Gustave Ondet, who lived in the building
which housed the Ancourt printing
works at 83 Rue du Faubourg Saint-
Denis, to have his titles designed by well-
known artists. In addition to Ibels himself,
Ondet asked Lautrec, Henri Rachou and
others to design title pages for the song
collection entitled *Les Vieilles Histoires*
(The Old Tales). These were poems by
Jean Goudezki set to popular romance
melodies by Désiré Dihau. Lautrec
designed the cover and titles 2, 4, 5, 8 and
9 in the first series published by Ondet,
which consisted of ten songs in all at 2
francs each. The lithographs are closely
related, in time and style, to the *Le Café
Concert* series. Each of the titles exists in a
state before the lettering was added in an
edition of 100, which was sold by
Edouard Kleinmann; 40 of these were
coloured by another hand using stencils.

27 'LES VIEILLES HISTOIRES',
COUVERTURE 1893
'Les Vieilles Histoires', Cover

Lithograph, cover for the *Les Vieilles
Histoires* suite.
First state. Without lettering.
Drawing in olive green; chalk, ink with
brush.
340 × 540 mm.
Monogram on the stone, lower left.
Vellum.
Delteil mentions impressions.
Delteil 18 I; Adhémar 19 I; Adriani 28 I;
Wittrock 5 I.
Second state. With lettering in black, not
designed by Lautrec, in the right half of
the picture: 'Les Vieilles Histoires/Poésies/
de Jean Goudezki/mises en musique/par/
Désiré Dihau/G. Ondet/éditeur/83. Fg.
St. Denis/à Paris./Prix: 12 f./SÉRIE'; and
in the lower left-hand half: 'Tous droits
d'exécution, traduction/et réproduction
réservés'.
Size of edition not known (more than
100).
Delteil 18 III; Adhémar 19 III;
Adriani 28 III; Wittrock 5 I.
Third state. The following text has been
removed: '83. Fg. St. Denis/à Paris/Prix:
12f./SÉRIE/Tous droits d'exécution,

traduction/et réproduction réservés'.
Drawing in olive green with grey, curry
brown, mauve and turquoise; chalk, ink
with brush and spraying technique.
355 × 546 mm.
Edition of 100, stamped lower left with
Lautrec's red monogram (Lugt 1338);
three trial proofs are also known,
including one not mentioned by Dortu,
coloured in watercolour with the
drawing in black (National Gallery,
Washington).
Delteil 18 II; Adhémar 19 II; Adriani 28 II;
Wittrock 5 II.

The main figure in the drawing is Désiré
Dihau (1835–1909). He played the
bassoon in the orchestra of the Opéra and
wrote cabaret songs in his free time, as
well as composing melodies to texts by
Jean Richepin, Achille Melandri and
others. In all Lautrec eventually designed
26 music titles for Dihau, who was a
distant cousin of his from Lille (*cf.* Nos. 28
and 144). Here we see him leading a bear
along the auspicious route to the Institut
de France which is dimly perceived in the
background (although reversed); the bear
being led by the nose is a satire on the
poet Jean Goudezki.

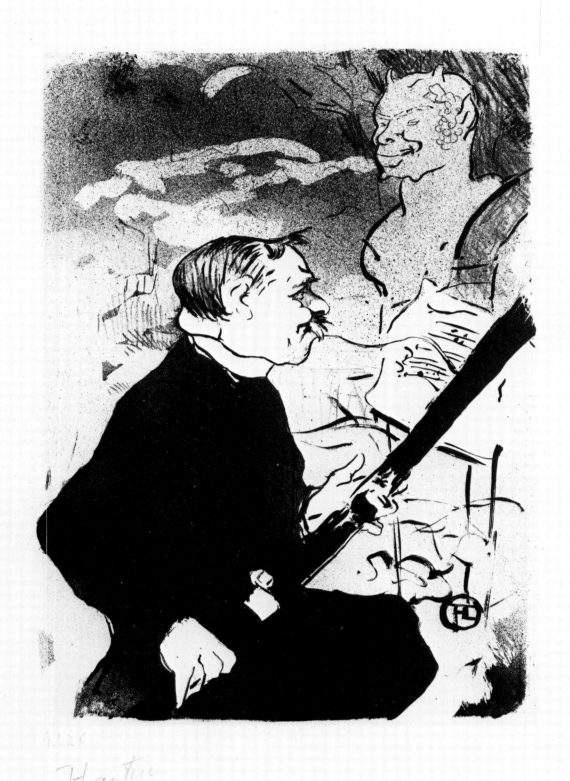

28·I

28 'Pour Toi! . . .' 1893

Lithograph, second song title (For You) from the *Les Vieilles Histoires* suite.
First state. Without lettering.
Drawing in black; chalk, ink with brush and spraying technique.
275 × 197 mm.
Monogram on the stone, lower right.
Imitation Japan paper, mounted vellum, vellum.
Edition of 100 numbered, signed by the artist in pencil, lower left, and stamped with the blind stamp of the publisher Kleinmann (Lugt 1573); 20 of these (Nos. 1–20) are on imitation Japan paper, 40 (Nos. 21–60) on mounted vellum and 40 (Nos. 61–100) on vellum; the last group are coloured by another hand using stencils (red, pink, turquoise and brown). Two trial proofs are also known; one in watercolour – Dortu A.208 (Jean Cailac Collection, Paris) – with the artist's instructions for the colouring: 'cinq teintes/cheveux verts'.
Delteil 19 I; Adhémar 20 I; Adriani 29 I; Wittrock 6.
Second state. The image transferred to a new stone and printed by Joly, Paris, with the following text, not designed by Lautrec: 'Les Vieilles Histoires/. . . Pour toi!/. . .' (with information on the edition, the address of the editor G. Ondet and of the publisher Ed. Kleinmann).
270 × 195 mm.
Vellum.
Size of edition not known (several hundred), some coloured with stencils.
Delteil 19 II; Adhémar 20 II; Adriani 29 II; Wittrock 6 (Wittrock mentions new editions with changes to the text without giving any further information).
New edition (1927). Without text, published by Henry Floury to mark the de luxe edition of Maurice Joyant's biography, *Henri de Toulouse-Lautrec. Dessins, Estampes, Affiches*, Paris 1927.
Drawing in black or olive green.
275 × 195 mm.
The monogram of the publisher, Henry Floury, added on the stone, lower left.
Imitation Japan paper, vellum.
400 impressions, of which 200 are numbered and printed in olive green on imitation Japan paper, and 200 in black on vellum.

Désiré Dihau (see No. 27) played a particular role in Lautrec's life on account of his friendship with Edgar Degas, and the cover of Pour Toi!, for which the preparatory pencil sketches Dortu D.3381 to D.3383 were made, can be seen as homage to the artist Lautrec so greatly admired and whom he had met in 1889 through the Dihau family. It is a variation on Degas' portrait of Dihau, who was a bassoonist, in an oil painting finished twenty-five years previously, L'Orchestre de l'Opéra. This hung in the Dihaus' apartment in the Avenue Frochot, and was probably the main reason for Lautrec's frequent visits to his relations. As late as 1898 Lautrec took dinner guests to the Dihaus late at night to show them Degas' masterpiece, (now in the Musée d'Orsay) 'as a dessert'. The litho stone (for the Floury edition) is in the Musée d'Albi.

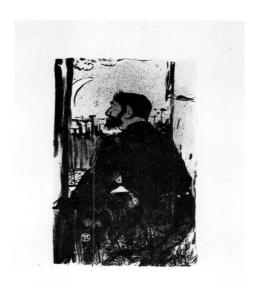

29 'Nuit Blanche' 1893

29·I

Lithograph, fourth title (Sleepless Night) from the *Les Vieilles Histoires* suite.
First state. Without lettering.
Drawing in black; ink with brush, and spraying technique, worked with the scraper.
253 × 170 mm.
Monogram on the stone, lower left.
Imitation Japan paper, mounted vellum, vellum.
Edition of 100 numbered, signed by the artist in pencil lower left and stamped with the blind stamp of the publisher Kleinmann (Lugt 1573); 20 of these (Nos. 1–20) are on imitation Japan paper, 40 (Nos. 21–60) on mounted vellum, and 40 (Nos. 61–100) on vellum; the last group have been coloured by another hand using stencils (blue). One impression with watercolour is also known, Dortu A.209 (Jean Cailac Collection, Paris), bearing the artist's instructions for the colouring: 'Deux tons de bleu violacé et verdâtre/Jaune dans la lune'.
Delteil 20 I; Adhémar 21 I; Adriani 30 I; Wittrock 8.
Second state. The image transferred to a new stone and printed by Joly, Paris, with the following text not designed by Lautrec: 'Les Vieilles Histoires/. . . Nuit Blanche . . .' (also information on the edition, the address of the publisher, Ed. Kleinmann, and the editor, G. Ondet).
260 × 173 mm.
Vellum.
Size of edition not known (several hundred), some coloured with stencils.
Delteil 20 II; Adhémar 21 II; Adriani 30 II; Wittrock 8 (Wittrock also mentions new editions with changes to the text without giving further information).

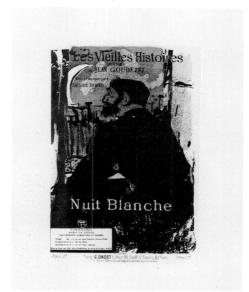

29·II

Lithograph, fifth title (Your Mouth) from the *Les Vieilles Histoires* suite.
First state. Without lettering.
Drawing in olive green; ink with brush.
253 × 177 mm.
Monogram on the stone, lower left.
Japan paper, vellum.
Edition of 100 numbered, signed by the artist in pencil lower left and stamped with the blind stamp of the publisher Kleinmann (Lugt 1573); 20 of these (Nos. 1−20) are on Japan paper, 40 (Nos. 21−60) on mounted vellum, and 40 (61−100) on vellum; the last group are coloured by another hand using stencils (green and red). Four trial proofs in different colours are also known, one of which bears the artist's instructions for colouring: 'J'aime [?] noir, bleu et vert' (Art Institute, Chicago).
Delteil 21 I; Adhémar 25 I; Adriani 31 I; Wittrock 7.
Second state. The image transferred to a new stone and printed by Joly, Paris, with the following text not designed by Lautrec: 'A Monsieur Yvain de l'Eden-Concert/Les Vieilles Histoires . . ./Ta Bouche/. . .' (with information on the edition, the address of the editor G. Ondet and the publisher Ed. Kleinmann).
Drawing in black.
Vellum.
Size of edition not known (several hundred), some coloured with stencils.
Delteil 21 II; Adhémar 25 II; Adriani 31 II; Wittrock 7 (Wittrock mentions new editions with changes to the text, without giving further information).
New edition (after 1901). No lettering.
Drawing in olive green or reddish brown.

The litho stone (second state) is in the Musée d'Albi. See the study for the sleeping woman Dortu D.3744 (Musée du Louvre, Paris).

30·I

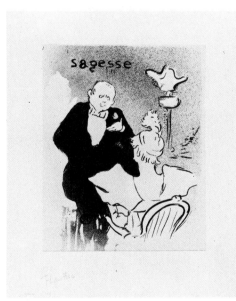

31·II

Lithograph, eighth title (Wisdom) from the *Les Vieilles Histoires* suite.
First state. White areas on the arms of the figure and the lamp; with lettering by Lautrec, upper left: 'sagesse'.
Drawing in olive green; ink with brush and spraying technique.
265 × 180 mm.
Monogram on the stone, lower left.
Vellum.
One impression known (Bibliothèque Nationale, Paris).
Delteil 22 (state not described); Adhémar 23 I; Adriani 32 I; Wittrock 9 I.
Second state. The white areas painted out or stippled, more drawing to the right of the lamp.
Drawing in black.
255 × 190 mm.
Japan paper, mounted vellum, vellum.
Edition of 100 numbered, signed by the artist in pencil lower left and stamped with the blind stamp of the publisher Kleinmann (Lugt 1573); of these, 20 (Nos. 1−20) are on Japan paper, 40 (Nos. 21−60) on mounted vellum, and 40 (61−100) on vellum; the last group are coloured by another hand using stencils (beige, pink, brown and turquoise). One impression with watercolour is also known, Dortu A.210 (Bibliothèque Nationale, Paris), bearing the artist's instructions: 'cinq teintes'.
Delteil 22 I; Adhémar 23 (state not described); Adriani 32 II; Wittrock 9 II.
Third state. The image transferred to a new stone and printed by Joly, Paris, with the following text not by Lautrec: 'Les Vieilles Histoires . . .' (with information on the edition, the address of the editor G. Ondet and the publisher Ed. Kleinmann).
260 × 180 mm.
Vellum.
Size of edition not known (several hundred), some coloured with stencils.
Delteil 22 II; Adhémar 23; Adriani 32 III; Wittrock 9 (Wittrock also mentions new editions with changes to the text but gives no further information).
New edition (1927). Without lettering.
Drawing in black or olive green.
260 × 195 mm.
The monogram of the publisher Henry Floury added on the stone, lower left.
Imitation Japan paper, vellum.
400 impressions, see No. 28.

The image, showing Miss Ethel Watts with Numa Baragnon, the editor of *Le Siècle*, at the Marquise de Villars' masked ball, was carefully prepared with five detail sketches, Dortu D.3377, D.3378, D.3384, D.3387 and D.3444. The litho stones (second and third state) are in the Musée d'Albi.

32 'ULTIME BALLADE' 1893

Lithograph, ninth title (Last Ballad) from the *Les Vieilles Histoires* suite.
First state. No lettering.
Drawing in black; ink with brush and spraying technique.
265 × 182 mm.
Monogram on the stone, lower edge.
Imitation Japan paper, mounted vellum, vellum.
Edition of 100 numbered, signed by the artist in pencil lower left, some with the blind stamp of the publisher Kleinmann (Lugt 1573); 20 of these (Nos. 1–20) are on imitation Japan paper, 40 (Nos. 21–60) on mounted vellum, and 40 (Nos. 61–100) on vellum. The last group are coloured by another hand with stencils (yellow).
Delteil 23 I; Adhémar 22 I; Adriani 33 I; Wittrock 10.
Second state. The image transferred to a new stone and printed by Joly, Paris, with the following text not by Lautrec: 'Les Vieilles Histoires/.../Ultime Ballade/...' (with information on the edition, the address of the editor G. Ondet and the publisher Ed. Kleinmann).
Vellum.
Size of edition not known (several hundred), some coloured with stencils.
Delteil 23 II; Adhémar 22 II; Adriani 33 II; Wittrock 10 (Wittrock mentions new editions with changes to the text but gives no further information).

32·I

33·I

33 'ETUDE DE FEMME' 1893

Lithograph; although treated in the same way as the previous prints, this song title (Study of a Woman) is not in the *Les Vieilles Histoires* suite.
First state. No lettering.
Drawing in olive green; ink with brush and spraying technique.
265 × 200 mm.
Monogram on the stone, lower right.
Japan paper, mounted vellum, vellum.
Edition of 100 numbered impressions, signed by the artist in pencil lower left, some with the blind stamp of the publisher Kleinmann (Lugt 1573); 20 (Nos. 1–20) are on Japan paper, 40 (Nos. 21–60) on mounted vellum, and 40 (Nos. 61–100) on vellum. The last group are coloured by another hand with stencils (turquoise and yellow). Three trial proofs are also known in reddish brown, green and red.
Delteil 24 I; Adhémar 26 I; Adriani 34 I; Wittrock 11.
Second state. The image transferred to a new stone and printed by Joly, Paris, with the following text not designed by Lautrec: 'ETUDE DE FEMME/Poésie d'Hector SOMBRE...' (with information on the edition, the address of the publisher Ed. Kleinmann and the editor G. Ondet).
Drawing in black.
Vellum.
Size of edition not known (several hundred), some coloured with stencils.
Delteil 24 II; Adhémar 26 II; Adriani 34 II; Wittrock 11 (Wittrock mentions new editions with changes to the text but gives no further information).
New edition (1927). Without lettering.
Drawing in black or olive green.
Monogram of the publisher Henry Floury added on the stone, lower left.
Imitation Japan paper, vellum.
400 impressions, see No. 28.

Compare the painted study Dortu P. 469 (Musée d'Albi); the litho stone for the Floury edition is also in the Musée d'Albi.

34 'CARNOT MALADE!' 1893

Lithograph; although treated in the same way as the above prints, this song title (Carnot Is Sick) is not in the *Les Vieilles Histoires* suite.
First state. Without lettering.
Drawing in black; ink with brush and spraying technique.
244 × 186 mm.
Monogram on the stone, lower left.
Imitation Japan paper, mounted vellum, vellum.
Edition of 100 numbered impressions, signed by the artist in pencil lower left, some with the blind stamp of the publisher Kleinmann (Lugt 1573); 20 (Nos. 1–20) are on imitation Japan paper, 40 (Nos. 21–60) on mounted vellum, and 40 (Nos. 61–100) on vellum. The last group are coloured by another hand with stencils (yellow, green, brown, blue and red).
Delteil 25 I; Adhémar 24; Adriani 35 II; Wittrock 12.
Second state. The image transferred to another stone and printed by Joly, Paris, with the following text not designed by Lautrec: 'Chansons du "Chat Noir"/CARNOT MALADE!/monologue/. . . d'Eugène LEMERCIER/. . .' (with information on the edition, the address of the publisher Ed. Kleinmann and the editor G. Ondet).
276 × 176 mm.
Vellum.
Size of edition not known (several hundred), some coloured with stencils.
Delteil 25 II; Adhémar 24; Adriani 35 III; Wittrock 12 (Wittrock also mentions new editions with changes to the text, but gives no further information).
New edition (after 1901). Text removed; new drawing on the edge of the pillow.
235 × 177 mm.
Imitation Japan paper.
Two impressions known (Bibliothèque Nationale, Paris; Rijksmuseum, Amsterdam).
New edition (1927). Without lettering.
Drawing in black or olive green.
244 × 186 mm.
Monogram of the publisher Henry Floury added on the stone, lower left.
Vellum, imitation Japan paper.
400 impressions, see No. 28.

The print shows Marie François Sadi Carnot (1837–1894), fourth president of the French Republic, who was ill in bed with a liver complaint in the summer of 1893; in June 1894 Carnot fell victim to an assassin. The satirical monologue compares the condition of the government under Carnot with his own illness. The litho stone (for the Floury edition) is in the Musée d'Albi.

35 'PAUVRE PIERREUSE!' 1893

Lithograph; although treated in the same way as the above prints, this song title (Poor Street-Walker) is not in the *Les Vieilles Histoires* suite.
First state. Without lettering.
Drawing in olive green; ink with brush.
240 × 172 mm.
Monogram on the stone, lower right.
Imitation Japan paper, mounted vellum, vellum.
Edition of 100 numbered impressions, signed by the artist in pencil lower left, some with the blind stamp of the publisher Kleinmann (Lugt 1573); 20 (Nos. 1–20) are on imitation Japan paper, 40 (Nos. 21–60) on mounted vellum, and 40 (Nos. 61–100) on vellum. The last group are coloured by another hand with stencils (grey, beige, reddish-brown and pink).
Delteil 26 I; Adhémar 27 I; Adriani 36 I; Wittrock 13.
Second state. The image transferred to a new stone and printed by Joly, Paris, with the following text not designed by Lautrec: '. . . PAUVRE PIERREUSE!/. . ./RÉPERTOIRE/D'EUGÉNIE BUFFET . . .' (with information on the edition, and the address of the editor G. Ondet and that of the publisher Ed. Kleinmann).
Drawing in black.
Vellum.
Size of edition not known (several hundred), some coloured with stencils.
Delteil 26 II; Adhémar 27 II; Adriani 36 II; Wittrock 13.
New edition (1918). The image transferred to a new stone and printed by Cavel, Paris, with the following text: 'L'Entôleuse/Chanson vécue/Créée par/YVETTE ANCENY . . .' (with the address of the editor G. Ondet).
Vellum, Japan paper.
Size of edition not known (several hundred).

The chalk drawing Dortu D.3449 and a painted study of the girl Dortu P.492 were used in the preparation of the lithograph. One litho stone (second state) is in the Musée d'Albi; another (new edition) is in the Museum of Fine Arts, Boston.

36 'LE PETIT TROTTIN' 1893

Lithograph, song title (The Little Errand Girl).
First state. With lettering designed by Lautrec: 'le petit trottin/paroles de/achille Melandri/musique/de/DESIRÉ/DIHAU'.
Drawing in black; ink with brush.
278 × 189 mm.
Monogram on the stone, lower left.
Imitation Japan paper, mounted vellum.
Edition of 30, signed by the artist in pencil lower left, some with the blind stamp of the publisher Kleinmann (Lugt 1573); one impression on hand-made Japan paper is also known (illustrated here) with a dedication 'à Maurice Guibert', who was the model for the print.
Delteil 27 I; Adhémar 18 I; Adriani 37 I; Wittrock 14.
Second state. The image transferred to a new stone and printed by Joly, Paris, with the following text not designed by Lautrec: 'Piano 3 f/Pt Format 1 f/Paris/A. FOUQUET, Éditr, 54, Fg. St. Denis'.
Drawing in black, coloured by another hand with stencils (yellow, green, pink, red and violet).
Vellum.
Size of edition not known (several hundred).
Delteil 27 II; Adhémar 18 II; Adriani 37 II; Wittrock 14.
New edition (after 1901). Additional text removed.
Drawing in olive green, coloured by another hand with stencils (yellow, green, pink, red and violet).
Vellum.
Size of edition not known.

Compare the rapid pen and ink sketch of the same girl Dortu D.3570.

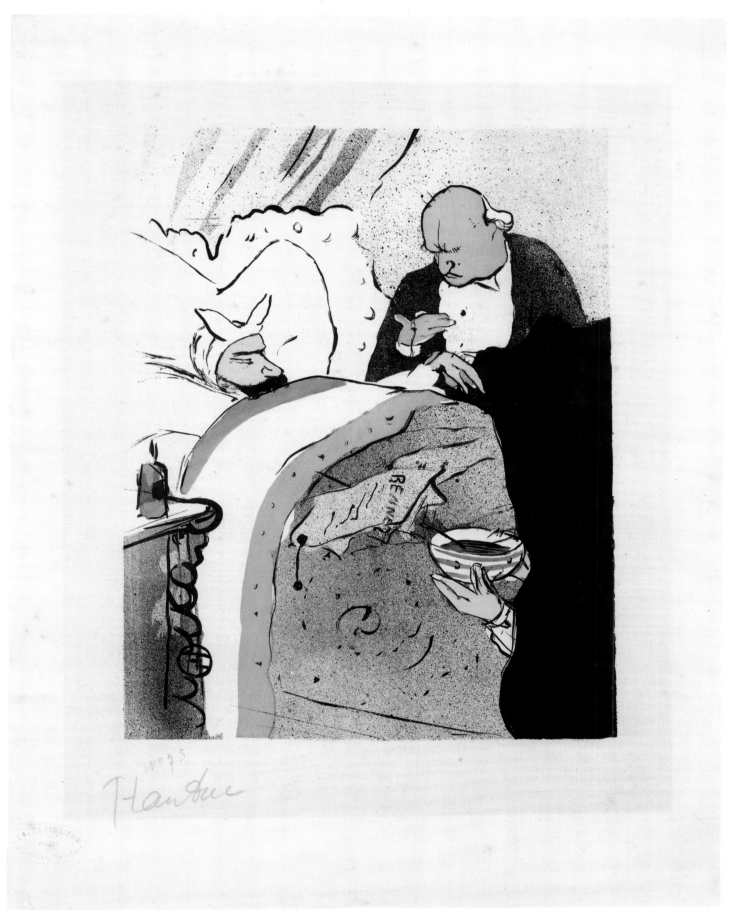

No 10.
HLautrec

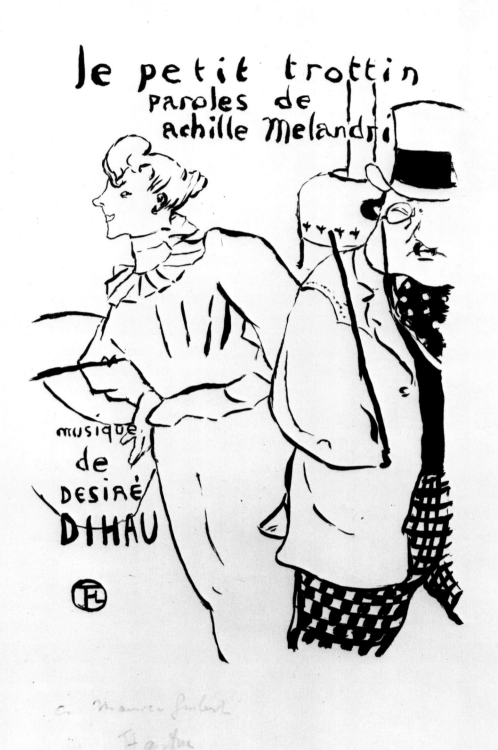

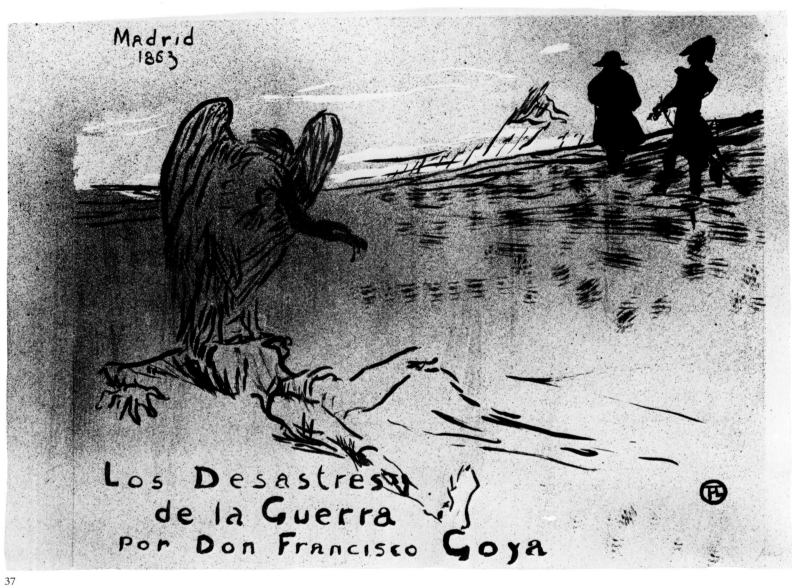

37

37 'LOS DESASTRES DE LA
 GUERRA' 1893

Lithograph, cover design with lettering
by Lautrec: 'Madrid/1863/Los Desastres/
de la Guerra/por Don Francisco Goya'.
Drawing in black; ink with brush and
spraying technique.
282 × 387 mm.
Monogram on the stone, lower right.
Vellum.
Three impressions known.
Delteil 295; Adhémar 234; Adriani 238;
Wittrock 29.

This cover was designed for a new edition
of Goya's series of etchings *Los Desastres
de la Guerra* (The Horrors of War), which
was published in full for the first time in
Madrid in 1863. One impression in the
Musée d'Albi was used as the cover for
the 1892 edition. For stylistic reasons in
particular the drawing should be dated
close to the ink and brush works for the
two series *Le Café Concert* (Nos. 16–26)
and *Les Vieilles Histoires* (Nos. 27–32).

38 TRUFFIER ET MORENO, DANS 'LES
 FEMMES SAVANTES' 1893
 *Truffier and Moreno in 'Les Femmes
 Savantes'*

Lithograph.
Drawing in black; chalk, sprayed ink,
worked with the scraper.
375 × 265 mm.
Monogram on the stone, upper left.
Vellum.
Edition of 50, some numbered, most with
Lautrec's red monogram stamp (Lugt
1338) lower left, and some with the blind
stamp of the publisher Kleinmann (Lugt
1573). Four impressions on imitation
Japan paper are also known (illustrated).
Delteil 54; Adhémar 60; Adriani 40 II;
Wittrock 46.

Lautrec's sudden enthusiasm for the
classical theatre arose from his friendship
with Romain Coolus, whose real name
was René Weil and who was Lautrec's
constant companion for a time, even on
his regular visits to the *maisons closes* in the
Rue d'Amboise and the Rue des Moulins
after 1892. Coolus was a great lover of
literature and the theatre, and Lautrec
frequently accompanied him to the
Comédie Française in the 1893–1894
season, where he admired, among others,
the actor Charles Jules Truffier
(1856–1943) in the role of Trissotin, and
Marguerite Monceau, known as Moreno
(1871–1948), as Armande in Molière's *Les
Femmes Savantes*. Here Lautrec has
illustrated the episode in which Trissotin
reads out a poem to the *précieuses ridicules*.
According to Adhémar the play was only
performed on 26 August and on 3 and 18
September 1893, since Moreno did not
find the role to her liking. The lithograph
must have been made directly afterwards,
although it was not published by
Kleinmann until February 1894.

39 MADEMOISELLE LENDER, DANS
 'MADAME SATAN' 1893
 *Mademoiselle Lender in 'Madame
 Satan'*

Lithograph.
First state. Chalk strokes upper left.
Drawing in black; chalk, sprayed ink.
355 × 260 mm.
Monogram on the stone, upper right.
Vellum.
One impression known (Bibliothèque
Nationale, Paris).
Delteil 58 I; Adhémar 76 I; Adriani 63 I;
Wittrock 47.
Second state. Chalk strokes upper left
removed.
Drawing in olive green.
Edition of 80, some numbered and some
with Lautrec's red monogram stamp
(Lugt 1338) lower right, and the blind
stamp of the publisher Kleinmann (Lugt
1573), left. Four impressions on imitation
Japan paper are also known.
Delteil 58 II; Adhémar 76 II; Adriani 63 II;
Wittrock 47.

Madam Satan was a *Singspiel* by Ernest
Blum and Raoul Toché. It had its
première on 26 September 1893 in the
Théâtre des Variétés with Anne-Marie
Bastien, known as Marcelle Lender
(1862–1926), and the operetta singer
Albert Brasseur (1862–1932) in the
leading roles.

39·II

40·III

40 LA COIFFURE, PROGRAMME DU
THÉÂTRE LIBRE 1893
*The Coiffure, Programme for the
Théâtre Libre*

Colour lithograph, programme.
First state. No lettering.
Drawing in black and olive green; chalk,
ink with brush.
315 × 239 mm.
Monogram on the stone, lower right.
Vellum.
One impression known (Bibliothèque
Nationale, Paris).
Delteil 14 (state not described);
Adhémar 40 I; Adriani 38 I;
Wittrock 15 I.
Second state. No lettering, additional
drawing in front of the face of the seated
woman, on the hand mirror and in front
of the hand.
Drawing in olive green with red and
yellow.
330 × 255 mm.
Vellum, imitation Japan paper.
Edition of 100 numbered impressions,
some signed by the artist in pencil lower
left, some also with the blind stamp of the
publisher Kleinmann (Lugt 1573).
Delteil 14 I; Adhémar 40 (state not
described); Adriani 38 II; Wittrock 15 II.
Third state. With lettering not designed by
Lautrec upper left: 'Le Théâtre Libre . . ./
Une Faillite/. . ./Le Poète et le
Financier/. . .' (and the address of the
printer, lower right-hand edge).
315 × 240 mm.
Size of edition not known (several
hundred).
Delteil 14 II (Delteil mentions a smaller
reproduction of the programme,
238 × 163 mm); Adhémar 40 II;
Adriani 38 III; Wittrock 15.

Lautrec's interest in the world of the
theatre began in the autumn of 1893. The
plays *Une Faillite* (A Bankruptcy) by
Björnstjerne Björnson (see No. 41) and *Le
Poète et le Financier* (The Poet and the
Financier) by Maurice Vaucaire had been
playing at the Théâtre Libre since 8
November. The colour lithograph, which
was printed by Eugène Verneau, Paris,
and the programme were modelled on
the painting Dortu P.506, which shows a
scene in the Rue des Moulins brothel. See
also the similar sketches Dortu P.633 and
D.4263, though these were made later.
The Théâtre Libre in the Rue Pigalle,
which was directed from 1887 to 1896 by
the actor André Antoine, had a
pioneering programme of naturalistic
works. In addition to Lautrec (see Nos. 69
and 133), Antoine also commissioned
Willette, Signac, Vuillard, Ibels,
Charpentier, Auriol and Rivière to design
programmes. He also exhibited works by
Seurat, Signac and Van Gogh in the foyer
of the theatre.

41

41 ANTOINE ET GÉMIER, DANS 'UNE
 FAILLITE' 1893
 Antoine and Gémier in 'Une Faillite'

Lithograph.
Drawing in black; chalk, sprayed ink.
298 × 370 mm.
Monogram on the stone, lower right.
Vellum.
Edition of 50 numbered impressions,
stamped with Lautrec's monogram in red
(Lugt 1338), lower right, some also with
the blind stamp of the publisher
Kleinmann (Lugt 1573), lower left. Two
impressions in olive green and black on
imitation Japan paper are also known.
Delteil 63; Adhémar 41; Adriani 39;
Wittrock 43.
The impression shown here is inscribed
by Kleinmann in pencil lower left:
'Antoine et Gemier Une Faillite'.

The main characters in the play *Une
Faillite* (A Bankruptcy) were played by
the actors Firmin Gémier (1869–1933),
whose real name was Tonnerre, and
André Antoine (1858–1943), who was
later director of the Odéon (*cf.* Nos. 40,
238); see also the rapid figure sketch
Dortu D.3661.

42

42 UNE REDOUTE AU MOULIN
 ROUGE 1893
 A Gala Evening at the Moulin Rouge

Lithograph.
Drawing in black or olive green; chalk,
sprayed ink, worked with the scraper.
295 × 470 mm.
Monogram on the stone, lower left.
Vellum.
Edition of 50, some numbered; these bear
Lautrec's red monogram stamp (Lugt
1338), lower right, and the blind stamp of
the publisher Kleinmann (Lugt 1573),
lower left; three trial proofs are also
known, each of which shows only half the
drawing.
Delteil 65; Adhémar 54; Adriani 55;
Wittrock 42.

In a mock antique triumphal procession,
we see, among others, La Goulue (riding
on a donkey) and beside her, probably the
female clown Cha-u-Kao (see Nos. 172
and 203). Behind them are the two figures
who can also be seen on lithograph
No. 55. The occasion was the autumn
gala at the Moulin Rouge to celebrate the
Franco-Russian alliance agreed in mid-
July 1893, and for which Aristide Bruant
wrote his famous song, *Vive la Russie*;
there was a similar revue at the Folies
Bergère at the end of the year entitled
France-Russie. Lautrec wrote sarcastically
to his mother on 17 or 24 July 1893 about
this political event: 'Long live Russia!!
And curious thing, there's such a patriotic
or international fervour that this 8-day
July 14 hasn't been tiring. Of course, I had

to put up with being kept waiting here
and there half an hour at a time, but it was
a question of the European balance of
power and I put a good face on it. The
policemen themselves tried to be decent
and that's not saying a little. Anyway,
they're leaving tomorrow [the two
Russian Grand Princes], probably tired
out' (Goldschmidt-Schimmel, No. 162).

43

44 BARTET ET MOUNET-SULLY, DANS 'ANTIGONE' 1893
Bartet and Mounet-Sully in 'Antigone'

Lithograph.
First state. Horizontal stroke upper left, scribbles on the bottom of the sheet.
Drawing in black; chalk, sprayed ink, worked with the scraper.
376 × 271 mm.
Monogram on the stone, upper right.
Vellum.
Three impressions known.
Delteil 53 I; Adhémar 59 I; Adriani 41 I; Wittrock 45 I.
Second state. Scribbles upper left and bottom removed.
Drawing in black with brown.
Vellum, imitation Japan paper.
Edition of 65 impressions, some numbered, a few with Lautrec's red monogram stamp (Lugt 1338) lower right; 50 are on vellum and 15 on imitation Japan paper.
Delteil 53 II; Adhémar 59 II; Adriani 41 II; Wittrock 45 II.

This scene from Sophocles' *Antigone*, which was performed in November 1893 at the Comédie Française, shows the tragic actress Jeanne Julia Régnault, known as Julia Bartet (1854–1941), and Jean Mounet-Sully (1841–1916). The lithograph was intended for the illustrated weekly *L'Escarmouche*, founded by the writer Georges Darien in November 1893, but it was not published there; see the portrait study Dortu D.3724 (Nationalmuseum, Stockholm).

43 JUDIC 1893

Lithograph.
Drawing in black; chalk, ink with brush and spraying technique, worked with the scraper.
357 × 267 mm.
Monogram on the stone, lower left.
Vellum.
Edition of 100 numbered impressions, some with Lautrec's red monogram stamp (Lugt 1338) lower left, and some with the blind stamp of the publisher Kleinmann (Lugt 1573); five impressions in olive green on imitation Japan paper or vellum are also known (illustrated), as well as five impressions in black on Japan paper.
Delteil 56; Adhémar 39; Adriani 54; Wittrock 54.

The popular singer of patriotic songs, Anne Damiens, known as Judic (1850–1911), is here visited in her dressing room by Désiré Dihau (see Nos. 27, 28 and 144), as she tries on a corset. A portrait of her, drawn by Lautrec, appeared on 9 December 1893 in the magazine *L'Echo de Paris*.

44·II

45–56 ILLUSTRATIONS FOR THE WEEKLY
 MAGAZINE
 'L'ESCARMOUCHE' 1893–1894

Twelve lithographs for the short-lived
illustrated weekly *L'Escarmouche* (The
Skirmish), founded by Georges Darien.
Lautrec was announced as one of the
contributors, along with several others:
'Anquetin, H. G. Ibels, de Toulouse-
Lautrec, Vuillard, A. Willette –
artistically this list is more than just a
programme – it is *the* programme!' The
editor goes on to say that, thanks to an
agreement with the illustrators, he is
happy to be able to offer for sale
electrotype prints of the original
lithographs of the illustrations that would
appear in the magazine. The lithographs
would be available from the offices of the
magazine in signed and numbered
editions of only 100 at 2.50 francs each.

 Within a very short space of time
Toulouse-Lautrec provided twelve
lithographs printed by Ancourt & Cie.,
Paris, for the ten issues of the magazine,
which appeared from 12 November 1893
to 14 January 1894. They are arranged
here according to the date on which they
were published. The corresponding
reproductions in the weekly (each issue of
which cost 20 centimes) are headed with
the cynical comment 'J'ai vu ça' (I saw
this) with which Goya prefaced his series
of etchings *Los Desastres de la Guerra* (see
No. 37).

 It was not without a certain pride that
Lautrec wrote to his mother: 'I'm very
busy and printing with might and main. I
have just invented a new process that can
bring me quite a bit of money. Only I
have to do it all myself . . . My
experiments are going awfully well. We
have just founded a periodical
[*L'Escarmouche*]. In short, you can see, all
is well' (Goldschmidt-Schimmel,
No. 168).

45 POURQUOI PAS? . . . UNE FOIS N'EST
 PAS COUTUME 1893
 *Why Not? . . . Once Is not to Make a
 Habit of It*

Lithograph, *L'Escarmouche* edition.
Drawing in black or olive green; chalk,
ink with brush and spraying technique.
335 × 260 mm.
Monogram on the stone, right.
Vellum.
Edition of 100 numbered impressions,
signed by the artist in pencil lower left;
some also have Lautrec's red monogram
stamp (Lugt 1338); Nos. 1–50 are printed
in black and Nos. 51–100, in olive green.
Two trial proofs are also known
(Bibliothèque Nationale, Paris).
Delteil 40; Adhémar 43; Adriani 42;
Wittrock 30.

This scene from the Théâtre de l'Œuvre
was reproduced in the first issue of
L'Escarmouche on 12 November 1893,
together with illustrations by Ibels and
Willette; see the rapid sketches Dortu
D.3197, D.3433 and D.3455.

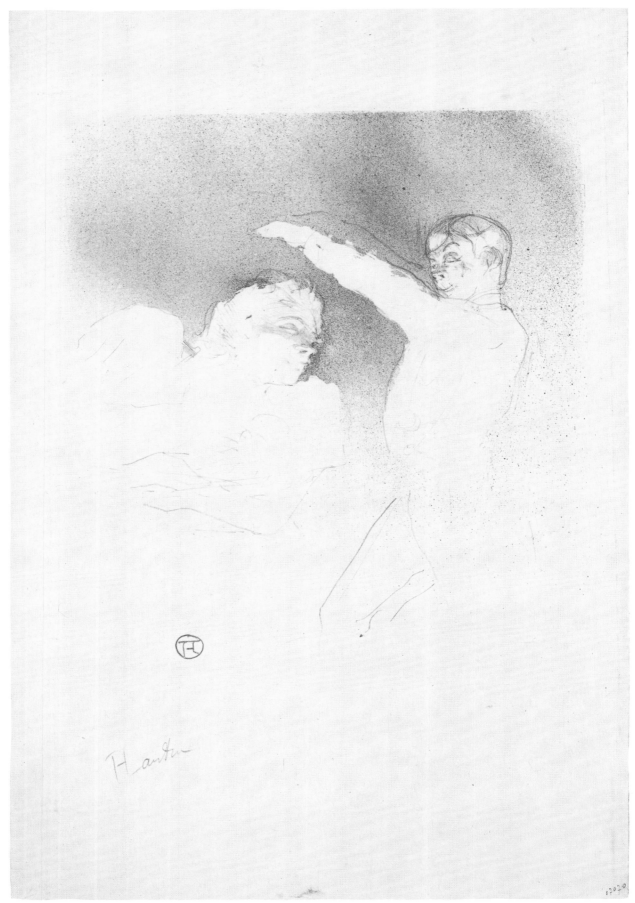

46·III

46 AUX VARIÉTÉS, MADEMOISELLE
LENDER ET BRASSEUR 1893
*At the Variétés, Mademoiselle Lender
and Brasseur*

Lithograph, *L'Escarmouche* edition.
First state. Only lettering in the lower part
designed by Lautrec: 'C'est vous!!'
Drawing in black or olive green; chalk,
ink with pen and spraying technique,
worked with the scraper.
283 × 258 mm.
Monogram on the stone, lower left.
Vellum.
One impression known (Private
collection, Berne).
Delteil 41 I; Adhémar 44 (state not
described); Adriani 43 I; Wittrock 31 I.
Second state. Original lettering removed
and new text added, designed by Lautrec:
'Est elle grasse? oui/Est elle ici?/oui oui
oui!!!/C'est vous!!!!!!'
335 × 265 mm.
Vellum.
Edition of 100 numbered impressions,
signed by the artist in pencil lower left;
some also have Lautrec's red monogram
stamp (Lugt 1338); Nos. 1–50 are printed
in black and Nos. 51–100, in olive green.
Delteil 41 II; Adhémar 44; Adriani 43 II;
Wittrock 31 II.
Third state. Lettering again removed.
Drawing in reddish brown or olive green.
285 × 266 mm.
Imitation Japan paper, Japan paper.
Four impressions known.
Delteil 41 III; Adhémar 44 (state not
described); Adriani 43 III; Wittrock 31 III.

The print shows Marcelle Lender, who
played an important part in Lautrec's
graphic art, particularly in 1894, with
Albert Brasseur at the Théâtre des
Variétés. It was published, without
lettering and with the monogram lower
right, in the second issue of the magazine
L'Escarmouche on 19 November 1893,
with illustrations by Ibels and Anquetin.
See the red chalk sketches Dortu D.3326
and D.3327.

47 EN QUARANTE 1893
In their Forties

Lithograph, *L'Escarmouche* edition.
Drawing in black or olive green; chalk.
285 × 235 mm.
Monogram on the stone, lower right.
Vellum, imitation Japan paper.
Edition of 100 numbered impressions; 90
printed in black on vellum and 10 in olive
green on imitation Japan paper; some of
the latter are signed by the artist in pencil
on the left edge; more than half the
edition also have Lautrec's red monogram
stamp (Lugt 1338) lower left. Three
impressions on Japan paper in olive green
or reddish brown are also known.
Delteil 42; Adhémar 45; Adriani 44;
Wittrock 32.

This sheet was reproduced, together with
illustrations by Ibels and Vallotton, in the
magazine *L'Escarmouche*, No. 3, on 26
November 1893. There are two rapid
portrait sketches Dortu D.3361 and
D.3448.

48 MADEMOISELLE LENDER ET
BARON 1893
Mademoiselle Lender and Baron

Lithograph, *L'Escarmouche* edition.
Drawing in black or olive green; chalk,
ink with brush and spraying technique.
320 × 235 mm.
Monogram on the stone, lower left.
Vellum.
Edition of 100 numbered impressions,
some of which have Lautrec's red
monogram stamp (Lugt 1338) lower left;
Nos. 1–50 are printed in olive green and
Nos. 51–100, in black. Three trial proofs
and an impression bearing a dedication
are also known.
Delteil 43; Adhémar 46; Adriani 45 I;
Wittrock 33.

This scene, which appeared in the fourth
issue of *L'Escarmouche* on 3 December
1893 with an illustration by Ibels, shows
Marcelle Lender with the comedian Louis
Bouchenez, known as 'Baron'
(1838–1920), who played at the Théâtre
des Variétés and the Comédie Française.

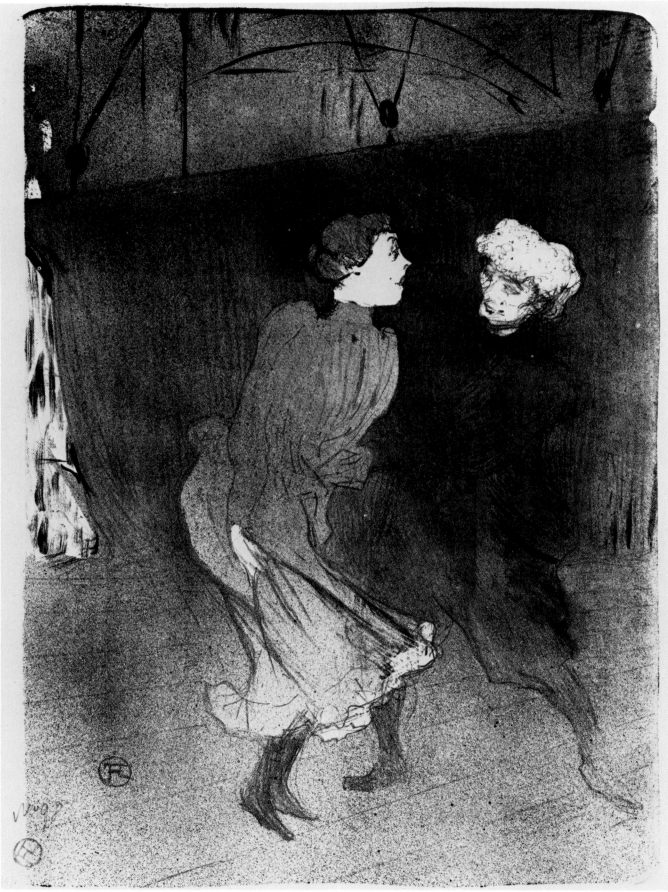

49 Répétition Générale aux Folies Bergère, Emilienne d'Alençon et Mariquita 1893
Dress Rehearsal at the Folies Bergère, Emilienne d'Alençon and Mariquita

Lithograph, *L'Escarmouche* edition.
First state. Drawing in black; chalk, ink with brush and spraying technique, worked with the scraper.
371 × 260 mm.
Monogram on the stone, lower left.
Vellum.
Edition of 100 numbered impressions, some with Lautrec's red monogram stamp (Lugt 1338) lower left; eight trial proofs, some signed, are also known.
Delteil 44; Adhémar 47; Adriani 46 I; Wittrock 34 I.
Second state. With additional brown ground.
Vellum, Japan paper.
Edition of about 100; one trial proof is also known.
Delteil 44 (state not described); Adhémar 47; Adriani 46 II; Wittrock 34 II.

The print appeared with an illustration by Ibels in *L'Escarmouche*, No. 4, on 3 December 1893. It shows Emilienne d'Alençon (born in 1869) and Mariquita from the Opéra rehearsing for the pantomime ballet, the *Bal des Quatr'z'Arts*, which had its première at the Folies Bergère on 16 December 1893. On 3 December *L'Escarmouche* had predicted that 'the pantomime ballet by Messieurs Courteline and Marsolleau will be a great success, adding yet another triumph to those already put on by this theatre – like that of Loïe Fuller, who is receiving tumultuous applause evening after evening'.

50 Au Moulin Rouge, un Rude! . . . Un Vrai Rude! 1893
At the Moulin Rouge, a Ruffian! . . . a Real Ruffian!

Lithograph, *L'Escarmouche* edition.
Drawing in black; chalk, ink with brush and spraying technique, worked with the scraper.
363 × 255 mm.
Monogram reversed on the stone, lower right.
Vellum.
Edition of 100 numbered impressions, some with Lautrec's red monogram stamp (Lugt 1338) lower left; three trial proofs on imitation Japan paper are also known.
Delteil 45; Adhémar 48; Adriani 47; Wittrock 35.

According to Delteil, the lithograph, which was reproduced with illustrations by Hermann Paul and Bonnard in *L'Escarmouche*, No. 5, on 10 December 1893, shows the artist's father, Count Alphonse de Toulouse-Lautrec, in the foreground and on his right, the lithographer Joseph Albert. But Adhémar believes the foreground figure to be the graphic artist Ernest Philippe Boetzel; see the rapid figure sketch Dortu D.3419 and the watercolour Dortu A.207, although this was probably made after the lithograph.

51 Folies Bergère, les Pudeurs de Monsieur Prudhomme 1893
Folies Bergère, the Modesty of Monsieur Prudhomme

Lithograph, *L'Escarmouche* edition.
Drawing in black; chalk, ink with brush and spraying technique.
375 × 270 mm.
Monogram on the stone, lower right.
Vellum.
Edition of 100 numbered impressions, stamped lower left with Lautrec's red monogram (Lugt 1338); one impression on imitation Japan paper is also known.
Delteil 46; Adhémar 49; Adriani 48; Wittrock 36.

The lithograph depicts a scene from the pantomime ballet, *Bal des Quatr'z'Arts* (see No. 49), at the Folies Bergère. It was reproduced in *L'Escarmouche*, No. 6, on 17 December 1893, with illustrations by Hermann Paul, Vallotton and Ibels.

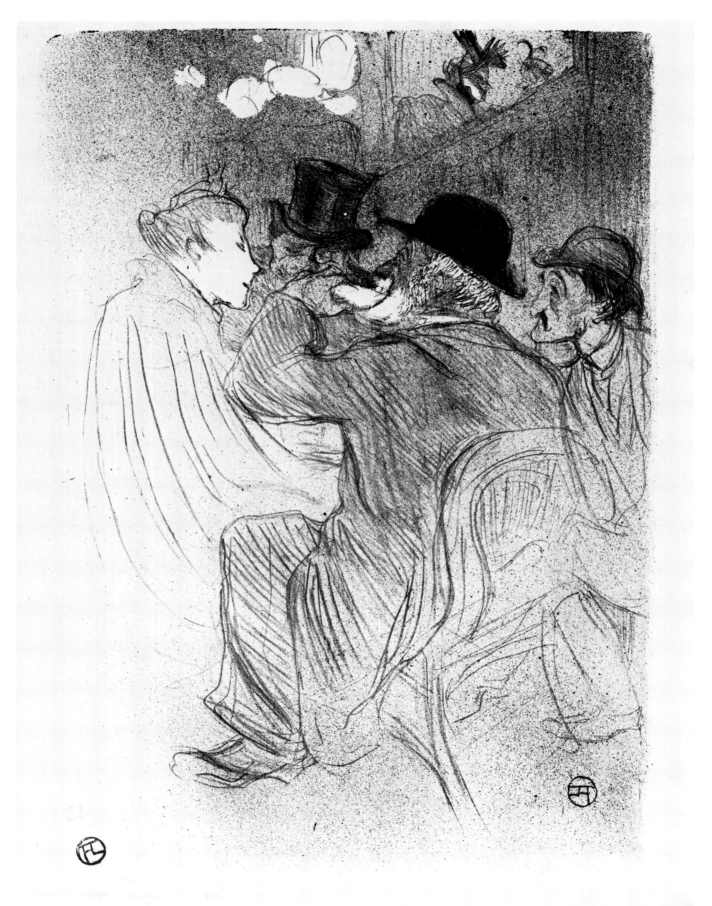

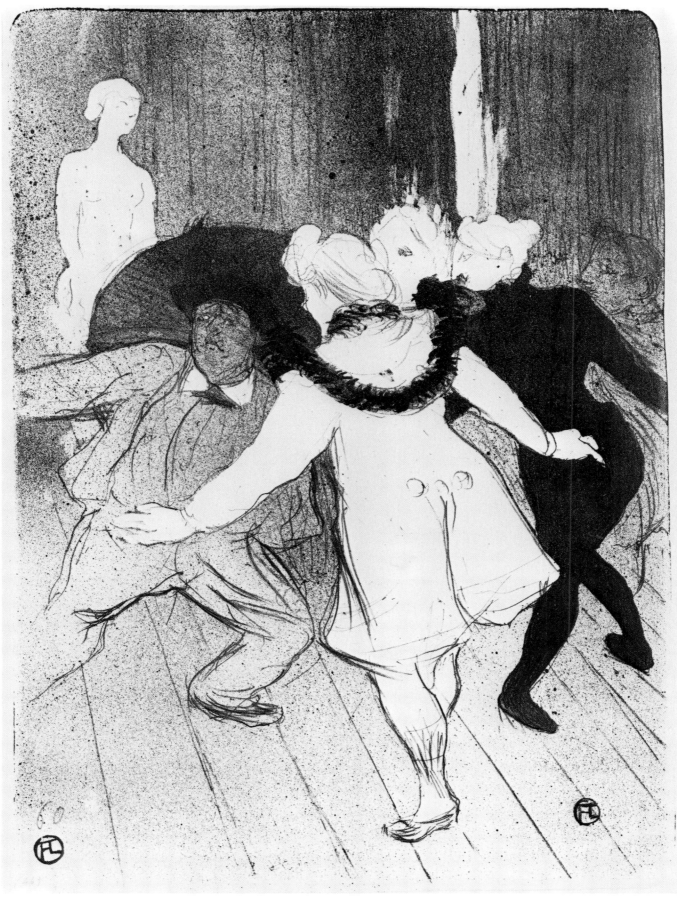

52 A LA RENAISSANCE, SARAH
BERNHARDT DANS 'PHÈDRE' 1893
*At the Renaissance, Sarah Bernhardt in
'Phèdre'*

Lithograph, *L'Escarmouche* edition.
Drawing in black; chalk, ink with brush
and spraying technique, worked with the
scraper.
342 × 235 mm.
Monogram on the stone, upper right.
Vellum.
Edition of 100 numbered impressions,
some with Lautrec's red monogram
stamp (Lugt 1338) lower left; three trial
proofs are also known.
Delteil 47; Adhémar 50; Adriani 49;
Wittrock 37.

The illustration appeared in
L'Escarmouche, No. 7, on 24 December
1893, with others by Hermann Paul. It
shows the celebrated Rosine Bernard,
known as Sarah Bernhardt (1844–1923),
in Racine's tragedy *Phèdre*, which was
being performed at the Théâtre de la
Renaissance, established by the actress.

53 A LA GAIETÉ ROCHECHOUART,
NICOLLE 1893
At the Gaieté Rochechouart, Nicolle

Lithograph, *L'Escarmouche* edition.
Drawing in black; chalk, ink with brush
and spraying technique.
370 × 265 mm.
Monogram on the stone, lower left.
Vellum.
Edition of 100, some numbered, with
Lautrec's red monogram stamp (Lugt
1338) lower left; three impressions on
imitation Japan paper are also known.
Delteil 48; Adhémar 51; Adriani 50;
Wittrock 38.

This lithograph of Nicolle at the Gaieté
Rochechouart cabaret was reproduced in
L'Escarmouche, No. 8, on 31 December
1893, together with illustrations by
Vallotton and Bonnard.

54 A L'OPÉRA, MADAME CARON DANS
'FAUST' 1893
*At the Opéra, Madame Caron in
'Faust'*

Lithograph, *L'Escarmouche* edition.
Drawing in olive green; chalk, sprayed
ink.
362 × 265 mm.
Monogram on the stone, lower edge.
Vellum.
Edition of 100 numbered impressions,
with Lautrec's red monogram stamp
(Lugt 1338) lower right; three impressions
on imitation Japan paper are also known;
one has the note: 'Faust Mme Caron bon à
tirer, 50 vert . . . 5 Japon vert . . .' (Art
Institute, Chicago).
Delteil 49; Adhémar 52; Adriani 51;
Wittrock 39.

The work was reproduced in
L'Escarmouche, No. 1, on 7 January 1894.
It shows the opera star, Lucile Meuniez,
whose stage name was Rose Caron
(1857–1930), as Gretchen in Charles
Gounod's opera *Faust* (see No. 194); *cf.*
the rapid figure study Dortu D.3657.

55 AU MOULIN ROUGE, L'UNION
FRANCO-RUSSE 1893
*At the Moulin Rouge, the Franco-
Russian Alliance*

Lithograph, *L'Escarmouche* edition.
Drawing in black; chalk, ink with brush
and spraying technique.
335 × 250 mm.
Monogram on the stone, lower right.
Vellum.
Edition of 100 numbered impressions,
some with Lautrec's red monogram
stamp (Lugt 1338) lower right; two
impressions on imitation Japan paper are
also known.
Delteil 50; Adhémar 53; Adriani 52;
Wittrock 40.

This lithograph was reproduced in No. 1
of *L'Escarmouche* on 7 January 1894; see
No. 42.

56 AU THÉÂTRE LIBRE, ANTOINE DANS
'L'INQUIÉTUDE' 1893
*At the Théâtre Libre, Antoine in
'L'Inquiétude'*

Lithograph, *L'Escarmouche* edition.
Drawing in black; chalk.
372 × 263 mm.
Monogram on the stone, lower right.
Vellum.
Edition of 100 numbered impressions,
most with Lautrec's red monogram stamp
(Lugt 1338) lower right; five impressions
on imitation Japan paper, signed by the
artist in pencil lower left, are also known
(illustrated).
Delteil 51; Adhémar 55; Adriani 53;
Wittrock 41.

The preparatory studies for this print are
the figure studies Dortu D.3659 and
D.3660. It appeared in No. 2 of the
magazine *L'Escarmouche* on 14 January
1894, and shows the actors André Antoine
and Madame Saville in the play
L'Inquiétude (Anxiety) by Jules Perrin and
Claude Couturier, which was being
performed at the Théâtre Libre.

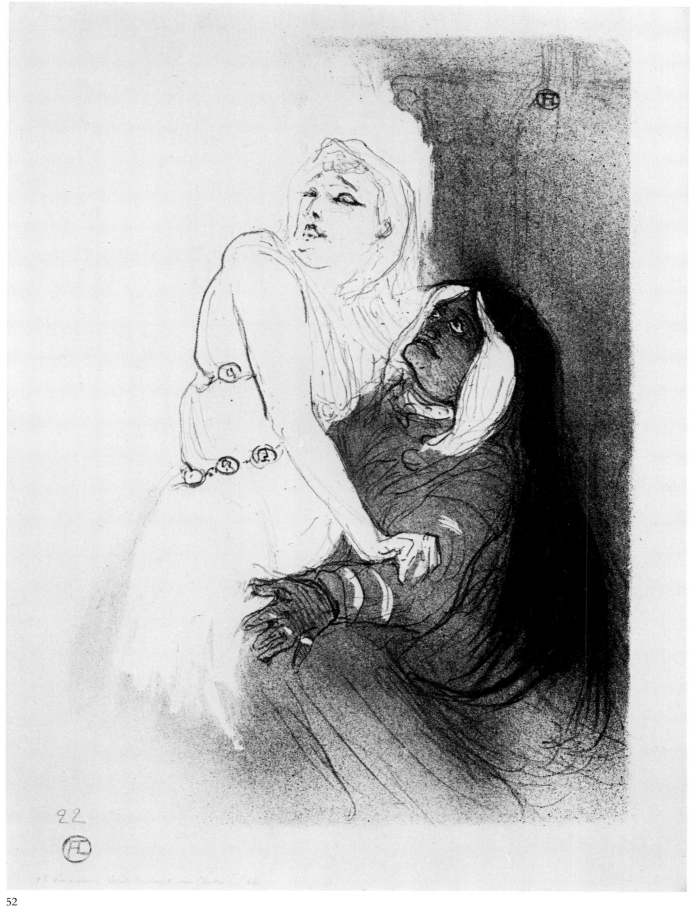

22

52

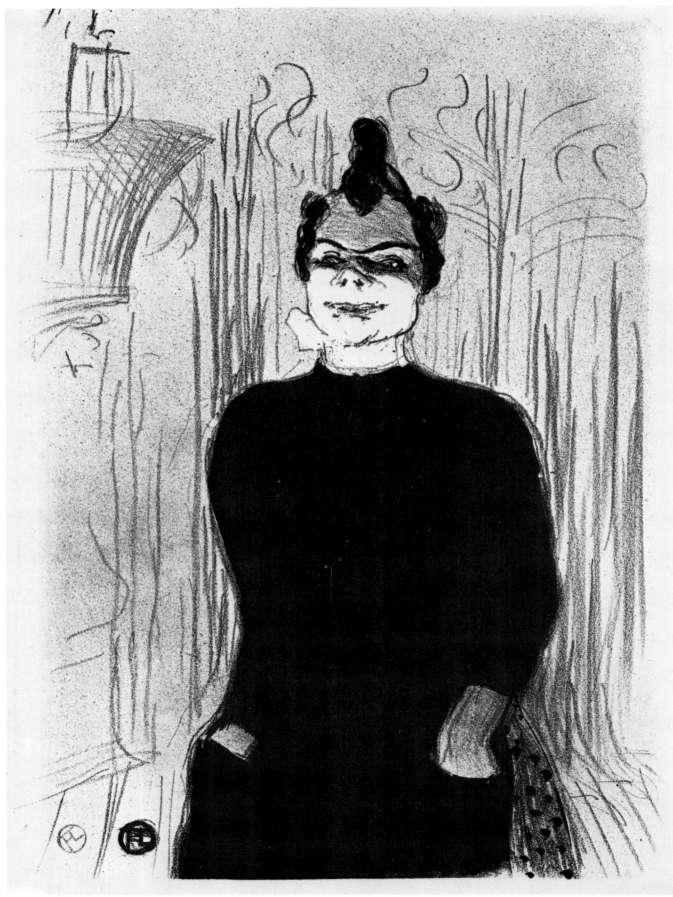

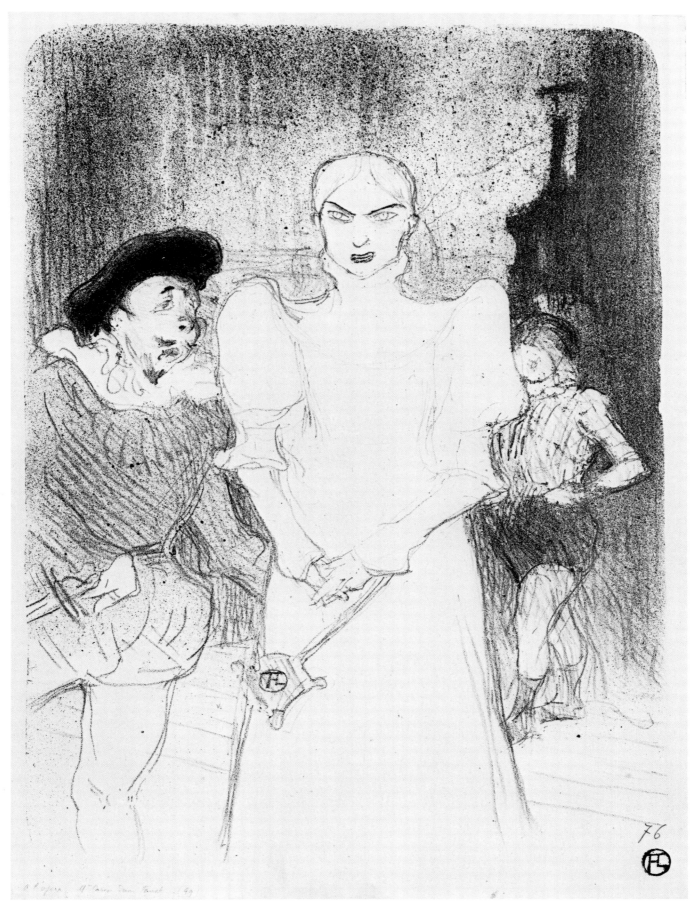

76

A Cooper. A Tours dans Faust. (4)

54

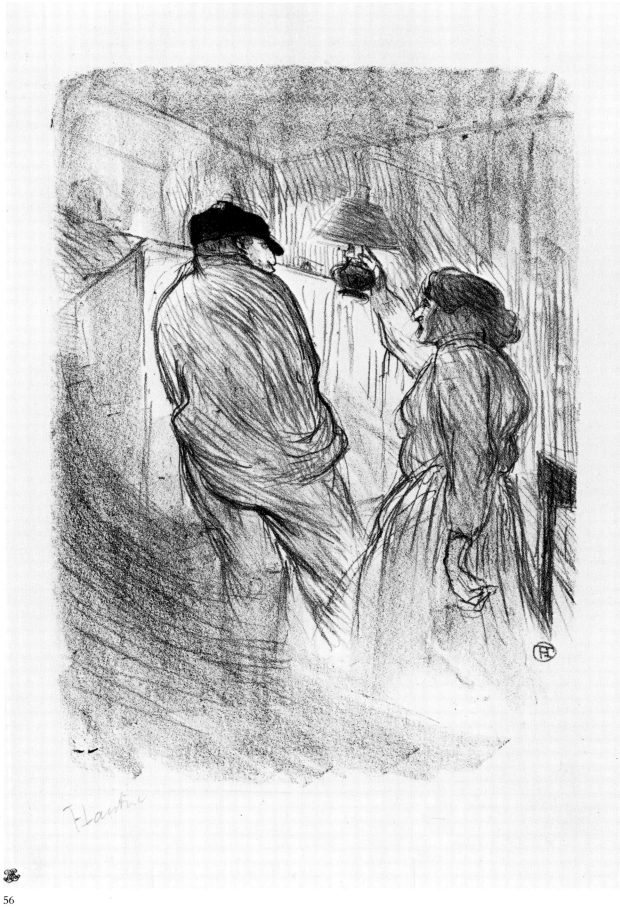

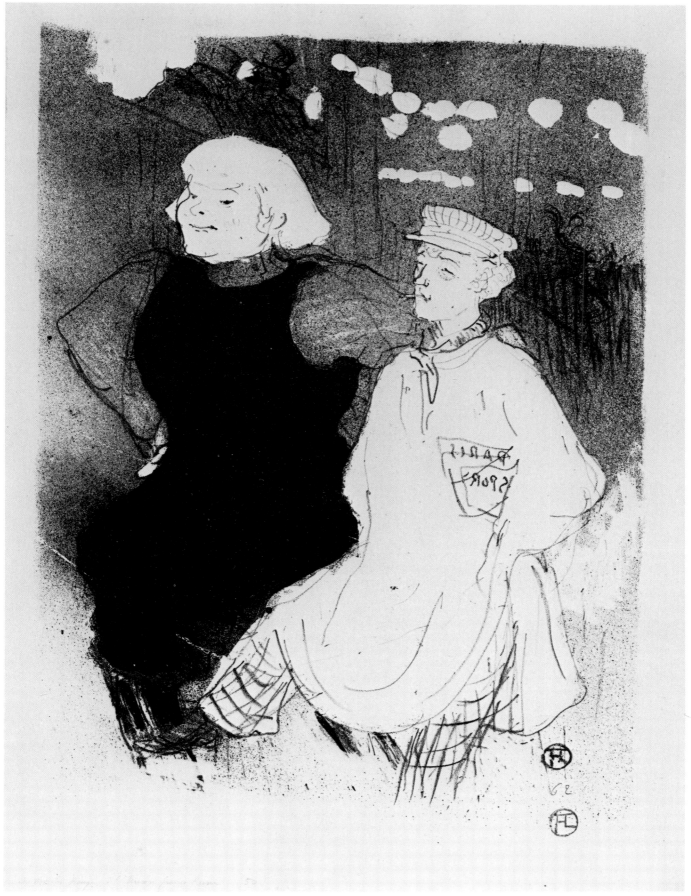

55

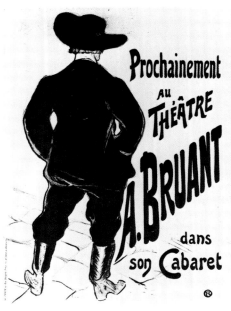

57·III

57 BRUANT AU MIRLITON 1893
Bruant at the Mirliton

Lithograph, poster.
First state. No lettering.
Drawing in olive green; chalk, ink with
brush and spraying technique.
850 × 596 mm.
Monogram on the stone, lower right.
Poster paper.
Two impressions known (Musée d'Albi;
Bibliothèque Nationale, Paris).
Delteil 349 I; Adhémar 71 I; Adriani 15 I;
Wittrock P 10.
Second state. With red on the collar and
the right sleeve, and new lettering not
designed by Lautrec on the right in red:
'TOUS LES SOIRS/BRUANT/AU/
MIRLITON/–/BOCK/13 Sous'.
Drawing in black with red.
810 × 550 mm.
Address of the printer added on the stone,
on left edge of picture: 'IMP. Chaix. 20.
Rue Bergère, Paris – 174–94 (ENCRES
CH. LORILLEUX & Cie.)'.
Size of edition not known (c. 100).
Delteil 349 II; Adhémar 71;
Adriani 15 II B; Wittrock P 10 A.
Third state. New lettering not designed by
Lautrec, in black; 'Prochainement/AU/
THÉÂTRE/A. BRUANT/dans/son
Cabaret'.
Two impressions known.
Delteil 349 (state not described);
Adhémar 71; Adriani 15 II A;
Wittrock P 10 B.
Fourth state. With new lettering not
designed by Lautrec, in olive green: 'LE/
DEUXIÈME/VOLUME/DE/
BRUANT/ILLUSTRÉ/PAR/
STEINLEN/VIENT DE PARAÎTRE/
EN VENTE/Chez tous les Libraires/ET
AU/MIRLITON'.
Several impressions known.
Delteil 349 III; Adhémar 71;
Adriani 15 II C; Wittrock P 10 C.

Delteil dated the poster to 1894 from the
fact that it appeared in Aristide Bruant's
magazine *Le Mirliton* on 15 November
1894. But he overlooked the fact that the
poster, which also advertised the second
volume of Bruant's songs (illustrated with
148 drawings by Théophile Alexandre
Steinlen), had also been reproduced, on a
smaller scale, as the cover illustration for
Oscar Méténier's brochure *Le Chansonnier
populaire ARISTIDE BRUANT/Dessins
de Steinlen*, which appeared in 1893.
Adhémar follows Delteil's dating,
although he reproduces an impression
without the lettering dedicated to
Lautrec's friend, the painter Maurice
Guibert, which was signed by the artist in

pencil lower left and dated 1893 (*Cat.
Toulouse-Lautrec*, A 12).
 The following notice appeared in
L'Escarmouche, No. 8, on 31 December
1893: 'M. de Toulouse-Lautrec, a
frequent contributor to *L'Escarmouche* [see
Nos. 45–56], is putting the last touches to
a poster of the *chansonnier* Bruant that will
attract great attention'. The striking
difference in style between the two
Bruant posters (Nos. 12 and 57) – the first
has a lavish monumentality, while the
second is smaller and more like an
illustration – may be due to the fact that
in the second Lautrec was aiming to keep
his work in proportion to the illustrations
by Steinlen, the social critic and
chronicler of Montmartre. There is an old
photograph that shows the façade of the
Mirliton and the Elysée Montmartre on
the Boulevard Rochechouart, in which
one can see several copies of Lautrec's
poster at the entrance to Bruant's cabaret
(Ill. p.12).

TOUS LES SOIRS

BRUANT

AU

MIRLITON

—

BOCK

13 SOUS

57·II

Colour lithograph, poster.
First state. No lettering.
Drawing in olive green with yellow, red, dark blue and black; ink with brush and spraying technique.
1200 × 845 mm.
Signed and dated on the stone, with Lautrec's monogram, lower left; on the left-hand edge, the address of the printer: '(1256) Imp. CHAIX. 20, Rue Bergère. PARIS (ENCRES CH. LORILLEUX & Cie)'.
Poster paper.
Several impressions known; four trial proofs from the drawing stone are also known.
Delteil 351 I; Adhémar 68 I; Adriani 56 II; Wittrock P 12 A.
Second state. With lettering not designed by Lautrec, in dark blue: 'Babylone/d'Allemagne/MOEURS BERLINOISES/par/Victor Joze/CHEZ TOUS LES LIBRAIRES'.
Size of edition not known (*c*. 1000–3000).
Delteil 351 II; Adhémar 68 II; Adriani 56 III; Wittrock P 12 B.

The drawing on the stone was carefully prepared with two coloured sketches Dortu P.532 and P.533, as well as the pencil studies Dortu D.3624 and D.3663. Lautrec wrote to his mother in Albi on 21 December 1893: 'I think I'll wait till the end of January to go the lovely town of Albi. I have an enormous lot to do. Two posters to deliver before January 15, and which are still not started' (Goldschmidt-Schimmel, No. 169).

The artist probably had in mind the poster which was registered at the Bibliothèque Nationale in Paris on 29 January 1894 for Victor Joze's book *Babylone d'Allemagne* (The German Babylon). Joze had written to the artist asking him to withdraw the poster, as he felt the depiction of a German officer, together with the anti-German tone of the book, would not be tolerated by the police and could cause a diplomatic incident. Nevertheless, on 18 February 1894 *Fin de Siècle* reported that it was on all the walls, presumably too late for Joze to intervene. To avoid causing the author the same problems which had arisen over the REINE DE JOIE poster (No. 5), Lautrec had paid for the printing himself, so presumably there was nothing to prevent him from displaying it.

58·II

59 'L'Artisan Moderne' 1894

Colour lithograph, poster.
First state. No lettering, except for the name 'NIEDERKORN' on the tool box. Drawing in dark blue with yellow, green and brown; ink with brush and spraying technique, chalk, worked with the scraper.
900 × 640 mm.
Monogram on the stone, right, with another monogram lower right in the shape of a small elephant.
Poster paper.
Two impressions known; one trial proof from the drawing stone also known.
Delteil 350 I; Adhémar 70 (state not described); Adriani 58 III; Wittrock P 24.
Second state. With lettering not designed by Lautrec in dark blue: 'l'Artisan Moderne/Objets d'art . . .'. Also on the stone, lower left above the lettering, a stylized twig of flowers, and on the edge of the sheet the address of the printer: 'IMP. BOURGERIE & Cie – 83, Fg St Denis, PARIS'.
Size of edition not known (*c.* 1000–3000).
Delteil 350 III; Adhémar 70;
Adriani 58 IV; Wittrock P 24 A.
Third state. The wallpaper pattern in the background has been overprinted with the word 'qui?' in large red letters.
One impression known (see the catalogue *Le Paris de Toulouse-Lautrec*, Harajuku Art Museum, Tokyo 1979, No. 16).
Delteil 350 (state not described); Adhémar 70 (state not described); Adriani 58 (state not described); Wittrock P 24 (state not described).
Fourth state. The wallpaper pattern in the background removed, leaving only the word 'qui?', now printed in dark blue.
One impression mentioned by Delteil.
Delteil 350 II; Adhémar 70; Adriani 58 II; Wittrock P24 B.

In the letter to his mother of 21 December 1893 quoted above (see No. 58), Lautrec mentions a second poster which he had to deliver by the middle of January 1894. It is possible that two colour posters, similar in style, were designed for his friends Marty and Sescau at the beginning of the year. André Marty was a publisher and dealer, often mentioned as an admirer of Lautrec's graphics. He was also the publisher of *L'Estampe Originale* and of other portfolios, and had founded the interior design business *L'Artisan Moderne* (The Modern Craftsman). The poster advertising the business shows a craftsman, the medallist Henri Nocq, taking instructions from his very charming lady client.

60·III

60 LE PHOTOGRAPHE SESCAU 1894
The Photographer Sescau

Colour lithograph, poster.
First state. With lettering not designed by
Lautrec: '9, Place Pigalle/P. Sescau/
Photographe'.
Drawing in dark blue with dark red,
yellow and green; ink with brush and
spraying technique, chalk.
607 × 795 mm.
Monogram in the shape of a little
elephant on the stone, lower right.
Poster paper.
Size of edition not known (c. 1000).
Delteil 353; Adhémar 69; Adriani 59 III;
Wittrock P 22 C.
Second state. The model on the left is now
wearing a yellow mask. Several
impressions known.
Delteil 353 (state not described);
Adhémar 69; Adriani 59 II;
Wittrock P 22 B.
Third state. Remarque added on the stone
upper right in black: a naked girl with a
whip and a little piglet.
Several impressions known.
Delteil 353 (state not described);
Adhémar 69 (state not described);
Adriani 59 I; Wittrock P 22 A.

This poster was made for Lautrec's friend,
the photographer Paul Sescau (see
No. 127). It is another example of the
exuberant ink drawing of the preceding
poster designs, combined with strongly
decorative elements which are
reminiscent of the decorative arabesques
of Bonnard and Vuillard.

61 RÉJANE ET GALIPAUX, DANS 'MADAME
SANS-GÊNE' 1894
*Réjane and Galipaux in 'Madame Sans-
Gêne'*

Lithograph.
Drawing in black or olive green; chalk,
worked with the scraper.
315 × 250 mm.
Monogram on the stone, lower right.
Vellum.
Edition of 100 impressions, some
numbered; some with Lautrec's red
monogram stamp (Lugt 1338), lower
right. Nos. 1–50 are printed in olive green
and Nos. 51–100 in black. Five
impressions (two in reddish-brown) on
Japan paper are also known.
Delteil 52; Adhémar 56; Adriani 64;
Wittrock 44.

The print shows the celebrated actress
Gabrielle Réju, known as Réjane
(1857–1920), who was immortalized by
Marcel Proust, together with Félix
Galipaux (1860–1931) in the play *Madame
Sans-Gêne* (Lady Inconsiderate) by
Victorien Sardou and Edouard Moreau,
which was then playing at the Théâtre des
Variétés. The print was to have been
published in *L'Escarmouche*, but the last
illustrated issue of the magazine appeared
on 14 January 1894. The publisher
Kleinmann distributed the edition. See
the rapid profile sketches Dortu D.3573
and D.3658 (Musée du Louvre, Paris).

62 CARNAVAL 1894
Carnival

Colour lithograph.
First state. Drawing in black; chalk,
worked with the scraper.
270 × 207 mm.
Monogram on the stone, lower right.
Vellum.
Two impressions known.
Delteil 64 I; Adhémar 42 I; Adriani 76 I;
Wittrock 61 I.
Second state. Drawing on the mouth of the
foreground figure removed.
Drawing in olive green or grey brown.
Three impressions known.
Delteil 64 (state not described);
Adhémar 42 (state not described); ·
Adriani 76 (state not described);
Wittrock 61 II.
Third state. Mouth on the foreground
figure in red.
Drawing in olive green with red; chalk,
ink with brush, worked with the scraper.
255 × 165 mm.
Edition of 100, some numbered; some
signed by the artist in pencil lower left;
one trial proof is also known
(Bibliothèque Nationale, Paris).
Delteil 64 II; Adhémar 42; Adriani 76 II;
Wittrock 61 III.
Fourth state. Drawing greatly reduced and
transferred to another stone.
246 × 162 mm.
Size of edition not known (c. 2000).
Delteil 64 II; Adhémar 42 II;
Adriani 76 III; Wittrock 61 III.

This carnival scene (fourth state) appeared
in the magazine *La Revue Blanche*, VI,
No. 29, March 1894. The third state was
also included in the *Album de la Revue
Blanche*, which contained lithographs by
twelve renowned artists and was
published in an edition of 50 at 25 francs
each in 1895.

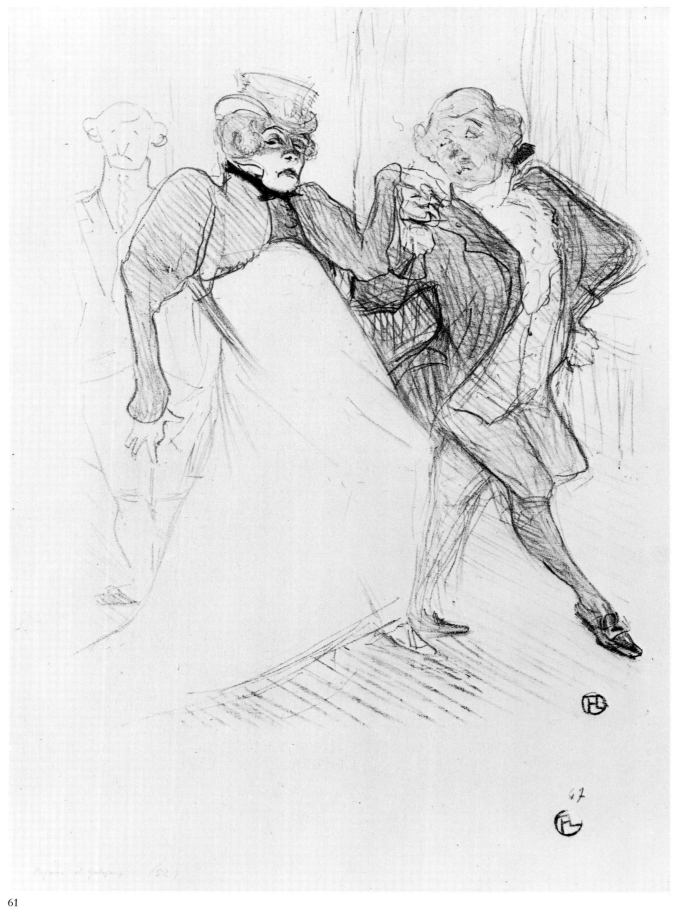

Pygmalion et Galatée 1895

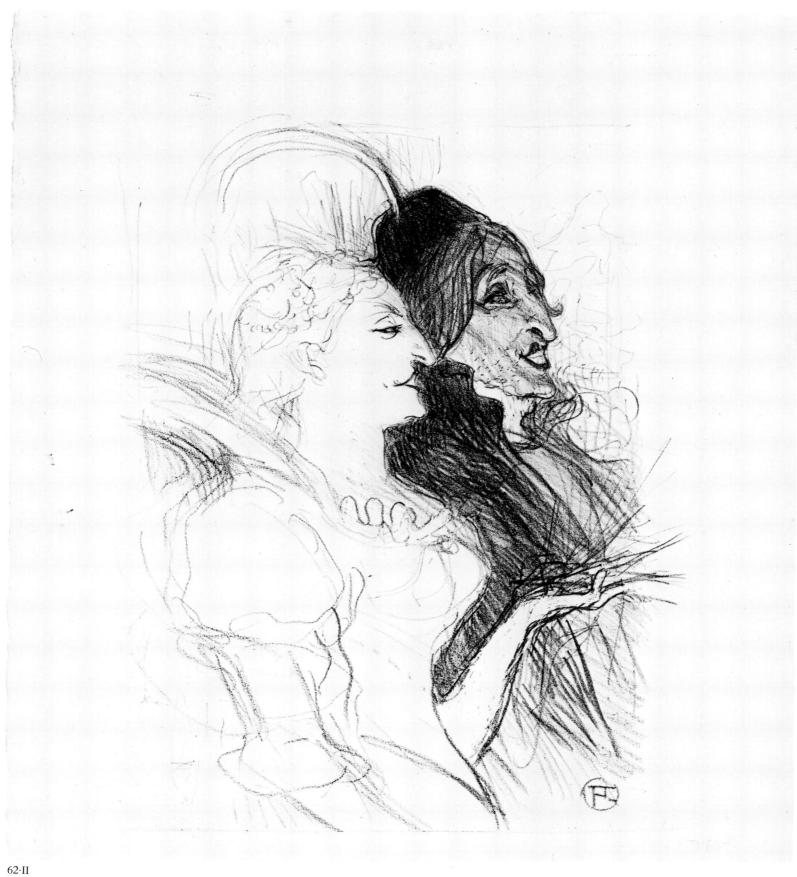

62·II

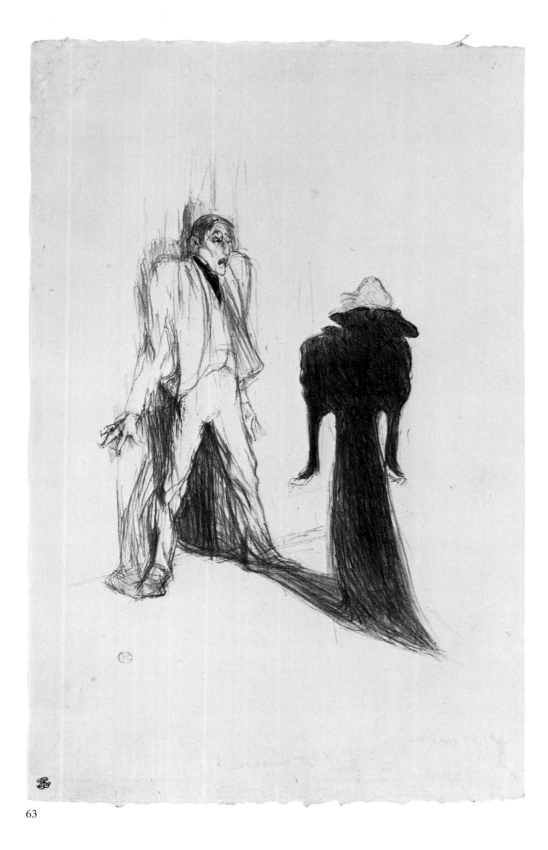

63

63 LUGNÉ-POË ET BERTHE BADY, DANS
'IMAGE' 1894
Lugné-Poë and Berthe Bady in 'Image'

Lithograph.
Drawing in black; chalk, worked with the
scraper.
329 × 240 mm.
Monogram on the stone, lower left.
Vellum.
Edition of 30, some numbered; some with
Lautrec's red monogram stamp (Lugt
1338) lower left, and the blind stamp of
the publisher Kleinmann (Lugt 1573).
Four impressions on imitation Japan
paper are also known (illustrated), one of
which is dedicated 'à Lugné-Poë' (Art
Institute, Williamstown).
Delteil 57; Adhémar 62; Adriani 60;
Wittrock 49.

We see here Aurélien Lugné-Poë
(1869–1940) and his partner in the play
Image (Picture) by Maurice Beaubourg,
which had been running at the Théâtre de
L'Œuvre since 27 February 1894 (see
No. 64). *La Vie Parisienne* reviewed the
play on 9 March 1894: 'A story of fools
who talk a literary language, torture each
other and finally throttle each other – all
to thunderous applause from the
audience'. The Théâtre de l'Œuvre was an
avant-garde company founded by Lugné-
Poë in 1893, and it gave the first
performance of a large number of plays
by Gide, Ibsen, Gorky, Wilde,
Hauptmann and Alfred Jarry. Leading
artists of the day designed programmes
for the company (see Nos. 105, 163 and
164).

64 L'EVANOUISSEMENT 1894
The Fainting Fit

Lithograph.
Drawing in black; chalk, sprayed ink,
worked with the scraper.
379 × 261 mm.
Monogram on the stone, lower left.
Vellum.
Four impressions known.
Delteil 294; Adhémar 61; Adriani 61;
Wittrock 50.

See No. 63.

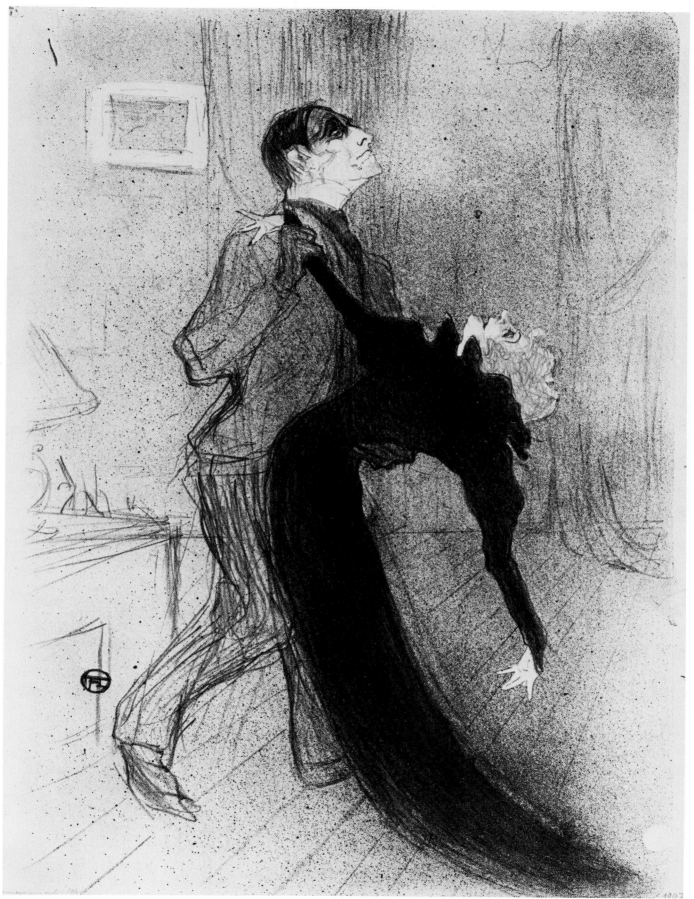

65

65 LUGNÉ-POË ET BERTHE BADY, DANS
'AU-DESSUS DES FORCES
HUMAINES' 1894
Lugné-Poë and Berthe Bady in 'Au-dessus des Forces Humaines'

Lithograph.
Drawing in black; chalk, worked with the scraper.
290 × 240 mm.
Monogram on the stone, lower left.
Vellum.
Edition of 50, some numbered, some with Lautrec's red monogram stamp (Lugt 1338) lower right, and some with the blind stamp of the publisher Kleinmann (Lugt 1573). Four impressions on imitation Japan paper are also known (illustrated).
Delteil 55; Adhémar 63; Adriani 62; Wittrock 48.

The actor and actress are shown in Björnstjerne Björnson's play *Au-dessus des Forces Humaines* (Beyond Human Strength), which was performed at the Théâtre de L'Œuvre.

66 BRANDÈS DANS SA LOGE 1894
Brandès in her Box

Lithograph.
Drawing in olive green or black; chalk, ink with brush and spraying technique.
375 × 270 mm.
Monogram on the stone, lower right.
Vellum.
Edition of 25, some numbered and some with the blind stamp of the publisher Kleinmann (Lugt 1573), lower left.
Delteil 60; Adhémar 64; Adriani 70; Wittrock 51.
The impression shown here is inscribed by Kleinmann in pencil lower left: 'Mlle Brandès dans sa loge'.

This print portrays the actress Marthe Brandès, born in 1862 – her real name was Marthe-Joséphine Brunswig – in her box at the Comédie Française; see the rapid chalk sketch Dortu D.3632 (erroneously also Ill. D.3273).

67 BRANDÈS ET LE BARGY, DANS
'CABOTINS' 1894
Brandès and Le Bargy in 'Les Cabotins'

Lithograph.
Drawing in olive green; chalk, sprayed ink, worked with the scraper.
428 × 335 mm.
Monogram on the stone, lower right.
Vellum.
Edition of 50, some numbered, and some with Lautrec's red monogram stamp (Lugt 1338), lower right; some with the blind stamp of the publisher Kleinmann (Lugt 1573). Two impressions on imitation Japan paper are also known (illustrated).
Delteil 61; Adhémar 65; Adriani 69; Wittrock 52.

Marthe Brandès (see No. 66) appeared at the Comédie Française in Edouard Pailleron's play *Les Cabotins* (The Scoundrels), which had been playing there since February 1894. Her role was that of the ageing rival of an eighteen-year-old girl, and we see her here creating a scene with her partner Charles le Bargy (1858–1936) in the studio of the sculptor Cardevent (see No. 68).

68 BRANDÈS ET LELOIR, DANS
'CABOTINS' 1894
Brandès and Leloir in 'Les Cabotins'

Lithograph.
Drawing in olive green; chalk, sprayed ink, worked with the scraper.
406 × 300 mm.
Monogram on the stone, lower right.
Vellum.
Edition of 50, some numbered and some with Lautrec's red monogram stamp (Lugt 1338) on the edge of the paper, lower right, and the blind stamp of the publisher Kleinmann (Lugt 1573); three impressions on imitation Japan paper are also known (illustrated).
Delteil 62; Adhémar 66; Adriani 68; Wittrock 53.

The two central characters in the play *Les Cabotins* (The Scoundrels, see No. 67) were played by Marthe Brandès and Leloir, who took the role of her husband; here we see them in a scene where each accuses the other of dubious origins.

69 La Loge au Mascaron Doré 1894
The Box with the Gilded Mask

Colour lithograph, programme.
First state. No lettering.
Drawing in olive green with red, yellow,
beige and black; instead of the red
background, some impressions have light
brown; chalk, ink with brush and
spraying technique.
372 × 317 mm.
Monogram on the stone, upper right.
Vellum, imitation Japan paper.
Edition of 100, some numbered, some
signed by the artist in pencil, lower left;
these also have the blind stamp of the
publisher Kleinmann (Lugt 1573). Two
trial proofs, three impressions with
dedications: 'à Alexandre', 'à Albert' and
'à Stern', and one impression on Japan
paper are also known.
Delteil 16 I; Adhémar 72; Adriani 71 II;
Wittrock 16.
Second state. With lettering not designed
by Lautrec: '. . . Le Missionnaire . . .'
308 × 240 mm.
Vellum.
Size of edition not known (several
hundred).
Delteil 16 II; Adhémar 72; Adriani 71 III;
Wittrock 16 (a reproduction of the
programme printed by Eugène Verneau
[206 × 164 mm] with changes to the text is
also mentioned).

For Lautrec the theatre was to be found in
the boxes as much as on the stage. One of
his best-known inventions (The Box with
the Gilded Mask) was a programme for
Marcel Luguet's play *Le Missionnaire* (The
Missionary), which had its première at the
Théâtre Libre on 24 April 1894. With its
economical use of colour, this is one of
Lautrec's greatest achievements in the
field of small-scale colour lithography.
Printed by Ancourt, Paris, the bold
composition was prepared with the sketch
Dortu P.471, of almost identical size; it
includes the lettering with ease, contrary
to other examples, where it is added, not
always satisfactorily, by another hand.

Above left we see the profile of the
English illustrator Charles Edward
Conder (1868–1909), who had met
Lautrec at the Moulin Rouge; see the
small profile study Dortu D.3441.

There is a letter from Lautrec to
Edouard Kleinmann asking for
impressions of the two Théâtre Libre
programmes (Nos. 40 and 69) before
lettering (Goldschmidt-Schimmel, No.
179).

110

Flautuc

IIIa

un monsieur et une dame bb.aa. *35*

70 AUX AMBASSADEURS 1894
 At the Ambassadeurs

Colour lithograph.
Drawing in olive green with yellow,
beige, a delicate pink, black and blue;
chalk, ink with brush and spraying
technique, worked with the scraper.
305 × 247 mm.
Monogram on the stone, lower left.
Vellum.
Edition of 100, some numbered, signed
by the artist in pencil, lower left; some
also have the blind stamp of the *L'Estampe
Originale* edition (Lugt 819). In addition,
altogether 19 trial proofs are known,
printed from the drawing stone and
colour stones, both singly and together.
Delteil 68; Adhémar 73; Adriani 72 II;
Wittrock 58.

This image of a singer at the
Ambassadeurs, printed by Ancourt, Paris,
was no doubt intended for the sixth
portfolio of the *L'Estampe Originale*
edition, for the quarter April to June 1894
(see Nos. 9 and 129).

26 avril
94

Menu Ad. Hébrard

71

71 MENU HÉBRARD 1894
Menu Card for Hébrard

Lithograph, menu card.
Drawing in black; chalk.
273 × 333 mm.
Dated on the stone, lower right: '26
avril/94'.
Vellum.
Seven impressions known, one a print in
olive green (Bibliothèque Nationale,
Paris).
Delteil 66; Adhémar 84; Adriani 74;
Wittrock 59.
The impression illustrated has the blind
stamp of the publisher Kleinmann (Lugt
1573), lower left, and is inscribed by
Kleinmann: 'Menu Adi Hébrard'.

Only a few impressions were made of this
drawing, which was designed as a menu
for Adrien Hébrard (1833–1914), editor
of the newspaper *Le Temps*; see the
portrait study D.3506 (Musée d'Albi).

72 DANSE EXCENTRIQUE 1894
Eccentric Dance

Lithograph.
Drawing in black; chalk, sprayed ink.
175 × 130 mm.
Monogram on the stone, lower left.
Vellum.
Edition of about 200.
Delteil 67; Adhémar 74; Adriani 73;
Wittrock 60.

The lithograph was printed by Ancourt,
Paris, and appeared in the second half of
May 1894 in a catalogue financed by
Arthur Huc, *Catalogue de l'Exposition de la
Dépêche de Toulouse illustré de 17
lithographies originales*, available at a cost of
one franc. It was for a group exhibition
organized by Huc in the entrance hall of
La Dépêche de Toulouse, and which
included works by Anquetin, Ibels,
Vuillard, Maurice Denis and others, as
well as Lautrec.

72

Yvette Guilbert (Photo: Bibliothèque Nationale, Paris)

73–89 ALBUM 'YVETTE
GUILBERT' 1894
'Yvette Guilbert' Album

An album devoted to Yvette Guilbert, published by André Marty (of *L'Estampe Originale*) and printed by Ancourt, Paris, with a cover and 16 illustrations down the side of the text, depicting the *diseuse*, singer and cabaret artist. After a brief interlude in the 'straight' theatre, since 1889 Yvette Guilbert had devoted herself to the *café concert* and enjoyed a huge success as a *fin-de-siècle* cabaret singer at the Divan Japonais (see No. 8), the Eldorado and the Moulin Rouge, the Scala and the Ambassadeurs. She had met Lautrec at the beginning of 1893 through her text-writer Maurice Donnay.

The album was intended solely as a celebration of her, and the text which accompanied the illustrations, mainly describing the Paris *cafés concert*, was written by the critic Gustave Geffroy, a great admirer of Lautrec. Lautrec wrote to Geffroy on 21 June 1894: 'As soon as you have the proofs of Yvette, be so kind as to let me know. I'd very much like us to finish all that together' (Goldschmidt-Schimmel, No. 180).

One hundred numbered copies of the album were printed, and each was signed by Yvette Guilbert on the imprint page in green (a few author's copies were also produced). In its exclusivity Lautrec's work for the album represents a modern form of apotheosis. It reveals the great variety of which an art of characterization is capable, by travestying to the utmost all that is reasonable or acceptable, without making the leap into the liberating exaggeration of caricature. At the same time Lautrec was clearly inspired by the profile in pale make-up above a long neck, the bold, lascivious mouth, the challenging wink of the eye, and the robust, accessible wit with which Guilbert intoned bawdy jokes to funereal melodies, in an impartial and cutting, or resentful, dragging manner. The text is set beside the olive green monochrome drawings so that it overlaps slightly in places at the edge, although there is no direct relation between text and drawing.

The albums, on sale at 50 francs each in a large format, were published in the middle of the year but were not deposited in the Bibliothèque Nationale until 2 October 1894. Reactions were mixed. On 18 August 1894 Arsène Alexandre reviewed the album in the magazine *Paris*; Jean Lorrain, writing in *L'Echo de Paris* on 15 October 1894, accused Lautrec of having taken 'the cult of ugliness' too far:

'I am well aware that Mademoiselle Guilbert is not a beautiful woman, but to allow these portraits to be published is . . . shameful. Mademoiselle Guilbert must have been blinded by her greed for publicity; what has become of her self-respect and female modesty? . . . You, Yvette, approved these drawings; they imitate those on the walls of Châtelet. They are printed in a green like goose-droppings, and the areas of shadow around the nose and chin are like a bespattering of dirt . . . I came home very depressed and slightly sickened, with that indefinite, unwilling unease which one feels when one has met a very pretty woman on the arm of a repulsive lover.' Yvette herself was upset at first, but allowed herself to be persuaded by Geffroy of the quality of the drawings, after Gaston Davenay had also praised them in *Le Figaro*. Even so, she was virtually effusive in her thanks to Lautrec: 'My dear friend, thank you for your wonderful drawings in Geoffroy's book [sic] . . . I am very, very pleased! and you may be sure I thank you with all my heart. Are you in Paris? If so, please come to lunch in my apartment next week, 79, Avenue de Villiers. Yours in friendship and with renewed thanks, Yvette' (Joyant I, pp.146 f.)

La Vie Parisienne wrote of the album on 20 October 1894: 'Lautrec is one of the boldest of draughtsmen; he has depicted Yvette in the full range of her gestures. Nothing is ordinary here; it is the apotheosis of the *café concert*. This work will last; it is unique of its kind.' The most detailed review was by Georges Clemenceau in *La Justice* on 15 September 1894; he discussed the collaboration of Yvette Guilbert, Geffroy and Lautrec: 'The idea of entrusting this macabre singer, with her cool, penetrating irony, to a quiet Breton with his dreams and will-power in his eyes (Geffroy) was certainly the fruit of deep insight, particularly when the pen of the philosopher joins forces with the biting pencil of Lautrec. Neither the philosopher nor the artist has hesitated. They have both marched straight up to the monster, and, one drawing, the other speaking – for I maintain that Geffroy did not write, so much as talk – they turned a *café-concert* song into a great work of art. Their accord reminds one very much of the serenade in "Don Giovanni". While one moans, prophesying a thousand evils, the other laughs with fearful scorn. From the unexpected interaction of these two opposites there emerges a feeling of pitiless understanding, and that may well be the most apposite judgment, the correct assessment of the *café concert* and its audience. For the audience of the *café concert* is really everyone. From the dinner jacket adorned with a white chrysanthemum to the overalls of a workman from the suburbs, the whole hierarchy meets and mixes there. And when these two men appear side by side, the one with his ironic greenish silhouettes, the other revealing the hypocrisy and the lies, the crowd assembled before them is really society as a whole, and they both mock this and drag it through the dirt at the same time. Look, listen, and if you have time, learn from this lesson. Watch this shadowy form freeze into expressive grimaces. What do you think of those eyes, too small, quite black, extended by a long black line of mascara, two dark patches in a pale face? And that nose, too long, with its wide nostrils, which suddenly twists out of line, instead of growing straight? And that broad mouth, the mouth of a peasant girl who can take everything and give everything. Watch, as the ugly lines of disgust, the great happy laugh, the impudent pout, the terrible lassitude follow one upon the other. And that neck, seemingly endless, the bunch of yellow curls and those two black feelers with their gestures, so simple and yet so moving? The shadows that are too harsh, and the light that is too lurid, bring out the sharp forms of this strange skeleton, and the stiff ghost is as moving as an apocalyptic vision . . . This figure with her bored, yet penetrating voice, singing a wedding song to a funeral march. Every syllable is like an arrow, shot out through the neck, the teeth, the tongue. Not one of her words or gestures is lost. But what wedding is she burying with her light dress and black gloves?'

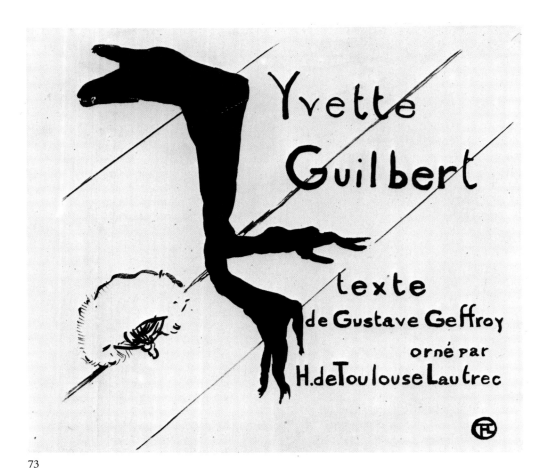

73

73 COUVERTURE DE L'ALBUM 'YVETTE
GUILBERT' 1894
Cover for the 'Yvette Guilbert' Album

Transfer lithograph, cover for the *Yvette
Guilbert* album, with lettering designed
by Lautrec in black: 'Yvette/Guilbert/
texte/de Gustave Geffroy/orné par/H. de
Toulouse Lautrec'.
Drawing in black; ink with brush, chalk,
worked with the scraper.
383 × 410 mm.
Monogram on the stone, lower right.
Japan paper.
Edition of 100.
Delteil 79; Adhémar 86; Adriani 77;
Wittrock 69.

The sketch prepared for the drawing on
the stone was done on a narrow, vertical
page format, and shows the black gloves
draped over a dressing-room table beside
the powder puff – Dortu P.518 (Musée
d'Albi). Yvette's discarded gloves seem to
be gliding down step by step, a ghostly,
alien trickle of black, ready to enter into a
liaison with the grotesque eccentricity of
their wearer which was to last for over 30
years.

74 YVETTE GUILBERT 1894

Lithograph, page 1 of the *Yvette Guilbert*
album.
First state. Without the block of text left
and below.
Drawing in olive green; chalk.
270 × 181 mm.
Monogram on the stone, left, on the
handbag.
Ten impressions known, printed on
different papers.
Delteil 80 I; Adhémar 87; Adriani 78 I;
Wittrock 70.
Second state. With block of text.
Hand-made paper.
Edition of 100.
Delteil 80 II; Adhémar 87; Adriani 78 II;
Wittrock 70.

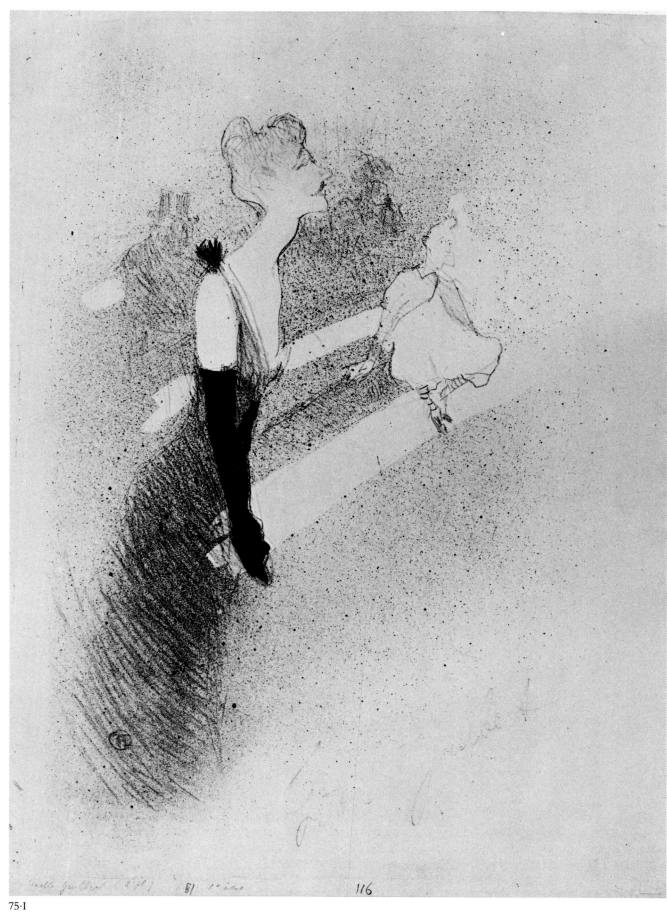

75·I

Lithograph, page 2 of the *Yvette Guilbert*
album.
First state. Without the block of text on
the right.
Drawing in olive green; chalk, ink with
brush and spraying technique, worked
with the scraper.
350 × 235 mm.
Monogram on the stone, lower left.
Six impressions known, printed on
different papers.
Delteil 81 I; Adhémar 88; Adriani 79 I;
Wittrock 71.
Second state. With block of text.
317 × 215 mm.
Hand–made paper.
Edition of 100.
Delteil 81 II; Adhémar 88; Adriani 79 II;
Wittrock 71.

76 Yvette Guilbert 1894

Lithograph, page 3 of the *Yvette Guilbert*
album.
First state. Without the block of text on
the right and below.
Drawing in olive green; chalk, ink with
brush and spraying technique, worked
with the scraper.
307 × 156 mm.
Monogram on the stone, lower left.
Six impressions known, printed on
different papers.
Delteil 82 I; Adhémar 89; Adriani 80 I;
Wittrock 72.
Second state. With block of text.
Hand–made paper.
Edition of 100.
Delteil 82 II; Adhémar 89; Adriani 80 II;
Wittrock 72.

See the rapid figure studies Dortu
D.3643–D.3645 (Musée du Louvre,
Paris). A similar watercolour Dortu
A.204 was made for the illustration to
Gustave Geffroy's article 'Le Plaisir à
Paris', which appeared in *Le Figaro
Illustré*, No. 40, July 1893.

76·II

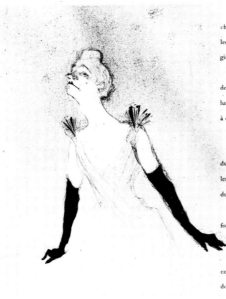

choisissent les pièces dont ils veulent se donner les représentations de
lecture à eux-mêmes, sans décors et sans acteurs, sur la scène de l'ima-
gination.

Pour les autres, l'important, qu'ils l'avouent donc, est de sortir
de chez eux où ils s'ennuient, et de s'en aller n'importe où chercher la
lumière, le bruit, et la complicité tacite de la foule, des êtres semblables
à eux, de la cohue des ennuyés.

En venir là, à cette constatation, c'est en venir, non à la défense
du café-concert, — le monstre est vivace, et nul ne défendrait son inso-
lente santé, — mais à la défense, ou plutôt, à l'explication du public
du café-concert.

On n'a pas tout dit quand on a dit l'abjection du spectacle, le bas-
fond remué, la montée de ruisseau, la débâcle de fange. Le réquisitoire
souvent été fait, et il est facilement fait, il se formule de lui-même.

Mais cette masse riante, qui applaudit les niaiseries et les
cochonneries, pourquoi est-elle là ? Tous ces gens qui pourraient
donner leurs cinquante sous au Drame, à la Comédie, ou à l'Opéra...
Comment dites-vous cela ?

Quelle erreur est la vôtre ! Ces cinquante sous, ils pourraient
les porter ailleurs, mais savez-vous bien à quelles conditions ? Avez-
vous réfléchi aux misères et aux vexations de la vie, à tout ce qui
poursuit le misérable homme, la pauvre unité sociale, jusque dans ses plaisirs ? Ces cinquante sous, pris sur
le nécessaire, sur la paie de la semaine, sur les appointements du mois, sur les bénéfices de la boutique, on n'est pas

77·II

admis a les donner aussi facilement, sur la simple inspection de l'affiche.
La journée finie, le dîner vite pris, la course faite, il est bien temps de
se présenter au guichet d'un théâtre ! Les quelques places du parterre au
Théâtre-Français ou à l'Opéra-Comique sont vite prises par ceux qui ont pu
attendre l'ouverture des portes entre les balustrades. Il reste les étages supé-
rieurs, d'où l'on entend et l'on voit comme on peut. Et encore ne faut-il pas
compter sur le premier rang.

Le plaisir, ainsi, devient vite une fatigue et une peine, une humiliation
pour les plus humbles. Pour être assis, pour voir et pour entendre, ce n'est
pas cinquante sous qu'il faut donner, c'est cinq francs, ou sept francs, et plus,
en s'y prenant d'avance. Le populo estime qu'il vaut mieux entrer tout de go,
à l'heure que l'on veut, au café-concert, s'installer devant un verre, sortir son
tabac et bourrer sa pipe.

Nous sommes en mil huit cent quatre-vingt-quatorze, et il va y avoir
bientôt vingt-quatre ans que la troisième République existe. Depuis ce temps-
là, et même depuis un peu plus longtemps, les plus retentissants orateurs de la
démocratie n'ont cessé de réclamer la mise enfin à l'ordre du jour de l'éduca-
tion du peuple. Ils ont affirmé en discours et en écrits la nécessité de faire et
de parfaire la mentalité et la moralité de l'homme nouveau. Mais en pratique,
et même dans la plus simple pratique, ils se sont montrés plus timides.
Nombre d'efforts, et des plus sincères, des mieux persistants, des plus tenaces,
ont porté sur l'Ecole. Qui oserait en contester ici l'utilité et la justice ? Seuls
quelques personnages, parfois instruits et gradés, proclament le mal fondé de ce budget d'instruction. Ils diraient volontiers, et ils disent,
qu'il faut l'ignorance pour le peuple, comme il lui faut la religion. Eux peuvent se passer de l'une et de l'autre, et s'en passent, à l'aide de
quelques consolations matérielles extraites des biens de ce monde. Aussi ont-ils inventé les Ecoles fondées sur l'esprit de caste, celles qui

78·II

77 YVETTE GUILBERT 1894

Lithograph, page 4 of the *Yvette Guilbert*
album.
First state. Without the block of text on
the right and below.
Drawing in olive green; chalk, ink with
brush and spraying technique, worked
with the scraper.
342 × 202 mm.
Monogram on the stone, lower left.
Five impressions known, printed on
different papers.
Delteil 83 I; Adhémar 90; Adriani 81 I;
Wittrock 73.
Second state. With block of text.
Hand-made paper.
Edition of 100.
Delteil 83 II; Adhémar 90; Adriani 81 II;
Wittrock 73.

The lithograph was reproduced in *Le
Courrier Français* on 2 September 1894.
See the large study in charcoal,
heightened with colour, for a poster that
was never printed Dortu P.519 (Musée
d'Albi), and the sketches Dortu D.3636
(Musée du Louvre, Paris), and D.3638 to
D.3640.

78 YVETTE GUILBERT 1894

Lithograph, page 5 of the *Yvette Guilbert*
album.
First state. Without the block of text on
the left and below.
Drawing in olive green; chalk, sprayed
ink, worked with the scraper.
320 × 142 mm.
Monogram on the stone, left.
Six impressions printed on different
papers.
Delteil 84 I; Adhémar 91; Adriani 82 I;
Wittrock 74.
Second state. With block of text.
Hand-made paper.
Edition of 100.
Delteil 84 II; Adhémar 91; Adriani 82 II;
Wittrock 74.

79 YVETTE GUILBERT 1894

Lithograph, page 6 of the *Yvette Guilbert* album.
First state. Without the block of text on the right and below.
Drawing in olive green; chalk, sprayed ink.
328 × 188 mm.
Monogram on the stone, lower left.
Six impressions known, printed on different papers.
Delteil 85 I; Adhémar 92; Adriani 83 I; Wittrock 75.
Second state. With block of text.
Hand-made paper.
Edition of 100.
Delteil 85 II; Adhémar 92; Adriani 83 II; Wittrock 75.

79·II

80 YVETTE GUILBERT 1894

Lithograph, page 7 of the *Yvette Guilbert* album.
First state. Without the block of text on the left and below.
Drawing in olive green; chalk.
282 × 115 mm.
Monogram on the stone, lower left.
Six impressions known, printed on different papers.
Delteil 86 I; Adhémar 93; Adriani 84 I; Wittrock 76.
Second state. With block of text.
Hand-made paper.
Edition of 100.
Delteil 86 II; Adhémar 93; Adriani 84 II; Wittrock 76.

See the sketches Dortu D.3642 and D.3648 (both Musée du Louvre, Paris).

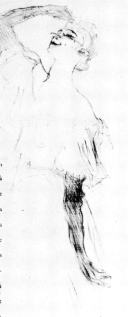

80·II

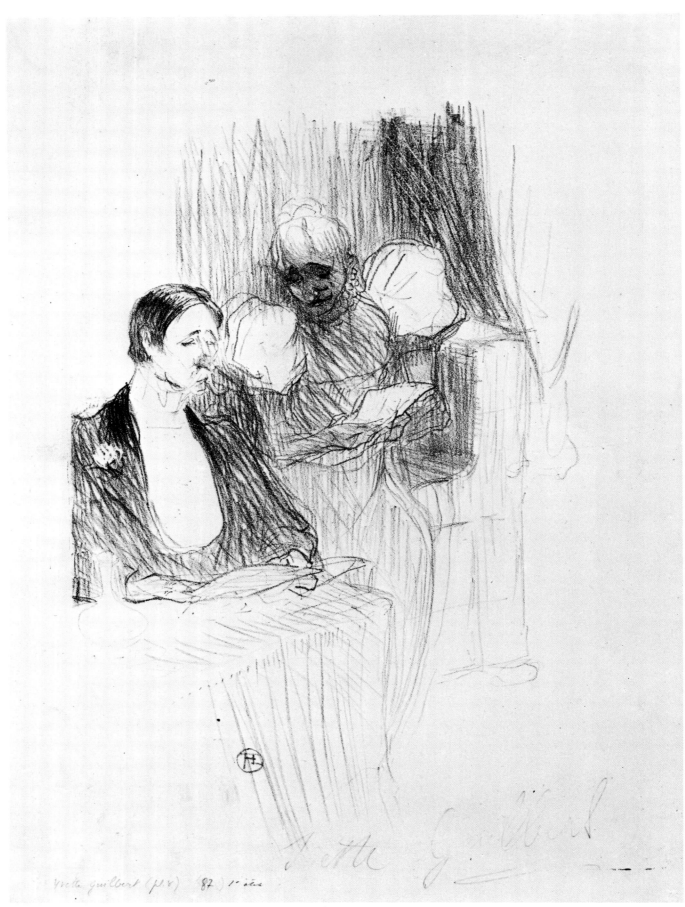

Yvette Guilbert (pl. 8) (87) 1.ière

Yvette Guilbert

81 Yvette Guilbert 1894

Lithograph, page 8 of the *Yvette Guilbert* album.
First state. Without the block of text on the right and below.
Drawing in olive green; chalk, worked with the scraper.
303 × 207 mm.
Monogram on the stone, below.
Six impressions known, printed on different papers.
Delteil 87 I; Adhémar 94; Adriani 85 I; Wittrock 77.
Second state. With block of text.
Hand-made paper.
Edition of 100.
Delteil 87 II; Adhémar 94; Adriani 85 II; Wittrock 77.

82 Yvette Guilbert 1894

Lithograph, page 9 of the *Yvette Guilbert* album.
First state. Without the block of text on the left.
Drawing in olive green; chalk, sprayed ink, worked with the scraper.
313 × 142 mm.
Monogram on the stone, lower right.
Five impressions known, printed on different papers.
Delteil 88 I; Adhémar 95; Adriani 86 I; Wittrock 78.
Second state. With block of text.
Hand-made paper.
Edition of 100.
Delteil 88 II; Adhémar 95; Adriani 86 II; Wittrock 78.

éclairé électriquement, qu'en Angleterre.

Et encore ?

La soirée achevée lentement avec la femme et les mioches, l'heure du repas liée à l'heure du sommeil par quelque causerie, ou quelque promenade au long de la rue de faubourg. C'est la manière la plus usitée, en somme. On les verra tous, l'été, en groupe au pas des portes, ou assis au bord du trottoir, ou attablés autour de la table de zinc. Le samedi, c'est le théâtre, le théâtre suburbain, et c'est surtout le café-concert, et nous y voilà revenus.

C'est donc là ce que veut la foule, ou une partie de la foule, ce que veut la foule ouvrière à Belleville et à Montparnasse, ce que veut la foule bureaucrate et commerçante boulevard de Strasbourg et faubourg Saint-Denis. Elle veut de la musique, des illuminations, et de la gaîté, de la gaîté surtout, la gaîté du petit bleu, de la chair et des déjections !

Voir apparaître un pochard, un type titubant, la cravate défaite, les mains pendantes, le chapeau de travers, le nez rouge, le petit œil brillant, et l'entendre dégoiser le récit de tout ce qu'il a bu et vomi en revenant de Suresnes, et d'ailleurs, de n'importe où il y a des comptoirs de zinc, des litres et des verres, c'est une joie.

C'en est une autre que d'assister aux ébats d'une commère qui raconte les privautés de l'alcôve avec ses yeux, son sourire, ses mots entrecoupés, son torse, ses hanches, tout.

C'en est encore une autre que de respirer l'incongruité, la purge et le water-closet.

82·II

L'estomac, la tripe et le reste ont ainsi leur fête. Les nécessaires fonctions humaines ont leur apothéose.

C'est désolant, répugnant, mais que l'on ne se hâte pas tout de même de jeter une défaveur spéciale sur ceux qui vont se réjouir de ces rappels des conditions de la vie. Ils font partie d'une lignée, ils sont dans une tradition qui n'est pas moins que l'une des traditions classiques françaises.

Il n'est peut-être pas nécessaire d'ouvrir les bibliothèques, de rechercher toutes les pièces justificatives. Il suffit d'éveiller le souvenir, de montrer l'âme d'un pays flottante au-dessus de l'Histoire. La France n'est-elle pas une terre de vignes, de la Bourgogne au Bordelais, du Jura à la Touraine, de la Champagne au Roussillon ? Il est difficile, à ceux qui sont nés de cette race, d'échapper aux antécédents séculaires, à cette vapeur de terroir. La France ne fut-elle pas aussi un séjour d'amour vif et de galants propos ? Et son réalisme aussi s'embarrassa-t-il des basses fonctions, contrepoids nécessaires d'une cérébralité alerte, rétablissement d'équilibre utile à la spéculation de la pensée ? N'en a-t-il pas été fait un élément de comique et de force ?

En plein moyen-âge, aux pierres même des cathédrales, ce réalisme de la race s'affirme et triomphe, nargue le destin, se réjouit de la minute concédée à l'être. La nationalité française n'a pas attendu le grand docteur François Rabelais, le bon docteur qui décrète la Renaissance, qui rassure définitivement l'humanité, qui lui enjoint d'accepter son sort et de vivre sa vie.

Hélas ! sans doute, le rabelaisisme est à bon marché, et ceux qui se payent de mots et détournent les ordures en affirmant continuer l'ancêtre, n'ont rien recueilli de la haute philosophie du vaste esprit, de son mystérieux savoir, de sa prévoyante et bienveillante conscience. Ils pataugent dans le marécage d'une manière, ne s'en iront jamais, comme l'autre, sur le libre océan de la pensée.

Mais ceux-là qui viennent du fin fond des foules pour assister à quelque spectacle, entendre quelque parole, ceux-là

83·II

n'apportent que leur instinct. Ils veulent qu'on leur parle, mais ils ne savent que confusément ce qu'ils veulent qu'on leur dise. S'ils le savaient, ils se le diraient eux-mêmes, réaliseraient sans aide la conception harmonique. Il se trouve qu'ils ont besoin des autres pour se formuler une signification de la vie, mais ce n'est pas de leur faute si ces autres abusent de cette nécessité, ou ne sont pas à la hauteur de leur fonction. La foule est confiante, elle accepte comme de la vérité et de la poésie ce qui lui est offert. Avant de la réformer, elle, cette foule, réformez-vous donc vous mêmes, vous qui lui parlez, soi-disant apporteurs de vérité, prétendus poètes. Ne dites pas que vous lui donnez ce qu'elle aime, qu'elle vous force à vos cuisines. Il n'y a de sûr que ceci : c'est qu'elle a faim et soif, qu'elle veut manger et boire, et qu'elle mange et boit ce que vous lui servez, pour ne pas tomber d'inanition. Elle croit que c'est cela, la vérité, que c'est cela, la poésie, que c'est cela, la chanson, et elle se précipite en affamée, comme se précipite l'enfant naïf. Il est affreux de lui donner, pour la réjouir et l'apaiser, les infectes sauces, le mauvais pain, le mauvais vin, le tord-boyaux.

L'assistance conviée à ces festins s'habituerait bien à d'autres mets. Pas tout de suite, peut-être, car elle a le palais brûlé, le goût dépravé, l'estomac effondré, et les saveurs naturelles lui paraîtraient mystificatrices. Les patients soumis depuis si longtemps à ce régime débilitant, excitant et abrutissant, ne peuvent se sentir tout de suite remis en liberté, rendus à la saine perception des choses.

Tout de même, aujourd'hui, dans le grouillement des couplets grossiers qui excitent les instincts à la brutalité sans leur dire les fins de la nature et l'épanouissement de la matière par l'esprit, qu'il se fasse un appel à la sentimentalité ou au désintéressement, il sera entendu.

84·II

83 Yvette Guilbert 1894

Lithograph, page 10 of the *Yvette Guilbert* album.
First state. Without the block of text on the left and below.
Drawing in olive green; chalk, ink with brush, worked with the scraper.
248 × 90 mm.
Monogram on the stone, lower left.
Six impressions known, printed on different papers.
Delteil 89 I; Adhémar 96; Adriani 87 I; Wittrock 79.
Second state. With block of text.
Hand-made paper.
Edition of 100.
Delteil 89 II; Adhémar 96; Adriani 87 II; Wittrock 79.

84 Yvette Guilbert 1894

Lithograph, page 11 of the *Yvette Guilbert* album.
First state. Without the block of text on the right and below.
Drawing in olive green; chalk, sprayed ink.
300 × 150 mm.
Monogram on the stone, lower left.
Six impressions known, printed on different papers.
Delteil 90 I; Adhémar 97; Adriani 88 I; Wittrock 80.
Second state. With block of text.
Hand-made paper.
Edition of 100.
Delteil 90 II; Adhémar 97; Adriani 88 II; Wittrock 80.

See the profile studies Dortu D.3641 and D.3649 (Musée du Louvre, Paris), D.3651 and D.3653 (Musée du Louvre, Paris).

Lithograph, page 12 of the *Yvette Guilbert*
album.
First state. Without the block of text on
the left and below.
Drawing in olive green; chalk, sprayed
ink.
255 × 200 mm.
Monogram on the stone, upper right.
Four impressions known, printed on
different papers.
Delteil 91 I; Adhémar 98; Adriani 89 I;
Wittrock 81.
Second state. With block of text.
247 × 196 mm.
Hand-made paper.
Edition of 100.
Delteil 91 II; Adhémar 98; Adriani 89 II;
Wittrock 81.

85·II

Lithograph, page 13 of the *Yvette Guilbert*
album.
First state. Without the block of text on
the right and below.
Drawing in olive green; chalk, sprayed
ink, worked with the scraper.
330 × 190 mm.
Six impressions known, printed on
different papers.
Delteil 92 I; Adhémar 99; Adriani 90 I;
Wittrock 82.
Second state. With block of text.
Hand-made paper.
Edition of 100.
Delteil 92 II; Adhémar 99; Adriani 90 II;
Wittrock 82.

This is one of the few lithographs in
which Lautrec did not include his
monogram on the stone.

86·II

87·II

89·III

Lithograph, page 14 of the *Yvette Guilbert* album.
First state. Without the block of text on the right and below.
Drawing in olive green; chalk, sprayed ink.
323 × 220 mm.
Monogram on the stone, below.
Four impressions known, printed on different papers.
Delteil 93 I; Adhémar 100; Adriani 91 I; Wittrock 83.
Second state. With block of text.
Hand-made paper.
Edition of 100.
Delteil 93 II; Adhémar 100; Adriani 91 II; Wittrock 83.

89 YVETTE GUILBERT 1894

Lithograph, page 16 of the *Yvette Guilbert* album.
First state. Before the stage set was altered and without the block of text on the right.
Drawing in olive green; chalk, ink with brush and spraying technique, worked with the scraper.
340 × 167 mm.
Monogram on the stone, lower left.
Japan paper, hand-made paper.
Two impressions known.
Delteil 95 I; Adhémar 102 (state not described); Adriani 93 I; Wittrock 85.
Second state. Scenery left and above reduced in size.
340 × 160 mm.
Hand-made paper.
Three impressions known.
Delteil 95 II; Adhémar 102; Adriani 93 II; Wittrock 85.
Third state. With block of text.
Hand-made paper.
Edition of 100.
Delteil 95 III; Adhémar 102; Adriani 93 III; Wittrock 85.

This portrait of Yvette Guilbert was based on several carefully executed studies and sketches – Dortu P.520 (Musée d'Albi), A.214 (Museum of Art, Providence), D.3373, D.3646, D.3647 (all Musée du Louvre, Paris).

Lithograph, page 15 of the *Yvette Guilbert*
album.
First state. Without the block of text on
the right and below.
Drawing in olive green; chalk, sprayed
ink.
350 × 250 mm.
Monogram on the stone, on the right.
Four impressions known, printed on
different papers.
Delteil 94 I; Adhémar 101; Adriani 92 I;
Wittrock 84.
Second state. With block of text.
314 × 177 mm.
Hand-made paper.
Edition of 100.
Delteil 94 II; Adhémar 101; Adriani 92 II;
Wittrock 84.

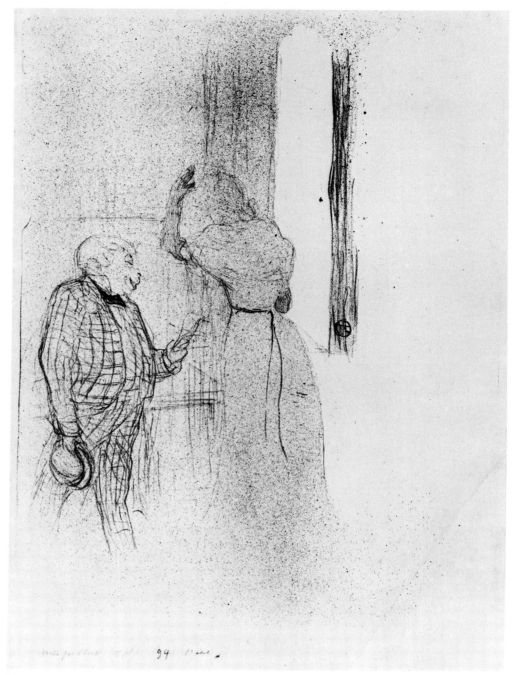

88·I

90 Yvette Guilbert, dans 'Colombine
 à Pierrot' 1894
 Yvette Guilbert in 'Colombine à Pierrot'

Lithograph, song title (Columbine to
Pierrot).
First state. Without lettering.
Drawing in dark green; chalk.
230 × 115 mm.
Monogram on the stone, lower left.
Vellum.
Edition of 50 numbered impressions, with
Lautrec's red monogram stamp (Lugt
1338), lower right, and the blind stamp of
the publisher Kleinmann (Lugt 1573), left.
Delteil 96 I; Adhémar 103 I; Adriani 94 I;
Wittrock 68.
Second state. With text not designed by
Lautrec, in dark green; 'Colombine/à/
Pierrot/Réponse/Créée par/YVETTE
GUILBERT/...' (with information on
the edition before lettering, the address of
the publisher, Ed. Kleinmann, and the
publishing house).
Size of edition not known (several
hundred, printed by Joly-Crevel Frères,
Successeurs, Paris).
Delteil 96 II; Adhémar 103 II;
Adriani 94 III; Wittrock 68.
New edition (after 1901). Lettering
removed; drawing in blue, coloured by
another hand (in blue and violet) using
stencils.
220 × 108 mm.
New edition (1950). As first state.
1950 numbered impressions as
supplement to the book by Claude
Roger-Marx, *Yvette Guilbert vue par
Toulouse-Lautrec*, Paris 1951. Of the total
edition, 50 impressions are printed in
black, 50 in olive green and 50 in sepia on
imitation Japan paper; another 300 are
also printed in black or olive green on
imitation Japan paper, while the
remaining 1500 have the drawing in olive
green and are coloured (in violet, pink,
yellow and olive green) with stencils.

The music for this song, which Yvette
Guilbert included in her repertoire, was
written by Désiré Dihau. The litho stone
for the first state is now in the Musée
d'Albi.

90·I

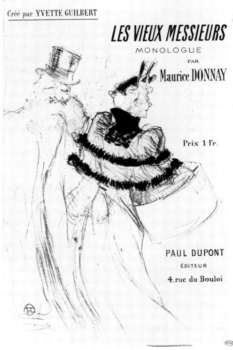

91·II

91 'Les Vieux Messieurs' 1894

Lithograph, song title (The Old
Gentlemen).
First state. No lettering, line marking the
edge, upper left.
Drawing in olive green; chalk, ink with
brush, worked with the scraper.
246 × 167 mm.
Monogram on the stone, lower left.
Vellum, Japan paper.
Two impressions known.
Delteil 75 I; Adhémar 80 I; Adriani 95 I;
Wittrock 57.
Second state. The image transferred to
another stone and with the following text
not designed by Lautrec: 'Créé par
YVETTE GUILBERT/LES VIEUX
MESSIEURS/...' (with the address of the
publisher, Paul Dupont).
Drawing in black or olive green.
227 × 165 mm.
Vellum.
Size of edition not known (several
hundred).
Delteil 75 II; Adhémar 80 II; Adriani 95 II;
Wittrock 57 (also mentions new editions
with changes to the text and different
publishers, without giving further
details).
First new edition (after 1901). As first state,
but with the edging upper left removed.
Drawing in olive green, brown or black.
Vellum, Japan paper.
About 45 impressions, 15 on Japan paper
and about 30 on vellum with the
watermark: 'G. PELLET/T. LAUTREC';
most of these have Lautrec's red
monogram stamp (Lugt 1338), lower left.
Second new edition (after 1901). With the
two figures on the left wearing top hats
removed.
220 × 166 mm.
Approximately 20 impressions, about 10
on Japan paper, and about 10 on vellum
with the watermark: 'G. PELLET/T.
LAUTREC'; some of these have Lautrec's
red monogram stamp (Lugt 1338), lower
left.

This monologue, recited by Yvette
Guilbert, was by Maurice Donnay. It was
about the 'old gentlemen who run after
milliners with sly looks or who ogle
naughty errand girls'.

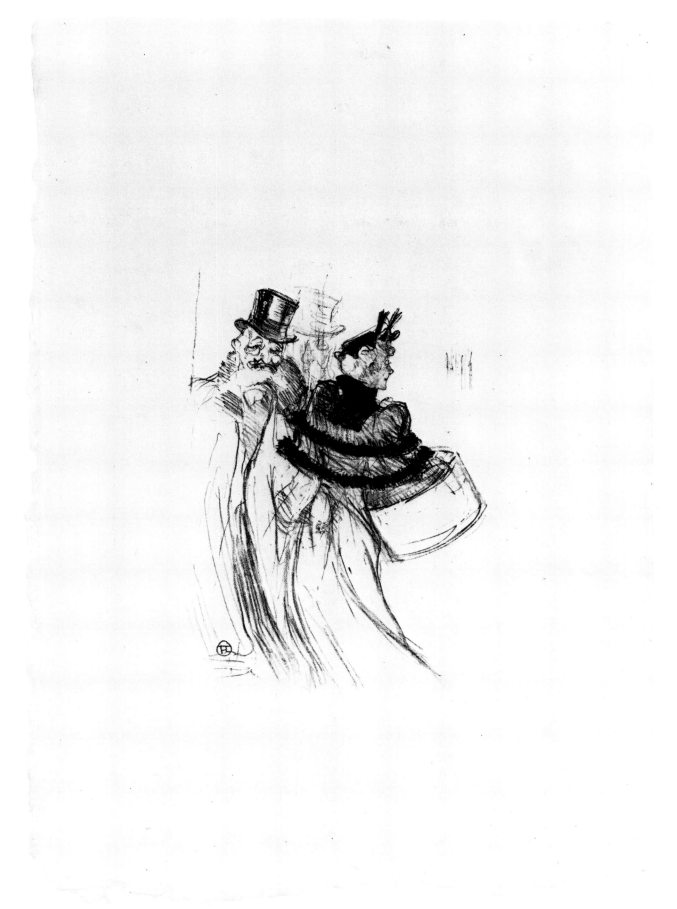

91 New edition

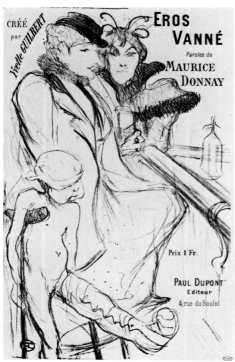

92·II

92 'Eros Vanné' 1894

Lithograph, song title (Eros Vanquished).
First state. No lettering, edging lines upper left.
Drawing in olive green or black; chalk.
290 × 225 mm.
Monogram on the stone, lower left.
Vellum.
Four impressions known.
Delteil 74 I; Adhémar 81 I; Adriani 96 II; Wittrock 56.
Second state. The image transferred to another stone and slightly reduced at the lower edge. With the following text, not designed by Lautrec: 'CRÉÉ/par/Yvette GUILBERT/EROS/VANNÉ/...' (with the address of the publisher Paul Dupont).
Drawing in black.
275 × 180 mm.
Size of edition not known (several hundred); a watercolour impression Dortu A.216 (Bibliothèque Nationale, Paris) is also known.
Delteil 74 III; Adhémar 81 III; Adriani 96 III; Wittrock 56 (new editions with changes to the text mentioned, but no further details given).
First new edition (after 1901). As first state, but with edging upper left removed.
Drawing in olive green, brown or black.
Vellum, Japan paper.
About 45 impressions, 15 on Japan paper, about 30 on vellum with watermark: 'G. PELLET/T. LAUTREC'; most of these have Lautrec's red monogram stamp (Lugt 1338), lower left.
Second new edition (after 1901). The figures removed except for the heavily bandaged Eros.
185 × 185 mm.
Approximately 30 impressions, of which about 10 are on Japan paper, and about 20 on vellum with the matermark: 'G. PELLET/T. LAUTREC'; most of these have Lautrec's red monogram stamp (Lugt 1338), lower left.

This encounter at the bar is a sarcastic pointer to the limited possibilities of lesbian relationships; *cf.* a preliminary sketch of the scene Dortu D.3664. Yvette Guilbert, who popularized Maurice Donnay's song at the Scala, wrote to Lautrec about it: 'My dear friend, very impressive, EROS VANNÉ! I am delighted ... delighted ... just carry on, young man ... just carry on like that ... I am not joking, I am really enchanted and send you a thousand thanks. In friendship, Yvette' (Joyant I, p. 147).

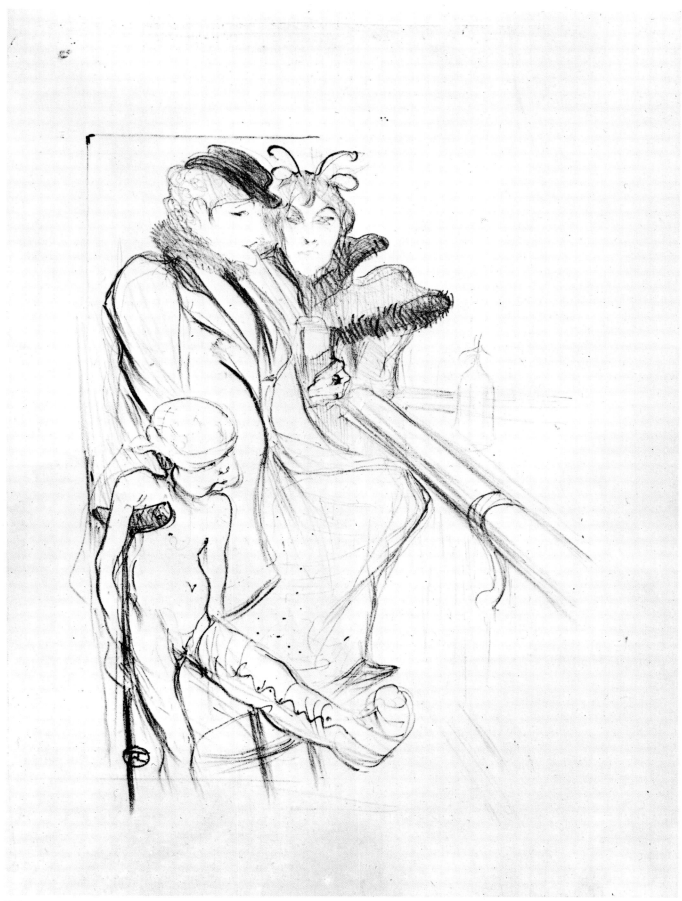

93 New edition

93 'ADOLPHE OU LE JEUNE HOMME TRISTE' 1894

Lithograph, song title (Adolphe, or The Sad Young Man).
First state. No lettering, edging lines upper left.
Drawing in black; chalk.
260 × 183 mm.
Monogram on the stone, lower right.
Vellum.
One impression known (Bibliothèque Nationale, Paris).
Delteil 73 (state not described); Adhémar 82 (state not described); Adriani 97 I; Wittrock 55.
Second state. The image transferred to a new stone with the following text, not designed by Lautrec: 'CRÉÉ/par/ YVETTE GUILBERT/ADOLPHE/OU/ LE JEUNE HOMME TRISTE . . .' (with the address of the publisher Paul Dupont).
248 × 165 mm.
Size of edition not known (several hundred).
Delteil 73 II; Adhémar 82 II; Adriani 97 III; Wittrock 55 (new editions mentioned with changes to the text, but no further details given).
New edition (after 1901). As first state, but with edging lines upper left removed.
Drawing in olive green, brown or black.
Vellum, Japan paper.
Approximately 45 impressions, about 15 on Japan paper, and about 30 on vellum with the watermark: 'G. PELLET/T. LAUTREC'; most of these have Lautrec's red monogram stamp (Lugt 1338), lower left.

Maurice Donnay wrote this song for Yvette Guilbert. The model for the sad young man was probably Gabriel Tapié de Céleyran (1869–1930). Céleyran, who was studying medicine in Paris, was Lautrec's cousin and had been his constant companion since 1891. See the portrait study Dortu D.3667 and the full-length portrait Dortu P.521 (Musée d'Albi).

93·II

94·I

94 ZIMMERMAN ET SA MACHINE 1894
Zimmerman and his Bicycle

Lithograph.
First state. No lettering.
Drawing in black; chalk, worked with the scraper.
230 × 136 mm.
Monogram on the stone, upper left.
Vellum.
Three impressions known.
Delteil 145 I; Adhémar 83 II; Adriani 98 I; Wittrock 111.
Second state. The image transferred to a new stone with new lettering, not designed by Lautrec: 'ZIMMERMAN/ET SA MACHINE'.
Drawing in grey.
Vellum, Japan paper.
Size of edition not known (50,000 were announced as illustrations for the June 1895 edition of *La Revue Franco-Américaine*; the first 45 were printed on Japan paper).
Delteil 145; Adhémar 83; Adriani 98; Wittrock 111.

Lautrec's friend Paul Leclercq has left us a vivid description of this little print, which appeared in June 1895 as the illustration to a report by Tristan Bernard in *La Revue Franco-Américaine*, but which is stylistically close to the ADOLPHE print (No. 93): 'The print shows the celebrated racing cyclist Zimmerman [an American who had been in France since May 1893, had his first major successes in Paris in July 1894, and returned to the United States in April 1895] wearing his jersey, leaning on his bicycle. Through this lively image I can see Lautrec, armed with his litho chalk, bending over the stone, and I can still hear him eulogizing on the benefits of sports training, with the short, vivid and trenchant expressions which he used to such effect' (Paul Leclerq [sic], *Henri de Toulouse-Lautrec*, Zurich 1958, p. 13); *cf.* the pencil study Dortu D.3936.

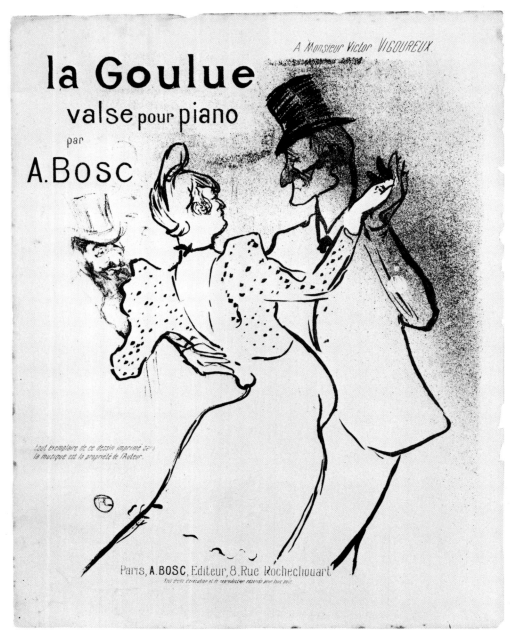

95·II

95 'LA GOULUE' 1894

Lithograph, title of a piece of music.
First state. No lettering.
Drawing in olive green or black; ink with
brush and spraying technique, chalk,
worked with the scraper.
314 × 257 mm.
Monogram on the stone, lower left.
Vellum.
Edition of 100 numbered impressions
(from 50 to 100), some signed; most have
Lautrec's red monogram stamp (Lugt
1338), lower left, and the blind stamp of
the publisher Kleinmann (Lugt 1573).
Delteil 71 I; Adhémar 77; Adriani 99 I;
Wittrock 65.
Second state. The image transferred to a
new stone with the following text, not
designed by Lautrec: '. . . la Goulue/valse
pour piano/. . .' (and the address of the
publisher A. Bosc).
Drawing in olive green.
295 × 230 mm.
Size of edition not known (several
hundred).
Delteil 71 II; Adhémar 77; Adriani 99 II;
Wittrock 65.

The music was printed by Chaimbaud,
Paris, and the print shows La Goulue and
Valentin de Désossé waltzing (see No. 1);
cf. the studies of La Goulue Dortu D.3202,
D.3219 and D.3311.

95·I

96 'LA TERREUR DE GRENELLE' 1894

Lithograph, song title (The Terror of Grenelle).
First state. No lettering.
Drawing in olive green; chalk.
178 × 135 mm.
Monogram on the stone, lower edge.
Vellum, hand-made Japan paper.
Three impressions known.
Delteil 72 (state not described);
Adhémar 79 (state not described);
Adriani 100 (state not described);
Wittrock 66.

Second state. No lettering, image reduced
upper edge, left and right.
174 × 114 mm.
Mounted vellum, imitation Japan paper.
Edition of 100 numbered impressions,
some with Lautrec's red monogram
stamp (Lugt 1338), lower right, and the
blind stamp of the publisher Kleinmann
(Lugt 1573) left; Nos. 1–50 are printed on
imitation Japan paper and Nos. 51–100 on
mounted vellum.
Delteil 72 I; Adhémar 79 I; Adriani 100 I;
Wittrock 66.
Third state. The image transferred to a
new stone with the following text, not
designed by Lautrec: 'CHANSONS de
Jules JOUY./La Terreur de Grenelle . . .'
(and the address of the publisher
G. Ondet, etc.).
Drawing in black.
Vellum.
Size of edition not known (several
hundred).
Delteil 72 II; Adhémar 79 II;
Adriani 100 II; Wittrock 66 (new editions
on Japan paper mentioned but no further
details given).

This song was printed by Joly-Crevel
Frères Successeurs, Paris; see the chalk
study Dortu D.3662.

96·I

97 LA TIGE, MOULIN ROUGE 1894
The Stalk, Moulin Rouge

Lithograph.
Drawing in black; chalk.
300 × 252 mm.
Monogram on the stone, lower left.
Vellum.
Edition of 100 numbered impressions,
some with Lautrec's red monogram
stamp (Lugt 1338), lower left, and the
blind stamp of the publisher Kleinmann
(Lugt 1573); three impressions on
imitation Japan paper are also known.

Delteil 70; Adhémar 78; Adriani 101;
Wittrock 63.

This print shows Maurice Guibert
(1856–1913), a champagne representative,
amateur painter, photographer and 'the
man who knows most about all the
floosies in Paris' (*Fin de Siècle*, 7 July
1895). For Lautrec he was also an
indispensable guide to the *maisons closes*.
Here we see him eyeing up a very bony
beauty in the Moulin Rouge who was
known as *La Tige* (the Stalk).

98 IDA HEATH AU BAR 1894
Ida Heath at the Bar

Lithograph.
Drawing in olive green or black; chalk,
sprayed ink, worked with the scraper.
340 × 255 mm.
Monogram on the stone, lower left.
Vellum.
Edition of 100, some with Lautrec's red
monogram stamp (Lugt 1338), lower
right; three impressions on imitation
Japan paper or hand-made Japan paper are
also known (illustrated).
Delteil 59; Adhémar 125; Adriani 67;
Wittrock 62.

Ida Heath was an English dancer; see
No. 99.

99 MISS IDA HEATH, DANSEUSE
ANGLAISE 1894
Miss Ida Heath, English Dancer

Lithograph.
Drawing in black or olive green; chalk,
ink with brush, worked with the scraper.
364 × 264 mm.
Monogram on the stone, upper left.
Vellum, hand-made Japan paper.
Edition of 40, some numbered, five in
olive green on hand-made Japan paper, 15
in olive green on vellum, five in black in
hand-made Japan paper and 15 in black
on vellum; most have Lautrec's red
monogram stamp (Lugt 1338), lower
right, and the blind stamp of the publisher
Kleinmann (Lugt 1573) lower left.
Two impressions bearing a dedication are
also known.
Delteil 165; Adhémar 104; Adriani 66;
Wittrock 64.

The print shows the English dancer Ida
Heath (see No. 98) on stage. The next
print, No. 100, is similar in composition.
A sketch Dortu D.3840 records the dance
step in what is virtually a caricature in
style.

100 CECY LOFTUS 1894

Lithograph.
Drawing in olive green; chalk, sprayed
ink.
370 × 250 mm.
Monogram on the stone, upper right.
Mounted vellum, mounted China paper.
Edition of about 35, some numbered,
some signed by the artist in pencil lower
left; some also have Lautrec's red
monogram stamp (Lugt 1338) and the
blind stamp of the publisher Kleinmann
(Lugt 1573).
Delteil 116; Adhémar 105; Adriani 65;
Wittrock 113.
The impression shown here is inscribed
by Kleinmann, lower left: 'Cecy Loftus'.

The print shows the singer Marie-Cecilia
Mc'Carthy, known as Cecy Loftus
(1876–1931), who came from Glasgow.
Delteil dated this lithograph to 1895, but
Adhémar mentions an impression which
Lautrec dedicated to the singer and dated
1894.

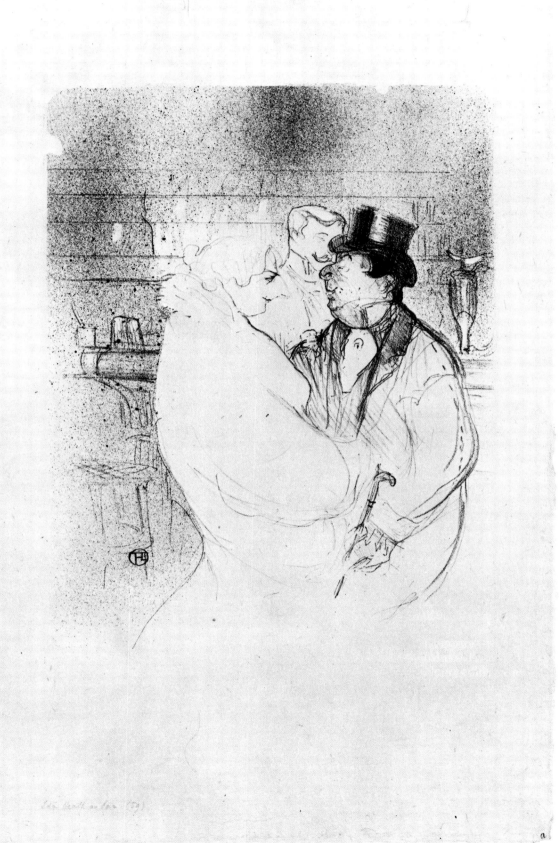

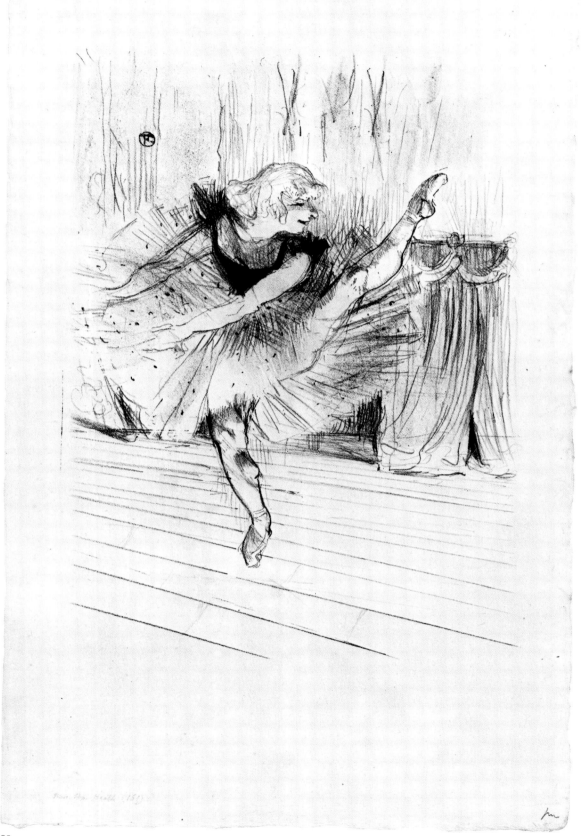

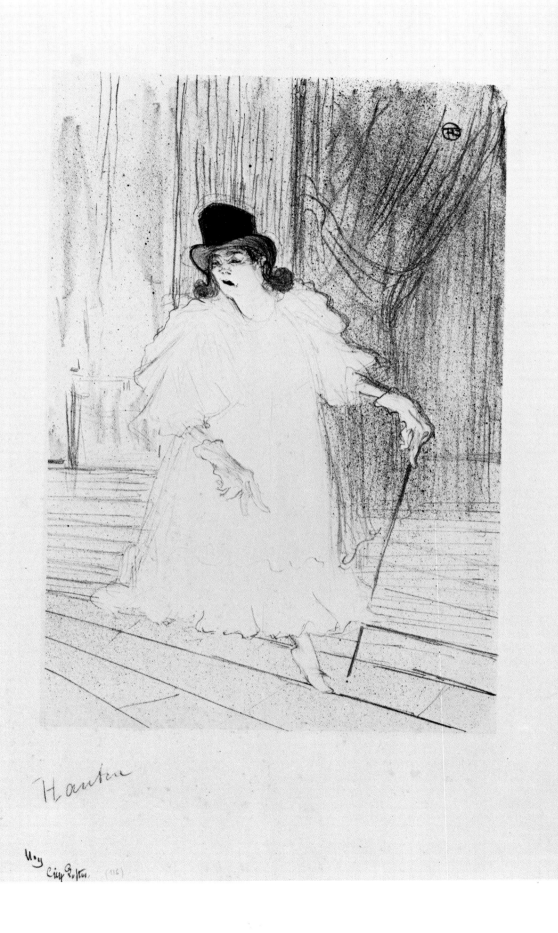

Hautrec

Colour lithograph, poster, with lettering
designed by Lautrec in dark olive green:
'Confetti', and writing, not designed by
Lautrec left: 'Manufactured
/by/J & E Bella,/113 Charing Cross Rd./
London/WC.'
Drawing in dark olive green with yellow
and red; ink with brush and spraying
technique, chalk.
570 × 390 mm.
Monogram on the stone, lower right,
with the address of the printer: 'imp. Bella
& de Malherbe London & Paris'.
Vellum.
Size of edition not known (about 1000).
Delteil 352; Adhémar 9; Adriani 109 II;
Wittrock P 13.

This small poster, made for the English
paper manufacturers J. and E. Bella, was
probably created in the late autumn of
1894; it was based on a coloured study on
canvas, also dated 1894, Dortu P.517
(Bührle Collection, Zurich). The Bella
brothers organized poster exhibitions at
the Royal Aquarium, London, in 1894
and 1896, to which they invited Lautrec.
Certainly, his participation in the first of
these shows at the end of October 1894
(see Goldschmidt–Schimmel No. 184)
reviewed by Jules Roques in the *Courrier
Français* on 11 November 1894, would
explain why the firm gave the
commission for their own advertisement,
not to an English artist, but to the
experienced poster designer from the
Continent (see Edward Bella, 'Les
Affiches Etrangères, l'Affiche Anglaise, H.
de Toulouse-Lautrec Confettis', in *La
Plume*, 155, 1 October 1895).

 The text, which is designed as part of
the drawing, forms an integral element of
the composition; it fits into the overall
character of the design to create an
effective advertisement without
impinging on the drawing in any way.

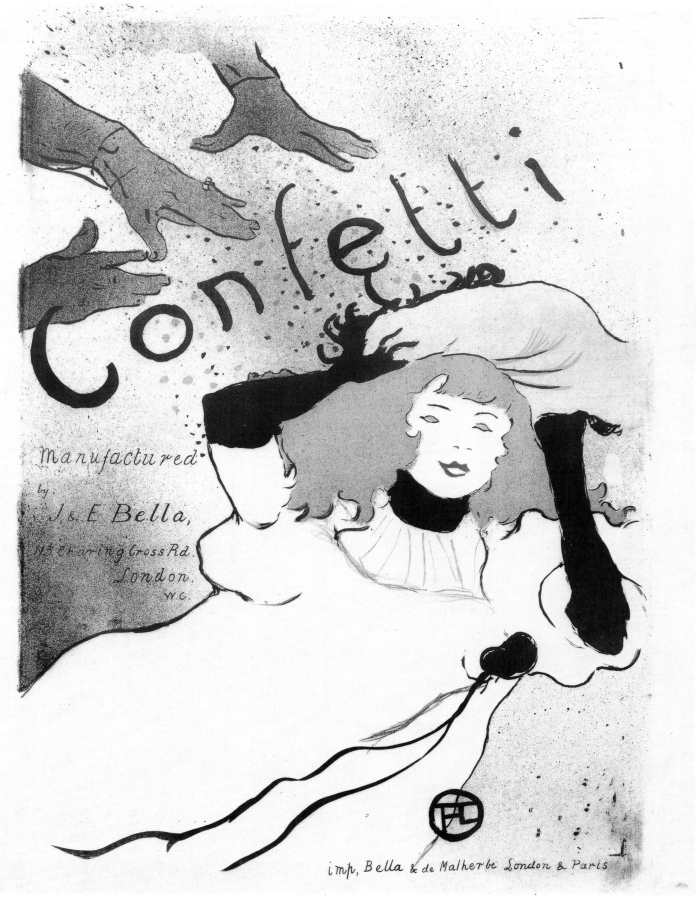

102 NIB OU LE PHOTOGRAPHE-
AMATEUR 1894
Nib, or the Amateur Photographer

Transfer lithograph, page 1 of the 'Nib'
supplement, with lettering designed by
Lautrec: 'NIB'.
Drawing in black, chalk.
259 × 240 mm.
Monogram on the stone, lower right.
Beige vellum.
Edition of about 2000, 20 of which are on
white vellum, signed in pencil by the
artist, lower right; the other impressions
were published in 'NIB', a supplement to
La Revue Blanche. One impression of the
de luxe edition is known (illustrated).
Delteil 99 I, II; Adhémar 106; Adriani 102;
Wittrock 86.

Towards the end of 1894 Lautrec began
preliminary work on a project that had

long been close to his heart. Entitled 'Nib'
– a slang expression, meaning 'nothing
special' – this four-page supplement with
original prints and texts by celebrated
artists and writers was to be published
under Lautrec's direction, in co-
production with *La Revue Blanche*, on a
monthly basis. However, although it was
only small and included a whole page of
advertisements, the project had to be
dropped for cost reasons after only three
had appeared, designed by Lautrec,
Bonnard and Vallotton. Three
lithographs printed on one sheet by
Ancourt, Paris, appeared in the first of
these, which was co-edited with Tristan
Bernard and published with No. 39 of *La
Revue Blanche* on 1 January 1895. The title
page is an amusing and ironic depiction of
the amateur photographer, in the person
of the actor Lenoble, who is proudly
taking the world home with him in his

little box. A portrait of the Polish singer,
Anna Held (No. 103), followed on the
third page, opposite a political report by
Tristan Bernard and a remarque by
Lautrec, *Pieds dans le Plat* (Put his foot in
it), or a monogram in the shape of an
elephant. Half of the fourth page is filled
with the circus act by the clowns Georges
Footit and Chocolat (No. 104) advertising
Potin chocolate.

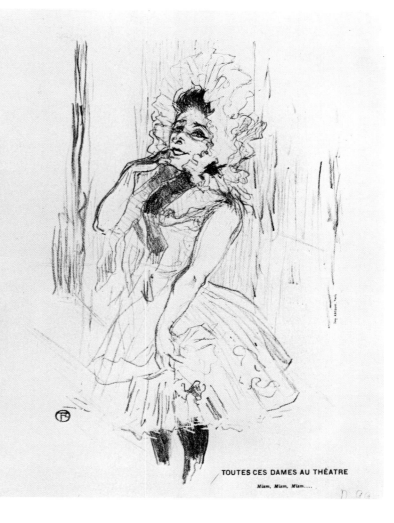

NIB
Supplément de
La revue blanche

Moniteur des Peaux et des Tringles

Bulletin Politique

Il n'y a rien encore d'absolument officiel dans l'avènement de Nicolas II. Beaucoup de bons esprits pensent, en effet, qu'au point de vue de la paix universelle, il vaudrait mieux que les princes du sang et autres personnages notables régnassent indifféremment sur les différens pays, et que les rois fussent désignés au choix ou à l'ancienneté par un concile international. Ainsi la mort ou la mise à la retraite d'un souverain donnerait lieu « à un mouvement impérial » qui paraîtrait au *Bulletin des Nations*.

Certains diplomates, persuadés de l'excellence de ce système, avaient déjà préparé le projet suivant où S. M. François-Joseph était nommé empereur de Russie.

M. de Savoie (Humbert), roi d'Italie, est nommé empereur d'Autriche-Hongrie, en remplacement de M. de Habsbourg (François-Joseph) appelé à d'autres fonctions.

M. Stuart de Nassau de Cobourg (Albert), prince de Galles, est nommé roi d'Italie, en remplacement de M. de Savoie (Humbert), appelé à d'autres fonctions.

M. Charles Dupuy, président du Conseil des Ministres de la R. F., est nommé prince de Galles, en remplacement de M. Albert Stuart.

M. de Holstein Glücksbourg (Christian), roi de Danemark, est nommé président du Conseil des Ministres de la R. F., en remplacement de de M. Charles Dupuy.

M. Porfirio Diaz, président de la République du Mexique, est nommé roi de Danemarck, en remplacement de M. de Holstein-Glücksbourg (Christian), appelé à d'autres fonctions.

M. Déroulède (Paul), en disponibilité, est nommé président de la République du Mexique, en remplacement de M. Porfirio Diaz.

Que les personnes qui ne seraient pas comprises dans le présent mouvement n'aient pas trop d'inquiétudes, car un autre mouvement est en préparation, S. M. la reine Victoria devant être admise incessamment à faire valoir ses droits à la retraite. C'est par erreur qu'un diplomate suisse a prétendu qu'un grand bureau de tabac ou d'opium serait donné à la gracieuse souveraine, qui n'a pas besoin de telles compensations. On parle de Madame Adam pour lui succéder. C'est Madame Carmen Sylva qui prendrait la direction de la Nouvelle Revue, et M. Jules Simon serait nommé reine de Roumanie.

Il est également question de pourvoir au remplacement du gouverneur d'Algérie. Pour concilier les vœux de ceux qui réclament un homme politique et les desiderata des partisans du gouvernement militaire, on ferait choix de M. Mirman, député de la Marne, et fusilier de 2ᵉ classe au 29ᵉ bataillon de chasseurs à pied.

T. B.

PIEDS DANS LE PLAT
« La bière n'a jamais été que de l'urine avant la lettre.»
Louis Nuna Baragnon-junior.

103·II

TOUTES CES DAMES AU THÉÂTRE
Miam, Miam, Miam....

103 ANNA HELD DANS 'TOUTES CES DAMES AU THÉÂTRE' 1894
Anna Held in 'Toutes ces Dames au Théâtre'

Transfer lithograph, page 3 of the 'Nib' supplement.
First state. No lettering, the drawing incomplete on the right edge.
Drawing in black; chalk, worked with the scraper.
330 × 210 mm.
Monogram on the stone, lower left.
Vellum.
Edition of about 25, some numbered, some signed by the artist in pencil, lower left.
Delteil 100 I; Adhémar 112 I; Adriani 103 I; Wittrock 88.
Second state. Several vertical chalk strokes added to the drawing on the right edge; the following text, not designed by Lautrec, has also been added: 'TOUTES CES DAMES AU THÉÂTRE/Miam, Miam, Miam . . .'
322 × 218 mm.
Address of the printer added on the stone, right edge: 'Imp. ANCOURT, Paris'.
Beige vellum.
Edition of about 2000, 20 of which are on white vellum; the other impressions were published in 'Nib', a supplement to *La Revue Blanche*. One impression from the de luxe edition is known (illustrated).
Delteil 100 II; Adhémar 112 II; Adriani 103 II; Wittrock 88.

A rapid chalk study Dortu D.3890 (Musée du Louvre, Paris) was made in preparation for this depiction of Anna Held (1865–1918), playing the coquette in the role of a child; see the later portrait of the singer, who was born in Warsaw (No. 266).

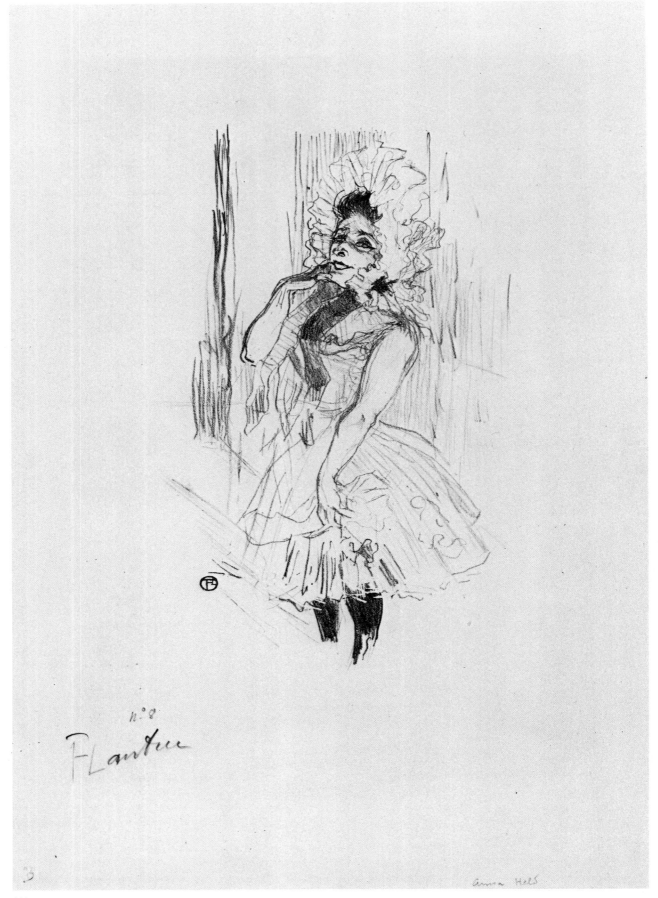

n°8

FLautrec

Anna Held

104 FOOTIT ET CHOCOLAT 1894
 Footit and Chocolat

Transfer lithograph, page 4 of the 'Nib'
supplement.
First state. Without the block of text
below; the drawing continues above the
heads of the spectators at the top.
Drawing in black; chalk.
240 × 247 mm.
Monogram on the stone, upper left.
Vellum.
One impression known (illustrated).
Delteil 98 I; Adhémar 108 I; Adriani 104 I;
Wittrock 87.
Second state. With block of text, the
drawing reduced at the top, so removing
the monogram, upper left.
200 × 245 mm.
New monogram on the stone, lower
right.
Beige vellum.
Edition of about 2000, of which 20 are on
white vellum; the other impressions were
published in 'Nib', a supplement to *La
Revue Blanche*. One impression of the de
luxe edition is known (illustrated).
Delteil 98 II; Adhémar 108 II;
Adriani 104 II; Wittrock 87.

The clowns Georges Footit (1864–1921)
and Chocolat, a negro from Bilbao,
appeared in a joint act at the Nouveau
Cirque, 251 Rue Saint-Honoré.

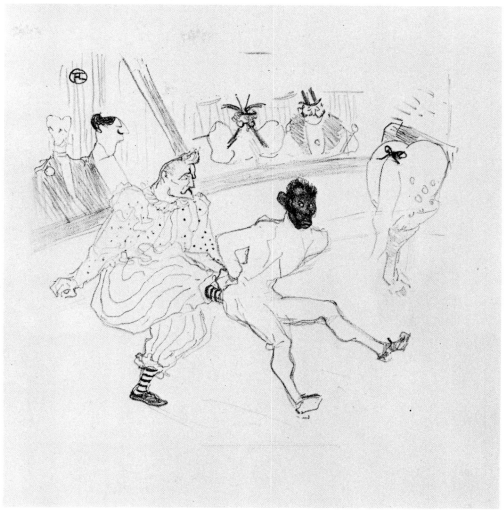

104·I

105·II

105 PROGRAMME DU 'CHARIOT DE TERRE
CUITE' 1895
*Programme for 'Le Chariot de Terre
Cuite'*

Lithograph, programme.
First state. No lettering, irregular cut-out
for the block of text.
Drawing in blue or black; chalk, sprayed
ink.
440 × 282 mm.
Monogram on the stone, below.
Vellum.
Two impressions known (Bibliothèque
Nationale, Paris).
Delteil 77 I; Adhémar 109 I; Adriani 105 I;
Wittrock 89.
Second state. With lettering not designed
by Lautrec: '. . . Le Chariot/de Terre
Cuite . . .' Drawing reduced on the left,
cut-out for the text straightened.
Drawing in blue with beige ground plate.
Size of edition not known (several
hundred); one impression also has a note
in pencil: '22 Mardi 1895'
(Kupferstichkabinett, Berlin).
Delteil 77 II; Adhémar 109 II;
Adriani 105 II; Wittrock 89.

At the beginning of 1895 Lautrec turned
to a task which he took immensely
seriously: 'I have even made my début in
a new line, that of stage-designer. I have
to do the stage scenery for a play
translated from the Hindustani, called *Le
Chariot de Terre Cuite* (The Terracotta
Cart). It's very interesting, but not easy'
(Goldschmidt-Schimmel, No. 186). The
Sanskrit drama had its première on 22
January 1895 at the Théâtre de l'Œuvre in
the version by Victor Barrucand, but
unfortunately, apart from a little sketch
for a painting that belonged to Lugné-Poë
– Dortu P.534 – only the lithographed
programme and a cover designed by
Lautrec for the published text have
survived. There is a note in the
programme, which was commissioned by
Lugné-Poë, which states that the stage
designs for the fifth act were by Lautrec.
The print shows Félix Fénéon
(1861–1944) as a Hindu priest, standing
on an elephant with his arms raised in
supplication. This may be a joking
reference to his many-sided activities: he
was an official in the Ministry of Defence;
accused of anarchist activities, he became
editorial secretary of *La Revue Blanche*,
was founder, publisher and contributor to
altogether 14 journals, a supporter of the
Symbolists and wholehearted admirer of
the Neo-Impressionists, whose spokesman
he was.

Two drawings for the design have
survived, Dortu D.3665 (Musée du
Louvre, Paris) and D.3666, which is
dedicated to Fénéon; see also the detail
study Dortu D.3889.

106 YAHNE ET ANTOINE, DANS 'L'AGE
DIFFICILE' 1895
Yahne and Antoine in 'L'Age Difficile'

Lithograph.
Drawing in dark grey; chalk, ink with
brush, worked with the scraper.
353 × 260 mm.
Monogram on the stone, upper right.
Vellum.
Edition of 25 impressions, some
numbered, some with Lautrec's red
monogram stamp (Lugt 1338), lower
right, and the blind stamp of the publisher
Kleinmann (Lugt 1573) lower left; one
impression in olive green on hand-made
Japan paper is also known (Bibliothèque
Nationale, Paris).
Delteil 112; Adhémar 117; Adriani 128;
Wittrock 92.

At the beginning of 1895, the Théâtre
Gymnase had a great success with Jules
Lemaître's comedy *L'Age Difficile* (The
Difficult Age). The leading roles were
played by the beautiful Léonie Yahne,
together with André Antoine and Henri
Mayer (see No. 107).

107

107 YAHNE ET MAYER, DANS 'L'AGE DIFFICILE' 1895
Yahne and Mayer in 'L'Age Difficile'

Lithograph.
Drawing in olive green; chalk, sprayed ink, worked with the scraper.
330 × 223 mm.
Monogram on the stone, lower left.
Vellum.
Edition of 25, some numbered, some with Lautrec's red monogram stamp (Lugt 1338), lower right, and the blind stamp of the publisher Kleinmann (Lugt 1573), lower left; one impression in olive green on hand-made Japan paper is also known (Bibliothèque Nationale, Paris).
Delteil 98 I; Adhémar 108 I; Adriani 104 I; Wittrock 87.
The impression illustrated has a note in pencil by Kleinmann, lower left: 'Yahne et Mayer/age difficile'.

Léonie Yahne is shown here with Henry Mayer in her role as a lady cyclist (see No. 106).

108 YAHNE DANS SA LOGE 1895
Yahne in her Box

Lithograph.
Drawing in olive green or grey; chalk, sprayed ink, worked with the scraper.
320 × 225 mm.
Monogram on the stone, upper left.
Vellum.
Edition of 25 impressions, some numbered, some with Lautrec's red monogram stamp (Lugt 1338), lower right, and the blind stamp of the publisher Kleinmann (Lugt 1573), lower left; one impression with a dedication 'à Nys' is also known (illustrated).
Delteil 111; Adhémar 113; Adriani 130; Wittrock 91.

See No. 106.

à Nys
Lautrec

109 INVITATION ALEXANDRE NATANSON 1895
Invitation Card for Alexandre Natanson

Lithograph, invitation card.
First state. No lettering.
Drawing in olive green; chalk, ink with brush.
256 × 155 mm.
Monogram in the shape of a little elephant on the stone, lower right; small kangaroo above it.
Imitation Japan paper.
Two impressions known.
Delteil 101 I; Adhémar 123 I;
Adriani 110 I; Wittrock 90.
Second state. With lettering not designed by Lautrec: 'American/and other drinks . . .'.
Edition of about 300.
Delteil 101 II; Adhémar 123 II;
Adriani 110 II; Wittrock 90.

On 16 February 1895, to mark the unveiling of ten murals by Vuillard, a remarkable celebration was held in the villa of Alexandre Natanson at 60 Avenue du Bois de Boulogne. Lautrec drew the invitation card, which was in English, and also acted as 'maître de plaisir' and as the barman for 300 invited guests; dressed in a white linen jacket and a waistcoat patterned with the Union Jack, he served with great dexterity. To provide an amusing contrast, he asked his huge painter friend, Maxime Dethomas, to act as his assistant. They mixed 'American' cocktails Lautrec had invented himself, and pressed these upon the guests until the party ended in chaos.

109·II

110 ENTRÉE DE BRASSEUR, DANS 'CHILPÉRIC' 1895
Brasseur's Entrance in 'Chilpéric'

Lithograph.
First state. Without monogram, irregular lower edge.
Drawing in olive green or black; chalk, sprayed ink, worked with the scraper.
376 × 270 mm.
Vellum.
Two impressions known.
Delteil 110 I; Adhémar 126 I;
Adriani 113 I; Wittrock 107.
Second state. With monogram, lower edge straightened.
Drawing in olive green.
Monogram on the stone, lower left.
Edition of 20 impressions, some numbered, some with Lautrec's red monogram stamp (Lugt 1338), lower right, and the blind stamp of the publisher Kleinmann (Lugt 1573), lower left; two impressions in dark olive green are also known (Bibliothèque Nationale, Paris).
Delteil 110 II; Adhémar 126 II;
Adriani 113 II; Wittrock 107.

Florimond Ronger Hervé's operetta-revue *Chilpéric* was revived at the Théâtre des Variétés on 18 February 1895. Lautrec actually admired the leading lady Marcelle Lender (see Nos. 111–115) in this medieval farce more than he did Albert Brasseur in his farcical role as King Chilpéric. The edition was printed by Ancourt, Paris; see the rapid portrait sketch Dortu D.3829.

154

111 LENDER DE DOS, DANSANT LE
BOLÉRO, DANS 'CHILPÉRIC' 1895
*Rear View of Lender Dancing the
Bolero in 'Chilpéric'*

Lithograph.
Drawing in olive green; chalk, sprayed
ink.
375 × 265 mm.
Monogram on the stone, lower left.
Vellum.
Edition of about 50, some numbered,
some with Lautrec's red monogram
stamp (Lugt 1338), lower right, and the
blind stamp of the publisher Kleinmann
(Lugt 1573), lower left.
Delteil 106; Adhémar 127; Adriani 114;
Wittrock 105.
The impression illustrated is inscribed by
Kleinmann in pencil, lower left: 'Lender
de dos'.

The main attraction in *Chilpéric* was the
bolero, danced by Marcelle Lender as
Galaswintha at the court of King
Chilpéric. It was not so much the flimsy
plot of this medieval farce as the actress,
who had been appearing mainly at the
Théâtre des Variétés on the Boulevard
Montmartre since 1889, who led Lautrec
to sit through the operetta nearly twenty
times. Always watching from the same
angle, from one of the first tiers on the
left, he would lie in wait with his sketch
pad. His companion, Romain Coolus,
finally went on strike after seeing the
operetta so many times, and demanded to
know the reason for such unusual
persistence. Lautrec maintained that he
was only interested in Lender's entrancing
back. 'Look at it properly, you won't find
anything to equal it!' (Romain Coolus,
'Souvenirs sur Toulouse-Lautrec', in
L'Amour de l'Art, 4 April 1931, p. 139).
The edition was printed by Ancourt,
Paris.

112 LENDER DANSANT LE PAS DU
BOLÉRO, DANS 'CHILPÉRIC' 1895
*Lender Dancing the Bolero in
'Chilpéric'*

Lithograph.
Drawing in olive green; chalk.
370 × 270 mm.
Monogram on the stone, below.
Vellum.
Edition of about 50, some numbered,
some with Lautrec's red monogram
stamp (Lugt 1338), lower right, and the
blind stamp of the publisher Kleinmann
(Lugt 1573), lower left.
Delteil 104; Adhémar 128; Adriani 115;
Wittrock 103.

Two studies of movement Dortu D.3897
(Musée du Louvre, Paris) were executed
in preparation for this work, which was
printed by Ancourt, Paris (see No. 111).

113 LENDER DE FACE, DANS
'CHILPÉRIC' 1895
Lender in 'Chilpéric', Front View

Lithograph.
Drawing in olive green; chalk, sprayed
ink.
372 × 265 mm.
Monogram on the stone, lower left.
Vellum.
Edition of about 25, some numbered,
some with Lautrec's red monogram
stamp (Lugt 1338), lower right, and the
blind stamp of the publisher Kleinmann
(Lugt 1573), lower left; one impression on
hand-made Japan paper is also known
(Bibliothèque Nationale, Paris).
Delteil 105; Adhémar 129; Adriani 116;
Wittrock 104.

Two portrait studies Dortu D.3898 and
D.4241 were the preparatory works for
this lithograph, which was printed by
Ancourt, Paris (see No. 111). A similar
painting dated 1896, Dortu P.626, could
have been composed after the lithograph.

114 LENDER SALUANT 1895
Lender Taking a Bow

Lithograph.
Drawing in olive green; chalk.
320 × 264 mm.
Monogram on the stone, lower right.
Vellum.
Edition of 50, some numbered, some with
Lautrec's red monogram stamp (Lugt
1338), lower left, and the blind stamp of
the publisher Kleinmann (Lugt 1573).
One impression bearing a dedication 'à
Stern' and one impression on hand-made
Japan paper are also known.
Delteil 107; Adhémar 130; Adriani 117;
Wittrock 106.
The edition was printed by Ancourt,
Paris.

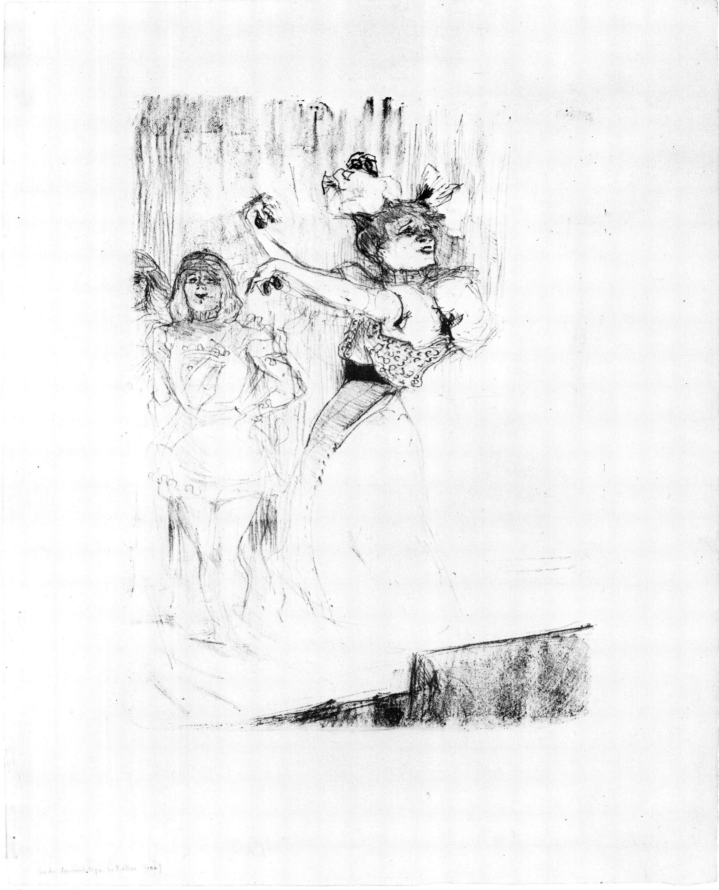

Les deux danseuses Elyes de Berlin (1894)

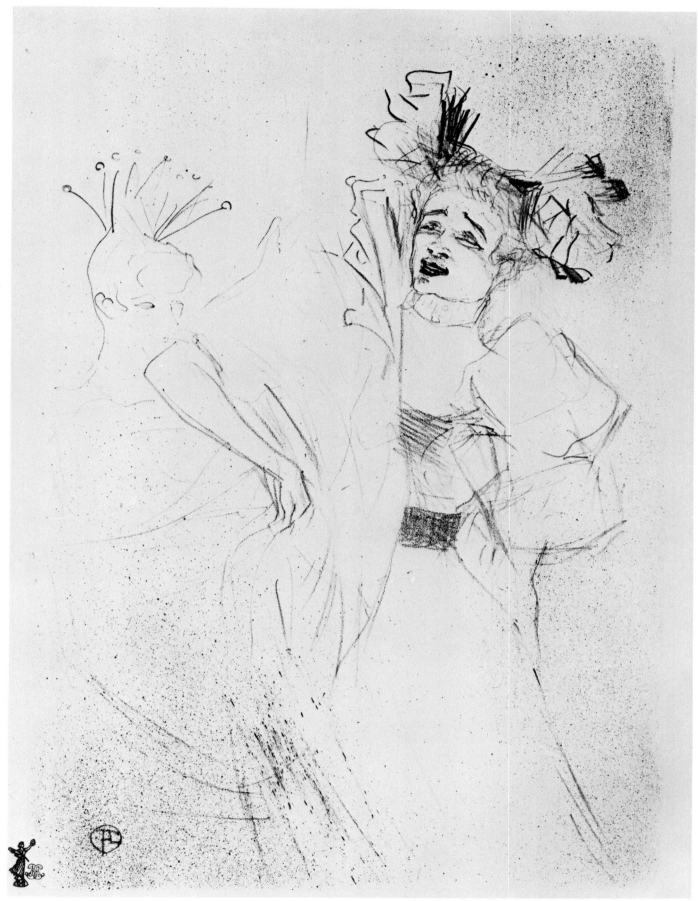

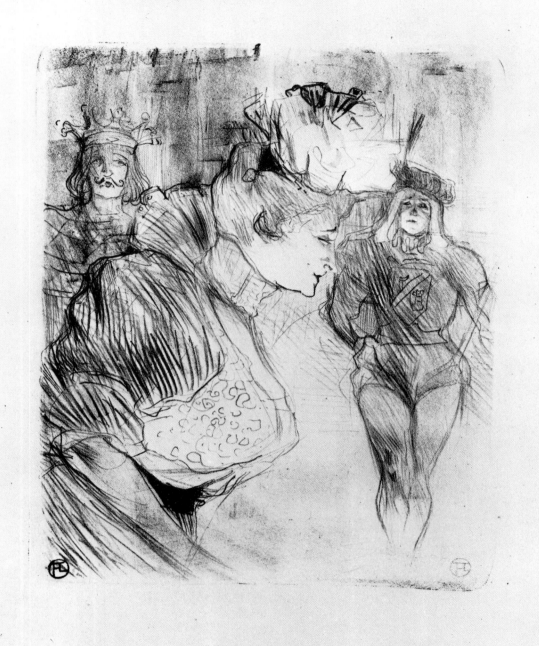

Colour lithograph.
First state.
Drawing in olive green; chalk.
435 × 320 mm.
Monogram on the stone, upper left.
Vellum.
Two impressions known, one in watercolour – Dortu A.231 (Bibliothèque Nationale, Paris).
Delteil 102 I; Adhémar 131 I; Adriani 118 I; Wittrock 99 I.
Second state. Drawing reduced, particularly left and below.
Drawing in olive green with yellow, pink, blue, turquoise and red; chalk, ink with brush.
325 × 240 mm.
One impression known (Bibliothèque Nationale, Paris).
Delteil 102 (state not described); Adhémar 131 (state not described); Adriani 118 II; Wittrock 99 II.
Third state. Drawing framed in lines.
Drawing in olive green.
329 × 242 mm.
Imitation Japan paper.
Edition of 111, some numbered, some signed by the artist in pencil lower left, inscribed on the right edge 'I.E' (I. Etat) and blind-stamped 'Pan'. 36 impressions of this version were included in the portfolio of the artist's edition, and 75 in the de luxe edition of the periodical *Pan*.
One impression on Japan paper and one trial proof are also known (Bibliothèque Nationale, Paris).
Delteil 102 (state not described); Adhémar 131 II; Adriani 118 III; Wittrock 99 III.
Fourth state.
a) Drawing in olive green with yellow, grey, vermilion, carmine red, turquoise, dark blue and ochre; chalk, ink with brush and spraying technique.
329 × 244 mm.
Vellum.
Edition of 100 numbered impressions, some inscribed 'II.E.' (II. Etat); some also have Lautrec's orange-red monogram stamp (Lugt 1338), lower left, and the blind stamp 'Pan', lower right (Paris edition). In addition, altogether eight trial proofs are known (seven in the Bibliothèque Nationale, Paris), printed from the drawing stone with the colour stones added.
Delteil 102 II; Adhémar 131 (state not described); Adriani 118 IV a;

Wittrock 99 IV.
b) With lettering not designed by Lautrec, on the lower left-hand edge: 'ORIGINALLITHOGRAPHIE IN ACHT FARBEN VON H. DE TOULOUSE-LAUTREC. PAN I 3.'
Edition of 1211 impressions, published in an artist's edition (36 impressions), a de luxe edition (75) and the standard edition (1100) of the periodical *Pan*, Vol. I, No. 3, 1895, pp. 196–197.
Delteil 102 III; Adhémar 131 III; Adriani 118 IVb; Wittrock 99 IV.
The finest of the six 'Chilpéric' works (Nos. 110–115) is this sheet, published in the German magazine *Pan* in September 1895, an eight-colour half-length portrait of Marcelle Lender in a fantastic Spanish costume, bowing in response to the applause of the audience. No other lithograph is printed with such a wealth of subtle colour combinations, and none embodies, as this does, the opulent decoration of an age moving towards its close. Apart from various trial proofs, four states of differing sizes are known, printed by Ancourt, Paris. The first, in olive green, of which only two impressions exist, sets the image on the paper in a wonderfully free and flowing style; the monogram also plays a striking part in the composition. To try out new colour effects the impression in the Bibliothèque Nationale, Paris, was watercoloured in turquoise, dark blue, red and pink, green, yellow and orange – Dortu A.231. A second coloured state has a smaller image, with the main reductions made on the left and lower edges. In a further state this smaller version has a strong line framing it, so that the image takes on the character of a picture and loses some of its original openness and opulence. Thirty-six impressions of this monochrome state were included in the portfolio of the artist's edition, and seventy-five in the de luxe edition published by *Pan*.

The sheet then takes on its final form, with altogether seven colours laid over the olive green drawing stone in the following sequence: yellow for the hair and a smear on the forehead; grey in the sleeve and the headdress; then the powerful vermilion printed over this in the hair, to outline the face, on the lips, over the flower in the bodice and a slight touch in the corner of the eye; the soft carmine in the headdress, as a faint smear around the eye and on the flower seems to have been added later; the fifth colour is the turquoise green of the scarf, which also appears in the dress, over the brows and the eyelids, in the headdress and in

individual soft outlines; finally, the background was worked in yellow ochre.

One hundred numbered impressions of these colour prints were made on vellum before the 'German' edition. Then, with the addition of the lettering: 'ORIGINALLITHOGRAPHIE IN ACHT FARBEN VON H. DE TOULOUSE-LAUTREC. PAN I 3.', the unusually large edition was printed as follows: 36 for the artist's edition, 75 for the de luxe, and 1100 for the standard edition for the *Pan* magazine (1895, Vol. I, No. 3), where it was bound in between pages 196 and 197. A short text by Arsène Alexandre provided some information on the artist. Lautrec wrote from Taussat on this subject to Alexandre on 8 September 1895: 'Henri Albert, Paris editor of the magazine *Pan*, which is publishing one of my prints, will come to ask you for some facts on my paltry self. Since you were the first one to speak well of me, I'm anxious that you should be the one to trumpet my great deeds the other side of the Rhine' (Goldschmidt-Schimmel, No. 193).

The *Pan* magazine, founded in Berlin in 1895 as an independent organ of art and literature, counted among its contributors names ranging from Verlaine and Dehmel to Panizza, Heinrich Mann and Maeterlinck. In Otto Julius Bierbaum and the twenty-seven-year-old Julius Meier-Graefe it had editors who were passionate advocates of all that was new. Meier-Graefe, who had come in contact with young French artists when he was in Paris on the staff of Samuel Bing's gallery, was determined to propagate this in Germany and make *Pan* its main mouthpiece. But the project did not last long. Meier-Graefe's aim to make original French graphics accessible to his readers at a low cost met with considerable resistance from his financiers after the publication of Lautrec's colour lithograph, and they used a programmatic article by Alfred Lichtwark to speak out for maintaining the German character of the periodical (*Pan* I, 3, pp. 173 ff.). Finally, Meier-Graefe was urged to resign, especially since Lautrec, who had provided the lithograph free of charge for the editor's sake, was regarded, not only in court circles, as a prime example of French frivolity. Eberhard von Bodenhausen, one of the publishers of *Pan*, commented in 1895: 'This adulation of all that is foreign reached its peak when Toulouse-Lautrec, the "first and most inventive poster artist of France", sent us a colour lithograph. The style of the poster would have caused the Parisians, who have a

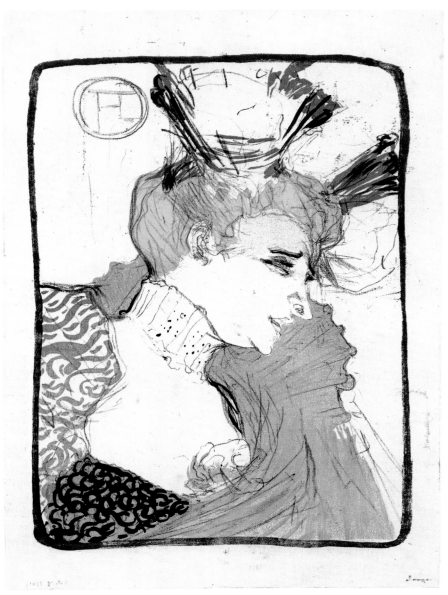

115·IVa Trial proof

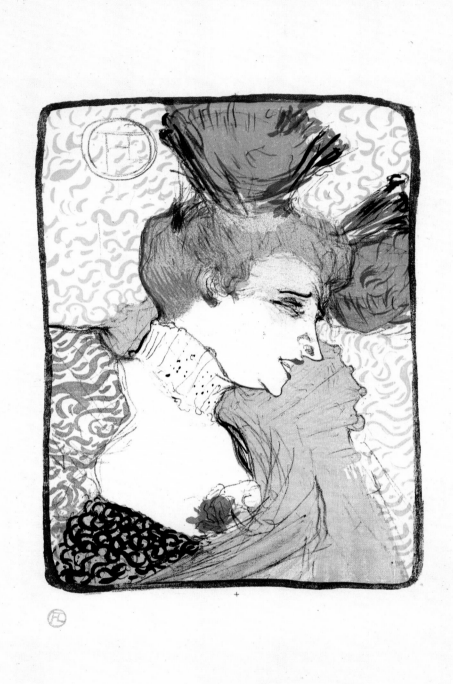

115·IVa

Hautrec

115·III

MADEMOISELLE LENDER, EN BUSTE
Mademoiselle Lender, Half-length

Colour lithograph.
A newly drawn, reversed version of the
motif (drawing in olive green with grey,
grey-green, yellow, pink; chalk, ink with
brush, 328 × 244 mm, vellum) was offered
for sale by an art dealer in 1982 (auction
catalogue *Moderne Kunst*, Galerie
Kornfeld, Berne, 23–25 June 1982,
No. 897).

first-class technical training, to have
jeered at him, and it is my firm opinion
that he wanted to see how far the stupid
Germans would go in their lack of
national feeling and their blind adoration
of the foreign . . . Here were two German
editors trying to pass off as the

culmination of art something by a new
French artist which was not only utterly
superficial, but even faulty in its
technique. I immediately told Meier-
Graefe at the time that the sheet was the
stone over which one of us would have to
fall.'

116 MADEMOISELLE MARCELLE LENDER,
 DEBOUT 1895
 Mademoiselle Marcelle Lender,
 Standing

Colour lithograph.
First state.
Drawing in dark olive green; chalk,
worked with the scraper.
355 × 250 mm.
Monogram on the stone, lower right.
Vellum.
Edition of 15, some numbered, some with
Lautrec's red monogram stamp (Lugt
1338), lower right, and the blind stamp of
the publisher Kleinmann (Lugt 1573),
lower left; four trial proofs are also
known.
Delteil 103; Adhémar 134; Adriani 119 I;
Wittrock 101 I.
Second state.
Drawing in brown or dark green, with
dark red, olive grey (colour tones vary in
the edition); ink with brush.
367 × 243 mm.
Edition of 12, some numbered, some
signed by the artist in pencil, lower left;
one trial proof, one impression dedicated
'à Jeancot' and one impression worked
over in colour are also known.
Delteil 103; Adhémar 134; Adriani 119 II;
Wittrock 101 II.

This coloured impression was offered for
sale by the publisher Kleinmann for 50
francs; see the portrait sketch Dortu
D.3814.

117 LENDER ASSISE 1895
 Lender Seated

Lithograph.
Drawing in grey-black; chalk, worked
with the scraper.
355 × 245 mm.
Monogram on the stone, upper right.
Vellum.
Edition of 20, some numbered, some with
Lautrec's red monogram stamp (Lugt
1338), lower right, and the blind stamp of
the publisher Kleinmann (Lugt 1573),
lower left.
Delteil 163; Adhémar 132; Adriani 120;
Wittrock 102.
The impression illustrated here is
inscribed by Kleinmann, lower left:
'Lender assise'.

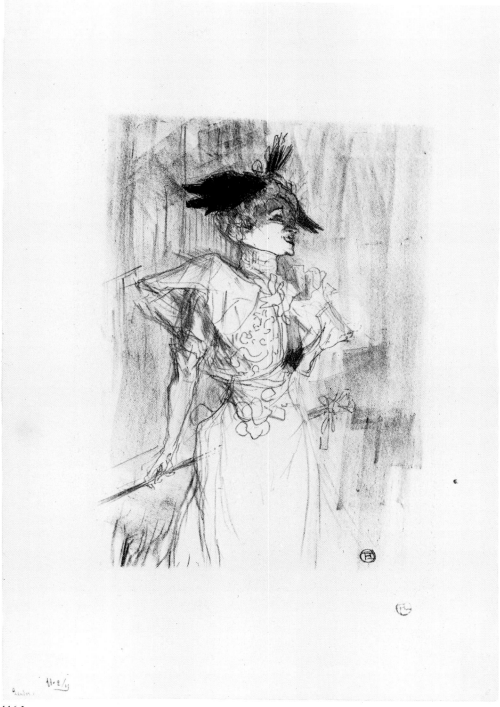

116·I

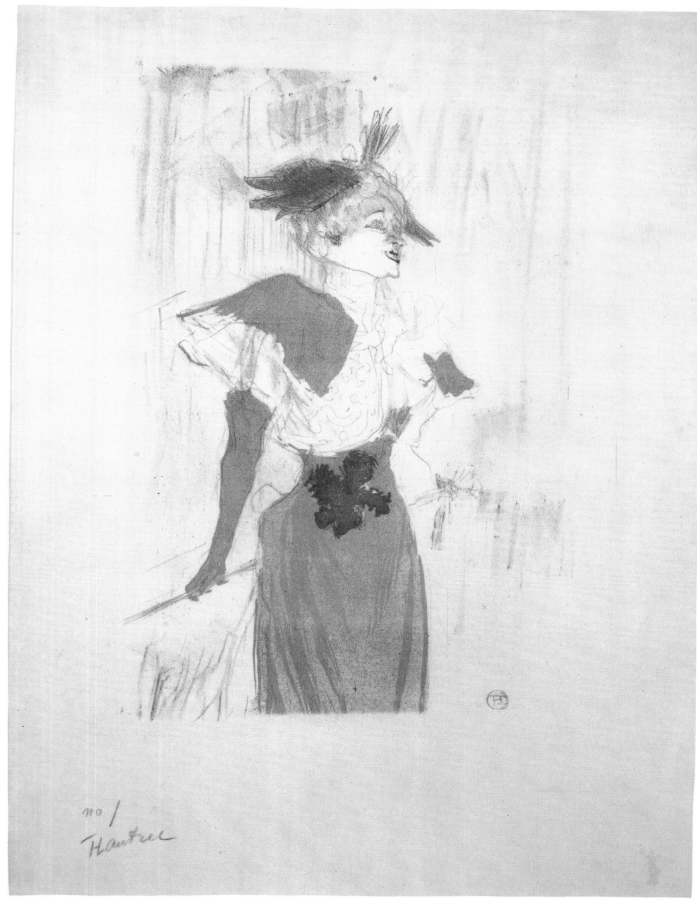

116·II

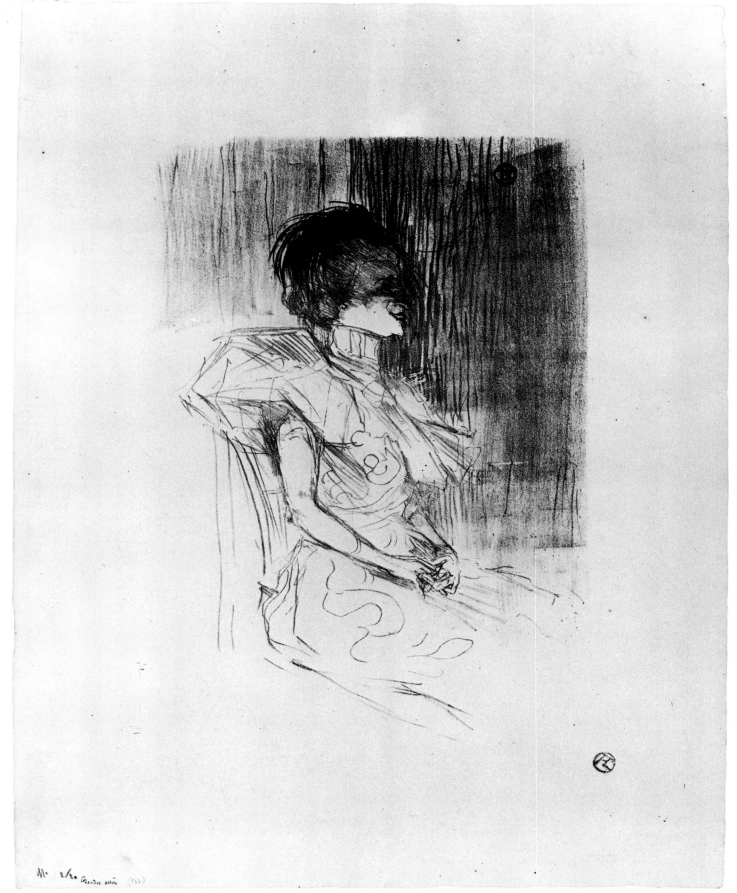

M. 2/20 Rendu autre (143)

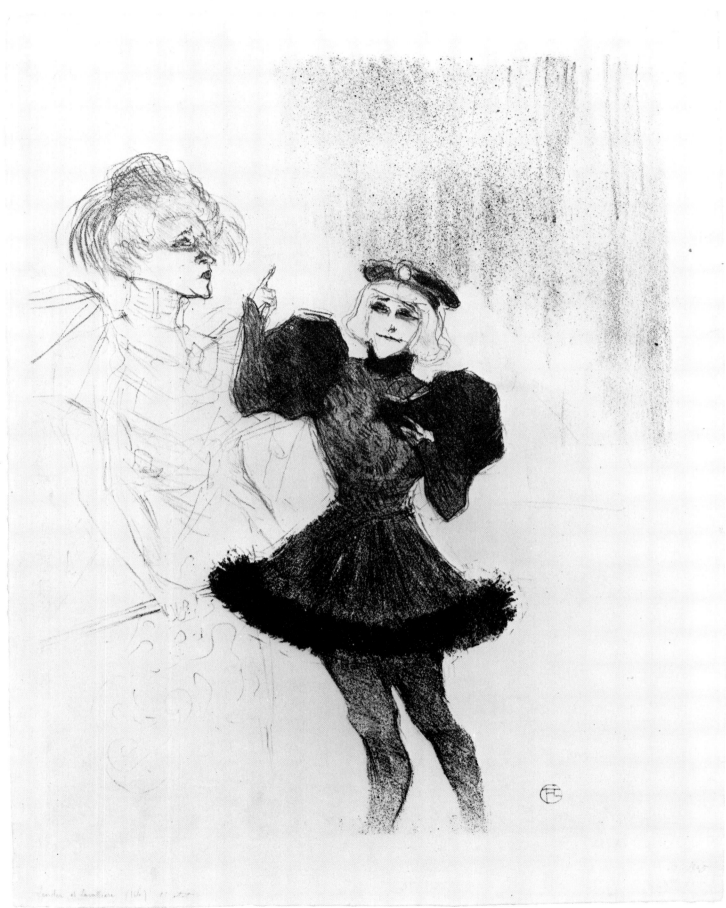

118 LENDER ET LAVALLIÈRE 1895
Lender and Lavallière

Lithograph.
First state.
Drawing in black; chalk, ink with brush
and spraying technique, worked with the
scraper.
465 × 365 mm.
Monogram on the stone, lower right.
Beige vellum.
Edition of 20, some numbered, some with
Lautrec's red monogram stamp (Lugt
1338), lower left, and the blind stamp of
the publisher Kleinmann (Lugt 1573).
Delteil 164 I; Adhémar 133 I;
Adriani 121 I; Wittrock 109 I.
Second state. Image greatly reduced, figure
in the foreground removed, Marcelle
Lender alone.
Drawing in reddish brown; chalk,
worked with the scraper.
325 × 145 mm.
Vellum, hand-made Japan paper.
Four impressions known.
Delteil 164 II; Adhémar 133 II;
Adriani 121 II; Wittrock 109 II.

The two figures are not convincingly
related to each other in the composition,
and they were probably drawn
independently. The depiction of Marcelle
Lender on the left has a close affinity with
the preceding sheets, Nos. 116 and 117.
The actress Eugénie Fenoglio, known as
Eve Lavallière (1868–1929) may be
shown here in *Hamlet*; see the portrait
sketch of her Dortu D.4238
(Kunstmuseum, Göteborg).

119 LENDER ET LAVALLIÈRE, DANS UNE
REVUE AUX VARIÉTÉS 1895
*Lender and Lavallière in a Revue at the
Variétés*

Lithograph.
Drawing in olive green; chalk.
305 × 250 mm.
Monogram on the stone, lower right.
Vellum.
Edition of 20, some numbered, some with
Lautrec's red monogram stamp (Lugt
1338), lower right, and the blind stamp of
the publisher Kleinmann (Lugt 1573).
Delteil 109; Adhémar 135; Adriani 122;
Wittrock 110.

See the portrait sketches of Eve Lavallière
as a page, Dortu D.4239 (Musée du
Louvre, Paris) and D.4240.

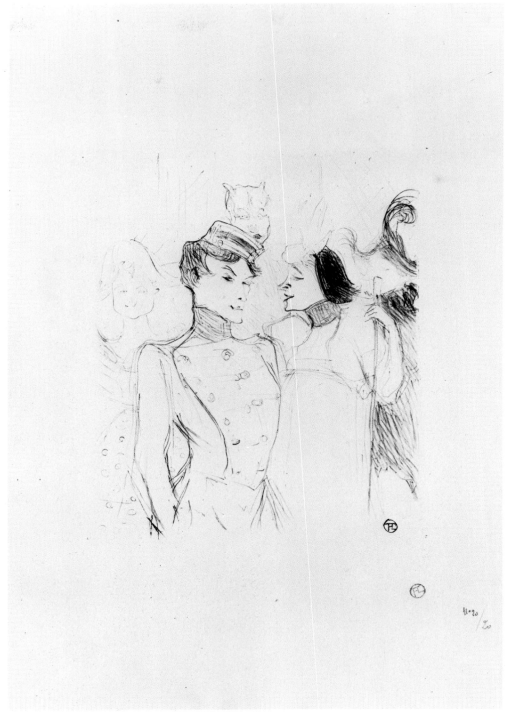

119

120

**120 LENDER ET AUGUEZ, DANS 'LA
CHANSON DE FORTUNIO' 1895**
*Lender and Auguez in 'La Chanson de
Fortunio'*

Lithograph.
Drawing in olive green; chalk, worked
with the scraper.
370 × 215 mm.
Monogram on the stone, upper right.
Vellum.
Edition of about 25, some numbered,
some with Lautrec's red monogram
stamp (Lugt 1338), lower right, and the
blind stamp of the publisher Kleinmann
(Lugt 1573), lower left; one impression on
hand-made Japan paper is also known.
Delteil 108; Adhémar 138; Adriani 123;
Wittrock 108.
The impression illustrated is inscribed by
Kleinmann lower left: 'Lender et
Auguez'.

Marcelle Lender and Numa Auguez were
a great success in Offenbach's operetta *La
Chanson de Fortunio* (Fortunio's song) in
the spring of 1895 at the Théâtre des
Variétés.

121 MISS MAY BELFORT SALUANT 1895
Miss May Belfort Taking a Bow

Lithograph.
Drawing in dark olive green; chalk,
sprayed ink, worked with the scraper.
357 × 260 mm.
Monogram on the stone, lower left.
Vellum, hand-made Japan paper.
Edition of 65, of which five are on hand-
made Japan paper and some have
Lautrec's red monogram stamp (Lugt
1338), lower right; one impression with a
dedication 'à Stern', and one with the
note 'bon à tirer/60 et 5 Japon Marty'
(Bibliothèque Nationale, Paris) are also
known.
Delteil 117; Adhémar 121; Adriani 131;
Wittrock 115.

In the spring of 1895 Lautrec's interest
also turned to the *chanteuse* May Belfort
(May Egan), who came from Ireland, and
whose charming accent was mentioned in
the *Courrier Français* on 20 January 1895.
There was a great vogue for English-
speaking women singers in Paris at the
time. In a frilly Kate Greenaway dress, a
mob cap with a big bow and with a cat
lying in her arms May Belfort sang
nursery rhymes filled with double
meanings in a lisping voice and with a
dead straight face. She appeared at the
Cabaret des Décadents, 16a Rue Fontaine;
Lautrec saw her there and immortalized
her in five lithographs printed by Stern
(Nos. 121–125); see the study Dortu
P.586.

**122 MISS MAY BELFORT EN
CHEVEUX 1895**
Miss May Belfort with her Hair Down

Lithograph.
Drawing in olive green or black; chalk,
worked with the scraper.
323 × 220 mm.
Vellum.
Edition of 30, some numbered, 15 in olive
green and 15 in black, some with
Lautrec's red monogram stamp (Lugt
1338), lower right, and the blind stamp of
the publisher Kleinmann (Lugt 1573),
lower left; one impression bearing a
dedication 'à Nys' and one on hand-made
Japan paper are also known.
Delteil 118; Adhémar 118; Adriani 132;
Wittrock 116.

See the studies Dortu P.585 and A.230.

**123 MISS MAY BELFORT (GRANDE
PLANCHE) 1895**
Miss May Belfort (large plate)

Lithograph.
First state. Only the figure of the singer.
Drawing in dark olive green; chalk,
sprayed ink.
497 × 340 mm.
Monogram on the stone, lower left.
Vellum.
Edition of 13, some numbered, two with
Lautrec's red monogram stamp (Lugt
1338) and others with the blind stamp of
the publisher Kleinmann (Lugt 1573).
Delteil 119 II; Adhémar 122 II;
Adriani 133 I; Wittrock 114 I.
Second state. The image of the singer
transferred to a new stone and the pianist
added, left, with part of the head of a
spectator against the edge of the stage,
right, and the outline of a sash window,
left.
Drawing in black.
530 × 420 mm.
Monogram on the stone, now on the
music stand on the piano.
One impression in watercolour is known,
Dortu A.229 (Bibliothèque Nationale,
Paris).
Delteil 119 (state not described);
Adhémar 122 (state not described);
Adriani 133 (state not described);
Wittrock 114 II.
Third state. With an additional stone
(Delteil 122), used to add to the drawing,
mainly in the singer's dress, her hair and
the cat's tail; it also served to tint the
background.
Drawing in dark olive green and olive
grey.
543 × 426 mm.
Edition of about 25, some numbered,
some signed by the artist in pencil, lower
right, and stamped with Lautrec's red
monogram (Lugt 1338); four trial proofs
are also known.
Delteil 119 I; Adhémar 122 I; Adriani 133
III; Wittrock 114 III.

See No. 121; the edition was published by
the magazine *La Revue Blanche*.

May Belfort

Miss May Belfort (5th blanche)

123·I

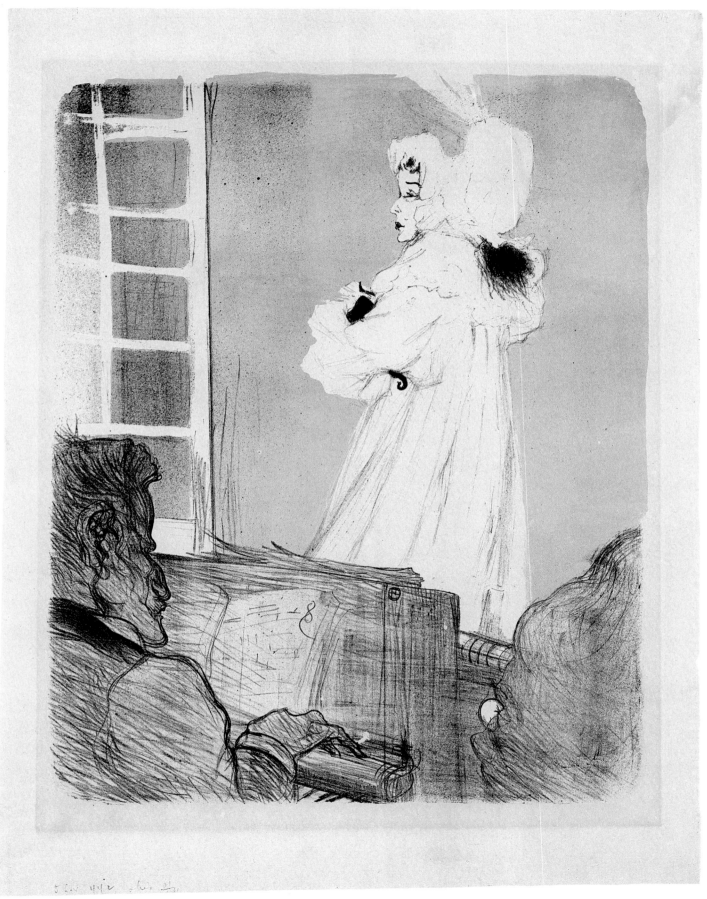

123·III

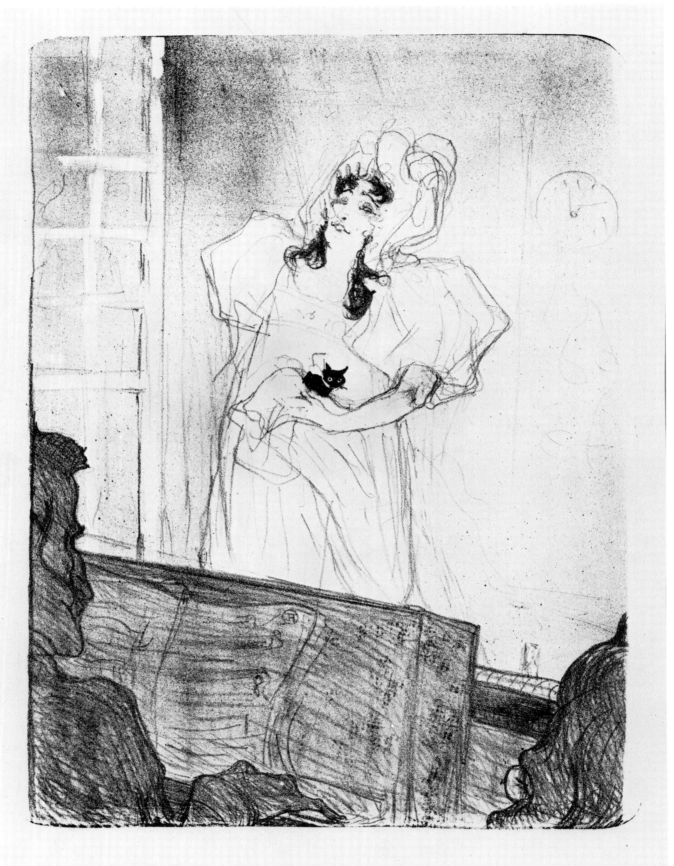

124

124 Miss May Belfort (moyenne planche) 1895
Miss May Belfort (medium plate)

Lithograph.
Drawing in dark olive green; chalk, ink with brush and spraying technique.
435 × 319 mm.
The monogram reversed on the stone, on the pianist's music.
Vellum.
Six impressions known, two signed and three with Lautrec's red monogram stamp (Lugt 1338), lower right.
Delteil 120; Adhémar 119; Adriani 134; Wittrock 117.

See No. 123; the painting Dortu P.587 has a similar view of the singer.

125 Miss May Belfort, de Profil, Rejetée en Arrière 1895
Miss May Belfort in Profile, Leaning Backwards

Lithograph.
Drawing in black; chalk, ink with brush and spraying technique, worked with the scraper.
487 × 315 mm.
Monogram on the stone, lower left.
Vellum.
One impression known (Bibliothèque Nationale, Paris).
Delteil 121; Adhémar 120; Adriani 135; Wittrock 118.

See No. 121.

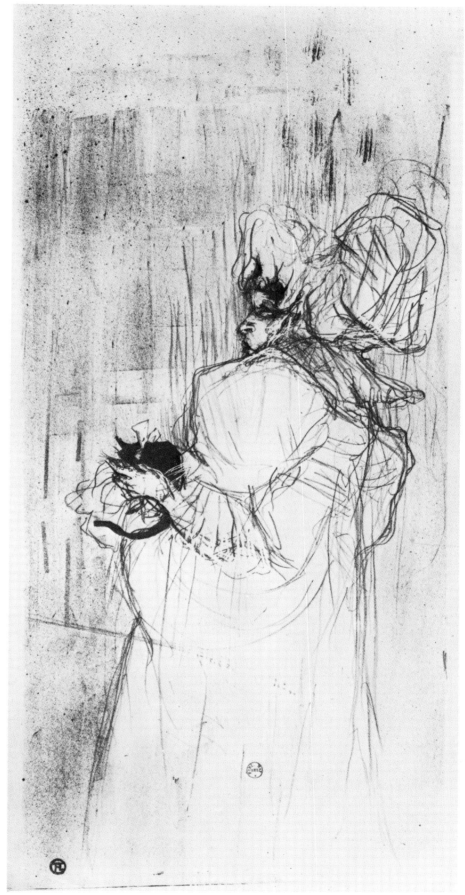

125

Colour lithograph, poster.
First state. With lettering designed by Lautrec in olive green: 'May Belfort'.
The singer in a red dress sketched with the brush.
Drawing in olive green with red, black and yellow; ink with brush and spraying technique, worked with the scraper.
795 × 610 mm.
Monogram on the stone, lower left.
Poster paper.
One impression known; in addition four trial proofs have survived, taken from the drawing stone and colour stones, both individually and together.
Delteil 354 (state not described);
Adhémar 116; Adriani 136 II;
Wittrock P 14 (state not described).
Second state. With additional oblique lettering not designed by Lautrec, in olive green: 'petit/Casino'.
One impression known (Herbert D. Schimmel, New York).
Delteil 354 (state not described);
Adhémar 116 (state not described);
Adriani 136 (state not described);
Wittrock P 14 C.
Third state. The singer's dress is now all red; without the additional lettering. Remarque in brownish-grey added in the stone, upper right: a seated cat with a ribbon round its neck. Edition of 25 numbered impressions, signed by the artist in pencil, lower left.
Delteil 354 I; Adhémar 116 I;
Adriani 136 III; Wittrock P 14 A.
Fourth state. Remarque removed. The addresses of the following printers added on the stone, lower right: 'Edw. Ancourt, Paris' (one impression known); 'Arnould, 7, rue Racine' (one impression known); 'Bella, 113 Charing Cross Road, London' (one impression known). There is also an impression of the poster with the address of the publisher Kleinmann, lower right: 'Kleinmann, 8, rue de la Victoire'.
Size of the edition not known.
Delteil 354 II; Adhémar 116 II;
Adriani 136 IV; Wittrock P 14 B.
Fifth state. Again, oblique lettering not designed by Lautrec, added in olive green: 'petit/Casino'.
Address of the printer added in the stone, lower right: 'Edw. Ancourt, Paris'.
Three impressions known.
Delteil 354 (state not described);
Adhémar 116 III; Adriani 136 V;
Wittrock P 14 C.

This four-colour poster of the singer was made for her appearance at the Petit Casino, and it once more demonstrates how sensitive the artist was to the various different media and the different modes of creation they offered (see the previous sheets Nos. 121–125). The colour study Dortu P.589, which is nearly the same size, shows May Belfort's dress with vertical stripes, like those in the first state of the poster; see the painting Dortu P.587.

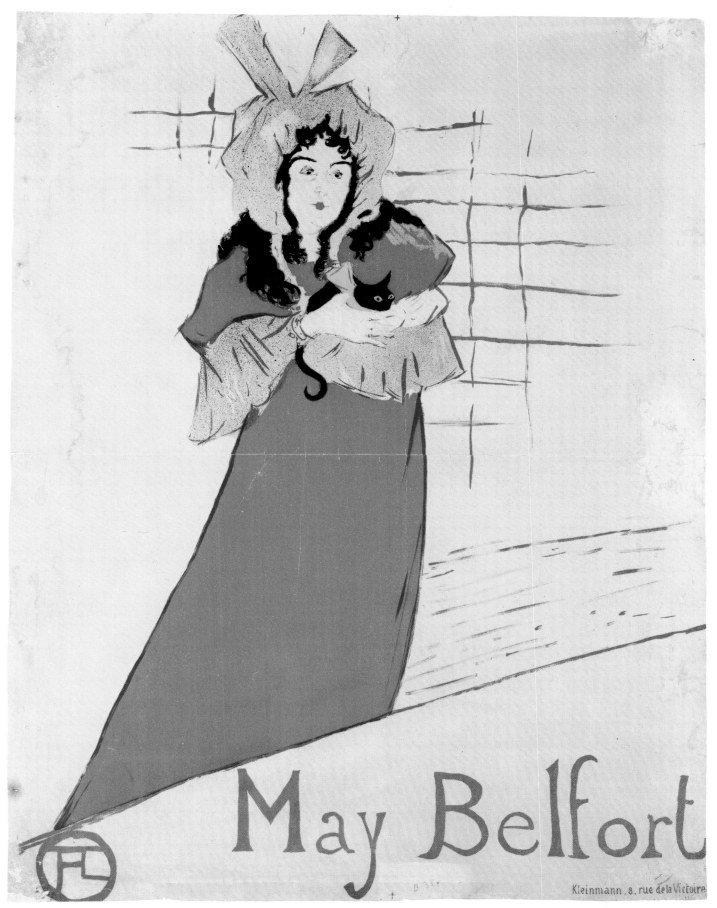

May Belfort

Kleinmann, 8, rue de la Victoire

126·IV

127

128·II

127 La Bouillabaisse, Menu
Sescau 1895
Sescau Menu Card, La Bouillabaisse

Lithograph, menu card.
With lettering not designed by Lautrec:
'16 Mars 1895/53, Rue Rodier/
MENU/...'.
Drawing in dark olive green; chalk, ink
with brush.
231 × 145 mm.
Monogram on the stone, lower left.
Vellum, imitation Japan paper.
Size of edition not known.
Delteil 144; Adhémar 137; Adriani 111;
Wittrock 94.

This menu card for 16 March 1895 is
decorated with a drawing of the
photographer Sescau playing the banjo
(see No. 60) and a caricature of Maurice
Guibert. The witty fantasy menu,
probably written by Lautrec himself,
includes 'Foies gras de l'oïe Fuller' – a pun
on the name of the American dancer, Loïe
Fuller.

128 'Les Pieds Nickelés' 1895

Lithograph, book cover.
First state. No lettering.
Drawing in olive green; chalk.
186 × 265 mm.
Monogram on the stone, lower right.
Vellum.
Delteil mentions impressions.
Delteil 128 I; Adhémar 142 I;
Adriani 112 I; Wittrock 95.
Second state. The image transferred to a
new stone, with the following text not
designed by Lautrec: 'TRISTAN
BERNARD/Les Pieds/nickelés...' (and
the address of the publisher Paul
Ollendorff).
Vellum, imitation Japan paper.
Size of edition not known (about
1000–3000).
Delteil 128 II; Adhémar 142 II;
Adriani 112 II; Wittrock 95.

The lithograph was designed as the cover
for the text to Tristan Bernard's comedy,
Les Pieds Nickelés, which had its première
at the Théâtre de l'Œuvre on 15 March
1895.

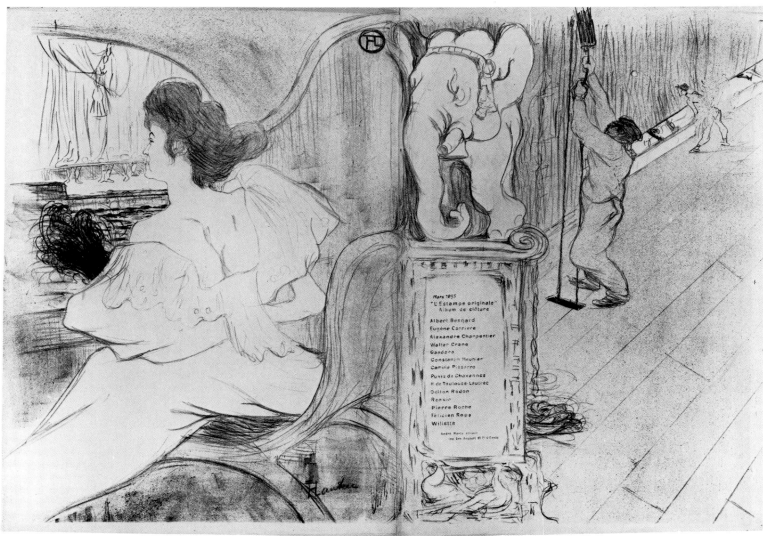

129·III

129 Couverture de 'L'Estampe
 Originale' 1895
 Cover for 'L'Estampe Originale'

Colour lithograph, cover.
First state. No lettering.
Drawing in olive green; chalk, sprayed
ink.
632 × 890 mm.
Monogram on the stone, above.
Vellum.
One impression known (Bibliothèque
Nationale, Paris).
Delteil 127 (state not described);
Adhémar 111 (state not described);
Adriani 107 I; Wittrock 96.
Second state. With lettering not designed
by Lautrec: 'Mars 1895/"L'Estampe
originale"/Album de clôture . . .', and

additions to the drawing on the left.
612 × 900 mm.
Imitation Japan paper.
One impression known (Bibliothèque
Nationale, Paris).
Delteil 127 (state not described);
Adhémar 111 (state not described);
Adriani 107 II; Wittrock 96.
Third state. The image is now in two
colours and slightly reduced.
Drawing in dark olive green with beige.
585 × 827 mm.
Vellum.
Edition of 100 impressions, signed by the
artist in pencil, below. Used in this
version as a cover for the *L'Estampe
Originale* edition. One impression with
the note 'passe' is also known (Musée
d'Albi).

Delteil 127; Adhémar 111; Adriani 107 III;
Wittrock 96.

The scenery for the unsuccessful play *Le
Chariot de Terre Cuite* (see No. 105) makes
another appearance in this cover for the
ninth and last edition of *L'Estampe
Originale* in March 1895, printed by
Ancourt, Paris. On the left half of the
large sheet, which is used in horizontal
format, Lautrec has varied the motif of
the Divan Japonais poster (No. 8),
though the much-fêted Misia Natanson
(1872–1950) is now seated in the box
instead of Jane Avril (see No. 130). One
impression of the cover was registered at
the Bibliothèque Nationale, Paris on 22
March 1895; *cf.* the figure study Dortu
P.599.

130·I The remarque printed separately

130 'LA REVUE BLANCHE' 1895

Colour lithograph, poster, on two stones,
but some impressions printed on one and
some on two sheets of paper.
First state. No lettering, with remarque.
Drawing in olive green with blue, red and
black; ink with brush and spraying
technique, chalk, worked with the
scraper.
1255 × 912 mm.
Monogram on the stone, lower left with
the date; above this, the remarque in
mauve: Liane de Lancy (see No. 161)
skating; remarque also printed separately
(162 × 115 mm), two impressions known;
address of the printer on right edge: 'Imp.
Edw. Ancourt, Paris.'
Poster paper.
Edition of 50.
Delteil 355 I; Adhémar 115 I;
Adriani 108 I; Wittrock P 16 A.
Second state. Remarque removed.
Two impressions known.
Delteil 355 (state not described);
Adhémar 115 (state not described);
Adriani 108 II; Wittrock P 16 B.
Third state. With lettering not designed by
Lautrec, in blue (partly over red): 'La
revue/blanche/. . .'.
Size of edition not known (between 1000
and 3000).
Delteil 355 II; Adhémar 115 II;
Adriani 108 III; Wittrock P 16 C.

The portrait of Misia Natanson (see
No. 129) skating adorned this poster,
intended for use in 1896 by the art and
literary magazine *La Revue Blanche*, which
appeared until April 1903. For Marcel
Proust Misia Natanson's *salon* was the
epitome of society life; she was the wife of
Thadée Natanson, who was co-editor of
La Revue Blanche with his brothers
Alexandre and Louis Alfred from
October 1891, and she succeeded in
winning a number of avant-garde writers,
composers and artists for the magazine.
Lautrec was a frequent visitor to the
Natanson home in the Rue Saint-
Florentin after 1893, as were Paul Valéry,
Henri de Régnier and Léon Blum, Catulle
Mendès, the writer Octave Mirbeau,
Alfred Jarry, Debussy and Claude
Terrasse; later, the art-dealer Vollard,
André Gide and the young Colette were
to join the circle. It was here that Lautrec,
who created the style of *La Revue Blanche*
from 1894 to 1895 along with Bonnard,
Vuillard and Vallotton, met Félix Fénéon,
Jules Renard and Tristan Bernard.
 Two oil sketches, Dortu P.568 (Stavros
Niarchos Collection, London) and P.569
(Musée d'Albi) were the preparatory
works for the poster; *cf.* also the portrait
sketch Dortu P.593.

131 LUCE MYRÈS, DE PROFIL 1895
Luce Myrès in Profile

Lithograph.
Drawing in olive green; chalk.
221 × 209 mm.
Monogram on the stone, lower right.
Vellum.
Edition of about 30 impressions, some
numbered, some with Lautrec's red
monogram stamp (Lugt 1338), lower
right, and the blind stamp of the publisher
Kleinmann (Lugt 1573).
Delteil 124; Adhémar 140; Adriani 124;
Wittrock 120.

Luce Myrès appeared in Offenbach's
operetta *La Périchole* at the Théâtre des
Variétés; she is shown here in a similar
profile view to Marcelle Lender in
Nos. 114 and 115.

132 LUCE MYRÈS, DE FACE 1895
Luce Myrès, Front View

Lithograph.
Drawing in olive green; chalk, sprayed
ink.
365 × 245 mm.
Monogram on the stone, upper right.
Vellum.
Edition of about 30 impressions, some
numbered, some with Lautrec's red
monogram stamp (Lugt 1338), lower
right, and the blind stamp of the publisher
Kleinmann (Lugt 1573), lower left; four
impressions in reddish brown are also
known.
Delteil 125; Adhémar 139; Adriani 125;
Wittrock 121.

See No. 131.

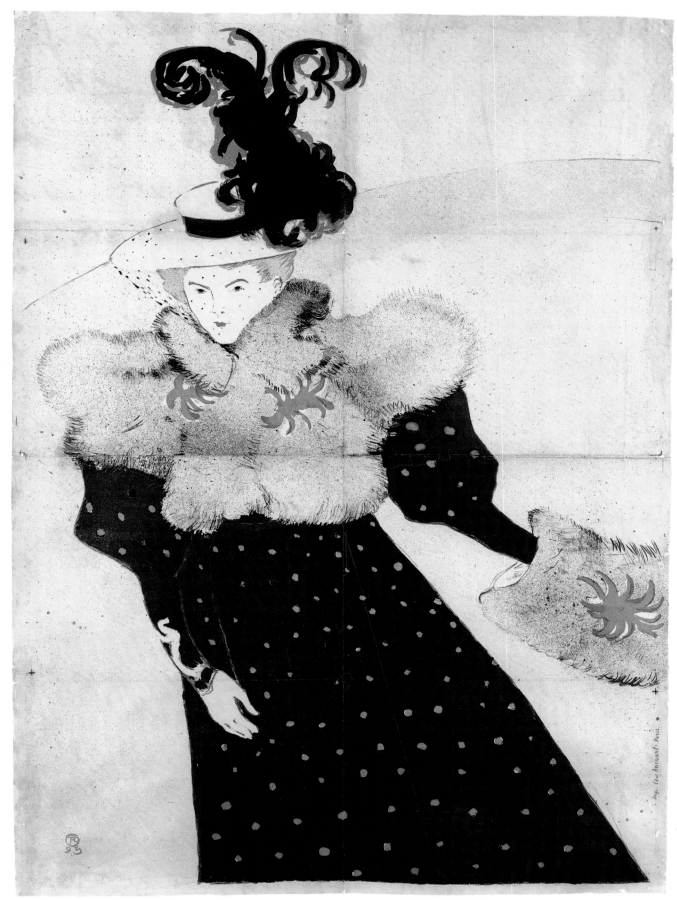

130·II

133 UN MONSIEUR ET UNE DAME,
 PROGRAMME POUR
 'L'ARGENT' 1895
 A Lady and a Gentleman, Programme
 for 'L'Argent'

Colour lithograph, programme.
First state.
Drawing in black; ink with brush and
spraying technique.
370 × 263 mm.
Monogram on the stone, upper left.
Grey-green vellum.
One impression known (Bibliothèque
Nationale, Paris).
Delteil 15 I; Adhémar 148 I; Adriani 137 I;
Wittrock 98.
Second state. New drawing, image slightly
reduced overall, with lettering not
designed by Lautrec: 'L'ARGENT/
Comédie en 4 actes de M. Emile
FABRE . . .'.
Drawing in olive green with red, black,
pink, yellow and blue; ink with brush and
sprayed; chalk.
319 × 239 mm.
Monogram on the stone, upper left;
lower left, the address of the printer:
'Paris, Imp. Eugene Verneau, 108, rue de
la Folie-Méricourt.'
Vellum.
Size of edition not known (several
hundred).
Delteil 15 II; Adhémar 148 II;
Adriani 137 III; Wittrock 97.

On this coloured programme for the
comedy *L'Argent* (Money) by Emile
Fabre, the large figures – Henriot and
Arquillière as Monsieur and Madame
Reynard – are only coloured shapes and
there is no indication of modelling in the
bodies.
 Since the play had its première on 5
May 1895 at André Antoine's Théâtre
Libre, the lithograph was presumably
made just before that date. The
composition and details of the place-
setting on the table are reminiscent of the
REINE DE JOIE poster (No. 5). *Cf.* the
composition study Dortu P.603, the
dimensions of which are almost the same
as the larger first state of this lithograph.

L'ARGENT

Comédie en 4 actes de M. Émile FABRE

(EN PROSE)

DISTRIBUTION :

Reynard.	MM. ARQUILLIÈRE
Laurent, son fils	LAROCHELLE
Roux, son gendre. . . .	ANTOINE
Bousquet	PAUL EDMOND
Madame Reynard. . . .	M^{mes} HENRIOT
Mathilde Roux	BRIENNE
Irma.	LUCE COLAS
Julienne.	ZAPOLSKA

De la part de M. Émile FABRE. (15)

Paris. Imp. Eugène Verneau, 108, rue de la Folie-Méricourt.

134·I The remarque printed separately

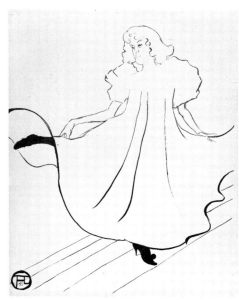

134·II Trial proof

Colour lithograph, poster, with lettering designed by Lautrec in transfer: 'May Milton'.
First state. With remarque.
Drawing in olive green with blue, red, yellow and black; ink with brush and spraying technique, chalk, transfer.
795 × 610 mm.
Monogram on the stone, lower left, with the date; remarque lower right in black: a negro playing the banjo; remarque also printed separately, 114 × 94 mm, one impression known (illustrated).
Vellum.
Edition of 25 numbered impressions, signed by the artist, lower left, in blue chalk.
Delteil 356 I; Adhémar 149 I;
Adriani 138 II; Wittrock P 17 A.
Second state. Remarque removed.
Edition of 100; four trial proofs also known, printed from the drawing stone in black (illustrated).
Delteil 356 II; Adhémar 149 II;
Adriani 138 III; Wittrock P 17 B.

This five-colour design, with the lettering restricted to the arched name 'May Milton', was printed by Ancourt, Paris, for the dancer's tour of the United States, and it is one of Lautrec's boldest poster compositions. The motif was carefully worked out in a drawing in coloured crayon Dortu D.3887 (Yale University Art Gallery, New Haven) but the poster only became known in France in a slightly altered reproduction in Arsène Alexandre's magazine *Le Rire* of 3 August 1895. May Milton was an English dancer with a pale, serious face and strong chin who appeared at the Moulin Rouge – see the portrait study Dortu P.570 – wearing a white débutante's dress with puff sleeves. Mindful of her liaison with May Belfort, Lautrec printed the posters for the two women (see No. 126) in complementary colours: red and green in one case, and blue and yellow in the other. The MAY MILTON poster must still have been hanging in Picasso's studio on the Boulevard de Clichy in 1901, for in his *Interior with Bather* (Philipps Memorial Gallery, Washington), it adorns the wall of the studio in the background.

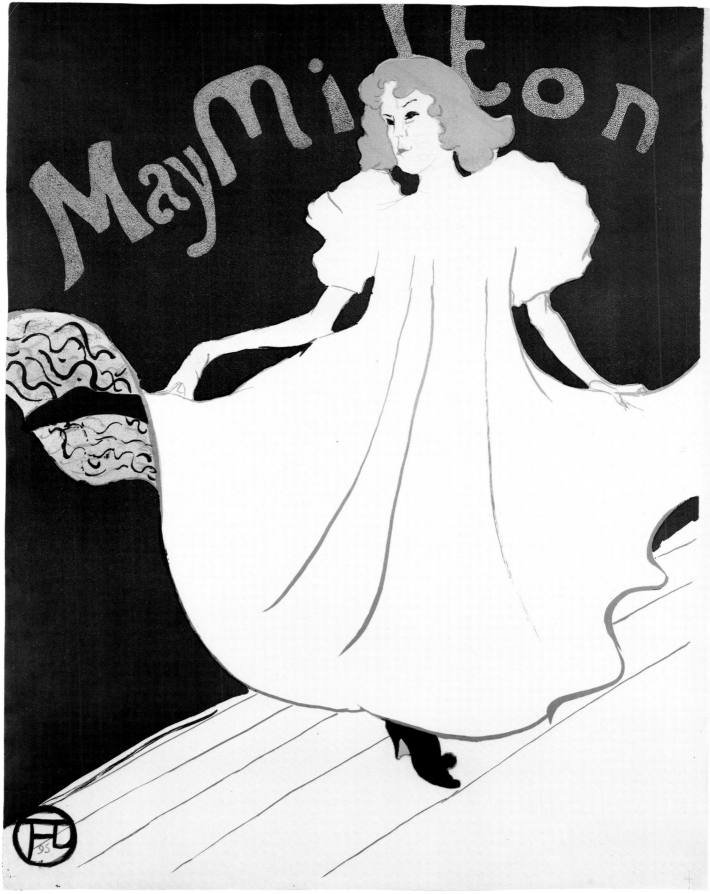

134·II

135 NAPOLÉON 1895

Colour lithograph, poster design.
Drawing in olive green with reddish
brown, yellow, blue and black; chalk, ink
with brush and spraying technique.
593 × 460 mm.
Monogram on the stone, lower left.
Vellum.
Edition of 100 numbered impressions,
signed by the artist in pencil, lower left.
Delteil 358; Adhémar 150; Adriani 141;
Wittrock 140.

In the summer of 1895 a competition was
held by the art-dealers Boussod, Valadon
et Cie. for a poster to advertise a
biography of Napoleon by William
Milligan Sloan, which was to be
published in the *Century Magazine* in
New York in 1896. No doubt encouraged
by Maurice Joyant, a friend from his
youth and director of Boussod and
Valadon, Lautrec entered the competition
with a coloured design on card Dortu
P.573 (Bührle Collection, Zurich).
Although the handling of the motif
should actually have appealed to the
specially selected jury – the successful
society painters Detaille, Gérôme and
Vibert, and the Napoleon scholar Frédéric
Masson – the design was not judged
worthy of a prize. From the 21 entries,
Lucien Métivet, a minor illustrator and
former fellow student of Lautrec's in the
Atelier Cormon, won the prize.
 The rejection of Lautrec's work is all
the more astonishing since Lautrec, no
doubt with the jury in mind, produced a
composition in full sympathy with the
elevated traditional image of the great
man, and aimed to give an accurate
representation of the historical facts, even
down to the details of the uniforms. After
vain attempts to sell his design elsewhere,
the artist decided to have an edition
printed at his own expense.

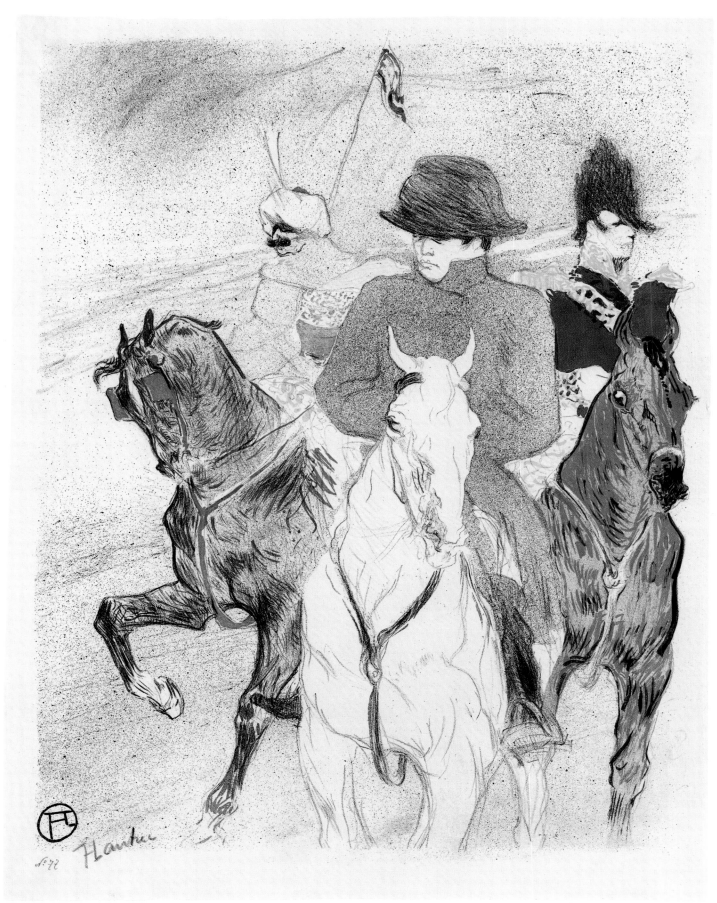

136 Le Bésigue, 'La Belle et la
Bête' 1895
The Game of Bezique in 'La Belle et la Bête'

Lithograph.
Drawing in grey; chalk.
308 × 265 mm.
Monogram on the stone, lower left.
Vellum.
Three impressions known with Lautrec's
red monogram stamp (Lugt 1338), lower
right, one coloured in watercolour Dortu
A.226 (Art Institute, Chicago).
Delteil 115; Adhémar 143; Adriani 139;
Wittrock 112.

This picture of the king playing bezique,
of which only three impressions exist, was
also reproduced – at half its original size –
as a colour illustration to Romain Coolus'
novella *La Belle et la Bête* (Beauty and the
Beast) in *Le Figaro Illustré*, No. 66 of
September 1895, along with three other
drawings; the watercolour version of the
lithograph, Dortu A.226, served as the
model for the reproduction in the
magazine. See the colour study Dortu
P.565, the dimensions of which are the
same as those of the lithograph, and a
watercolour study of the motif of the
card-player in reverse, Dortu A.223.

137 La Passagère du 54, ou
Promenade en Yacht 1895
*The Passenger in Cabin 54, or a
Cruise*

Colour lithograph, poster.
First state. No lettering, no monogram.
Drawing in olive green; chalk, ink with
brush and spraying technique.
600 × 400 mm.
Imitation Japan paper.
Edition of 50 numbered impressions,
signed by the artist, lower left, in black
chalk; also with Lautrec's red monogram
stamp (Lugt 1338), lower left. One
watercolour impression from the drawing
stone in black is also known, not
mentioned by Dortu (Art Institute,
Chicago).
Delteil 366 (state not described);
Adhémar 188 (state not described);
Adriani 145 I; Wittrock P 20 I.
Second state. No lettering, no monogram.
Drawing in olive green with beige, red,
yellow, blue and black.
610 × 447 mm.
Vellum.
Edition of 50 impressions, some
numbered, signed by the artist in black
chalk, lower left; these also have Lautrec's
red monogram stamp (Lugt 1338), lower
left.
Delteil 366 I; Adhémar 188 I;
Adriani 145 II; Wittrock P 20 II.
Third state. With lettering designed by
Lautrec in dark green: 'Salon des Cent/31
rue Bonaparte./EXPOSITION/
INTERNATIONALE/d'affiches'.
602 × 400 mm.
Monogram on the stone, lower right,
with the address of the printer on the
right edge: 'IMP.BOURGERIE & Cie
PARIS'.
Beige vellum.
Size of edition not known (about 1000).
Delteil 366 II; Adhémar 188 II;
Adriani 145 III; Wittrock P 20 III.

In the summer of 1895 Lautrec embarked
on a voyage from Le Havre to Bordeaux
with Maurice Guibert, on the steamer *Le
Chili*. During the voyage he discovered a
young woman, one of his fellow
passengers, in cabin No. 54, who was on
her way to join her husband, a colonial
official in Senegal. He was so fascinated by
her beauty that, despite protests from
Guibert, he determined to stay on board
when the ship reached Bordeaux and
continue south with the vessel. It was not
until they reached Lisbon that his friend
succeeded in getting Lautrec – who was
determined to carry on as far as Dakar –
off the ship. Guibert then took the artist

137·III

via Madrid and Toledo to the spa of
Taussat, and the trip ended in late summer
near Bordeaux, at the Château de
Malromé, the main residence of Lautrec's
mother.

Lautrec produced this large print, La
Passagère du 54, in the autumn of 1895
from a photograph taken on board, from
the sketches Dortu D.4183 (Musée d'Albi)
and D.4199, and the carefully executed
overall study Dortu D.4254, the
dimensions of which are the same as those
of the lithograph. The third state,
commissioned by the magazine *La Plume*,
was used as the advertisement for an
international poster exhibition held from
October 1895 to March 1896 on the
premises of the Salon des Cent, 31 rue
Bonaparte (the second state was
distributed to 20 subscribers to the de luxe
edition of *La Plume* in October 1895). The
avant-garde periodical had been founded
by the writer Léon Deschamps and it had
been putting on exhibitions, which
changed every month, since February
1894.

Flantin

137·1

137·II

138 AU BAR PICTON, RUE SCRIBE 1895
In the Picton Bar, Rue Scribe

Lithograph.
Drawing in brownish black; chalk.
298 × 246 mm.
Monogram on the stone, lower left.
Vellum.
Edition of 25 impressions, some of which
have Lautrec's red monogram stamp
(Lugt 1338), lower right.
Delteil 173; Adhémar 195; Adriani 142;
Wittrock 170.
The impression illustrated is signed, lower
right, in pencil and bears the note 'bon à
tirer 25'.

From 1895 to 1896 the artist was a
frequent visitor to the bars around the
Madeleine: the Weber at 25 rue Royale,
the meeting-place of a literary circle, the
Irish American Bar and the less exclusive
Cosmopolitan American Bar, 4 rue
Scribe, run by Achille Picton, who always
addressed Lautrec as 'Monsieur le
Vicomte Marquis'. Here, as in the two
following prints, Nos. 139 and 140, we
see the portly figure of Tom, the
Rothschilds' coachman, a particular
favourite with Lautrec for his supercilious
manner. The pen and ink drawing Dortu
D.4244 is related to the lithograph.

139 IRISH AMERICAN BAR, RUE ROYALE,
THE CHAP BOOK 1895

Colour lithograph, poster.
First state. No lettering.
Drawing in olive green with blue,
yellow, pink and red; ink with brush and
spraying technique, chalk.
412 × 618 mm.
Monogram in the shape of a little
elephant on the stone, lower left.
Vellum.
Edition of 100 impressions, some
numbered, most with Lautrec's red
monogram stamp (Lugt 1338), lower left;
one trial proof, worked in coloured
chalks, is also known, not mentioned by
Dortu (Marcel Lecomte Collection,
Paris).
Delteil 362 I; Adhémar 189;
Adriani 143 II; Wittrock P 18 A.
Second state. With lettering not designed
by Lautrec, in blue: 'The Chap/Book'.
Also on the stone, lower left, the address
of the printer: 'IMPRIMERIE CHAIX
(Atelier Chéret). 20, rue Bergère, Paris
12922-6-96 (Encres LORILLEUX)'; and
lower right: 'Affiches Artistiques de LA
PLUME, 31, rue Bonaparte, PARIS' with
the monogram of the printer Chaix.
Size of edition not known (about 1000).
Delteil 362 II; Adhémar 189;
Adriani 143 III; Wittrock P 18 B.

The Irish American Bar at 33 rue Royale,
was furnished in gleaming mahogany,
and had a Chinese-Indian bar-keeper
called Ralph, who with stoical calm
served the British jockeys and trainers and
the local coachmen who frequented the
bar, as well as the clowns Footit and
Chocolat, the negro from Bilbao, who
would dance and sing there for his own
pleasure after his appearances at the
Nouveau Cirque. Here, too, the florid
figure of Tom is visible among the
customers (see Nos. 138 and 140), being
served by Ralph with a special
concoction. Lautrec had already drawn
similar bar scenes with the unmistakable
figure of Ralph behind the bar, in July
1895 for Romain Coolus' article 'Le Bon
Jockey' in No. 64 of *Le Figaro Illustré*.
This coloured poster in a horizontal
format, was published by the magazine *La
Plume* (see No. 137) to advertise the
American literary periodical *The Chap
Book*. Lautrec also confirmed in a letter of
14 November 1895 to Léon Deschamps,
the publisher of *La Plume*, that he had
received 200 francs from the magazine for
reproduction rights to the poster THE
CHAP BOOK (Goldschmidt-Schimmel,
No. 196).

140 MISS MAY BELFORT AU IRISH
AMERICAN BAR, RUE
ROYALE (?) 1895
*Miss May Belfort in the Irish
American Bar, Rue Royale (?)*

Lithograph.
Drawing in dark olive green; chalk.
330 × 263 mm.
Monogram on the stone, lower right.
Vellum.
Edition of 25 impressions, some
numbered, some with Lautrec's red
monogram stamp (Lugt 1338), lower
right, and the blind stamp of the publisher
Kleinmann (Lugt 1573), lower left; three
impressions in black on Japan paper are
also known, two of which bear the
following inscription: 'Hommage à Miss
Belfort après l'avoir tourmentée pendant
1 heure' (Museum of Fine Arts, Boston)
and 'tirée a 25 epr. May Belford [sic] au
Bar Achille' (Public Library, Boston).
Delteil 123; Adhémar 124; Adriani 144;
Wittrock 119.
The impression illustrated is inscribed by
Kleinmann, lower left: 'May Belford
[sic]/au bar'.

Although the artist noted on one
impression that May Belford [sic] was
shown in the Bar Achille – that is, the
Cosmopolitan American Bar run by
Achille Picton (see No. 138) – Ralph, the
bar-keeper at the Irish American Bar (see
No. 139), is visible in the background
beside Tom, the Rothschilds' coachman.
See the portrait sketches Dortu D.3916
and D.3919.

138

139·I

May Belfort

141 MADEMOISELLE POIS VERT 1895

Lithograph.
Drawing in olive green; chalk.
187 × 190 mm.
Monogram on the stone, lower left.
Vellum.
Edition of 25 impressions, some
numbered, some with Lautrec's red
monogram stamp (Lugt 1338), lower
right, and the blind stamp of the publisher
Kleinmann (Lugt 1573), lower left; one
impression on hand-made Japan paper is
also known (Bibliothèque Nationale,
Paris).
Delteil 126; Adhémar 141; Adriani 126;
Wittrock 122.

See the portrait study Dortu D.3788.

142 MARY HAMILTON 1895

Lithograph.
Drawing in black; chalk, worked with the
scraper.
266 × 148 mm.
Monogram on the stone, lower left.
Vellum.
One impression known (illustrated).
Delteil 175; Adhémar 215; Adriani 127;
Wittrock 67.
New edition (after 1901). 20 impressions.
New edition (1925). 625 impressions, of
which 525 are on China paper and 100 on
Japan paper, some with the blind stamp of
the publisher Galerie des Peintres
Graveurs. Edmond Frapier (Galerie des
Peintres Graveurs) published the new
edition in connection with the book
*Histoire de la Lithographie de Manet à nos
Jours*, Paris 1925.

The English *diseuse* is shown here in a
similar costume to No. 19 of the *Café
Concert* series, made in 1893. However,
the style of the drawing here is unlike that
of 1893; with its parallel strokes and cross-
hatchings set down firmly in chalk and
the frequently broken contour lines, it is
more like Lautrec's drawing style of the
mid-nineties. Lautrec showed various
lithographs at the exhibition 'La Libre
Esthétique' in Brussels in 1895, as well as
the two posters Nos. 2 and 101; one of the
lithographs was No. 578 'the fair Miss
Mary H.', which may have been this
portrait of Mary Hamilton made in 1895.

143 La Châtelaine ou 'Le
 Tocsin' 1895
 The Chatelaine, or 'Le Tocsin'

Colour lithograph, poster.
First state. No lettering.
Drawing in blue with turquoise-green
tinted plate; ink with brush and spraying
technique.
572 × 452 mm.
Monogram on the stone, lower left, with
date.
Vellum.
Size of edition not known; two trial
proofs with drawing in black are also
known.
Delteil 357 I; Adhémar 147 I;
Adriani 140 I; Wittrock P 19 A.
Second state. With lettering not designed
by Lautrec, above, in blue: 'LA
DÉPÊCHE', and lower left, in red: 'Le
Tocsin'; the image was also transferred to
a new stone and reduced on the right and
below. To make room for the lettering
lower left, the monogram and the date
were moved further up.
Drawing in grey-blue with grey-green
tinted plate.
558 × 427 mm.
In addition, the address of the printer on
the stone, lower right: 'IMP. CASSAN
FILS, TOULOUSE'.
Size of edition not known.
Delteil 357 II; Adhémar 147 II;
Adriani 140 II; Wittrock P 19 B.
Third state. Without the tinted ground;
the image transferred to a new stone and
reduced on the left edge, the lettering
now in grey-green or red.
Drawing in grey-green.
537 × 400 mm.
Beige vellum.
Size of edition not known.
Delteil 357 (state not described);
Adhémar 147 (state not described);
Adriani 140 (state not described);
Wittrock P 19 C.

It is evident from this rather historical
design, which was no doubt made to suit
the taste of his client, that Lautrec
certainly did not confine himself to a
single style for his poster work; in place of
the more familiar monumental flat shapes,
we find here a nervous play of lines drawn
over a delicately nuanced background.
This poster was commissioned by Arthur
Huc, after the success of the first he had
ordered from Lautrec (No. 2), which 'is
now almost impossible to get hold of in
the art trade, and is never sold for under
one *louis d'or*' (*Dépêche de Toulouse*). It was
designed to advertise the novel *Le Tocsin*
(The Tocsin) by Jules de Gastyne, which

144

was published in the periodical *La Dépêche
de Toulouse*. The impressions of the first
state, before lettering, were probably
intended for poster collectors.

144 Désiré Dihau 1895/1896

Lithograph.
Drawing in violet-brown; chalk, worked
with the scraper.

144 × 143 mm.
Reversed monogram on the stone, lower
left.
Vellum, Japan paper.
Three impressions known, one bearing a
dedication and inscribed: 'à Degas/
souvenir de Dihau et de Lautrec T-L' (Art
Institute, Chicago).
Delteil 176; Adhémar 196; Adriani 146;
Wittrock 123.

The portrait of Désiré Dihau (see Nos. 27
and 28) was probably made in connection
with a series of song titles (Nos. 145–158).

145·I

146·I

145–158 MÉLODIES DE DÉSIRÉ
DIHAU 1895/1896
Songs by Désiré Dihau

Lautrec was very fond of sentimental
ballads, which he would intone fervently
off-key and in a loud voice. These 16 song
titles, with music by Désiré Dihau on the
reverse, were probably commissioned by
Lautrec's cousin and drawn 1895–1896,
together with the portrait of Dihau
(No. 144). Fourteen of the titles, which
are not exactly among Lautrec's most
inventive works, were published by the
Paris music publisher C. Joubert under
the title 'MÉLODIES/DE/Désiré
DIHAU/de l'Opéra/. . . Mélodies sur des
Poésies de JEAN RICHEPIN/AVEC
ACCOMPAGNEMENT DE PIANO
. . .'. (The firm of Katto in Brussels took
on the distribution for Belgium, and
Breitkopf und Hartel in Leipzig were
responsible for Germany and Austria-
Hungary.) The works were offered at a
cost of between 1 and 2 francs. Apart
from 20 impressions each of the states
before lettering, and the editions of the
song titles produced by the printing firms
Crevel Frères or Bigeard, Paris, there are
new editions with the addresses of
different printers. The litho stones
remained in the possession of the music
publisher Joubert, Paris.

Delteil dates the series to 1895, but one
impression of No. 152 bears a dedication
and is dated by the artist 1896.

145 'ADIEU' 1895/1896

Lithograph, first song title (Farewell) in
the *Mélodies de Désiré Dihau* series.
First state. No lettering.
Drawing in black; chalk, worked with the
scraper.
240 × 203 mm.
Monogram on the stone, lower left.
Vellum.
Edition of 20 impressions, some
numbered, with Lautrec's orange-red
monogram stamp (Lugt 1338), lower left.
Delteil 129 I; Adhémar 158 I;
Adriani 147 I; Wittrock 124.
Second state. The image transferred to a
new stone with the following text, not
designed by Lautrec: '. . . ADIEU/
Barcarolle . . .' (with the address of the
publisher, etc.).
Size of edition not known (several
hundred).
Delteil 129 II; Adhémar 158 II;
Adriani 147 II; Wittrock 124 (Wittrock
also mentions new contemporary editions
with changes to the text without giving
further details).
New edition (1935). Without lettering; 140
impressions, 100 in black on vellum, 20
on China paper and 20 in olive green, also
on China paper. H. Lefèbre edition, Paris.
New edition (1978). No lettering; 500
numbered impressions, 450 in dark
brown and 50 in olive green on hand-
made paper. A. C. Mazo edition, Paris.

146 'BALLADE DE NOËL' 1895/1896

Lithograph, second song title (Christmas
Ballad) in the *Mélodies de Désiré Dihau*
series.
First state. No lettering.
Drawing in black; chalk, worked with the
scraper.
247 × 195 mm.
Monogram on the stone, lower right.
Vellum.
Edition of 20, some numbered, with
Lautrec's orange-red monogram stamp
(Lugt 1338), lower left.
Delteil 130 I; Adhémar 159 I;
Adriani 148 I; Wittrock 125.
Second state. The image transferred to a
new stone, with the following text, not
designed by Lautrec: '. . . BALLADE DE
NOËL/. . .' (with the address of the
publisher, etc.).
Drawing in violet.
Address of the printer added on the stone,
right: 'Imp. CREVEL fres. PARIS'.
Size of edition not known (several
hundred).
Delteil 130 II; Adhémar 159 II;
Adriani 148 II; Wittrock 125 (Wittrock
also mentions contemporary new
editions, without giving further details).
New editions (1935 and 1978). See No.
145.

147·I

148·I

149·I

147 'CE QUE DIT LA PLUIE' 1895/1896

Lithograph, third song title (What the Rain Says) in the *Mélodies de Désiré Dihau* series.
First state. No lettering.
Drawing in black; chalk.
166 × 188 mm.
Monogram on the stone, lower left.
Vellum.
Edition of 20 impressions, some numbered, with Lautrec's orange-red monogram stamp (Lugt 1338), lower left.
Delteil 131 I; Adhémar 153 I;
Adriani 149 I; Wittrock 126.
Second state. The image transferred to a new stone, with the following text, not designed by Lautrec: '. . . CE QUE DIT LA PLUIE/Mélodie . . .' (with the address of the publisher, etc.).
Size of edition not known (several hundred).
Delteil 131 II; Adhémar 153 II;
Adriani 149 II; Wittrock 126 (Wittrock also mentions contemporary new editions, without giving further details).
New editions (1935 and 1978). See No. 145.

148 'LE FOU' 1895/1896

Lithograph, fourth song title (The Madman) in the *Mélodies de Désiré Dihau* series.
First state. No lettering.
Drawing in black; chalk.
243 × 145 mm.
Monogram on the stone, lower left.
Vellum.
Edition of 20 impressions, some numbered, with Lautrec's orange-red monogram stamp (Lugt 1338), lower left.
Delteil 132 I; Adhémar 163 I;
Adriani 150 I; Wittrock 127.
Second state. The image transferred to a new stone, with the following text, not designed by Lautrec: '. . . Le Fou/Chanson . . .' (with the address of the publisher, etc.).
210 × 138 mm.
The address of the printer also added on the stone, lower left: 'imp. CREVEL fres.'
Size of edition not known (several hundred).
Delteil 132 II; Adhémar 163 II;
Adriani 150 II; Wittrock 127 (Wittrock also mentions contemporary new editions with changes to the text, but gives no further details).
New editions (1935 and 1978). See No. 145.

149 'LES PAPILLONS' 1895/1896

Lithograph, fifth song title (The Butterflies) in the *Mélodies de Désiré Dihau* series.
First state. No lettering.
Drawing in black; chalk.
213 × 200 mm.
Monogram on the stone, lower left.
Vellum.
Edition of 20 impressions, some numbered, some with Lautrec's red monogram stamp (Lugt 1338), lower left.
Delteil 133 I; Adhémar 154 I;
Adriani 151 I; Wittrock 128.
Second state. The image transferred to a new stone, with the following text, not designed by Lautrec: '. . . LES PAPILLONS/Rondo . . .' (with the address of the publisher, etc.). Also the address of the printer on the lower edge: 'Imp. BIGEARD. Paris'.
Size of edition not known (several hundred).
Delteil 133 II; Adhémar 154 II;
Adriani 151 II; Wittrock 128 (Wittrock also mentions contemporary new editions with changes to the text, but gives no further details).
New editions (1935 and 1978). See No. 145.

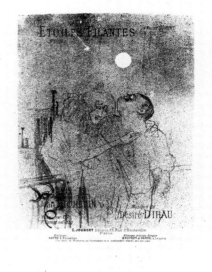

150·I

151·II

152·III

150 'L'HARENG SAUR' 1895/1896

Lithograph, sixth song title (The Smoked Herring) in the *Mélodies de Désiré Dihau* series.
First state. No lettering.
Drawing in black; chalk, worked with the scraper.
232 × 214 mm.
Monogram on the stone, upper left.
Vellum.
Edition of 20 impressions, some numbered, with Lautrec's orange-red monogram stamp (Lugt 1338), lower left.
Delteil 134 I; Adhémar 155 I; Adriani 152 I; Wittrock 129.
Second state. The image transferred to a new stone, with the following text, not designed by Lautrec: '. . . L'HARENG SAUR/Chanson . . .' (with the address of the publisher, etc.). The address of the printer also added on the stone, lower right: 'Imp. BIGEARD Paris.'
Size of edition not known (several hundred).
Delteil 134 II; Adhémar 155 II; Adriani 152 II; Wittrock 129 (Wittrock also mentions contemporary new editions with changes to the text, without giving further details).
New editions (1935 and 1978). See No. 145.

151 'LE SECRET' 1895/1896

Lithograph, seventh song title (The Secret) in the *Mélodies de Désiré Dihau* series.
First state. No lettering.
Drawing in black; chalk.
247 × 188 mm.
Monogram on the stone, lower right.
Vellum.
Edition of 20 impressions, some numbered, with Lautrec's orange-red monogram stamp (Lugt 1338), lower left.
Delteil 135 I; Adhémar 151 I; Adriani 153 I; Wittrock 130.
Second state. The image transferred to a new stone, and with the following text, not designed by Lautrec: 'Le/Secret/À Mlle. Marie DIHAU . . .'.
237 × 187 mm.
Size of edition not known (several hundred).
Delteil 135 II; Adhémar 151 II; Adriani 153 II; Wittrock 130 (Wittrock also mentions contemporary new editions with changes to the text, but gives no further details).
New editions (1935 and 1978). See No. 145.

152 'ETOILES FILANTES' 1895/1896

Lithograph, eighth song title (Shooting Stars) in the *Mélodies de Désiré Dihau* series.
First state. No lettering and without the shooting star.
Drawing in black; chalk, sprayed ink, worked with the scraper.
290 × 240 mm.
Vellum.
One impression known (illustrated).
Delteil 136 I; Adhémar 161 I; Adriani 154 I; Wittrock 131 I.
Second state. No lettering, the shooting star added and the image reduced in size.
265 × 209 mm.
Edition of 20 impressions, some numbered, with Lautrec's orange-red monogram stamp (Lugt 1338) lower left; an impression dated 1896 and dedicated 'à M. Guibert' on hand-made Japan paper is also known.
Delteil 136 II; Adhémar 161 II; Adriani 154 II; Wittrock 131 II.
Third state. The image transferred to a new stone and with the following text, not designed by Lautrec: 'ETOILES FILANTES . . .' (with the address of the publisher, etc.).
Size of edition not known (several hundred).
Delteil 136 III; Adhémar 161 III; Adriani 154 III; Wittrock 131 II (Wittrock also mentions contemporary new editions with changes to the text, but gives no further details).
New editions (1935 and 1978). See No. 145.

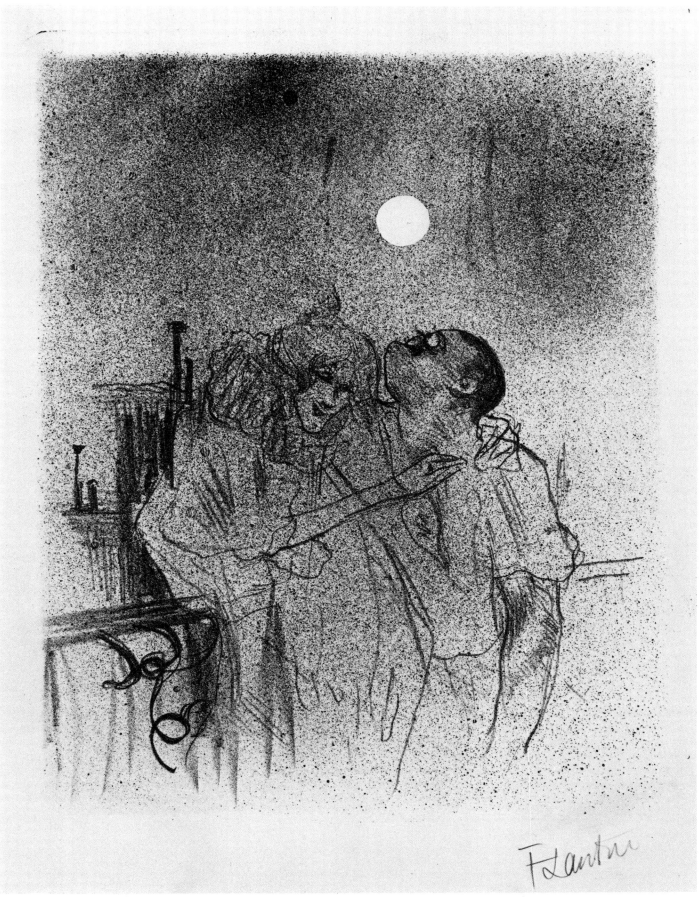

152·1

153·I

154·I

155·I

153 'OCEANO NOX' 1895/1896

Lithograph, ninth song title (At Sea by Night) in the *Mélodies de Désiré Dihau* series.
First state. No lettering.
Drawing in black; chalk, sprayed ink.
258 × 206 mm.
Monogram on the stone, lower right.
Vellum.
Edition of 20 impressions, some numbered, some with Lautrec's orange-red monogram stamp (Lugt 1338) lower left.
Delteil 137 I; Adhémar 157 I; Adriani 155 I; Wittrock 132.
Second state. The image transferred to a new stone, and with the following text, not designed by Lautrec: 'A Madame A. de TOULOUSE LAUTREC/OCEANO NOX . . .' (with the address of the publisher, etc.).
Size of edition not known (several hundred).
Delteil 137 II; Adhémar 157 II; Adriani 155 II; Wittrock 132 (Wittrock also mentions contemporary new editions with changes to the text, but gives no further details).
New editions (1935 and 1978). See No. 154.

This sheet is dedicated to the artist's mother.

154 'LES HIRONDELLES DE MER' 1895/1896

Lithograph, tenth song title (The Sea Swallows) in the *Mélodies de Désiré Dihau* series.
First state. No lettering.
Drawing in black; chalk.
213 × 201 mm.
Monogram on the stone, lower left.
Vellum.
Edition of 20 impressions, some numbered, some with Lautrec's orange-red monogram stamp (Lugt 1338), lower left.
Delteil 138 I; Adhémar 156 I; Adriani 156 I; Wittrock 133.
Second state. The image transferred to a new stone, and with the following text, not designed by Lautrec: '. . . LES/ HIRONDELLES DE MER/ . . .' (with the address of the publisher, etc.).
Size of edition not known (several hundred).
Delteil 138 II; Adhémar 156 II; Adriani 156 II; Wittrock 133 (Wittrock also mentions contemporary new editions with changes to the text, but gives no further details).
New editions (1935 and 1978). See No. 145.

155 'FLORÉAL' 1895/1896

Lithograph, eleventh song title (Springtime) in the *Mélodies de Désiré Dihau* series.
First state. No lettering.
Drawing in black; chalk.
228 × 186 mm.
Monogram on the stone, lower left.
Vellum.
Edition of 20 impressions, some numbered, some with Lautrec's orange-red monogram stamp (Lugt 1338), lower left.
Delteil 139 I; Adhémar 164 I; Adriani 157 I; Wittrock 134.
Second state. The image transferred to a new stone, and with the following text, not designed by Lautrec: 'A Madame RICHEPIN/FLORÉAL . . .' (with the address of the publisher, etc.). The address of the printer also added on the stone, lower right: 'Imp. BIGEARD Paris'.
Size of edition not known (several hundred).
Delteil 139 II; Adhémar 164 II; Adriani 157 II; Wittrock 134 (Wittrock also mentions contemporary new editions with changes to the text, but gives no further details).
New editions (1935 and 1978). See No. 145.

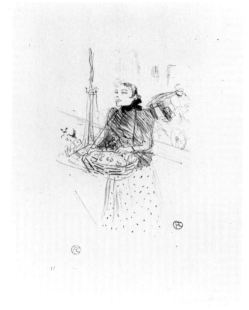

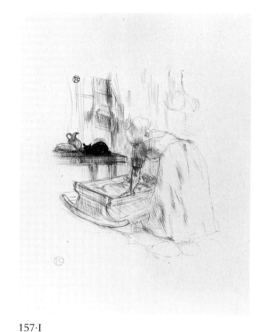

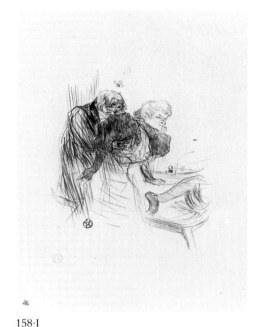

156·I 157·I 158·I

156 'ACHETEZ MES BELLES VIOLETTES' 1895/1896

Lithograph, twelfth song title (Buy my Pretty Violets) in the *Mélodies de Désiré Dihau* series.
First state. No lettering.
Drawing in black; chalk.
240 × 177 mm.
Monogram on the stone, lower right.
Vellum.
Edition of 20 impressions, some numbered, some with Lautrec's orange-red monogram stamp (Lugt 1338), lower left.
Delteil 140 I; Adhémar 165 I; Adriani 158 I; Wittrock 135.
Second state. The image transferred to a new stone, and with the following text, not designed by Lautrec: '. . . ACHETEZ MES BELLES VIOLETTES/. . .' (with the address of the publisher, etc.).
Address of the printer also added on the stone, lower right: 'Imp. BIGEARD. Paris'.
Size of edition not known (several hundred).
Delteil 140 II; Adhémar 165 II; Adriani 158 II; Wittrock 135 (Wittrock also mentions contemporary new editions with changes to the text, but gives no further details).
New editions (1935 and 1978). See No. 145.

157 'BERCEUSE' 1895/1896

Lithograph, thirteenth song title (Cradle Song) in the *Mélodies de Désiré Dihau* series.
First state. No lettering.
Drawing in grey; chalk.
245 × 207 mm.
Monogram on the stone, upper left.
Vellum.
Edition of 20 impressions, some numbered, some with Lautrec's orange-red monogram stamp (Lugt 1338), lower left.
Delteil 141 I; Adhémar 152 I; Adriani 159 I; Wittrock 136.
Second state. The image transferred to a new stone, and with the following text, not designed by Lautrec: 'BERCEUSE . . ./ A Madame Emile ZOLA . . .' (with the address of the publisher, etc.).
Size of edition not known (several hundred).
Delteil 141 II; Adhémar 152 II; Adriani 159 II; Wittrock 136 (Wittrock also mentions contemporary new editions with changes to the text, but gives no further details).
New editions (1935 and 1978). See No. 145.

158 'LES VIEUX PAPILLONS' 1895/1896

Lithograph, fourteenth song title (The Old Flirts) in the *Mélodies de Désiré Dihau* series.
First state. No lettering.
Drawing in black; chalk.
236 × 198 mm.
Monogram on the stone, lower left.
Vellum.
Edition of 20 impressions, some numbered, some with Lautrec's orange-red monogram stamp (Lugt 1338), lower left.
Delteil 142 I; Adhémar 162 I; Adriani 160 I; Wittrock 137.
Second state. The image transferred to a new stone, and with the following text, not designed by Lautrec: '. . . LES VIEUX/PAPILLONS/Menuet . . .' (with the address of the publisher, etc.).
Size of edition not known (several hundred).
Delteil 142 II; Adhémar 162 II; Adriani 160 II; Wittrock 137 (Wittrock also mentions contemporary new editions with changes to the text, but gives no further details).
New editions (1935 and 1978). See No. 145.

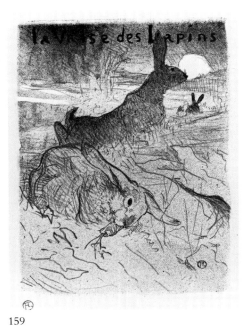

159

160·I

159 'LA VALSE DES LAPINS' 1895/1896

Lithograph, song title (The Rabbits'
Waltz), with lettering designed by
Lautrec: 'la Valse des Lapins'.
Drawing in black; chalk, ink with brush
and spraying technique.
317 × 235 mm.
Monogram on the stone, lower right.
Vellum.
Edition of about 20 impressions, some
numbered, some with Lautrec's red
monogram stamp (Lugt 1338), lower left,
and the blind stamp of the publisher
Kleinmann (Lugt 1573); two impressions
on Japan paper are also known.
Delteil 143; Adhémar 160 I; Adriani 162 I;
Wittrock 138.
New edition (after 1901). The image
transferred to a new stone, the dimensions
reduced and the following text added, not
designed by Lautrec: 'Hommage à Mlle
Assourd/créé par YVAIN/. . .' (with the
address of the publisher A. Bosc, etc.).
Drawing in black or olive green.
302 × 235 mm.
Size of edition not known (several
hundred).
The song title was printed by Ancourt,
Paris, and the new edition by Chaimbaud
& Cie., Paris.

160 'LES ROIS MAGES' 1895/1896

Lithograph, song title (The Three Wise
Men).
First state. No lettering.
Drawing in black; chalk, sprayed ink.
363 × 270 mm.
Monogram on the stone, lower left.
Vellum.
One impression known (illustrated).
Delteil 293 I; Adhémar 233 I;
Adriani 163 I; Wittrock 139.
Second state. The image transferred to a
new stone, the dimensions reduced and
the following text added, not designed by
Lautrec: '. . . Les Rois Mages/Légende/. . .'
(with the address of the publisher
Quinzard, etc.).
Drawing in blue; also worked with the
scraper.
348 × 253 mm.
Size of edition not known (several
hundred).
Delteil 293 II; Adhémar 233 II;
Adriani 163 II; Wittrock 139 (Wittrock
also mentions contemporary new editions
with changes to the text, but gives no
further details).
Delteil dates this song, which was also set
to music by Désiré Dihau, to 1899; but
the style of the depiction rather indicates
the mid-nineties.

161 AU PALAIS DE GLACE 1895/1896
In the Palais de Glace

Lithograph.
Drawing in olive green; chalk.
320 × 253 mm.
Monogram on the stone, lower left.
Vellum.
Four impressions known, two with
Lautrec's red monogram stamp (Lugt
1338), lower right.
Delteil 190; Adhémar 136; Adriani 164;
Wittrock 144.

This small lithograph shows the dancer
Liane de Lancy at the Palais de Glace,
which was opened by Jules Roques at the
Rond-Point in 1894. There is a similar
depiction of the ice-skater in the drawing
Dortu D.4110 (Museum of Art,
Providence), which was reproduced in
the magazine *Le Rire*, No. 62, of 20
January 1896; see the sketches Dortu
P.619 and D.4111 (both Musée d'Albi).
The woman shown here is probably the
same as the skater whom Lautrec used as a
remarque in the REVUE BLANCHE poster
(No. 130).

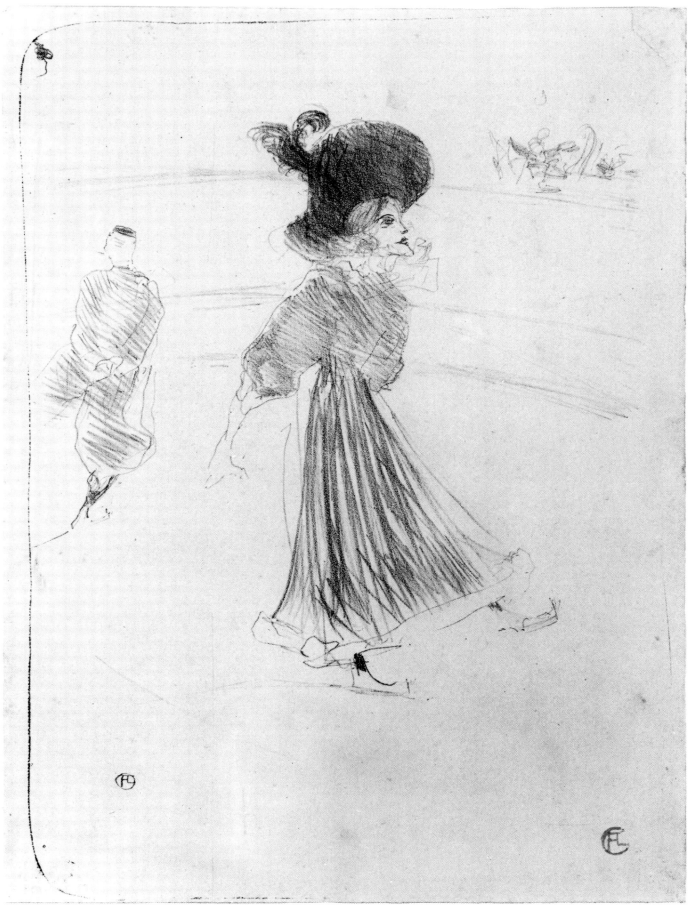

161

Mlle Eglantine's troupe (Photo: Bibliothèque Nationale, Paris)

162·I The remarque printed separately

162 LA TROUPE DE MADEMOISELLE
EGLANTINE 1895/1896
Mademoiselle Eglantine's Troupe

Colour lithograph, poster.
First state. No lettering, with remarque.
Drawing in turquoise blue with red,
yellow and dark brown; ink with brush
and spraying technique, chalk.
617 × 804 mm.
Signed on the stone, lower left, with
monogram and remarque in black: a
negro running with an umbrella.
Remarque also printed separately,
73 × 92 mm.
Three impressions known.
Vellum.
Edition of 25 impressions, some
numbered.
Delteil 361 I; Adhémar 198 I;
Adriani 165 I; Wittrock P 21 A.
Second state. No lettering, remarque
removed.
One impression known (Museum of Art,
Philadelphia); two trial proofs of the
drawing stone have also survived.
Delteil 361 II; Adhémar 198 II;
Adriani 165 II; Wittrock P 21 B.
Third state. With lettering not designed by
Lautrec, in red: 'Troupe de/Mlle
ÉGLANTINE . . .'.
Size of edition not known (about 1000).
Delteil 361 III; Adhémar 198 III;
Adriani 165 III; Wittrock P 21 C.

The poster, with its particularly enticing
exuberance, was reproduced in
monochrome in *Le Courrier Français* on
16 February 1896. It was used to advertise
the appearance of Eglantine Demay, Jane
Avril, Cléopâtre and Gazelle in the
Quadrille Naturaliste at the Palace
Theatre in London. The dance had been
developed from the can-can, created by
Céleste Mogador, and it was performed
in the formation of four, usual at the time,
mainly at the Elysée Montmartre, the
Jardin de Paris, the Frascati and the
Moulin Rouge.
 In a letter written on 19 January 1896 in
London (Musée d'Albi), Jane Avril and
Eglantine asked Lautrec for the poster and
gave exact wording for the text: 'Troupe
de Mlle Eglantine./1 Eglantine, 2 Jane
Avril/3 Cléopâtre 4 Gazelle/"Palace
Théâtre". Well, you will design it as you
think best, but please keep the order
1/2/3/4. On second thoughts, it might be
better not to include "Palace Theatre",
because we shall certainly be appearing in
other places as well, and then we could
use the same poster. Thanks in advance
and good luck and every success with the
work . . . Please answer straight away,
because the first night is the evening of
Monday 20th, and we want people to see
our poster before that. So please do your
best . . .'. A photograph of the four
dancers (above), a pencil sketch, not

mentioned by Dortu (116 × 185 mm,
Victoria and Albert Museum, London)
and a detailed colour study Dortu P.631
were used as preparation for the
lithograph.

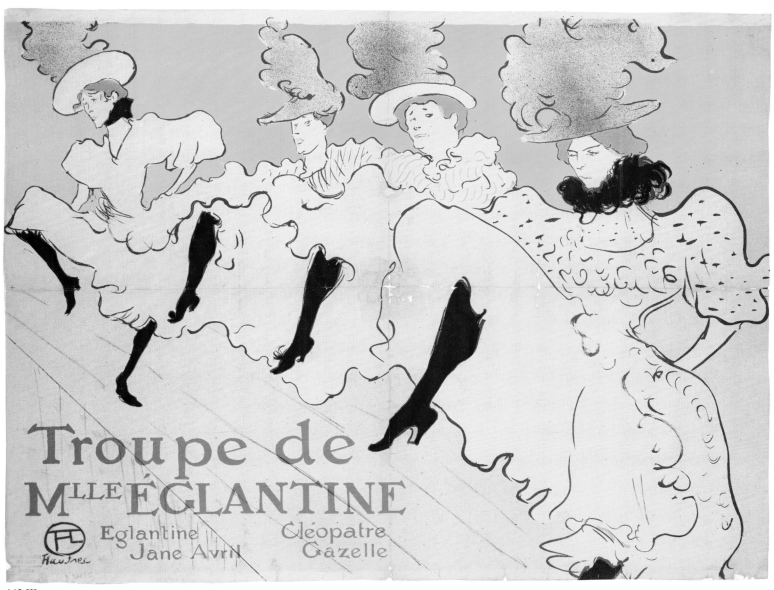

162·III

163·II

163 OSCAR WILDE ET ROMAIN
COOLUS 1896
Oscar Wilde and Romain Coolus

Colour lithograph, programme.
First state. No lettering.
Drawing in greyish blue or black; chalk,
ink with brush and spraying technique.
308 × 490 mm.
Monogram on the stone, upper right.
Beige vellum.
Three impressions known.
Delteil 195 I; Adhémar 186 I;
Adriani 167 I; Wittrock 146.
Second state. With lettering not designed
by Lautrec, upper left in black:
'"l'Œuvre"/administration: 23, rue
Turgot'; the sprayed parts in the text area
left and on the figure, left and lower right,
have also been reduced.
Drawing in black.
Vellum.
Five impressions known, one bearing a
dedication 'à Kleinmann' (illustrated).
Delteil 195 II; Adhémar 186 II;
Adriani 167 II; Wittrock 146.
Third state. Additional block of text,
lower right: 'LA REVUE
ENCYCLOPÉDIQUE . . .'.
Beige vellum.
Nine impressions known.
Delteil 195 III; Adhémar 186 III;
Adriani 167 III; Wittrock 146.
Fourth state. Added, upper left, the
programme: '. . . Raphaël/. . . Salomé/. . .'.
Brownish vellum.
Size of edition not known (several
hundred).
Delteil 195 IV; Adhémar 186 IV;
Adriani 167 IV; Wittrock 146.

For a programme commissioned by the
actor Lugné-Poë for his Théâtre de
l'Œuvre, Lautrec portrayed the writer
Romain Coolus (left), whose real name
was René Weil (1868–1952), and (right)
the bloated form of Oscar Wilde
(1856–1900), with a sketchy suggestion of
the Houses of Parliament in London in
the background. In its final state the
lithograph was used, along with a single
column advertisement for the *Revue
Encyclopédique*, as the programme for
Coolus' play *Raphaël* and Oscar Wilde's
Salomé, which had been banned in
London. The premières took place on 10
February 1896 at the Théâtre de l'Œuvre.
The portrait of Oscar Wilde was based on
the painting Dortu P.574; the overall
design of the programme, with the
appropriate blanks left for the text, was
worked out in the drawing Dortu
D.4250.

164 PROSPECTUS-PROGRAMME DE
L'ŒUVRE 1896
Brochure for the Théâtre de l'Œuvre

Transfer lithograph, programme.
First state. No lettering.
Drawing in black; chalk, sprayed ink.
213 × 365 mm.
Monogram on the stone, left.
Beige vellum.
One impression known (Bibliothèque
Nationale, Paris).
Delteil 149 I; Adhémar 183 I;
Adriani 168 I; Wittrock 143.
Second state. The image transferred to a
new stone, reduced in size and the
following text added, not designed by
Lautrec: 'L'ŒUVRE/Paris, 23 rue
Turgot./Dessin de M de Toulouse-
Lautrec.'
Drawing in grey.
213 × 340 mm.
Brownish vellum.
Size of edition not known (several
hundred).
Delteil 149 II; Adhémar 183 II;
Adriani 168 II; Wittrock 143.

As in the previous lithograph (No. 163),
the artist left a blank space for the
lettering on this leaflet, printed by E.
Robert, Paris, for the Théâtre de l'Œuvre.
In addition to Lautrec's drawing, the
leaflet contained illustrations by Charles
Doudelet, Maurice Denis, Edouard
Vuillard, Antonio de la Gandara and Félix
Vallotton; it also contained texts on the
Théâtre de l'Œuvre in French, English
and Dutch.

164·II

165·II

166

165 LA VACHE ENRAGÉE 1896
The Mad Cow

Colour lithograph, poster.
First state. No lettering.
Drawing in dark blue, black or dark olive green; ink with brush, chalk.
790 × 575 mm.
Monogram and date on the stone, upper right.
Vellum.
Three impressions known.
Delteil 364 (state not described);
Adhémar 197 (state not described);
Adriani 175 I; Wittrock P 27.
Second state. With a dedication by Lautrec and the monogram of the printer.
Drawing in dark blue with turquoise, red and yellow; ink with brush and sprayed, chalk.
Monogram of the printer Chaix and a dedication by Lautrec: 'à l'ami Simonet' added on the stone, left, in turquoise.
Edition of 230 impressions, 30 of which are on Japan paper.
Delteil 364 I; Adhémar 197 I;
Adriani 175 II; Wittrock P 27 A.
Third state. With lettering not designed by Lautrec, in turquoise: 'LA VACHE ENRAGEE/...'; left, under the monogram of the printer Chaix, his address in blue: 'RUE BERGÈRE 20 PARIS'; and in blue on the upper right-hand edge, the words: 'IMPRIMERIE CHAIX Rue Bergère 20 PARIS (Encres Lorilleux)'.
Poster paper.
Size of edition not known (about 1000).
Delteil 364 II; Adhémar 197 II;
Adriani 175 III; Wittrock P 27 B.

Several examples are known where Lautrec drew on work by other artists whom he admired. In this poster and the following picnic scene, No. 166, there are clear references to Adolphe Willette's humorous themes and rococo style of illustration. Willette was the founder and illustrator of the short-lived monthly *La Vache Enragée*, edited by the cartoonist Adolphe Roedel. This coloured poster of the same title was commissioned for the appearance of the magazine on 11 March 1896, and deposited in the Bibliothèque Nationale, Paris, on 25th of that month. See the watercolour drawing of almost identical dimensions Dortu A.253 and the sketches on the same theme Dortu D.4163 (British Museum, London) to D.4165. As a reference to the wretched financial state of most artists, the term '*manger de la vache enragée*' (meaning roughly, 'not having enough to eat') was adopted as the motto for the *Vachalcade*, which was held on

Montmartre annually from 1896. This was an artists' procession, with fanfares and allegories on fame and the muses; it also included a furious cow and a troupe of pretty girls as a satire on Europa with the bull. The event was organized by Roedel.

166 PIQUE-NIQUE 1896
Picnic

Lithograph.
Drawing in dark violet; chalk, worked with the scraper.
210 × 200 mm.
Monogram on the stone, lower left.
Vellum.
Edition of about 15 impressions, some with Lautrec's red monogram stamp (Lugt 1338).
Delteil 174; Adhémar 317; Adriani 176; Wittrock 286.

Perhaps this little drawing was intended as an invitation to a picnic outside the city. The Arc de Triomphe is visible in the background.

167·III

167 Procès Lebaudy, Déposition de
Mademoiselle Marsy 1896
*The Lebaudy Trial, Mademoiselle
Marsy Giving Evidence*

Lithograph.
First state. Full drawing.
Drawing in black; chalk, worked with the
scraper.
475 × 608 mm.
Monogram on the stone, lower right,
with date.
Japan paper.
Eleven impressions known, six of which
are signed and bear a dedication (e.g., to
Kleinmann or Roger-Marx); the
impression illustrated here is dedicated 'à
Stern mon imprimeur/cordialement, T–
Lautrec'.
Delteil 194 I; Adhémar 191 I;
Adriani 169 I; Wittrock 152 I.
Second state. Three figures on the right;
the monogram and the date removed.
425 × 477 mm.
New monogram on the stone, lower left,
in ink with brush.
Vellum, China paper.
Seven impressions known.
Delteil 194 II; Adhémar 191 II;
Adriani 169 II; Wittrock 152 II.
Third state. The image again reduced to
the five persons in the central group.
Drawing in black or reddish brown.
295 × 190 mm.
Hand-made Japan paper.
Eight impressions known.
Delteil 194 III; Adhémar 191 III;
Adriani 169 III; Wittrock 152 III.

On one occasion Lautrec took on the role
of a picture journalist in the true sense of
the phrase, when he 'reported' on the
Lebaudy and Arton trials, which were the
talk of Paris in March and April 1896
(Nos. 167–170). The social issues raised by
the trials did not interest him greatly,
particularly since he was not prepared to
concern himself with the social questions
which his age was forced to face, such as
the repercussions of the Dreyfus affair. He
only observed the facts, the situation of
the main protagonists and the minor
characters. Max Lebaudy was the young
heir to a vast fortune, who had died of
tuberculosis in 1895 during his military
service; some of his superior officers were
accused of not having released him soon
enough. The artist went to great pains to
obtain an objective depiction of the scene,
and for the portrait of Anne-Marie-
Louise-Joséphine Brochard, known as
Marie-Louise Marsy (1866–1942), from
the Comédie Française (see No. 268), who
as Lebaudy's lover was obliged to appear

as a witness, he made seven rapid sketches
while she was giving evidence (Dortu
D.4051, D.4052, D.4054,
D.4089–D.4092). None of these shows
her at all as she appears in the lithograph,
however, surrounded by court officials,
policemen and the military. A small
number of impressions were printed by
Ancourt, Paris; see also the portrait
sketches Dortu D.4080, D.4082, D.4084,
D.4085 and D.4088.

167·I

168

169

168 PROCÈS ARTON, DÉPOSITION
ARTON 1896
*The Arton Trial, Arton Speaking in
his Own Defence*

Lithograph.
Drawing in black; chalk.
365 × 475 mm.
Monogram on the stone, lower left, with
date.
Vellum.
Edition of 100 impressions, some with
Lautrec's red monogram stamp (Lugt
1338), lower left, and the blind stamp of
the publisher Kleinmann (Lugt 1573).
Delteil 191; Adhémar 192; Adriani 170;
Wittrock 149.

After making 20 pencil studies – Dortu
D.4053, D.4057, D.4059, D.4060, D.4062,
D.4064, D.4065, D.4068,
D.4070–D.4077, D.4081, D.4086, D.4093
and D.4141 – Lautrec produced three
lithographs on the Arton trial, printed by
Ancourt, Paris, which show Arton
speaking in his own defence (No. 168),
the Minister of Justice, Alexandre Ribot,
giving evidence (No. 169), and the
Inspector-General of the Security
Services, Soudais, also giving evidence
(No. 170). Léopold Emile Aaron
(1850–1905), who used the name Arton,
was accused of paying bribes to the sum
of 1.5 million francs to deputies in
connection with the building of the
Panama Canal, and on the instructions of
Baron Reinach. After successfully evading
the clutches of the police for several years,
he was finally put on trial, but despite
massive public protests he was
pronounced not guilty; it was feared that
further investigations would uncover
even more scandals and corruption in
government circles.

169 PROCÈS ARTON, DÉPOSITION
RIBOT 1896
*The Arton Trial, Ribot Giving
Evidence*

Lithograph.
Drawing in black; chalk.
450 × 560 mm.
Monogram on the stone, lower right,
with date.
Vellum.
Edition of 100 impressions, some with
Lautrec's red monogram stamp (Lugt
1338), left, and the blind stamp of the
publisher Kleinmann (Lugt 1573).
Delteil 192; Adhémar 193; Adriani 171;
Wittrock 150.

See No. 168.

170

170 Procès Arton, Déposition
 Soudais 1896
 *The Arton Trial, Soudais Giving
 Evidence*

Lithograph.
Drawing in black; chalk.
430 × 565 mm.
Monogram on the stone, lower left, with
date.
Vellum.
Edition of 100 impressions, some with
Lautrec's red monogram stamp (Lugt
1338), lower left, and the blind stamp of
the publisher Kleinmann (Lugt 1573).
Delteil 193; Adhémar 194; Adriani 172;
Wittrock 151.

See No. 168.

Lautrec's series *Elles* (consisting of ten sheets with a frontispiece and cover) is one of the high-points of nineteenth-century art. It was the pictorial epilogue to what the artist had experienced in the *maisons closes* of the Rue des Moulins, the Rue d'Amboise and the Rue Joubert. 'They' are 'women to my liking', as he used to say cynically, and he often lived with them for weeks at a time during the years 1892 to 1895, a constant witness of their daily lives, of their suffering and intimacy. Attentively he noted their monotonous routine at the wash-stand, 'in the humble pose of bodily hygiene', as Huysmans called it, at breakfast, waiting for customers or during the medical inspection. These places on the periphery of society seemed to him ideally suited for a social allegory, in which the 'unavoidable myth' (Mallarmé) could emerge, albeit in half-reflections, through images of transience and the attributes of Venus and Luxuria (Nos. 171 and 177). Prosaically, he depicts the different ages, as Madame Juliette Baron comes to her daughter in the morning – a confrontation of premature vice and age, now fit only for servitude (Nos. 173 and 179) – while the top hat and erotic accessories on the title page (No. 171), and the pictures of Leda and the Swan, or the chivalric and bucolic scenes on the walls (Nos. 175, 176 and 180), recall the moral habits of the eighteenth century and the neo-rococo of the 1860s.

Lautrec showed the prostitute marked by the meaninglessness of her acts – gone are the poses of the desirable temptress – and he gave back to his Olympias and Nanas their humanity, as he showed them in their daily routine; the *grandes cocottes* are now humbled women 'who cast off their decency with their clothes' (Zola), abandoned, their value as goods lowered, and seeking among their own kind a partnership denied to them with men. Yet Lautrec does not take a direct moral stand. His sense of decency lies hidden in the graphic detail, in the beauty and reserve of the colour in these sheets printed on differently tinted papers, their drawings in black, in olive green, red chalk and dark violet, in some cases underlaid with a tinted ground.

What, for us, gives the series its exemplary quality did not supply bourgeois morality with what it expected in the way of aesthetic values and charming contents, and the success of the 100 portfolios, signed by Lautrec on the monochrome cover and shown at the end

of April in the offices of *La Plume*, rue Bonaparte, was minimal in terms of sales. A second attempt made by the art-dealer Ambroise Vollard in June 1897 at his gallery, 41 rue Laffitte, was also an almost total failure, despite the relatively low price of 300 francs and the fact that the French press were all quite positive in their reviews. It was left to a German art historian named Gensel, on the staff of the Department of Prints and Drawings in Berlin, to give expression to sound and healthy national feeling in the periodical *Kunst für Alle*: 'Naturally, there can be no question of respect for this master in the depiction of all that is mean and perverse. That such filth – there is no milder expression for it – as *Elles* can be publicly displayed without a cry of horror being heard is only to be explained by the fact that some of the public at large simply fail to understand the series, while the rest are ashamed to admit that they do!'

Gustave Pellet, the 'intrepid publisher', as Lautrec called him in his dedication (see No. 199), soon decided to sell the sheets singly, printed on paper with the watermark 'G. PELLET/T. LAUTREC' and mostly with Pellet's stamp, his initials and a number, lower right; for each sheet – apart from the edition of 100 probably printed by Auguste Clot, Paris – there are also impressions without a stamp and number.

171 FRONTISPICE POUR 'ELLES' 1896
Frontispiece for 'Elles'

Colour lithograph, cover and frontispiece for the *Elles* series.
First state. With lettering designed by Lautrec: 'ELLES/par ⓕ'.
Drawing in grey-black or grey-brown; chalk, ink with brush and spraying technique.
575 × 468 mm.
Hand-made Japan paper.
Edition of 100 numbered impressions, signed by the artist in black chalk, lower

right; most also have the initials and the monogram stamp of the publisher Pellet (Lugt 1194, 1190 or 1191); used in this form as cover (with the edges folded in) for the *Elles* portfolio. One unsigned trial proof and an impression bearing a dedication 'à G. Pellet l'inventeur de jeune maître' are also known.
Delteil 179 (state not described); Adhémar 200 (state not described); Adriani 177 I; Wittrock 155 I.
Second state. The image now in colour and reduced on all sides to fit the sheet. Mainly the contours, the drawing inside the standing figure and the top hat, worked over with ink and brush. Drawing in olive green with blue and orange.
524 × 404 mm.
Vellum with the watermark: 'G. PELLET/T. LAUTREC'.
Edition of 100 numbered impressions, most with the initials and the monogram stamp of the publisher Pellet (Lugt 1194, 1190 or 1191), lower right; used in this form as frontispiece for the ten prints in the series. Two trial proofs are also known, and one impression of the drawing stone in black with the text not designed by Lautrec: 'Gustave PELLET EDITEUR/9 QUAI VOLTAIRE' (illustrated).
Delteil 179; Adhémar 200 I; Adriani 177 II; Wittrock 155 II.
Third state. Printed on paper sheets of 620 × 480 mm, the depiction, now in a stronger blue tone, was almost back to its original size of 577 × 463 mm.
Beige vellum.
Four unsigned impressions known.
Delteil 179 (state not described); Adhémar 200 (state not described); Adriani 177 (state not described); Wittrock 155 III.
Fourth state. With additional lettering not designed by Lautrec, in red: 'Lithographies/éditées par/G. Pellet/9, Quai Voltaire à Paris/Exposées à la PLUME/31, rue Bonaparte, à partir du/22 Avril 1896'.
Size of edition not known (about 1000), some numbered, some of these with the monogram stamp of the publisher Pellet (Lugt 1190 or 1191), lower right; used in this form as the poster for an exhibition of the *Elles* portfolio, which opened on 22 April 1896 in the Salon des Cent at the offices of *La Plume*.
Delteil 179; Adhémar 200 II; Adriani 177 III; Wittrock 155 III.

See the figure and detail studies Dortu D.4118, D.4119 (both Musée d'Albi) and D.4268.

171·II Trial proof

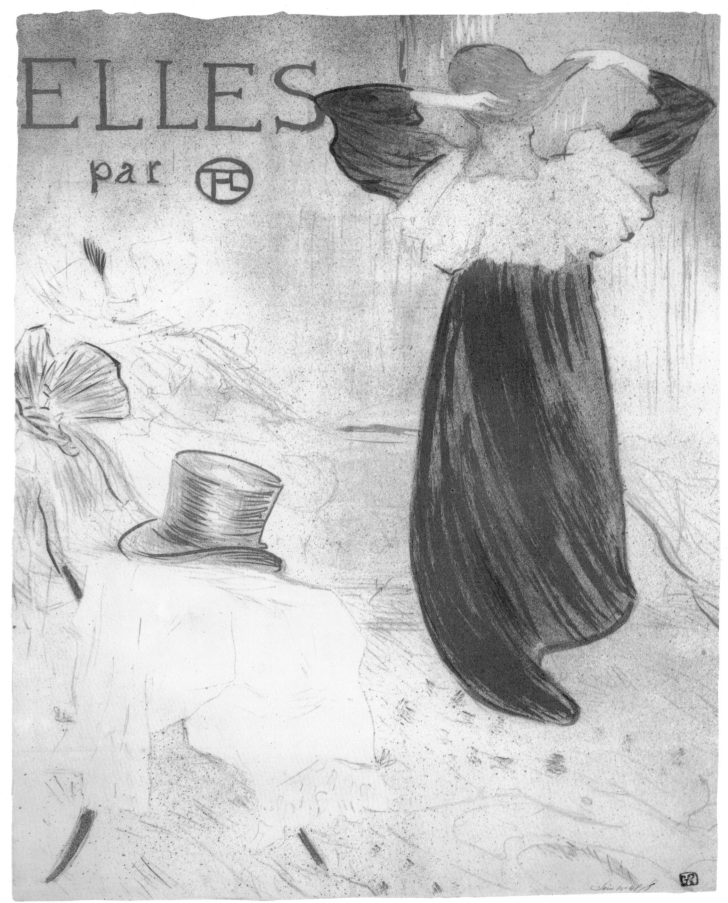

171·II

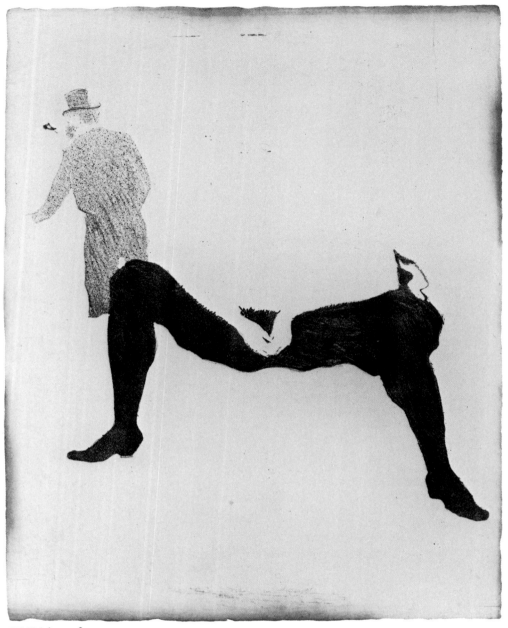

172 Trial proof

172 La Clownesse Assise,
Mademoiselle Cha-u-Kao 1896
*Mademoiselle Cha-u-Kao, Female
Clown, Seated*

Colour lithograph, first sheet in the *Elles*
series.
Drawing in grey-green with black,
yellow, red and blue; chalk, ink with
brush and spraying technique, worked
with the scraper.
527 × 405 mm.
Monogram on the stone, upper right.
Vellum with the watermark:
'G. PELLET/T. LAUTREC'.
Edition of 100 numbered impressions,
most with the initials and monogram
stamp of the publisher Pellet (Lugt 1194,
1190), lower right; some have Lautrec's
red monogram stamp (Lugt 1338), lower
left. Nine trial proofs are also known,
taken from the drawing stone and colour
stones, singly and together; on one
impression some of the contours are
traced over in black chalk (Bibliothèque
Nationale, Paris).
Delteil 180; Adhémar 201; Adriani 178 II;
Wittrock 156.
The trial proof illustrated (363 × 370 mm)
has only Cha-u-Kao's eyes and trousers,
with details of the two figures in the
background; black on vellum.

The only one of the *Elles* series that is not
a scene in one of the *maisons closes*: it
shows the female clown Cha-u-Kao
(derived from the *Chahut-Chaos* dance),
who had made her name mainly as a
dancer and acrobat at the Moulin Rouge
and the Nouveau Cirque; see the colour
study on card Dortu P.580.

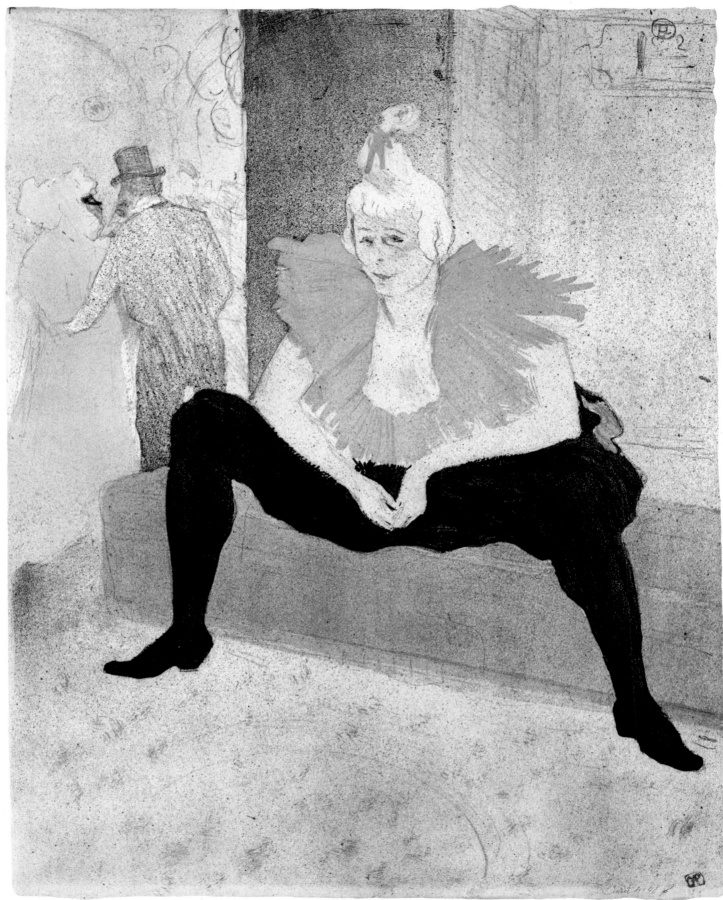

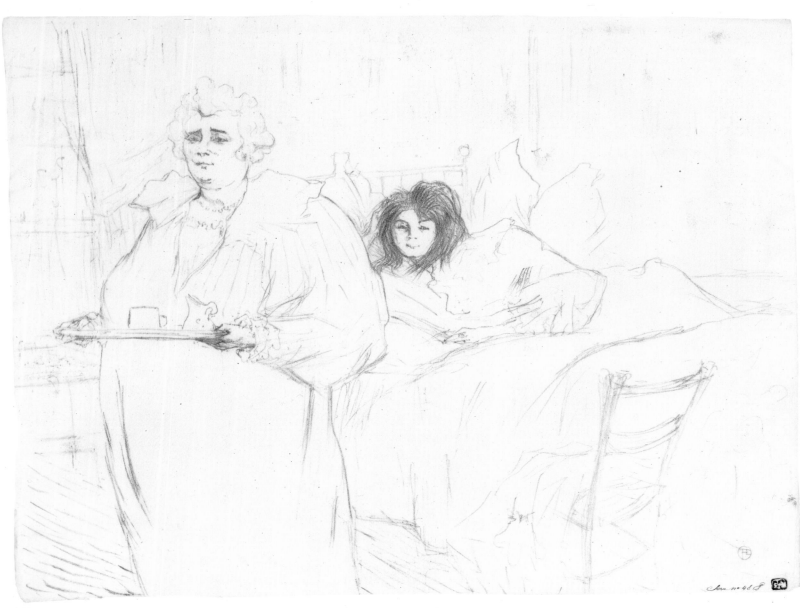

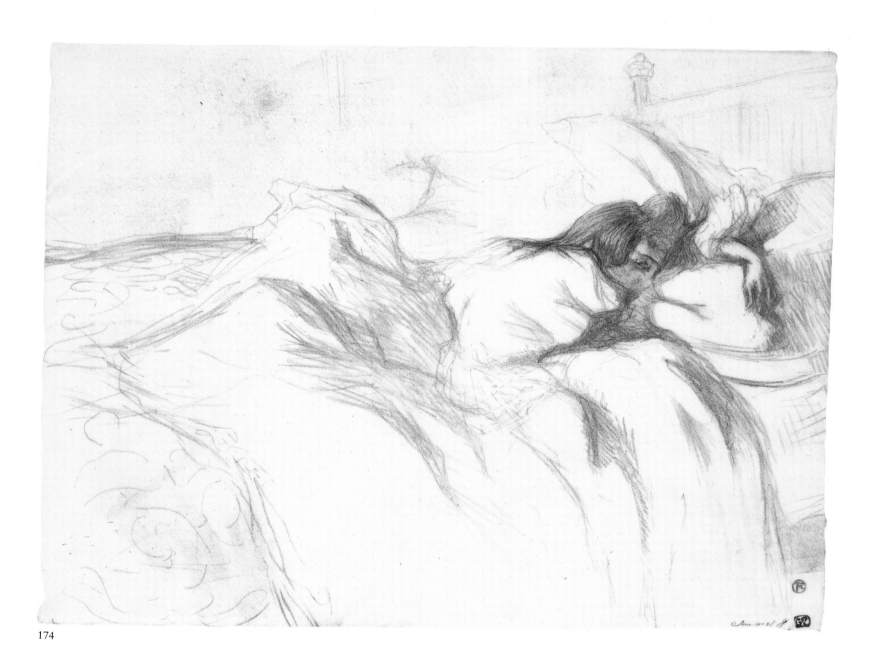

174

173 FEMME AU PLATEAU, PETIT DÉJEUNER, MADAME BARON ET MADEMOISELLE POPO 1896
Woman with a Tray, Breakfast, Madame Baron and Mademoiselle Popo

Lithograph, second sheet from the *Elles* series.
Drawing in reddish-brown; chalk, worked with the scraper.
402 × 520 mm.
Monogram on the stone, lower right.
Vellum with the watermark:
'G. PELLET/T. LAUTREC'.
Edition of 100 numbered impressions, most with the initials and monogram stamp of the publisher Pellet (Lugt 1194, 1190 or 1191), lower right; one impression in olive green and one with the note 'bon à tirer' are also known.
Delteil 181; Adhémar 202; Adriani 179; Wittrock 157.

This picture of Juliette Baron carrying the breakfast tray and her daughter Paulette, Mademoiselle Popo, both of whom worked in the brothel in the Rue des Moulins (see No. 179), was reproduced in the *Courrier Français* on 17 May 1896; see the chalk studies Dortu D.4269 to D.4272.

174 FEMME COUCHÉE, RÉVEIL 1896
Woman Waking up in Bed

Lithograph, third sheet in the *Elles* series.
Drawing in olive green; chalk, worked with the scraper.
405 × 525 mm.
Monogram on the stone, lower right.
Vellum with the watermark:
'G. PELLET/T. LAUTREC'.
Edition of 100 numbered impressions, most of which have the initials and monogram stamp of the publisher Pellet (Lugt 1194, 1190 or 1191), lower right; trial proofs from a brown drawing stone and one impression with the note 'bon à tirer' are also known.
Delteil 182; Adhémar 203; Adriani 180; Wittrock 158.

See the red chalk drawing of the woman sleeping Dortu D.4265.

175 FEMME AU TUB 1896
Woman with a Tub

Colour lithograph, fourth sheet in the *Elles* series.
Drawing in olive green with blue-grey, red, yellow and brown; chalk, ink with brush and spraying technique, worked with the scraper.
400 × 525 mm.
Monogram on the red colour stone, lower left.
Vellum with the watermark:
'G. PELLET/T. LAUTREC'.
Edition of 100 numbered impressions, most with the initials and the monogram stamp of the publisher Pellet (Lugt 1194, 1190 or 1191), lower right; seven trial proofs are also known, taken from the drawing stone and the colour stones, both singly and together. On one impression, which bears the note 'à mettre . . . jaune', the contours of the woman etc. are traced in black chalk (Kunsthalle Bremen).
Delteil 183; Adhémar 204; Adriani 181 II; Wittrock 159.

This image of a woman with a bath tub was prepared down to the last details, in the drawings, mostly of the same dimensions, Dortu D.4055, D.4056, D.4121, D.4273 and D.4277.

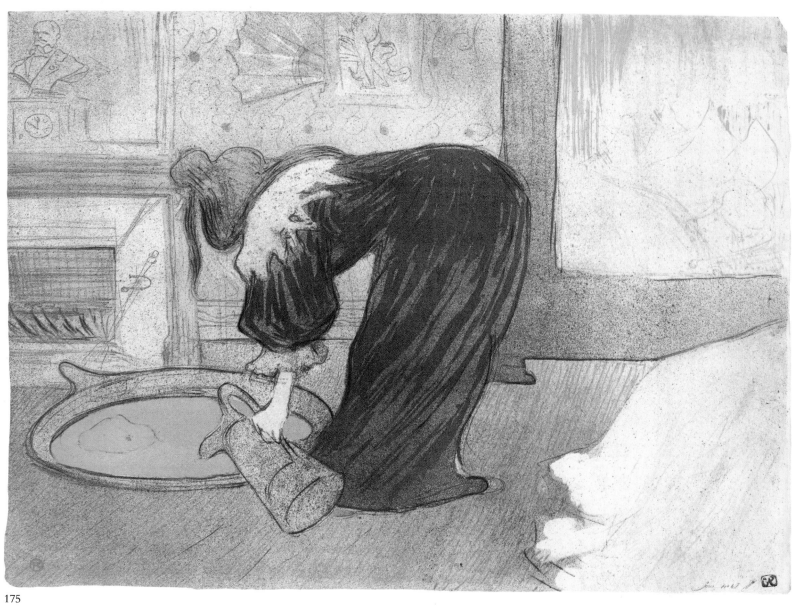

175

176 FEMME QUI SE LAVE, LA
 TOILETTE 1896
 *Woman at her Toilet, Washing
 Herself*

Colour lithograph, fifth sheet in the *Elles*
series.
Drawing in olive brown with blue; chalk.
525 × 403 mm.
Monogram on the stone, upper right.
Vellum with the watermark:
'G. PELLET/T. LAUTREC'.
Edition of 100 numbered impressions,
most with the initials and monogram
stamp of the publisher Pellet (Lugt 1194,
1190 or 1191), lower right; five trial
proofs from the drawing stone in reddish
brown or olive green are also known.
Delteil 184; Adhémar 205; Adriani 182 II;
Wittrock 160.

Compare the oil study of the woman
washing herself, dedicated to Maurice
Joyant, Dortu P.616.

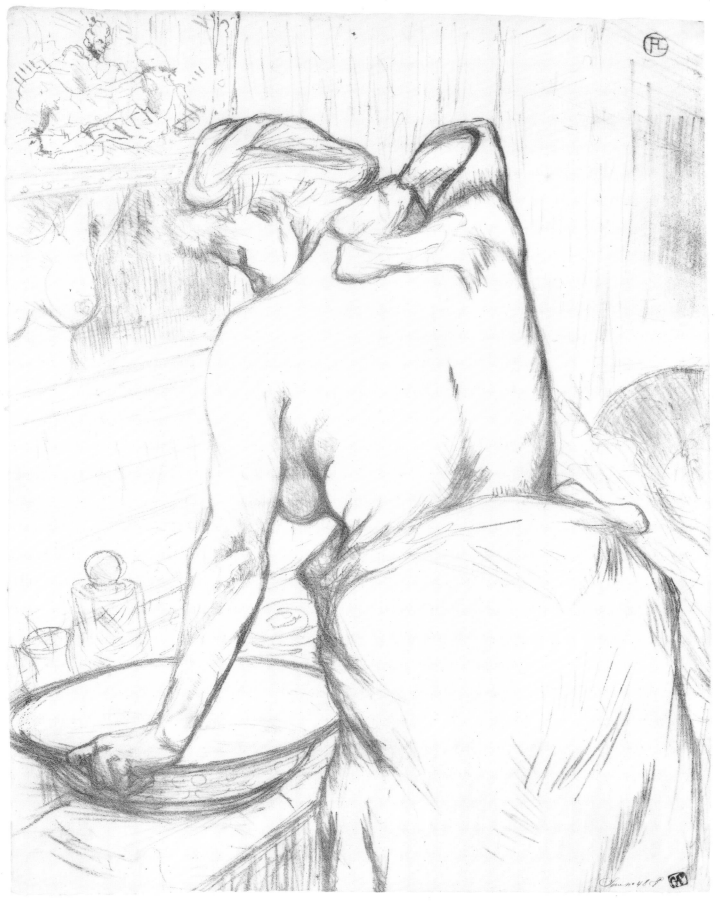

176

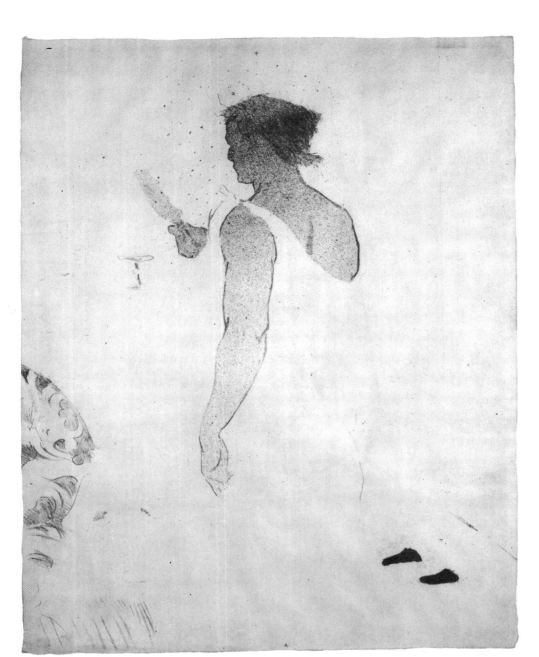

177 Trial proof

177 FEMME À GLACE, LA GLACE À
MAIN 1896
*Woman Looking into a Mirror Held in
her Hand*

Colour lithograph, sixth in the *Elles* series.
Drawing in grey with yellow and beige;
chalk, ink with brush and spraying
technique.
522 × 400 mm.
Monogram on the stone, lower right.
Vellum with the watermark:
'G. PELLET/T. LAUTREC'.
Edition of 100 numbered impressions,
most with the initials and monogram
stamp of the publisher Pellet (Lugt 1194,
1190 or 1191), lower right; seven trial
proofs are also known, taken from the
drawing stone and the colour stones, both
singly and together.
Delteil 185; Adhémar 206; Adriani 183 II;
Wittrock 161.
The trial proof shown is taken only from
the yellow colour stone.
On the verso, the initials and monogram
stamp of Gustave Pellet.

See the oil study and charcoal drawing of
a woman with a hand mirror, Dortu
P.632 and D.4278.

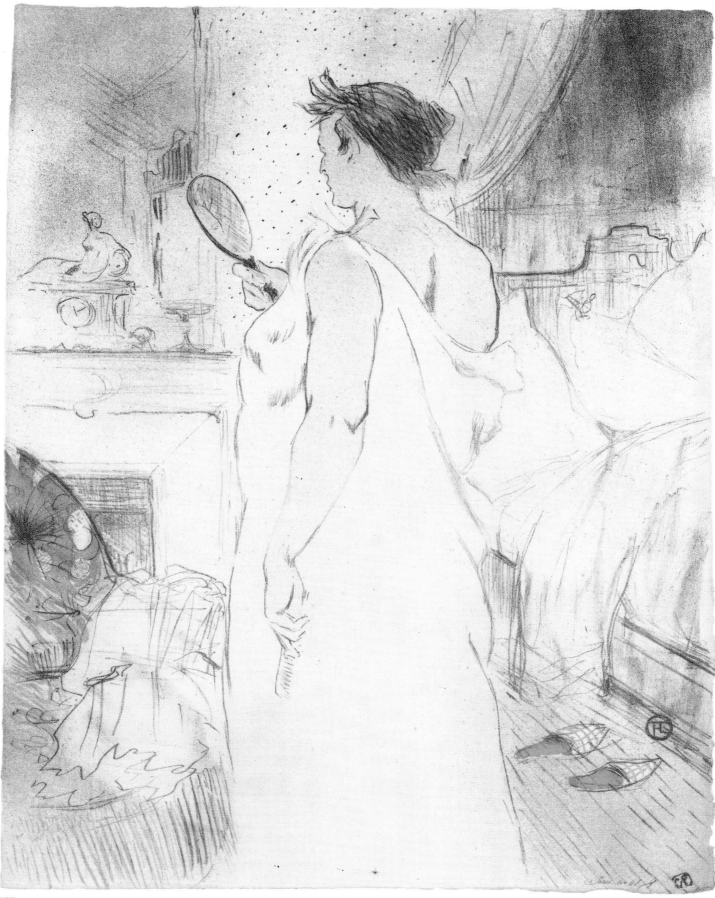

177

178 FEMME QUI SE PEIGNE, LA
COIFFURE 1896
Woman Combing her Hair

Colour lithograph, seventh sheet in the
Elles series.
Drawing in brownish violet with olive
brown; chalk, ink with brush and
spraying technique.
525 × 403 mm.
Monogram on the stone, upper right.
Vellum with the watermark:
'G. PELLET/T. LAUTREC'.
Edition of 100 numbered impressions,
most with the initials and the monogram
stamp of the publisher Pellet (Lugt 1194,
1190 or 1191), lower right; six trial proofs
are also known, some taken from the
drawing stone in black.
Delteil 186; Adhémar 207; Adriani 184;
Wittrock 162.

See the oil study of a woman combing
her hair, of roughly the same dimensions
as this lithograph, Dortu P.622 (Musée
d'Albi), and the drawing, also of the same
dimensions but dated by Dortu to around
1894, Dortu D.3736.

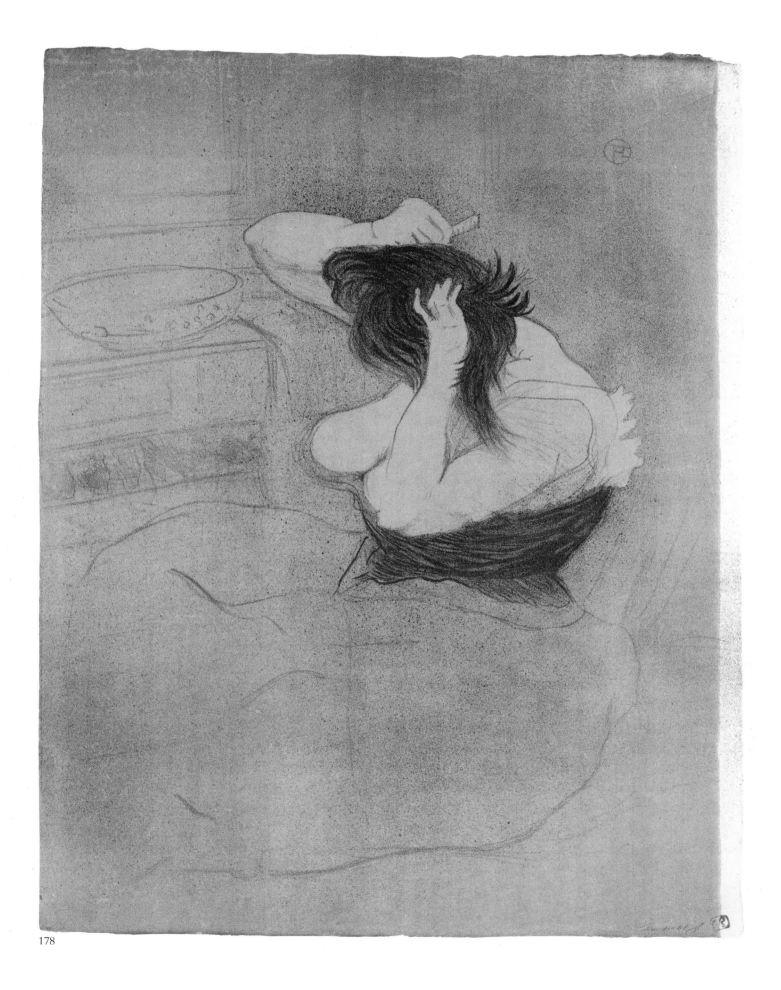

178

179 FEMME AU LIT, PROFIL, AU PETIT
 LEVER 1896
 Woman in Bed, Profile, Getting Up

Colour lithograph, eighth sheet in the
Elles series.
First state. With fan on the wall.
Drawing in black; chalk.
392 × 512 mm.
Monogram on the stone, lower left.
Grey-green or beige vellum.
Two impressions known (Bibliothèque
Nationale, Paris).
Delteil 187 (state not described);
Adhémar 208 (state not described);
Adriani 185 I; Wittrock 163.
Second state. Fan removed, drawing of the
bed-cover changed; bed-cover and the
girl's eyes an intense red.
Drawing in olive green with grey, yellow
and red; chalk, ink with brush and
sprayed.
404 × 520 mm.
Vellum.
One impression known, with a note by
the artist in pencil: 'j enl/enlever rouge/
rouge decharger et attendre'
(Bibliothèque Nationale, Paris).
Delteil 187 (state not described);
Adhémar 208 (state not described);
Adriani 185 III; Wittrock 163.
Third state. Red bed-cover lightened and
partly worked with the scraper; red
removed from the girl's eyes.
Vellum with the watermark:
'G. PELLET/T. LAUTREC'.
Edition of 100 numbered impressions,
most with the initials and monogram
stamp of the publisher Pellet (Lugt 1194,
1190 or 1191).
Delteil 187; Adhémar 208;
Adriani 185 IV; Wittrock 163.

This depiction of the morning visit shows
– like No. 173 – Madame Baron and
Mademoiselle Popo; see the figure studies
Dortu D.4279 (Musée du Louvre, Paris)
and D.4280.

180 FEMME EN CORSET, CONQUÊTE DE
 PASSAGE 1896
 *Woman Fastening a Corset, Passing
 Conquest*

Colour lithograph, ninth in the *Elles*
series.
Drawing in olive green with yellow, grey
blue, light brown, reddish brown; chalk,
ink with brush and spraying technique,
worked with the scraper.
525 × 405 mm.
Vellum with the watermark:
'G. PELLET/T. LAUTREC'.
Edition of 100 numbered impressions,
most with the initials and monogram
stamp of the publisher Pellet (Lugt 1194,
1190 or 1191), lower right; most also have
Lautrec's blue monogram stamp (Lugt
1338), lower left. Six trial proofs are also
known, taken from the drawing stone
and the colour stones, both singly and
together.
Delteil 188; Adhémar 209; Adriani 186 II;
Wittrock 164.
The trial proof shown here
(512 × 397 mm) is from the drawing stone
in olive green and from the colour stones
in light brown and dark grey on vellum.
On the verso, Gustave Pellet's initials and
monogram stamp.

The artist has depicted a woman fastening
her corset in the presence of a man, who is
seated and wearing a top hat; see the large
painting, colour study and drawings
Dortu P.617 (Musée des Augustins,
Toulouse), P.618 (Musée d'Albi) and
D.4274–D.4276. Exceptionally, these
impressions have the monogram stamp in
blue instead of red.

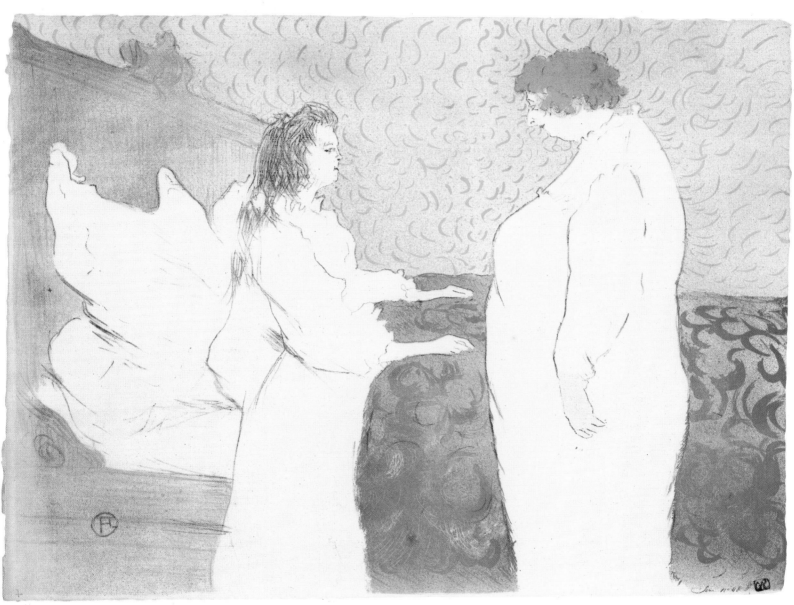

179·III

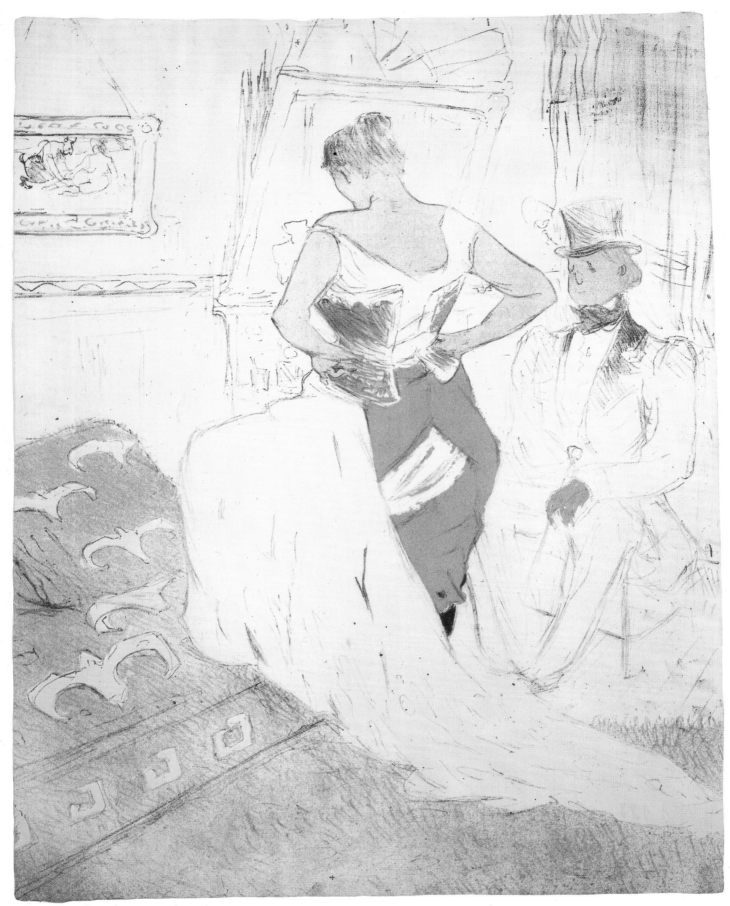

180 Trial proof

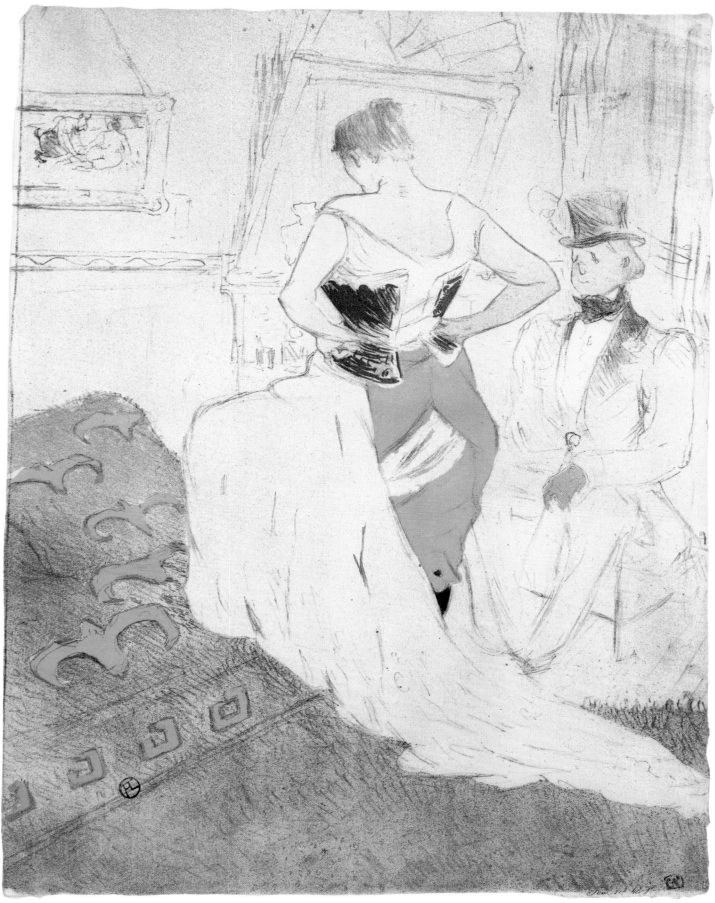

181 FEMME SUR LE DOS,
LASSITUDE 1896
Woman Lying on her Back, Lassitude

Colour lithograph, tenth in the *Elles*
series.
Drawing in reddish brown with olive
green tinted plate, mostly leaving about
10 mm of the drawing uncovered on the
lower edge.
402 × 523 mm.
Monogram on the stone, right.
Vellum with the watermark:
'G. PELLET/T. LAUTREC'.
Edition of 100 numbered impressions,
most with the initials and monogram
stamp of the publisher Pellet (Lugt 1194,
1190 or 1191), lower right; one trial proof
from the drawing stone in violet and two
with the note 'épreuve d'essai' and 'bon à
tirer' are also known.
Delteil 189; Adhémar 210; Adriani 187 II;
Wittrock 165.

This picture of a girl lying stretched out
on the bed in a state of exhaustion was
reproduced in *Le Courrier Français* of 3
May 1896; see the drawing Dortu D.4120
and a similar motif in the painting Dortu
P.635.

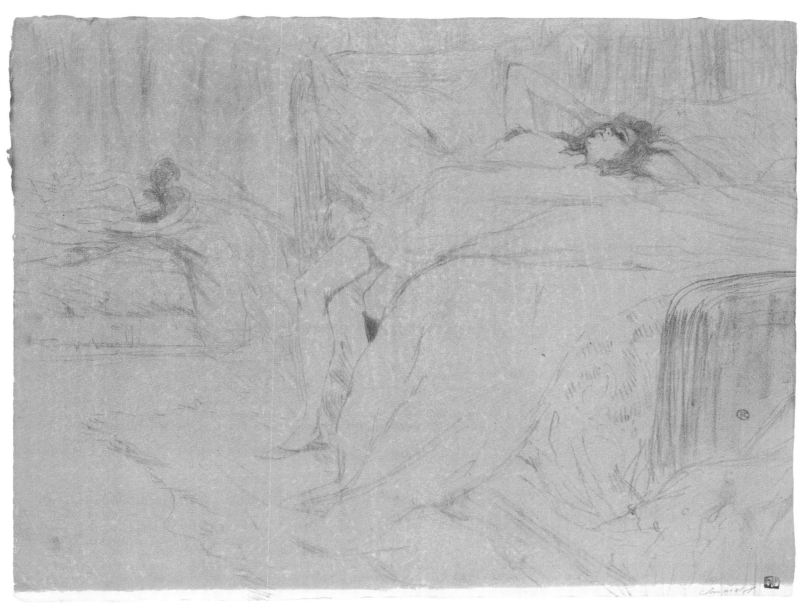

181

182 LE SOMMEIL 1896
 Sleep

Lithograph.
Drawing in reddish brown; chalk.
230 × 321 mm.
Monogram on the stone, lower left.
Hand-made Japan paper.
Edition of 12 numbered impressions,
signed by the artist in pencil, lower left;
some also have Lautrec's red monogram
stamp (Lugt 1338), lower left, or the
monogram stamp of the publisher Pellet
(Lugt 1190 or 1191), recto or verso. In
addition, two unsigned impressions are
known, one bearing the dedication 'à
Stern'.
Delteil 170; Adhémar 211; Adriani 188;
Wittrock 154.

This picture of a woman sleeping was
printed by Ancourt, Paris; see the studies
Dortu D.4100 and D.4266 (both in the
Boymans-van Beuningen Museum,
Rotterdam), and D.4267 (Daniel
Wildenstein Collection, Paris).

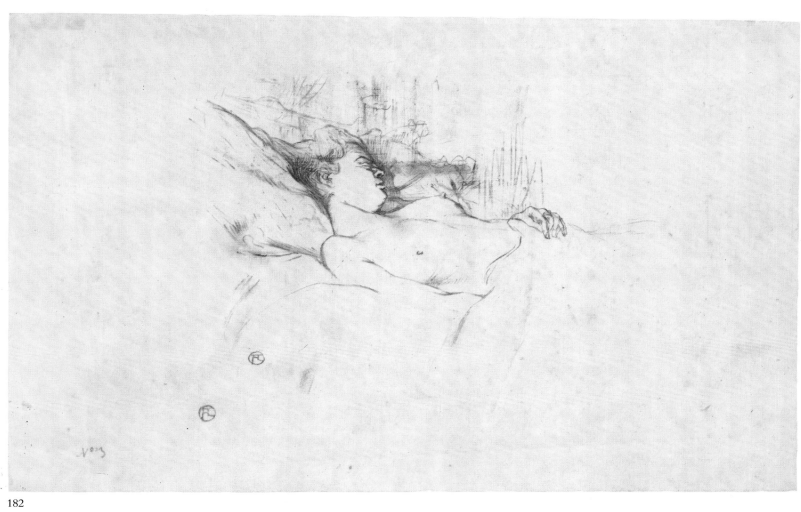

182

183 BLANCHE ET NOIRE 1896
Black and White

Lithograph.
Drawing in dark violet or black; chalk,
worked with the scraper.
453 × 293 mm.
Monogram on the stone, lower left.
Hand-made Japan paper.
Edition of 12 impressions, some
numbered, some signed by the artist,
lower left, in pencil; some also have
Lautrec's red monogram stamp (Lugt
1338) or the monogram stamp of the
publisher Pellet (Lugt 1190 or 1191). One
impression on mounted China paper is
also known (Ulm Museum).
Delteil 171; Adhémar 214; Adriani 189;
Wittrock 153.

As early as 1914 this lithograph was sold
for the enormous sum of 1620 francs, the
highest price that had ever been paid for a
monochrome print by Lautrec. Two
hundred and twenty numbered
reproductions (photolithographs) of this
print, which is one of the artist's finest
works, were made for the de luxe edition
of the book *Lautrec par Lautrec* by Ph.
Huisman and M. G. Dortu, Lausanne/
Paris 1964.

No 6 Planche

Blanche et noir

183

184

184 'L'AUBE' 1896

Colour lithograph, poster, with lettering
not designed by Lautrec: 'L'Aube/revue/
illustrée/26 quai d'Orléans'.
Drawing in dark blue with turquoise;
chalk, ink with brush and spraying
technique.
610 × 800 mm.
Monogram on the stone, lower right, in
the shape of a small elephant.
Vellum.
Size of edition not known (about 1000).
Delteil 363; Adhémar 220; Adriani 174;
Wittrock P 23.

The left-wing periodical *L'Aube* (The
Dawn), which this poster, printed by
Ancourt, Paris, was to advertise, probably
appeared for the first time in May 1896, as
on 16 April the publisher asked Jules de
Goncourt to provide a few lines for the
first issue. Lautrec wrote later to an
unidentified correspondent: 'I beg leave
to inform you that I have some Aube
posters at your disposal, stamped
impressions, at M. Ancourt's, at a price of
50 francs for 50. I would appreciate it if
you would send me the impression of my
little American poster [No. 196]. We can
make an exchange on this one. By the
way, I'll be at Ancourt's tomorrow,
Wednesday, at 11 o'clock' (Goldschmidt-
Schimmel, No. 208).

185 PROGRAMME POUR 'LA
 LÉPREUSE' 1896
 Programme for 'La Lépreuse'

Lithograph, programme.
First state. No lettering.
Drawing in reddish brown; chalk.
502 × 312 mm.
Monogram on the stone, above; dated.
Vellum.
Delteil mentions impressions.
Delteil 196 I; Adhémar 185 I;
Adriani 173 I; Wittrock 168.
Second state. With lettering not designed
by Lautrec: 'COMÉDIE PARISIENNE
.../LA LÉPREUSE/...'.
Size of edition not known (several
hundred).
Delteil 196 II; Adhémar 185 II;
Adriani 173 II; Wittrock 168.

This was a leaflet advertising the play *La
Lépreuse* (The Woman Leper) by Henry
Batailles at the Comédie Parisienne, in
which Berthe Bady played the lead; see
the portrait studies Dortu D.4132 and
D.4133.

185·II

186 DÉBAUCHE 1896
 Debauchery

Lithograph.
Drawing in black; chalk, worked with the
scraper.
234 × 324 mm.
Monogram on the stone, lower right.
Vellum.
Two impressions known, one signed in
black chalk, lower left (illustrated).
Delteil 177; Adhémar 213; Adriani 190;
Wittrock 166.

Only a few impressions of this lithograph
were made, and it was probably the first
draft for No. 187; see the pen and ink
drawing Dortu D.4245.

187 DÉBAUCHÉ 1896
 The Debaucher

Colour lithograph.
First state. No lettering.
Drawing in grey with yellow and red;
chalk, ink with brush and spraying
technique.
244 × 323 mm.
Monogram on the stone, upper right, in
the shape of a small elephant.
Vellum.
One impression known.
Delteil 178 (state not described);
Adhémar 212 (state not described);
Adriani 191 (state not described);
Wittrock 167 I.
Second state. Monogram upper right
removed. New monogram on the stone,
lower right.
Vellum, hand-made Japan paper.
Edition of 50 numbered impressions,
some signed by the artist in pencil, lower
left; most also have the initials of the
publisher Arnould, lower right. Three
impressions on silk are also known.
Delteil 178 I; Adhémar 212; Adriani 191 I;
Wittrock 167 II.
Third state. With lettering not designed by
Lautrec, in blue: 'Catalogue/d'Affiches/
artistiques/A.Arnould/7, rue Racine/
Paris'.
Vellum.
Edition of 100 impressions.
Delteil 178 II; Adhémar 212;
Adriani 191 II; Wittrock 167 II.

This colour lithograph – see No. 186 –
was used in its third state as cover for
the *Catalogue d'Affiches Artistiques*,
published in June 1896 by A. Arnould.
The model for the debaucher was Lautrec's
painter-friend Maxime Dethomas
(1868–1928); see Dortu D.4152–D.4154.

186

Débauche

187·II

Lithograph, design for a poster.
Drawing in olive green; ink with brush.
815 × 1210 mm.
Monogram on the stone, lower left, in the shape of a small elephant; inscribed: '96/ No − 200', and bearing the monogram of the printer Chaix.
Vellum.
Edition of 200 with numbering inserted, some signed by the artist in blue chalk, lower left; one impression in reddish brown is also known.
Delteil 359; Adhémar 184; Adriani 194; Wittrock P 25.

Cycling had become a fashionable sport in Paris since Dunlop's invention of the rubber tyre in 1889, and the velodromes became meeting-places for elegant society. On his Sunday visits there Lautrec was introduced to the famous riders by the chief editor of the *Journal des Vélocipédistes*, Tristan Bernard, who was in charge of racing at the Vélodrome Buffalo in Neuilly and de la Seine from 1895; he familiarized himself with the milieu and habits of the cyclists.

From two letters to his mother in May and early June 1896, we see how eagerly Lautrec followed the sport: 'I have two or three big deals with bicycle companies, all right, all right', and: 'I stayed there (in London) from Thursday to Monday. I was with a team of bicyclists who've gone to defend the flag the other side of the Channel. I spent three days outdoors and have come back here to make a poster advertising "Simpson's Lever Chain", which may be destined to be a sensational success' (Goldschmidt-Schimmel, No. 204).

The London meeting had been arranged by Louis Bouglé, the general representative of the British cycle and chain company, Simpson's, who was both an art-lover and an anglophile. Bouglé thought it appropriate to adopt the name of Spoke, as it sounded English, and he dressed in the English manner. He asked Lautrec for a poster on behalf of Simpson's to advertise the manufacturer's new bicycle chains. This first bold design shows the English cyclist Michael, the winner of two major races in May and June 1895, with the famous tooth-pick in his mouth; see the sketches Dortu D.4251−D.4253. The sports journalist Frantz Reichel stands on the right with stop-watch in hand, while the trainer Choppy Warburton is busy with his bag; see the small sketch Dortu D.4069. Spoke rejected this first design, however, because the pedals were not drawn accurately, and Lautrec had a limited edition of 200 printed by Chaix at his own expense; the charcoal drawing Dortu D.4104 (Musée d'Albi) was used for the drawing on the stone.

189 La Chaîne Simpson 1896
 The Simpson Chain

Colour lithograph, poster, with lettering
not designed by Lautrec, in red: 'La
Chaîne Simpson/L.B.Spoke/
DIRECTEUR POUR LA FRANCE/25,
Boulevard Haussmann.'
Drawing in dark blue with red and
yellow; ink with brush and spraying
technique, chalk.
828 × 1200 mm.
Monogram on the stone, lower right, in
the shape of a little elephant, with the
date; on the lower edge, the monogram
of the printer Chaix with his address:
'IMPRIMERIE CHAIX, 20, Rue
Bergère. PARIS. 10952.6.96 (ENCRES
LORILLEUX)'.
Poster paper.
Size of edition not known (about 1000).
Delteil 360; Adhémar 187; Adriani 195;
Wittrock P 26.

After rejecting the first design (No. 188),
Simpson, the English manufacturer of
bicycles and chains, accepted this version
in colour to advertise his Paris branch, and
the print was deposited at the
Bibliothèque Nationale, Paris, on 12 June
1896. In place of the English professional
racing cyclist Michael, the master rider
Constant Huret is to be seen in this
version, riding on a tandem behind his
trainer. In the background, Mr W. S.
Simpson, the English manufacturer, and
Louis Bouglé (alias L. B. Spoke), manager
of the Paris branch, stand watching the
ride.

189

190

190 Au Vélodrome, W. S. Simpson et
le Petit Michael 1896
*At the Velodrome, W. S. Simpson and
Young Michael*

Lithograph.
Drawing in black; chalk.
447 × 554 mm.
Monogram on the stone, lower left.
Vellum.
One impression known (Bibliothèque
Nationale, Paris).
Delteil 146; Adhémar 144; Adriani 192;
Wittrock 141.

The print shows Mr W. S. Simpson and
the English racing cyclist Michael at the
velodrome (see Nos. 188 and 189).

191

191 Au Vélodrome 1896
At the Velodrome

Lithograph.
Drawing in black; chalk.
340 × 455 mm.
Vellum.
Three impressions known.
Delteil 147; Adhémar 145; Adriani 193;
Wittrock 142.
The impression shown here, which is on
beige vellum, is inscribed on the verso: 'il
a tire 3 ep. de cette litho. Ancourt,
Lautrec, Stern'.

In the foreground we see Louis Bouglé,
alias L. B. Spoke, in his bold check suit at
the velodrome (see Nos. 188 to 190).

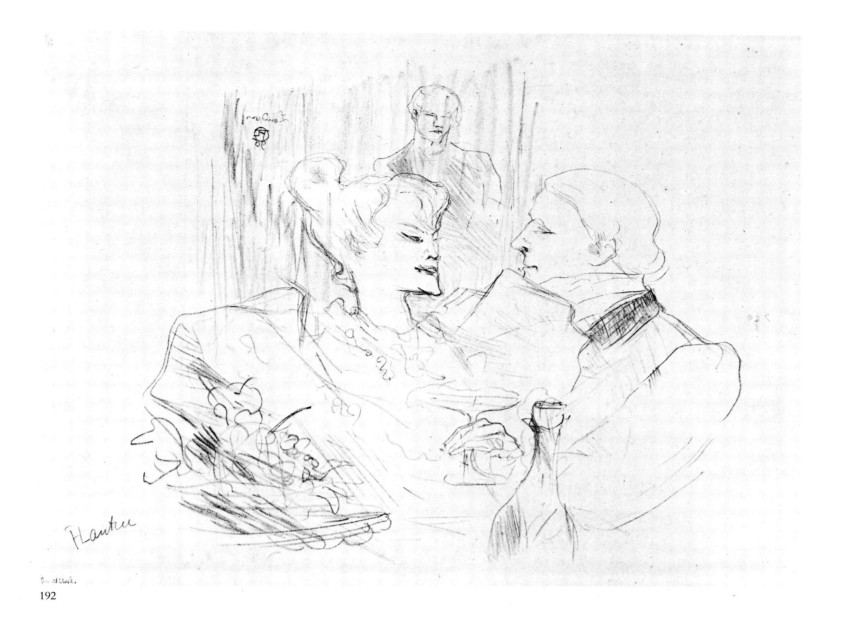

192

192 SOUPER À LONDRES 1896
Supper in London

Lithograph.
Drawing in grey; chalk.
312 × 362 mm.
Reverse monogram on the stone, upper
left, with the inscription: 'London/96'.
Beige vellum.
Edition of 100 impressions, some signed
by the artist in pencil, lower left; some
also have Lautrec's red monogram stamp
(Lugt 1338). Three impressions in black

on China and Japan paper are also known.
Delteil 167; Adhémar 190; Adriani 166;
Wittrock 169.
The impression shown here is inscribed
by Kleinmann in pencil, lower left: 'five
o'clock'.

Following his frequent visits to London –
in May 1892, June 1894 and May 1895 –
Lautrec made two lithographs in 1896
which may recall his visit to England in
the previous year (see No. 163). In this
one, printed by Eugène Lemercier, Paris,

and dated upper left on the stone, we see
the artist's friend, Charles Conder,
depicted as a dandy, with his female
companion in a *chambre séparée*. The
lithograph was published in the series
Études des Femmes in the art magazine *Le
Livre Vert*; see the portrait study Dortu
D.4243. One copy of the lithograph was
registered at the Bibliothèque Nationale,
Paris, on 2 July 1896.

193 ANNA HELD ET BALDY 1896
Anna Held and Baldy

Lithograph.
Drawing in black; chalk.
313 × 244 mm.
Monogram on the stone, upper right.
Vellum.
Edition of 20 impressions, some
numbered, some with Lautrec's red
monogram stamp (Lugt 1338), lower
right, and the blind stamp of the publisher
Kleinmann (Lugt 1573), lower left.
Delteil 168; Adhémar 216; Adriani 203;
Wittrock 145.

In contrast to previous years, Lautrec's
interest in the world of the theatre
slackened noticeably in 1896, and only a
few sheets depict the stars on stage or
show their audience.

194 LA LOGE, 'FAUST' 1896
*The Box during a Performance of
'Faust'*

Lithograph.
Drawing in dark violet; chalk.
372 × 268 mm.
Vellum.
Edition of 25; one trial proof is also
known, bearing the inscription: 'bon à
tirer 25'.
Delteil 166; Adhémar 217; Adriani 201;
Wittrock 148.

This fine sheet offers a view of the stage,
where we may see Rose Caron as
Gretchen in Charles Gounod's opera *Faust*
(see No. 54).

195 SORTIE DE THÉÂTRE 1896
Leaving the Theatre

Lithograph.
Drawing in black; chalk.
320 × 265 mm.
Reverse monogram on the stone, lower
right.
Vellum.
Edition of about 25; one trial proof with
the inscription 'Bon à tirer et deux en
plus' is also known.
Delteil 169; Adhémar 218; Adriani 204;
Wittrock 147.

The woman who ran the *maison close* in
the Rue des Moulins is seen here leaving
the theatre, with her companion, who is
depicted in a discreetly sketchy fashion.

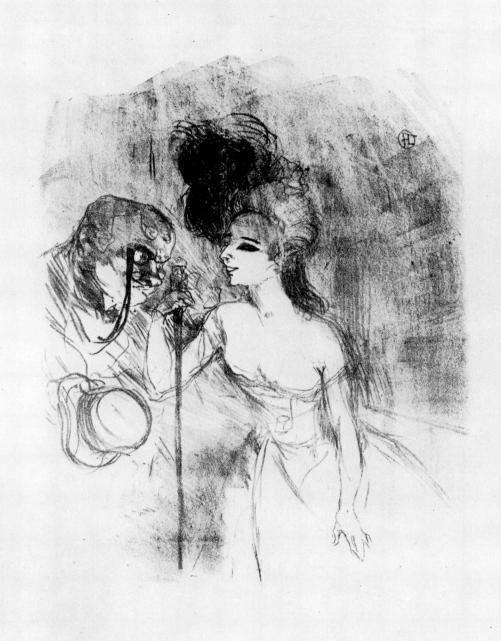

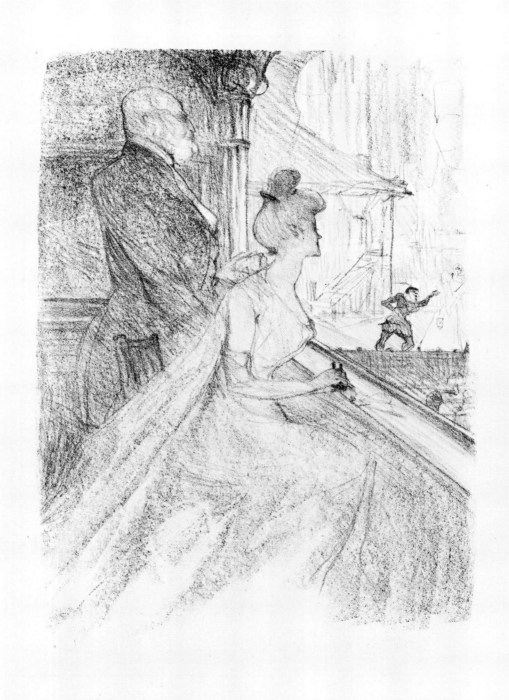

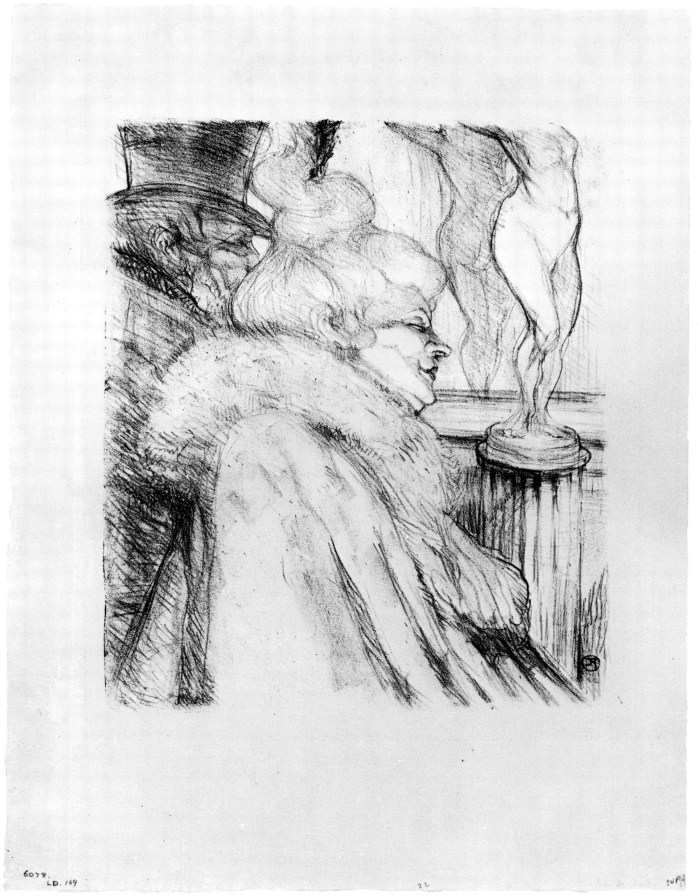

196 Au Concert 1896
At the Concert

Colour zincograph, poster.
First state. No lettering.
Drawing in brown with red, yellow and
black; ink with brush and spraying
technique, worked with the scraper.
320 × 252 mm.
Monogram on the stone, lower right,
with date.
Vellum.
One impression known (Art Institute,
Williamstown).
Delteil 365 I; Adhémar 199 I;
Adriani 202 I; Wittrock P 28 A.
Second state. With lettering not designed
by Lautrec, in brown, lower left:
'COPYRIGHTED BY CHAS. H.
AULT, CLEVELAND, O.'
Edition of about 20, signed by the artist in
pencil, lower left.
Delteil 365 II; Adhémar 199 II;
Adriani 202 II; Wittrock P 28 B.
Third state. With more lettering not
designed by Lautrec, in dark blue: 'THE/
AULT & WIBORG CO/MAKERS OF/
FINE PRINTING/AND
LITHOGRAPHIC/INKS/
CINCINNATI–NEW
YORK–CHICAGO.'
Size of edition not known (about 1000).
Delteil 365 III; Adhémar 199 III;
Adriani 202 III; Wittrock P 28 C.
New edition (1946). 100 numbered
impressions on China paper with the
appropriate mark, verso, published by the
Art Institute of Chicago.

This was Lautrec's smallest colour
lithograph, made for an American ink
manufacturer, and it shows Emilienne
d'Alençon and Gabriel Tapié de Céleyran
at the Cabaret des Décadents. The study
Dortu P.615, signed and dated 1896, also
bears the inscription: 'for the Ault and/
Wiborg Co./Cincinnati'. The edition of
the poster with full lettering was printed
in America after the zinc plates – which
are now in the Art Institute of Chicago –
had been sent there.

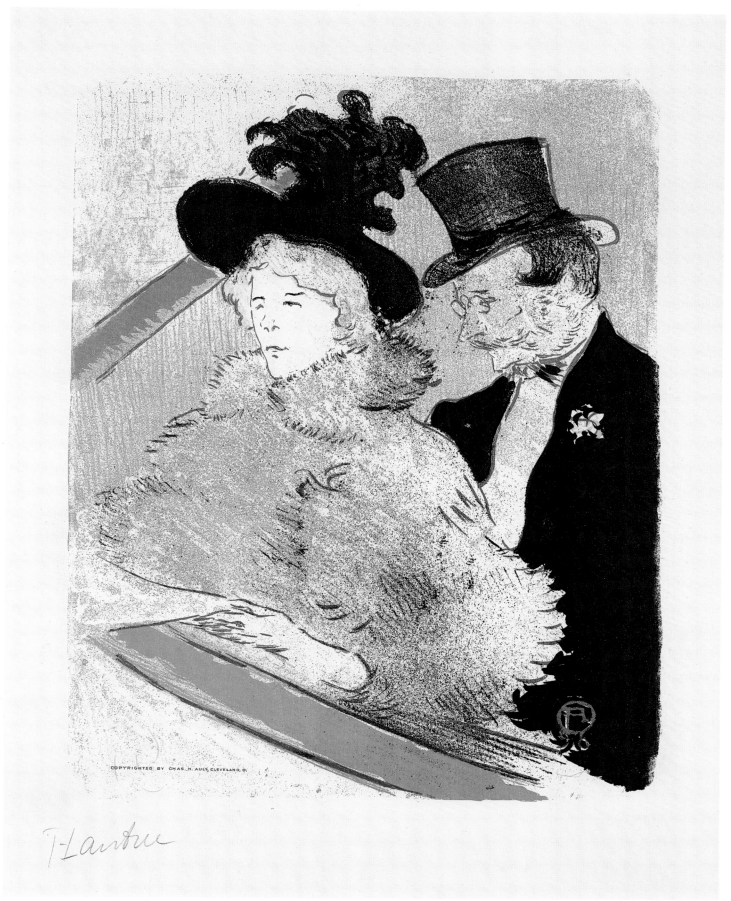

T-Lautrec

196·II

197

198·I

199·I

197 MENU SYLVAIN 1896
Menu Card for Sylvain

Lithograph, menu card, with lettering
designed by Lautrec: '2 Décembre 1896'.
Drawing in olive green; chalk, ink with
brush.
210 × 198 mm.
Monogram on the stone, lower left, in the
shape of a little elephant.
Imitation Japan paper.
Four impressions known.
Delteil 198; Adhémar 222; Adriani 197;
Wittrock 171.

Only four impressions of this menu card
survive. It was probably made for the
dinner given by Paul Guibert, the brother
of Lautrec's friend Maurice, to mark the
end of his bachelor days; see the study of a
dog Dortu D.4601.

198 LE SUISSE, MENU 1896
Menu Card, Le Suisse

Lithograph, menu card.
First state. No lettering.
Drawing in dark olive green; chalk,
worked with the scraper.
370 × 265 mm.
Monogram on the stone, lower right.
Vellum.
Two impressions known.
Delteil 199 I; Adhémar 223 I;
Adriani 198 I; Wittrock 174.
Second state. With lettering not designed
by Lautrec: 'MENU/du Dîner du 22
Décembre/1896'.
One impression known (Art Institute,
Chicago).
Delteil 199 II; Adhémar 223 II;
Adriani 198 II; Wittrock 174.

This menu was designed for a great
carousal on 22 December 1896, probably
another stag party – this time, no doubt,
that of Georges Lasserre, who is shown on
the right with a beauty on his arm (see
No. 5). Gabriel Tapié de Céleyran and
Maurice Guibert can be seen on the other
side of the table.

199 LE CROCODILE, MENU 1896
Menu Card, Le Crocodile

Lithograph, menu card.
First state. No lettering.
Drawing in dark olive green or black;
chalk.
323 × 226 mm.
Monogram on the stone, lower left.
Beige vellum, Japan paper.
Three impressions known.
Delteil 200 I; Adhémar 224 I;
Adriani 196 I; Wittrock 175 I.
Second state. With lettering not designed
by Lautrec: 'dîner du 23 Décembre 1896/
Huîtres de Burnham/...'.
Vellum.
Five impressions known.
Delteil 200 II; Adhémar 224 II;
Adriani 196 II; Wittrock 175 I.
Third state. Apart from the caricature of
Lautrec seated in the foreground, the
image covered over.
Drawing in black.
100 × 90 mm.
Imitation Japan paper, vellum.
Two signed impressions bearing a
dedication are also known: the first, listed
by Dortu as a drawing (D.4258), has the
inscription: 'à Pellet, l'intrépide éditeur'
(Musée d'Albi), while the other is
inscribed 'à M. Pochet'.
Delteil 200 (state not described);
Adhémar 224 III; Adriani 196;
Wittrock 175 II.

200

201

During an expedition to the châteaux of the Loire in November 1896 with his friends Maurice Guibert, Maurice Joyant and his cousin Gabriel, Lautrec visited Blois, where the party discussed the daring flight of Marie de' Medici from her son Louis XIII. For a dinner on 23 December 1896 held in honour of his fellow-travellers, Lautrec was inspired by the historical episode to create this grotesquely comical depiction, in which the main figures are Guibert in his nightshirt and Gabriel Tapié de Céleyran's girl-friend. Joyant (1864–1930) is the crocodile, while Tapié appears on the upper edge in the guise of a Hokusai monster reminiscent of Grandville's *hommes-bêtes* caricatures. Lautrec himself appears on the lower left, a silent observer seen from behind, seated on a stool and drawing; see the self-caricature Dortu D.4229.

200 MENU POUR UN DÎNER CHEZ MAY
 BELFORT 1896
 *Menu Card for a Dinner Given by
 May Belfort*

Lithograph, menu card, with lettering designed by Lautrec: '18 Rue Clapeyron'. Drawing in dark olive green; chalk.
74 × 164 mm.
Monogram on the stone, above.
Vellum, Japan paper.
Five impressions known: two with a hand-written menu, one of them by May Belfort and the other by Maurice Joyant.
Delteil 201; Adhémar 225; Adriani 199; Wittrock 176.

The cat was an essential feature of May Belfort's act (see Nos. 121, 123–126), and so this menu card shows the cat hunting a mouse which has taken refuge in the protective circle of Lautrec's monogram. In fact, the artist was most concerned with the cat's welfare; at any rate, so it would appear from a letter to Maxime Dethomas: 'Miss Belfort is asking around for a husband for her cat. Is your Siamese ready for this business? Drop me a line, if you please, and name a date' (Goldschmidt-Schimmel, No. 198).

201 A MERRY CHRISTMAS 1896

Lithograph, Christmas card, with lettering not designed by Lautrec: 'a merry christmas/and a happy/new year'. Drawing in olive green or blackish brown; chalk.
170 × 128 mm.
Monogram on the stone, lower right.
Vellum.
Five impressions known.
Delteil 202; Adhémar 226; Adriani 200; Wittrock 173.
The impression shown here is inscribed in black ink, lower left: 'May Belfort/1896.97'.

So the year 1896 ended with a Christmas card for May Belfort. It shows a negro dancing and playing the banjo, similar to the image used as a remarque in the first state of the MAY MILTON poster (No. 134).

202 La Grande Loge 1896–1897
Box in the Grand Tier

Colour lithograph.
First state. With yellow half-moon, upper right, etc.
Drawing in black with red, blue and yellow; chalk, ink with brush and spraying technique, worked with the scraper.
515 × 398 mm.
Monogram on the stone, lower right.
Vellum.
One impression known, with a note by the artist, lower left: 'passe' (Bibliothèque Nationale, Paris).
Delteil 204; Adhémar 229; Adriani 205 I; Wittrock 177.
Second state. New yellow colour stone, resulting in several changes, including the following: only the outline of the original yellow half-moon shape, upper right, can now be seen; the areas sprayed yellow in the clothes of the figure on the right and the hat on the centre figure have been taken out, while the walls of the box in the foreground have been resprayed in yellow. However, the main change from the first to the second state is to the ornamentation in yellow on the front of the box.
Drawing in black with beige added.
513 × 400 mm.
Edition of 12 numbered impressions, signed by the artist in pencil, lower right; some also have Lautrec's red monogram stamp (Lugt 1338), lower right, and the monogram stamp of the publisher Pellet (Lugt 1190). Apart from eleven trial proofs, two impressions are known, dedicated to Pellet and the printer Stern.
Delteil 204; Adhémar 229; Adriani 205 II; Wittrock 177.

The interaction of colour and form in Lautrec's work reached its peak in four large colour lithographs made in the spring of 1897 and printed by Stern (Nos. 202 to 205); these are among the finest works Toulouse-Lautrec ever produced. The relatively high prices of 50 and 60 francs asked by the publisher Pellet were due to the small editions, for the delicately sprayed tonal gradations enabled only a few impressions to be taken. In January 1897 twelve numbered impressions were published of this picture of the one-eyed landlady of the Bar Hanneton (the Ladybird Bar), which was frequented by lesbians; Madame Armande Brazier is shown in profile (see No. 303), with the dancer and actress Emilienne d'Alençon and Tom, the Rothschilds' coachman, in the background. This image is extended at the top and below from the oil study Dortu P.651, lending greater emphasis to the breadth of the depiction and the broad, sweeping lines of the box sides.

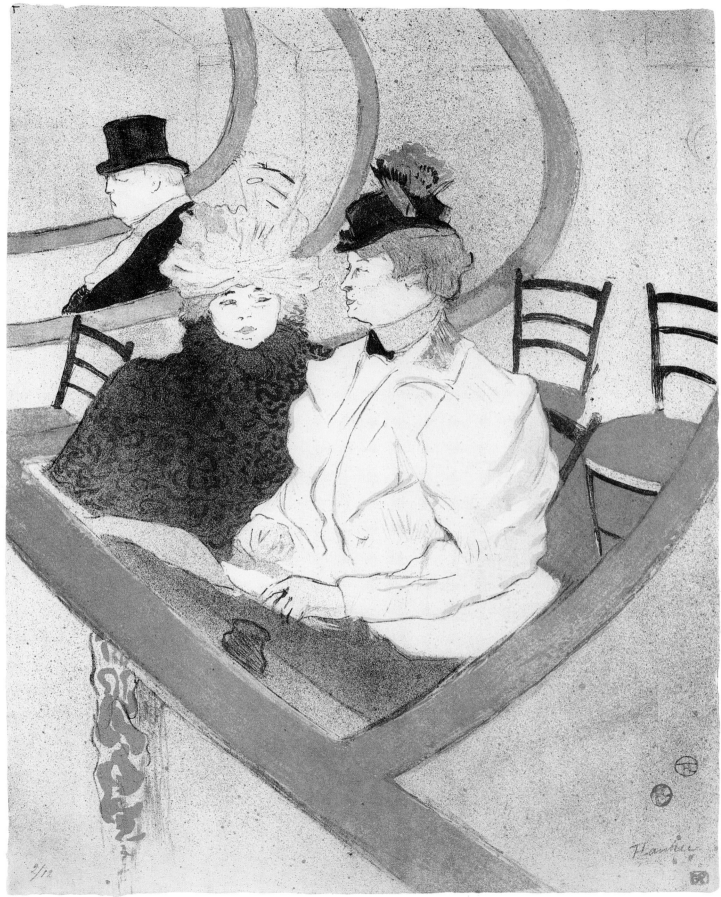

2/12

202·II

203 LA CLOWNESSE AU MOULIN
ROUGE 1897
Cha-u-Kao at the Moulin Rouge

Colour lithograph.
Drawing in dark brown with grey-
brown, orange, yellow, red and blue;
chalk, ink with brush and spraying
technique.
410 × 320 mm.
Monogram on the stone, lower left.
Vellum, China paper.
Edition of 20 numbered impressions,
signed by the artist in pencil, lower right;
some also have the monogram stamp of
the publisher Pellet (Lugt 1190), lower
left. Two impressions dedicated 'à Pellet'
(illustrated) and 'à Stern' are also known,
as well as four trial proofs taken from the
colour stones, both singly and together,
some before the edges had been
straightened.
Delteil 205; Adhémar 231; Adriani 206 II;
Wittrock 178.

This print shows Cha-u-Kao, the female
clown, in the Moulin Rouge, arm-in-arm
with Gabrielle la Danseuse (see the study
Dortu P.600), with Tristan Bernard
(1866–1947) in profile in the background.
It derives from a painting dated 1895 and
purchased from Joyant in 1896 by Ex-
King Milan of Serbia – Dortu P.583
(Oskar Reinhart Collection, Winterthur).
This magnificent lithograph, printed
from six stones, was published by Gustave
Pellet in March 1877 at 50 francs.

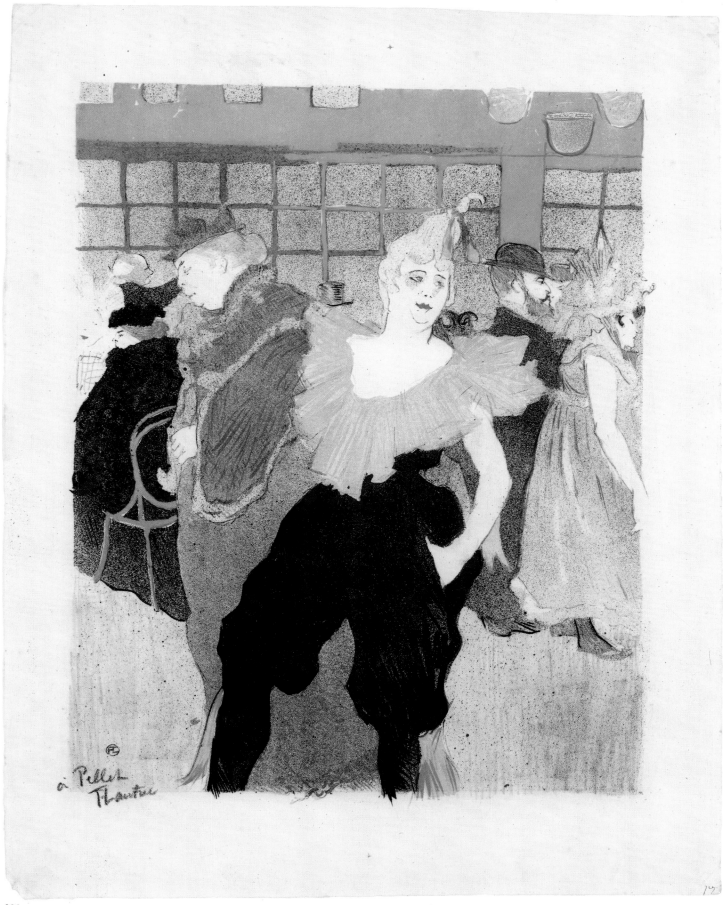

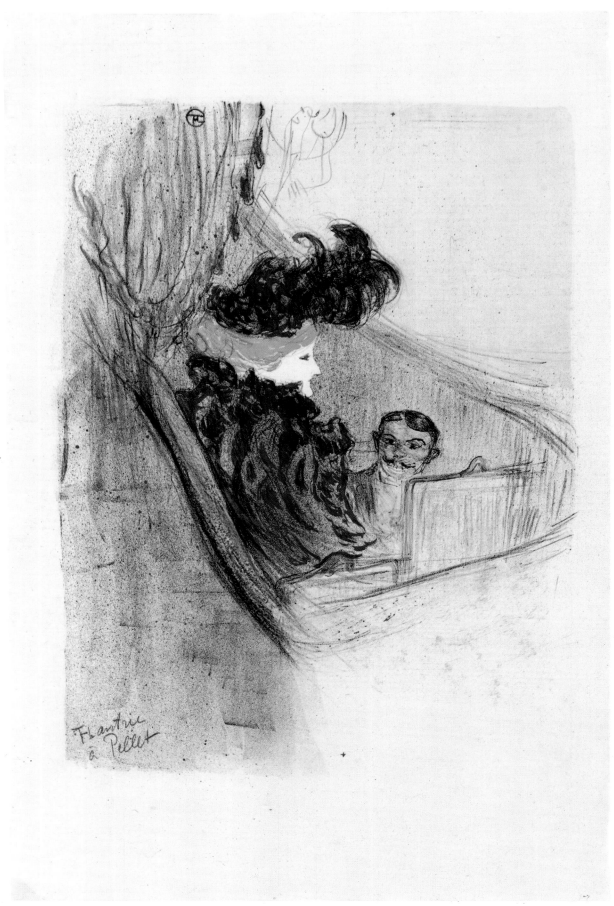

204 Idylle Princière 1897
Princely Idyll

Colour lithograph.
Drawing in black with blue, turquoise
blue, yellow, purple and pink; chalk, ink
with brush and spraying technique.
380 × 285 mm.
Monogram on the stone, upper left.
China paper.
Edition of 16 numbered impressions
signed by the artist in pencil, lower left;
some also have the monogram stamp of
the publisher Pellet (Lugt 1190), lower
left. In addition, one impression dedicated
'à Pellet' (illustrated) is known, and six
trial proofs taken from the drawing stone
and the colour stones, both singly and
together. One impression, not mentioned
by Dortu, is worked over in colour
(formerly Charell Collection; see the
auction catalogue *A Collection of Fine
Lithographs and Drawings by Henri de
Toulouse-Lautrec*, Sotheby & Co.,
London, 6 October 1966, No. 95).
Delteil 206; Adhémar 230; Adriani 207 II;
Wittrock 179.

This colour lithograph was published by
Gustave Pellet at the beginning of April
and reproduced in the middle of that
month in *L'Estampe et l'Affiche*. It was a
reference to a society scandal that
dominated the gossip columns in Paris at
that time. The heiress to a great fortune,
Clara Ward of Detroit, had married
Prince Caraman-Chimay, but after only
six years of marriage 'the most heavily
painted, artificially beautiful of all
American ladies let herself be seduced by a
pockmarked person, who was a master of
that art'. The magazine *Gil Blas* of 9
January 1897 meant by this the gypsy
Rigo, whom the American heiress
married in 1904, and with whom we see
her here in her box.

205 Elsa, dite la Viennoise 1897
Elsa, Known as the Viennese

Colour lithograph.
First state.
Drawing in black; chalk.
503 × 318 mm, 482 × 323 mm,
510 × 330 mm.
Monogram on the stone, lower left.
Vellum.
Three impressions known, one of which
is signed by the artist in pencil, lower left
(illustrated); one watercolour impression
is also known, Dortu A.255 (Bibliothèque
Nationale, Paris).
Delteil 207; Adhémar 232 (state not
described); Adriani 208 I; Wittrock 180.
Second state. Colouring now completed,
particularly in the dress and wrap.
Drawing in grey-brown with blue, grey-
violet and red; chalk, ink with brush and
sprayed.
565 × 400 mm.
China paper.
Edition of 17 numbered impressions,
signed by the artist in pencil, lower left;
some also have the monogram stamp of
the publisher Pellet (Lugt 1190), lower
right; five trial proofs are also known
from the drawing stone and the colour
stones, both singly and together (see the
auction catalogue *Henri de Toulouse-
Lautrec. Lithographs from the Collection of
Ludwig and Eric Charell*, Sotheby Parke
Bernet & Co., London 1978, Nos. 115
and 116), as well as six impressions outside
the edition, including impressions
dedicated to Pellet and the printer Stern.
Delteil 207; Adhémar 232; Adriani 208 II;
Wittrock 180.

This very fine colour lithograph, which
was published by Pellet in May 1897,
shows Elsa, the Viennese woman from the
Rue des Moulins, whose studied elegance
and mask-like painted face testify to the
indifference and impersonality of her
profession. Her figure is encased in a
delicately blue-patterned dress with a fur-
trimmed cape of the same colour draped
round her shoulders. The fascination of
this figure, who confronts us full-face in a
magisterial stance, derives from her
intuitively self-protective remoteness,
with not the slightest hint of sensuality or
eroticism. Yet despite the sublimation of
the material, the expression of loneliness
triumphs over the commercial value of
this object of pleasure and her costly
apparel.

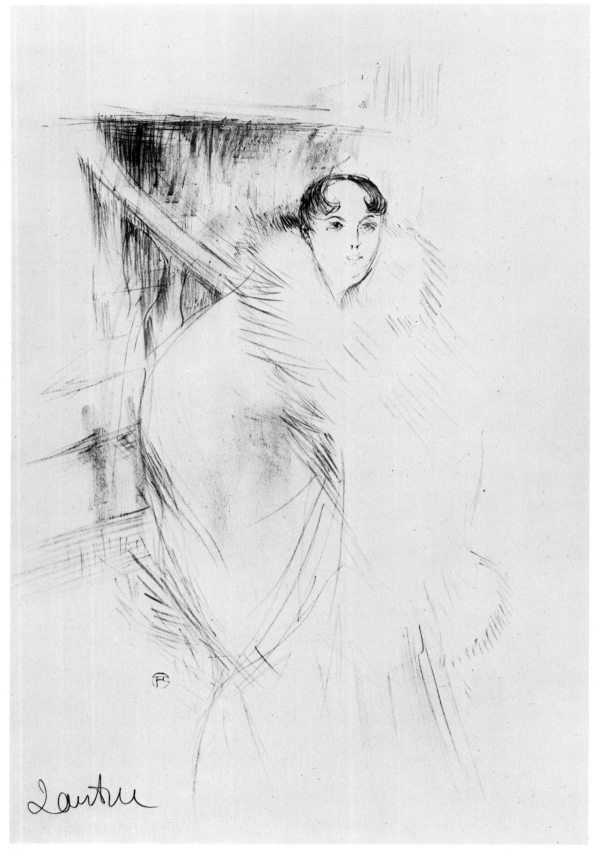

205·I

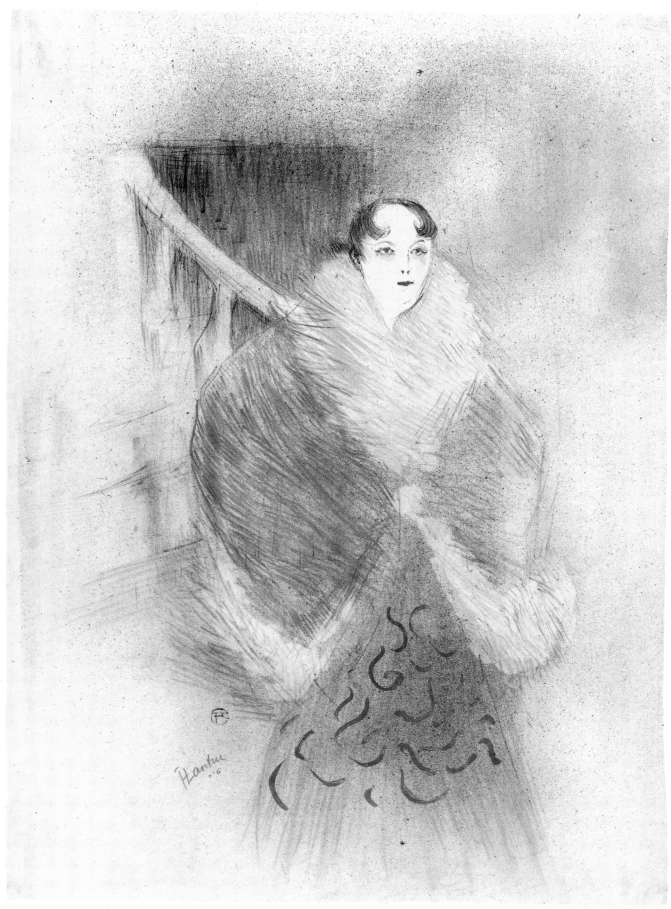

206·II

206 L'EPERVIER 1897
The Sparrow-Hawk

Lithograph, rejected as an illustration for
the book *Histoires Naturelles*.
First state. Without monogram 'EG'.
Drawing in dark olive green; chalk.
151 × 187 mm.
Monogram on the stone, left.
One impression mentioned by Delteil.
Delteil 322 I; Adhémar 267 I;
Adriani 350 I; Wittrock 226.
Second state. With the monogram not
designed by Lautrec, 'EG'.
183 × 183 mm.
Japan paper.
Four impressions known.
Delteil 322 II; Adhémar 267 II;
Adriani 350 II; Wittrock 226.

This lithograph, printed by Ancourt,
Paris, was also used as a menu card.
Certainly, a menu was written on an
impression dated 28 April 1897 (Marcel
Lecomte Collection, Paris, see catalogue
Henri de Toulouse-Lautrec, Ingelheim 1968,
No. 179). The date shows that Lautrec
worked over a protracted period on
illustrations for the book *Histoires
Naturelles* by Jules Renard; see the
preliminary remarks to Nos. 321–343,
especially No. 329.

**207 INVITATION À UNE TASSE DE
LAIT 1897**
Invitation to a Glass of Milk

Lithograph, invitation card with text
written by Lautrec: '5 avenue Frochot/
Henri de Toulouse Lautrec sera très fatté
[sic] si vous voulez/bien accepter une tasse
de lait le samedi 15 Mai/vers 3 heures et
demie après midi'.
Drawing in black; chalk, pen and ink.
267 × 205 mm.
Monograms on the stone, upper left and
lower right.
Vellum, hand-made Japan paper.
Ten impressions known.
Delteil 326; Adhémar 227; Adriani 214;
Wittrock 183.

On 11 May 1897 Lautrec left his studio in
the Rue Tourlaque – leaving behind 87
works, which the new tenant, Dr Billard,
either burned or gave to his housekeeper
– and took an apartment with a small
studio and front garden at No. 15 in the
quiet Avenue Frochot, near the Place
Pigalle. He wrote to his mother: 'I've
been fooled again by the concierge of the
new place, but I have finally found, for
1,600 francs, *don't tell a soul*, an
extraordinary apartment. I hope to end
my days in peace there. There's a
country-sized kitchen, trees and nine
windows giving out on gardens. It's the
whole top floor of a little town house next
to Mlle Dihau's' (Goldschmidt-
Schimmel, No. 210). On this card the
artist, wearing boots and spurs and
dressed as a cowherd, formally requests
the honour of the recipient's company at
the 'official opening' of his new home on
15 May at three in the afternoon, for a
glass of milk; clearly the new address was
still too recent for him to remember it
accurately.

**208 LA DANSE AU MOULIN
ROUGE 1897**
Dancing at the Moulin Rouge

Colour lithograph.
Grey drawing with blue-grey, red,
yellow and green; chalk, ink with brush
and spraying technique, worked with the
scraper.
The dimensions vary between
415 × 345 mm and 510 × 355 mm.
Monogram on the stone, upper left.
China paper.
Edition of 20 numbered impressions, five
of which have a border left on all sides.
The impressions are signed by the artist in
pencil, lower left; they also have the
monogram stamp of the publisher Pellet
(Lugt 1190), lower right. In addition, two
trial proofs are known, as well as three
impressions bearing dedications to Pellet,
Stern and the collector Barincourt.
Delteil 208; Adhémar 258; Adriani 209 II;
Wittrock 181.
The trial proof illustrated here is signed in
pencil on the verso, upper right, and
printed on vellum paper (510 × 402 mm);
it is taken from the drawing stone in dark
violet, and also bears the inscription:
'remplir/bleu bon non la/jupe tenir le/
pelerine charger/et la balustrade', and by
another hand: 'epreuves d'essai';
monogram stamp of the publisher Pellet,
lower right.

Following the relatively successful sales of
four colour lithographs (Nos. 202–205),
in July 1897 Pellet published this print of a
painting executed five years previously,
Dortu P.428 (National Gallery, Prague),
having 20 impressions printed by
Ancourt, Paris. We see the Moulin Rouge
with Cha-u-Kao in the centre, dancing
with a woman friend – see the portrait
study Dortu D.3280 – with a rear view of
Jane Avril on the right, and the two
friends Gauzi and Conder at the edges.

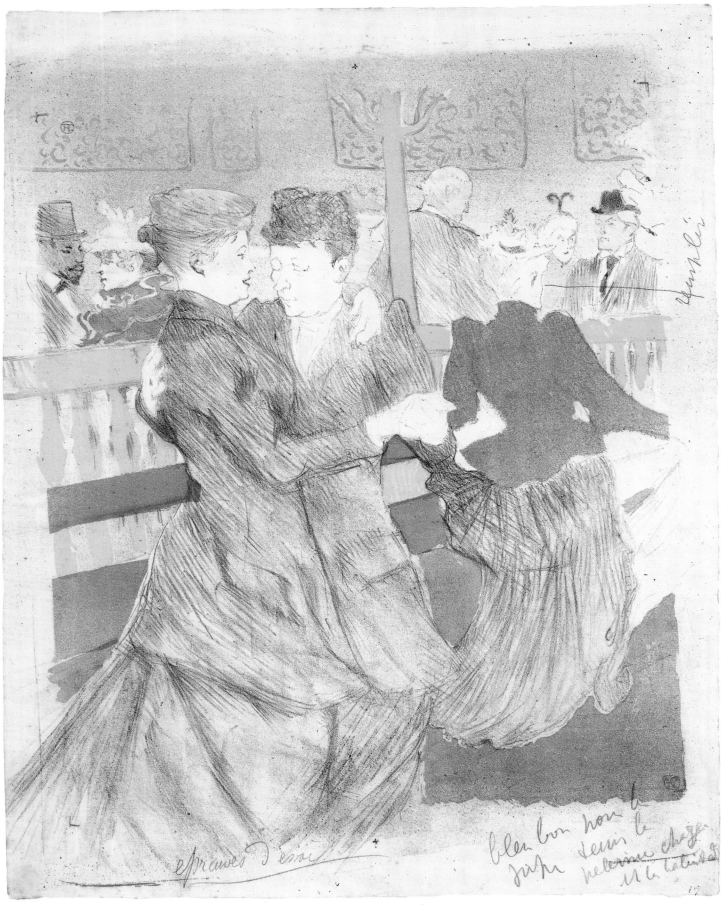

épreuves d'essai

208 Trial proof

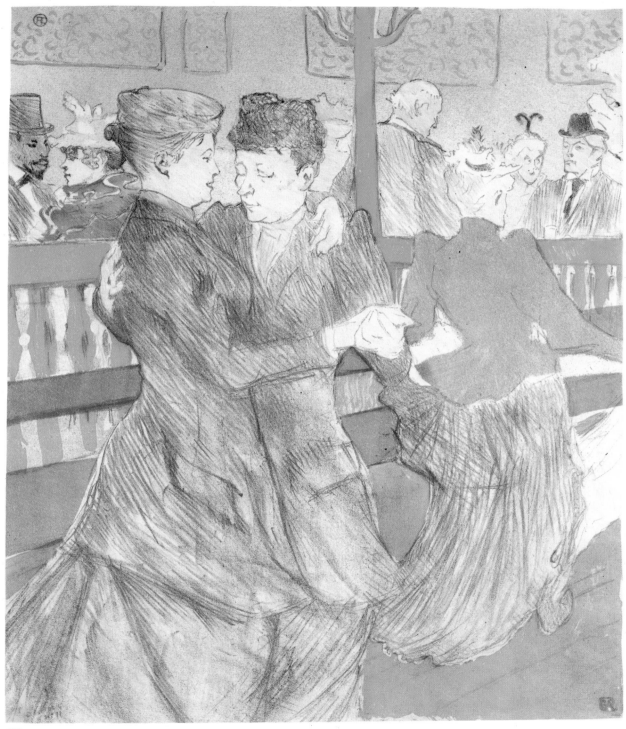

208

209 A LA SOURIS, MADAME
PALMYRE 1897
Madame Palmyre at La Souris

Lithograph.
First state.
Drawing in dark violet; chalk.
370 × 265 mm.
Monogram on the stone, lower left.
Grey-green hand-made paper.
One impression known (Bibliothèque
Nationale, Paris).
Delteil 210 I; Adhémar 252 I;
Adriani 210 I; Wittrock 184.
Second state. Image slightly reduced,
particularly in height.
358 × 252 mm.
China paper.
Edition of 25 impressions, some
numbered, some signed by the artist in
pencil or chalk, lower left; one impression
is also known dedicated 'à Stern' and
stamped with Pellet's name (illustrated).
Delteil 210 II; Adhémar 252 II;
Adriani 210 II; Wittrock 184.

While the subject of lesbian relationships
recurs frequently in Lautrec's paintings in
the context of brothel scenes after 1892, it
is particularly prominent in his prints of
1897, when he was a frequent visitor to
the Brasserie de la Souris at 29 Rue Henri
Monnier (formerly Rue Bréda). Madame
Palmyre – see the portrait sketches Dortu
D.4323 and D.4324 – ruled the
establishment and its fine women with a
rod of iron, with her bulldog Bouboule
and the assistance of Monsieur Brunswick
– see the portrait sketches Dortu D.4316
and D.4325; see also No. 310. 'Lautrec
would sit enthroned under the harsh light
of the electric lamps, surrounded by half a
dozen women with sagging skin and dyed
hair, dressed in loose, lurid-coloured
dresses or severe men's suits with stiff
collars. The evident dignity with which
Palmyre concerned herself with
everything and everyone amused Lautrec
. . . Almost always called "Monsieur
Henri", he was the darling of the house,
where Palmyre and her customers, most
of whom came for supper, lived like a
family' (Paul Leclerq [sic], *Henri de
Toulouse Lautrec*, Zurich 1958, p. 49).

210

210 MENU AU BULL DE PALMYRE 1897
Menu Card, Le Bull de Palmyre

Lithograph, menu card, with lettering not
by Lautrec: 'Menu'.
Drawing in dark violet; chalk, ink with
brush.
215 × 170 mm.
Monogram on the stone, left.
Vellum.
Six impressions known, one signed in
pencil, lower right, and dedicated 'à
Stern' (illustrated).
Delteil 211; Adhémar 253; Adriani 211;
Wittrock 186.

This menu card printed by Stern (the text
of the menu was added in handwriting)
was for a meal that may have taken place
at La Souris on 31 July 1897 (see No. 209).
It shows, among other things Madame
Palmyre's bulldog; see the colour study
on card and a small pencil sketch, Dortu
P.646 and D.4456 (both Musée d'Albi).

211

211 LE MARCHAND DE MARRONS 1897
The Roast-Chestnut Vendor

Lithograph.
Drawing in black; chalk, worked with the
scraper.
258 × 175 mm.
Monogram on the stone, lower left.
Grey China paper.
Edition of about 25 impressions, some
signed by the artist in pencil, lower left;
one dedicated 'à Stern' is also known
(Albertina, Vienna).
Delteil 335; Adhémar 254; Adriani 233;
Wittrock 232.
New edition (1925). 625 impressions; see
No. 142.

Since Madame Palmyre's bulldog also
appears in this scene, printed by Ancourt,
Paris (see Nos. 209, 210), Adhémar dates
the sheet to 1897 (see No. 218). This
dating is more convincing, for stylistic
reasons in particular, than Delteil's later
date of 1901. Adhémar also rightly
showed that the publisher Edmond Sagot
did not publish the lithograph, but merely
acquired 21 impressions of it in 1901.

212·II

212 LA PETITE LOGE 1897
The Little Box

Colour lithograph.
First state. Drawing of the hat incomplete.
Drawing in olive green with red, pink,
yellow and brown-grey; chalk, sprayed
ink.
270 × 360 mm.
Monogram on the stone, below.
Vellum.
Two impressions known.
Delteil 209 I; Adhémar 257 I;
Adriani 212 I; Wittrock 182 I.
Second state. Drawing in the hat
completed.
Drawing in black with red, pink, yellow
and grey-green.
240 × 320 mm.
China paper.
Edition of 12 impressions, some
numbered and signed by the artist in
pencil, lower left; some also have the
monogram stamp of the publisher Pellet
(Lugt 1190). One trial proof and one
impression dedicated 'à Pellet' are also
known (illustrated).
Delteil 209 II; Adhémar 257 II;
Adriani 212 II; Wittrock 182 II.

This colour lithograph, printed by
Ancourt, Paris, was published by Gustave
Pellet and offered for sale at 50 francs; see
the sketches Dortu D.4326 and D.4366.
Dortu believes that this shows a small box
at La Souris, a bar mainly frequented by
lesbians.

213·I

213–227 'Au Pied du Sinaï' 1897

Lautrec designed the cover and ten illustrations – printed by Chamerot et Renouard, 19 Rue des Saints-Pères – for Georges Clemenceau's book *Au Pied du Sinaï* (At the Foot of Sinaï). It was probably Clemenceau's secretary, Geffroy, who introduced Lautrec to Clemenceau, a medical doctor, art-lover, journalist and great French statesman. Although the publisher Henri Floury, a friend of André Marty, did not bring the book out until 20 April 1898, the drawings were probably finished by mid-1897 (see No. 220), as Lautrec wrote to Albi in the summer of 1897: 'I'm finishing a book with Clemenceau on the Jews' (Goldschmidt-Schimmel, No. 211).

The book appeared under the title: 'GEORGES CLEMENCEAU/AU PIED DU/SINAÏ/illustrations de Henri de/ Toulouse Lautrec/henri Floury,/1, Boulevard des Capucines/Paris'. It contains six chapters, each ending with a small vignette, which describe the life of the Jews in Poland. To get as close to reality as possible, Lautrec went to observe the Jews in the Tournelle quarter of Paris and based on them his illustrations, which are directly related to the text.

The first 25 impressions of this publication (380 impressions in all, numbered on the imprint page) were a de luxe edition, with a double cover, printed on imitation Japan paper or vellum; they include four complete series of the ten illustrations on heavy Japan paper (these are signed by the artist in pencil, lower left), Imperial Japan paper, China paper and vellum; and finally, they each contain a series of the four sheets that were not used in the book (Nos. 224–227), printed on heavy Japan paper. The remaining 355 copies of the book all contain two series of the ten lithographs, printed on China paper or vellum.

213 'Au Pied du Sinaï',
 Couverture 1897
 Cover for 'Au Pied du Sinaï'

Colour lithograph, cover for the book *Au Pied du Sinaï*.
First state. No lettering.
Drawing in black with yellow, violet and gold; chalk, ink with brush and spraying technique.
262 × 413 mm.
Monogram on the stone, lower right.
Beige vellum.
Two impressions known.
Delteil 235 I; Adhémar 240 (state not described); Adriani 217 I; Wittrock 188.
Second state. With lettering not designed by Lautrec, in black or grey-blue: 'G. Clemenceau/Au pied/du Sinaï/illustré/par H. de Toulouse-Lautrec/H. Floury, Editeur'.
Imitation Japan paper, vellum.
Edition of 405.
Delteil 235 II; Adhémar 240; Adriani 217 II; Wittrock 188.

A less successful title page (No. 224) was rejected in favour of this one, in a horizontal format which wraps right round the book. On the front it shows Moses receiving the Commandments, a lone figure merging dramatically with the silhouette of the mountain, in a remote, monumental style quite untypical of Lautrec. The back cover depicts the golden calf thrown from its pedestal, following the Old Testament story; see a sketch Dortu D.4392, in which Lautrec experiments with the placing of the lettering.

G. Clemenceau

Au pied du Sinaï

Au pied du Sinaï

illustré

par H. de Toulouse-Lautrec

H. Floury, Editeur

213·II

214

215

216

214 LE BARON MOÏSE, LA LOGE 1897
Baron Moïse, the Box

Lithograph, first sheet for *Au Pied du Sinaï*.
Drawing in blue-green, olive green, dark blue, black or brown; chalk, sprayed ink, worked with the scraper.
175 × 144 mm.
Monogram on the stone, upper right.
Heavy Japan paper, Imperial Japan paper, China paper, beige vellum, vellum.
Edition of 810 impressions, of which 25 are signed by the artist in black chalk, lower left, and printed in dark blue-green on heavy Japan paper, 25 in olive green on Imperial Japan, 25 in olive green, dark blue or black on China paper, 25 in grey-black on beige vellum, 355 in black, olive green or brown on China paper and 355 in black on vellum.
Delteil 236; Adhémar 241; Adriani 218; Wittrock 189.

215 LE BARON MOÏSE MENDIANT 1897
Baron Moïse Begging

Lithograph, second sheet for *Au Pied du Sinaï*.
Drawing in blue-green, brown-black, grey-green or black; chalk, sprayed ink, worked with the scraper.
175 × 142 mm.
Monogram on the stone, upper right.
Heavy Japan paper, Imperial Japan paper, China paper, beige vellum, vellum.
Edition of 810 impressions, of which 25 are signed by the artist in black chalk, lower left, and printed in dark blue-green on heavy Japan paper, 25 in brown-black on Imperial Japan, 25 in grey-green on China paper, 25 in grey-black on beige vellum, 355 in grey-green on China and 355 in black on vellum.
Delteil 237; Adhémar 246; Adriani 219; Wittrock 190.

216 ARRESTATION DE SCHLOMÉ FUSS 1897
Schlomé Fuss Being Arrested

Lithograph, third sheet for *Au Pied du Sinaï*.
Drawing in violet-brown, black, grey-green, green-black or dark grey; chalk, worked with the scraper.
173 × 140 mm.
Monogram on the stone, lower left.
Heavy Japan paper, Imperial Japan paper, China paper, vellum.
Edition of 810 impressions, of which 25 are signed by the artist in black chalk, lower left, and printed in violet-brown on heavy Japan paper, 25 in black on Imperial Japan paper, 25 in grey-green on China paper, 25 in green-black on vellum, 355 in grey-green on China paper and 355 in dark grey on vellum.
Delteil 238; Adhémar 248; Adriani 220; Wittrock 191.

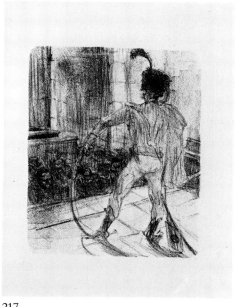

217

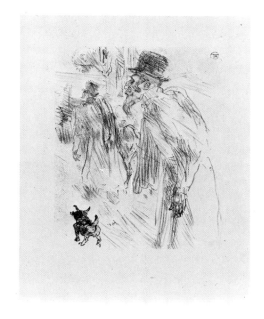

218

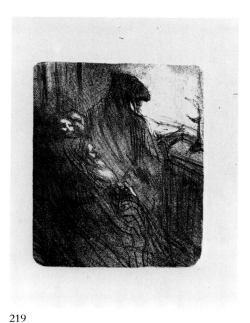

219

217 SCHLOMÉ FUSS À LA
 SYNAGOGUE 1897
 Schlomé Fuss in the Synagogue

Lithograph, fourth sheet for *Au Pied du
Sinaï*.
Drawing in black-green, dark brown,
blue-green, green-brown or black; chalk,
worked with the scraper.
180 × 142 mm.
Monogram on the stone, lower right.
Heavy Japan paper, Imperial Japan paper,
China paper, vellum.
Edition of 810 impressions, of which 25
are signed by the artist in black chalk,
lower left, and printed in black-green or
dark brown on heavy Japan paper, 25 in
blue-green on Imperial Japan paper, 25 in
dark brown or green-brown on China
paper, 25 in green-black on vellum, 355 in
dark brown on China paper and 355 in
black on vellum.
Delteil 239; Adhémar 244; Adriani 221;
Wittrock 192.

218 LES JUIFS POLONAIS,
 CARLSBAD 1897
 Polish Jews in Carlsbad

Lithograph, fifth sheet for *Au Pied du
Sinaï*.
Drawing in black, violet-brown, olive
green, dark brown or brown; chalk,
worked with the scraper.
175 × 140 mm.
Monogram on the stone, upper right.
Heavy Japan paper, Imperial Japan paper,
China paper, vellum.
Edition of 810 impressions, of which 25
are signed by the artist in black chalk,
lower left, and printed in black or violet-
brown on heavy Japan paper, 25 in olive
green on Imperial Japan paper, 25 in dark
brown or black on China paper, 25 in
black on vellum, 355 in black or brown
on China paper and 355 in black on
vellum.
Delteil 240; Adhémar 249; Adriani 222;
Wittrock 193.

219 LA PRIÈRE DES JUIFS
 POLONAIS 1897
 Polish Jews Praying

Lithograph, sixth sheet for *Au Pied du
Sinaï*.
Drawing in blue-green, grey-green, dark
brown, green-black or black; chalk,
sprayed ink, worked with the scraper.
176 × 142 mm.
Monogram on the stone, lower right.
Heavy Japan paper, Imperial Japan paper,
China paper, vellum.
Edition of 810 impressions, of which 25
are signed by the artist in black chalk,
lower left, and printed in blue-green or
grey-green on heavy Japan paper, 25 in
dark brown on Imperial Japan paper, 25
in green-black on China paper, 25 in
black on vellum, 355 in green-black on
China paper and 355 in black on vellum.
Delteil 241; Adhémar 242; Adriani 223;
Wittrock 194.

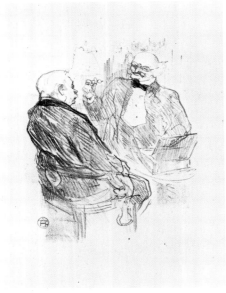

220

221

222

220 GEORGES CLEMENCEAU ET
 L'OCULISTE MAYER 1897
 *Georges Clemenceau and the Eye
 Specialist, Mayer*

Lithograph, seventh sheet for *Au Pied du
Sinaï*. Drawing in black, dark olive green
or violet-brown; chalk.
175 × 142 mm.
Monogram on the stone, lower left.
Heavy Japan paper, Imperial Japan paper,
China paper, vellum.
Edition of 810 impressions, of which 25
are signed by the artist in black chalk,
lower left, and printed in black or dark
olive green on heavy Japan paper, 25 in
olive green on Imperial Japan paper, 25 in
violet-brown on China paper, 25 in black
on vellum, 355 in violet-brown on China
paper and 355 in black on vellum. One
trial proof in black with untrimmed edges
(225 × 152 mm) is also known, signed by
the artist in pencil and inscribed: '1897
chez l'Opticien'. This impression also
bears the following dedication to
Clemenceau: 'pour le bon Poet de St.
Alary' (see auction catalogue *Moderne
Kunst des Neunzehnten und Zwanzigsten
Jahrhunderts*, Galerie Kornfeld, Berne,
22–24 June 1983, No. 881).
Delteil 242; Adhémar 247; Adriani 224;
Wittrock 195.

221 UNE ARRIÈRE-BOUTIQUE À
 CRACOVIE 1897
 A Basement Shop in Cracow

Lithograph, eighth sheet for *Au Pied du
Sinaï*.
Drawing in black, violet-brown, dark or
red-brown; chalk, worked with the
scraper.
173 × 143 mm.
Monogram on the stone, upper right.
Heavy Japan paper, Imperial Japan paper,
China paper, vellum.
Edition of 810 impressions, of which 25
are signed by the artist in black chalk,
lower left, and printed in black on heavy
Japan paper, 25 on Imperial Japan paper,
25 in violet-brown on China paper, 25 in
black on vellum, 355 in dark or red-
brown on China paper and 355 in black
on vellum.
Delteil 243; Adhémar 243; Adriani 225;
Wittrock 196.

222 LA HALLE AUX DRAPS,
 CRACOVIE 1897
 Textile Market in Cracow

Lithograph, ninth sheet for *Au Pied du
Sinaï*.
Drawing in blue-green, black, dark
brown or green-black; chalk, worked
with the scraper.
176 × 144 mm.
Monogram on the stone, upper left.
Heavy Japan paper, Imperial Japan paper,
China paper, vellum.
Edition of 810 impressions, of which 25
are signed by the artist in black chalk,
lower left, and printed in blue-green on
heavy Japan paper, 25 in black on
Imperial Japan, 25 in dark brown on
China paper, 25 in green-black or dark
brown on vellum, 355 in dark brown on
China paper and 355 in black on vellum.
Delteil 244; Adhémar 245; Adriani 226;
Wittrock 197.

223

224

223 CLEMENCEAU À BUSK 1897
Clemenceau in Busk

Lithograph, tenth sheet for *Au Pied du Sinaï*.
Drawing in dark grey, olive green, dark brown or green-black; chalk, worked with the scraper.
177 × 150 mm.
Monogram on the stone, lower left.
Heavy Japan paper, Imperial Japan paper, China paper, vellum.
Edition of 810 impressions, of which 25 are signed by the artist in black chalk, lower left, and printed in dark grey on heavy Japan paper, 25 in olive green on Imperial Japan paper, 25 in dark brown on China paper, 25 in green-black on vellum, 355 in dark brown on China paper and 355 in black-green on vellum.
Delteil 245; Adhémar 250; Adriani 227; Wittrock 198.

224 'AU PIED DU SINAÏ' 1897

Lithograph.
Drawing in black; chalk, sprayed ink, worked with the scraper.
262 × 416 mm.
Monogram on the stone, below.
Heavy Japan paper, imitation Japan paper.
Edition of 25; an impression dedicated 'à Stern' is also mentioned by Delteil.
Delteil 246; Adhémar 237; Adriani 228; Wittrock 187.

This design was rejected as the cover of the book *Au Pied du Sinaï*, and only 25 impressions were printed for the de luxe edition; see the figure sketch Dortu D.4428.

225

226

225 SCHLOMÉ FUSS À LA
 SYNAGOGUE 1897
 Schlomé Fuss in the Synagogue

Lithograph.
Drawing in black; chalk, sprayed ink.
175 × 144 mm.
Heavy Japan paper, China paper.
Edition of 25.
Delteil 247; Adhémar 238; Adriani 229;
Wittrock 199.

This illustration for the book *Au Pied du
Sinaï* was rejected, and only 25
impressions were printed for the de luxe
edition.

226 UN CIMETIÈRE EN GALICIE 1897
 A Cemetery in Galicia

Lithograph.
Drawing in black; chalk.
185 × 152 mm.
Monogram on the stone, lower left.
Heavy Japan paper, imitation Japan
paper.
Edition of 25.
Delteil 248; Adhémar 239; Adriani 230;
Wittrock 200.

This illustration for the book *Au Pied du
Sinaï* was rejected, and only 25
impressions were printed for the de luxe
edition.

227 LE CIMETIÈRE DE BUSK 1897
 Busk Cemetery

Lithograph.
Drawing in black; chalk, sprayed ink.
186 × 158 mm.
Heavy Japan paper, imitation Japan
paper.
Edition of 25 impressions; one (illustrated)
has a monogram by another hand.
Delteil 249; Adhémar does not include
this; Adriani 231; Wittrock 201.

This illustration for the book *Au Pied du
Sinaï* was rejected, and only 25
impressions were printed for the de luxe
edition.

227

228 PARTIE DE CAMPAGNE 1897
A Drive in the Country

Colour lithograph.
Drawing in black with yellow, red, blue,
grey-beige and olive green; chalk, ink
with brush and spraying technique.
400 × 520 mm.
Monogram on the stone, lower left.
Vellum.
Edition of 100 impressions, some
numbered, most with Lautrec's orange-
red monogram stamp (Lugt 1338); one
impression dedicated 'à Ancourt' and five
trial proofs are also known, from the
drawing stone and the colour stones, both
singly and together.
Delteil 219; Adhémar 322; Adriani 216 III;
Wittrock 228.

Lautrec's memories of a journey to
Holland with Maxime Dethomas or his
relaxing summer stay with the Natanson
family in Villeneuve-sur-Yonne may
have inspired this print of a drive in the
country, with its intense evocation of
movement within a horizontal format.
One hundred impressions were made by
the firm of Auguste Clot, where Degas,
Cézanne and Munch also had works
printed. The lithograph was included in
the second *Album d'Estampes Originales de
la Galerie Vollard*, published by the art-
dealer Ambroise Vollard in December
1897. Vollard says in his memoirs: 'I can
still see the small limping man with his
strange child-like gaze, saying to me: "I'll
do you a 'housewife'." But he then
produced this well-known sheet, still
regarded as one of his masterpieces. All
these sheets [by Renoir, Cézanne, Redon,
Bonnard, Vuillard, Munch and others],
the coloured and the black and white
ones, were for the "Peintres-Graveurs"
series, along with a few others. Two
portfolios, 100 of each, the first offered at
100 francs and the second and larger, at
150.' (Ambroise Vollard, *Erinnerungen
eines Kunsthändlers*, Berlin 1957, p. 112).

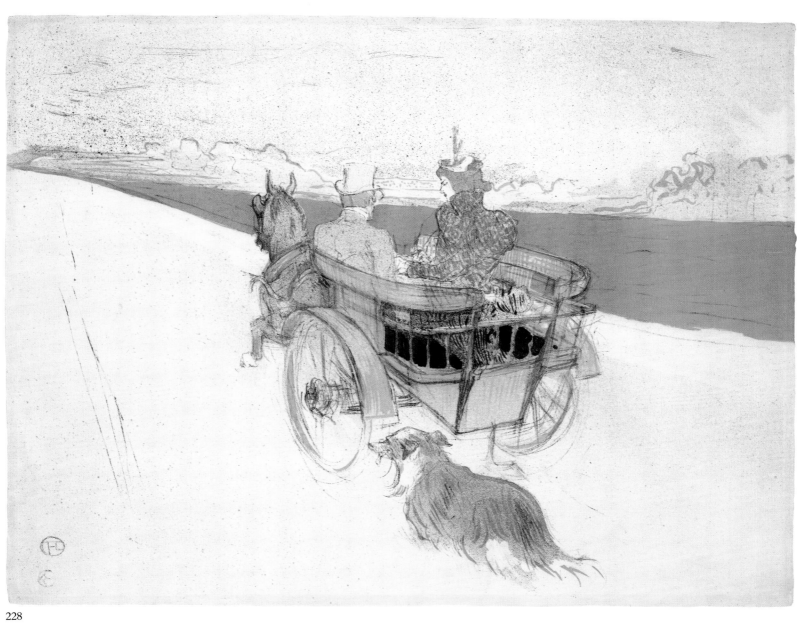

228

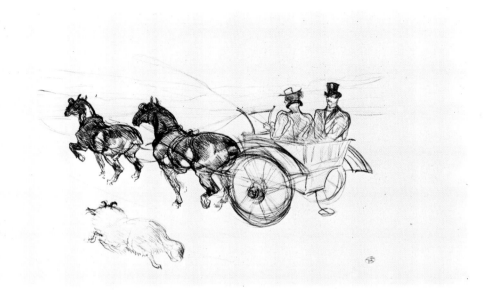

229

230

229 ATTELAGE EN TANDEM 1897
Double Harness

Lithograph.
Drawing in black; chalk.
264 × 412 mm.
Monogram on the stone, lower right.
Vellum.
Seven impressions known, one of which
is watercoloured and dedicated to the
printer Stern – Dortu A.254 (Art
Institute, Chicago).
Delteil 218; Adhémar 260; Adriani 215;
Wittrock 227.

This composition, which is similar to the
previous colour lithograph No. 228, is
based on the rapid pen and ink sketch
Dortu D.4372.

230 TILBURY 1897
The Tilbury Carriage

Lithograph.
Drawing in black; chalk.
258 × 242 mm.
Monogram on the stone, lower left.
Vellum.
Two impressions known.
Delteil 286; Adhémar 294; Adriani 235;
Wittrock 303.

The sheet was probably not made in 1898
or 1899, as Adhémar and Delteil assumed,
but in 1897, in connection with Nos. 228,
229 and 232.

231 COUVERTURE POUR 'LE FARDEAU DE LA LIBERTÉ' 1897
Cover for 'Le Fardeau de la Liberté'

Colour lithograph, book cover.
First state. No lettering.
Drawing in dark violet with yellow and grey-blue; chalk, ink with brush.
163 × 167 mm.
Monogram on the stone, lower left.
Imitation Japan paper.
Eight impressions known.
Delteil 214 I; Adhémar 236 I; Adriani 236 I; Wittrock 233.
Second state. The image transferred to a new stone with the following text not designed by Lautrec, in blue: 'Tristan Bernard/Le Fardeau de la Liberté/. . .'; the monogram is now inverted and placed rather higher than before.
Size of edition not known (several hundred).
Delteil 214 II; Adhémar 236 II; Adriani 236 II; Wittrock 233.

This print, which appeared in the *Edition de la Revue Blanche*, was used with lettering as the cover for Tristan Bernard's comedy *Le Fardeau de la Liberté* (The Burden of Freedom), published in 1897. In its unlettered state the lithograph was offered for sale at 5 francs in *La Revue Blanche*, 8, No. 102, on 1 September 1897.

231·I

232·I

232 COUVERTURE POUR 'LA TRIBU D'ISIDORE' 1897
Cover for 'La Tribu d'Isidore'

Lithograph, book cover.
First state. No lettering.
Drawing in violet-brown with beige tint stone; chalk.
210 × 150 mm.
Monogram on the stone, lower left.
Vellum, imitation Japan paper.
Edition of 50.
Delteil 215 (state not described); Adhémar 235 I; Adriani 234 I; Wittrock 234 I.
Second state. With text not designed by Lautrec, in blue: 'Victor Joze/La Tribu/ d'Isidore/roman/de/mœurs juives . . .' (with the address of the publisher Antony et Cie.).
Japan paper, vellum.
Edition of 30, of which 10 are on Japan paper and 20 on vellum.
Delteil 215 (state not described); Adhémar 235 (state not described); Adriani 234 (state not described); Wittrock 234 I.
Third state. No lettering; the two studies of heads above the coachman have been moved further to the right.
180 × 141 mm.
Vellum.
Edition of 50.
Delteil 215 I; Adhémar 235 (state not described); Adriani 234 (state not described); Wittrock 234 II.
Fourth state. The image transferred to a larger stone with the text from the second state added to the sheet in blue in four blocks.
188 × 120 mm.
Size of edition not known (several hundred).
Delteil 215 II; Adhémar 235 II; Adriani 234 II; Wittrock 234 II.

The magazine *La Critique* reproduced this picture on 5 November 1897 without the text. It was used with the text as the cover for Victor Joze's novel *La Tribu d'Isidore* (The Tribe of Isidore), which was published in 1897.

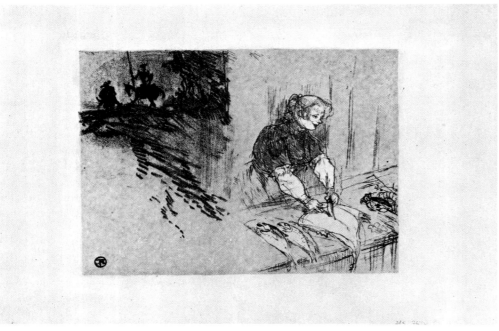

233·I

233 COUVERTURE POUR 'LES COURTES JOIES' 1897
Cover for 'Les Courtes Joies'

Lithograph, book cover.
First state. No lettering.
Drawing in olive green or black, with olive green or red-beige tint stone; chalk. 180 × 245 mm.
Monogram on the stone, lower left.
Imitation Japan paper.
Three impressions known.
Delteil 216 I; Adhémar 228 I; Adriani 237 I; Wittrock 236.
Second state. With text not designed by Lautrec, in red: 'Julien Sermet/Les Courtes/Joies/Poésies . . .' (with the address of the publisher Joubert etc.). Drawing in black with red-beige tint stone.
Vellum.
Size of edition not known (several hundred).
Delteil 216 II; Adhémar 228 II; Adriani 237 II; Wittrock 236.
New edition (1925). Without lettering, in black with brown-beige tint stone.

This depiction, with the figure Don Quixote in the style of Daumier in the background, was used with text as the cover for a volume of Julien Sermet's poetry (Brief Joys); the art critic Gustave Geffroy wrote a foreword for the book, which was published by Joubert in 1897.

234 'LE GAGE' 1897

Lithograph, programme.
First state. No lettering, with cuff-link, left.
Drawing in black or dark violet; chalk. 293 × 240 mm.
Monogram on the stone, below.
China paper, vellum.
Nine impressions known; one proof dedicated 'à Stern' and one with the note 'bon à tirer' are also known.
Delteil 212 I; Adhémar 264 I; Adriani 239 I; Wittrock 237.
Second state. Cuff-link on the left removed. The image transferred to a new stone and with the following text not designed by Lautrec: L'ŒUVRE/. . ./ SAISON 1897–1898/. . ./ ROSMERSHOLM LE GAGE/. . .' (with the address of the printer etc.).
Drawing in black.
Vellum.
Size of edition not known (several hundred).
Delteil 212 II; Adhémar 264 II; Adriani 239 II; Wittrock 237.

The lithograph, printed by the Grande Imprimerie Centrale, Paris, was used with text as a leaflet advertising Ibsen's *Rosmersholm*, which was performed in Count Prozor's translation at the Théâtre de L'Œuvre during the 1897/1898 season, and Frantz Jourdain's comedy *Le Gage* (The Guarantee). Jourdain was president of the Salon d'Automne, and he can be seen in the centre of the picture with Prozor.

MᵉᶜCᶦᵐᶦᵗᵉˡⁱⁿ 242 Conversation on Idea

234·I

235·I

235 HOMMAGE À MOLIÈRE 1897
Homage to Molière

Lithograph, programme.
First state. No lettering.
Drawing in olive green or black; chalk.
223 × 197 mm.
Monogram on the stone, right.
Imitation Japan paper, Japan paper.
Vellum.
Five impressions known.
Delteil 220 I; Adhémar 272 I;
Adriani 240 I; Wittrock 231.
Second state. The image transferred to a
new stone with the following text, not
designed by Lautrec, added in blue:
'Théâtre Antoine/. . ./LE BIEN
D'AUTRUI/. . ./HORS DES LOIS/. . .'
(with the address of the printer).
Drawing in olive green.
Size of edition not known (several
hundred).
Delteil 220 II; Adhémar 272 II;
Adriani 240 II; Wittrock 231.
Third state. The image transferred to a
new stone and with the following text,
not designed by Lautrec, added in blue:
'HORS les LOIS/Comédie/en un acte, en
vers/par Louis MARSOLLEAU et
ARTHUR BYL . . .'.
Drawing in grey-green.
187 × 200 mm.
Vellum.
Size of edition not known.
Delteil 220 III; Adhémar 272 III;
Adriani 240 III; Wittrock 231.

Two comedies intended as a homage to
Molière – *Le Bien d'Autrui* (The Good of
Others) and *Hors les Lois* (Outside the
Law) – were performed for the first time
on 5 November 1897. Lautrec designed
the programme for the actor André
Antoine, who changed the name of the
Théâtre Libre to the Théâtre Antoine in
1897, and it was printed by Eugène
Verneau, Paris (second state). In its third
state the lithograph was only used as the
title page for the comedy *Hors les Lois* by
Louis Marsolleau and Arthur Byl, Paris
1898.

236

237

236 A LA MAISON D'OR 1897
At the Maison d'Or

Lithograph.
Drawing in dark olive green or violet-
black; chalk.
137 × 160 mm.
Monogram on the stone, lower right.
Vellum.
Twelve impressions known, some
numbered, some with Lautrec's red
monogram stamp (Lugt 1338), lower
right, and the blind stamp of the publisher
Kleinmann (Lugt 1573), lower left; one
impression signed and on Japan paper is
also known.
Delteil 222; Adhémar 270; Adriani 242;
Wittrock 229.
The impression illustrated here is
inscribed by Kleinmann, lower left:
'Illustration pour une/Nouvelle non
publiée'.

237 LE PREMIER VENDEUR DE JOURDAN ET BROWN 1897
The Head Salesman at Jourdan et Brown

Lithograph.
Drawing in dark olive green or black;
chalk.
159 × 113 mm.
Monogram on the stone, lower right.
Vellum.
Eleven impressions known, some
numbered, some with Lautrec's red
monogram stamp (Lugt 1338), lower left,
and the blind stamp of the publisher
Kleinmann (Lugt 1573); one signed
impression on hand-made Japan paper is
also known.
Delteil 223; Adhémar 269; Adriani 243;
Wittrock 230.
The impression shown here is inscribed
by Kleinmann, lower left: 'non publié'.

Jourdan et Brown were a leading firm of
tailors in Paris in the eighteen-nineties.

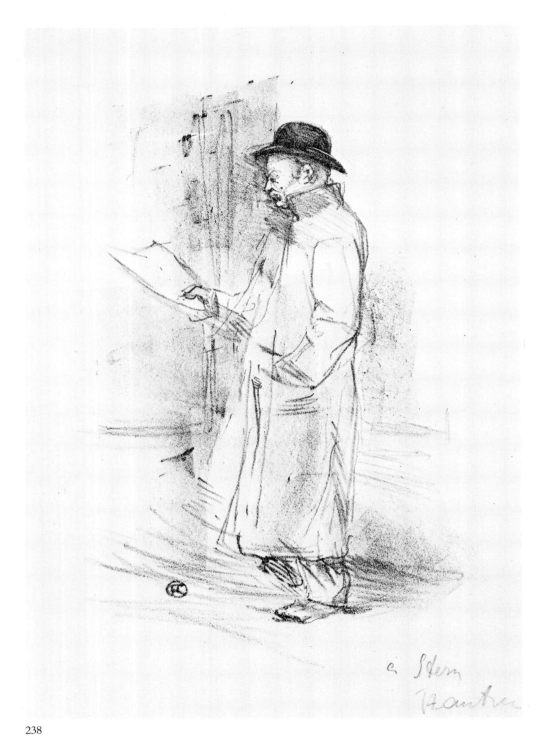

238 Program du Bénéfice
Gémier 1897
Programme for Gémier's Benefit Night

Lithograph, programme.
Drawing in black; chalk.
307 × 217 mm.
Monogram on the stone, lower left.
Grey vellum.
Edition of about 15; one impression
dedicated 'à Stern' is also known
(illustrated).
Delteil 221 I; Adhémar 268 I;
Adriani 241 I; Wittrock 235.

The lithograph was printed by Eugène
Verneau, Paris, and reproduced with the
addition of the text 'dessin de Toulouse-
Lautrec' (304 × 211 mm) on the occasion
of a benefit performance held for the
actor Firmin Gémier at the Théâtre
Antoine on 23 December 1897 (see
No. 41); see also the portrait study Dortu
D.4344.

239 Le Compliment du Jour de
l'An 1897
New Year's Greeting

Lithograph, New Year's card with text
written by Lautrec: 'Le jour de l'an/c'est
le moment/l'enfant tendre et sincère/(fair
connu) [?]'.
Drawing in black; chalk.
250 × 220 mm.
Monogram on the stone, upper right.
Vellum.
Ten impressions known, two of which
are dedicated 'à L.Deschamps. 1897/1898'
(Public Library, Boston) and 'à Stern
1897' (illustrated).
Delteil 217; Adhémar 271; Adriani 244;
Wittrock 238.

This New Year's card, printed by
Ancourt, Paris, appeared at the end of
1897 with the self-portrait, lower left; it
shows Gabriel Tapié de Céleyran offering
his compliments of the season, and was
also used as a visiting card.

238

Le jour do l'au
c'est le moment
l'enfant tendre et sincère
(air connu).

à Herm
Hauter
1897.

Lithograph.
Drawing in grey-black; chalk.
350 × 248 mm.
Monogram on the stone, lower left.
Vellum.
One impression known signed by the
artist in pencil, lower left (illustrated).
Delteil 227; Adhémar 58; Adriani 282;
Wittrock 248.
On the verso the sheet has the address,
written in another hand: 'Mr Leclerq 49
av des Ch. Elysee . . .'.
New edition (1930). 75 numbered
impressions, published in the de luxe
edition of the book *Dessins de Maîtres
Français, Tome IX, Henri de Toulouse-
Lautrec*, Helleu et Sargent, Paris, 1930.

Recalling her appearances at the
Ambassadeurs, the Folies Bergère, the
Eldorado and the Scala, this print shows
Emilie Marie Bouchard, known as Polaire
(born 1879), a full-figure portrait of
whom, Dortu D.3768 (Art Institute,
Chicago), had already been published on
23 February 1895 in No. 16 of *Le Rire*.

 'Toulouse-Lautrec and I often went to
the Scala on the Boulevard de Strasbourg,
where La Polaire was singing', as Leclerq
recalled. 'That tiny Egyptian statue come
to life, who could have worn a bracelet as
a belt, drew our interest. And although
neither he nor I had any closer
acquaintance with her, Toulouse-Lautrec
made a lithograph of the delicate singer –
from memory, for she never posed for
him. He gave it to me a few weeks later
for a song I had written, and which she
then sang throughout America. One
evening La Polaire called me to her box.
After I had been introduced to her I
confessed that I owned a portrait of her by
a great artist, the most like of all that had
ever been made. Polaire wanted to see this
mysterious work at once, and asked me to
join her in her carriage after the show. We
drove to my apartment in the Champs
Elysées . . . Impossible to describe her
surprise. And she retained an admiration
for Toulouse-Lautrec, whom I
introduced to her a short time later,
which was probably greater than that of
any other artiste whom he immortalized'
(Paul Leclerq [sic], *Henri de Toulouse-
Lautrec*, Zurich 1958, pp. 26f.).

 In a letter probably written in the
middle of January 1898 to the London
publisher W. H. B. Sands, Lautrec
mentions the portrait of Polaire
(Schimmel-Cate, p. 42; see also the letters
pp. 44 and 86, and Goldschmidt-
Schimmel, No. 200). A reproduction also
appeared in the journal *The Paris
Magazine*, I, No. 1, which was also
published by Sands, in December 1898.
The litho stone is now in the Musée
d'Albi.

241 242 1911 edition

241 MON PREMIER ZINC 1898
 My First Zinc

Drypoint.
263 × 117 mm.
Monogram on the plate, inscribed centre
and below: 'bonjour/Monsieur/Robin/
1898/25 janvier 1898/mon premier zinc'.
Hand-made paper, vellum, Japan paper.
Seven impressions known, of which three
are in black and four in dark brown.
Delteil 1; Adhémar 274; Adriani 245;
Wittrock 239.

Unlike his paintings and drawings,
Lautrec's graphic output was again
astonishingly rich in 1898. In January and
February he began experimenting with
the technique of drypoint, which was
new to him. However, he produced only
nine rather stereotyped portrait sketches
on zinc (Nos. 241–249) – of which only a
small number of impressions were printed
by Eugène Delâtre – and then abandoned
the technique. His first attempt at
drawing with a steel needle on the thin
zinc plates, cut to size by an ironmonger
in the Rue des Martyrs, has a dedication to
the engineer Robin Langlois, Lautrec's
helpful neighbour on the Avenue
Frochot.

242 L'EXPLORATEUR JEAN-JOSEPH
 VICOMTE DE BRETTES (?) 1898
 *The Explorer Jean-Joseph Vicomte de
 Brettes (?)*

Drypoint.
170 × 87 mm.
Inscribed in the middle of the plate:
'Fanny'.
Delteil 2; Adhémar 279; Adriani 246;
Wittrock 241.
1911 edition. 15 in black on Japan paper,
with Lautrec's red monogram stamp
(Lugt 1338), lower left.
New edition (1926). 350 impressions, of
which 175 are on Japan paper in red-
brown and 175 in black.

Seven drypoints with portraits of
Lautrec's friends and acquaintances (Nos.
242–248) were printed in 1911 by Manzi
and Joyant (Goupil & Cie.) in 15 albums,
numbered on the imprint page
(390 × 238 mm) and published with the
following title: 'H. de Toulouse-Lautrec/
SEPT POINTES SÈCHES/GOUPIL &
CIE/Editeurs – Imprimeurs/MANZI,
JOYANT & Cie, Editeurs – Imprimeurs,
Successeurs/24, BOULEVARD DES
CAPUCINES, PARIS'.
 The 350 impressions of the new edition
were published in a de luxe edition (175

copies, each with one print in black and
one in red-brown) of the biography of
Lautrec by Maurice Joyant, *Henri de
Toulouse-Lautrec 1864–1901. Peintre*, Paris
1926, published by Henri Floury (with
Nos. 243 and 244). Joyant's second
volume, *Henri de Toulouse-Lautrec
1864–1901. Dessins, Estampes, Affiches*,
Paris 1927, contained the 400 impressions
of Nos. 245, 246 and 248.
 This may be a portrait of the explorer
Viscomte de Brettes, a geologist who had
explored the Gran Chaco in South
America. He was a distant acquaintance of
Lautrec, who admired him for his
adventurous life.

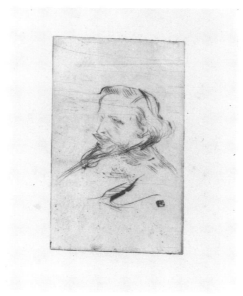

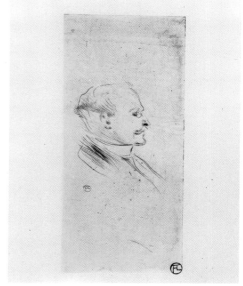

243 1911 edition

244

245 1911 edition

243 CHARLES MAURIN 1898

Drypoint.
170 × 96 mm.
Monogram on the plate, upper right.
Delteil mentions impressions.
Delteil 3; Adhémar 280; Adriani 247;
Wittrock 242.
1911 edition. 15 impressions printed in
black on Japan paper, with Lautrec's red
monogram stamp (Lugt 1338), lower
right.
New edition (1926). 350 impressions, of
which 175 are printed in red-brown on
Japan paper and 175 in black.

Charles Maurin (1856–1914) was a
painter and engraver, and he may well
have urged Lautrec to attempt these
drypoints (Nos. 241–249). He had been
one of Lautrec's closest companions for
many years, not only on account of his
enormous consumption of rum, but also
because of his knowledge of graphics,
which he pursued with a scholarly and
scientific persistence. See No. 242.

244 FRANCIS JOURDAIN 1898

Drypoint.
170 × 102 mm.
Monogram on the plate, upper right.
Beige hand-made paper.
One impression in black known
(illustrated); Delteil mentions two further
impressions.
Delteil 4; Adhémar 275; Adriani 248;
Wittrock 243.
1911 and 1926 editions. See No. 243.

The artist Francis Jourdain (1876–1958),
son of the Belgian architect and writer
Frantz Jourdain, recalled that Lautrec
asked him 'a few days after he had
finished the portrait of Charles Maurin
(No. 243) to come to the Avenue Frochot
on Sunday morning and sit for him.
While we were chatting he worked on a
little zinc plate which he had acquired
from an ironmonger, and which he then
gave me. Three impressions were made
by Eugène Delâtre. Lautrec was not
satisfied with the image and did not keep
any of them' (Delteil, No. 4).

245 W. H. B. SANDS, EDITEUR À
 EDIMBOURG 1898
 *W. H. B. Sands, the Edinburgh
 Publisher*

Drypoint.
260 × 118 mm.
Monogram on the rather dirty plate, left.
Hand-made paper.
One proof dedicated 'à Spoke' is known
(Bibliothèque d'Art Jacques Doucet,
Paris).
Delteil 5; Adhémar 277; Adriani 249;
Wittrock 247.
1911 edition. Spots removed; 15
impressions in black on Japan paper, with
Lautrec's red monogram stamp (Lugt
1338), lower right.
New edition (1927). 400 impressions, of
which 200 are in red-brown on Japan
paper and 200 in black.

Since 6 July 1896 Lautrec had been
corresponding with the Edinburgh
publisher W. H. B. Sands, whom he had
probably met in London in June 1896
through Louis Bouglé. Their letters spoke
of plans for a book (see Schimmel-Cate,
p. 39), and in 1898 Sands published an
Yvette Guilbert portfolio (Nos. 250–258)
and commissioned more lithographs from
Lautrec (Nos. 260–272); see No. 242.

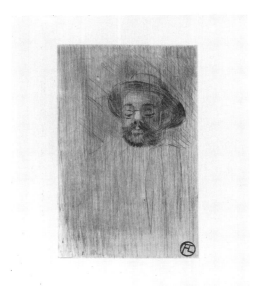

246 1911 edition

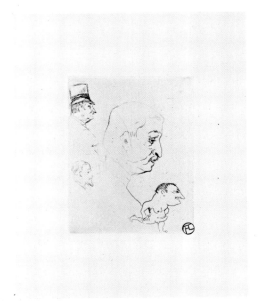

247 1911 edition

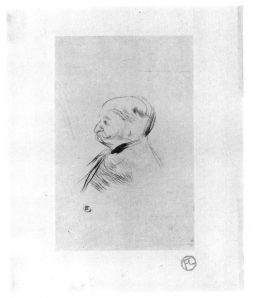

248 1911 edition

246 HENRY SOMM 1898

Drypoint.
170 × 108 mm.
Delteil 6; Adhémar 281; Adriani 250;
Wittrock 244.
1911 and 1927 editions. See No. 245.

François-Clément Sommier, alias Henry
Somm (1844–1907), worked in Paris as an
illustrator and commercial artist.

247 LE LUTTEUR VILLE (?) 1898
 The Wrestler Ville (?)

Drypoint.
158 × 121 mm.
Delteil 7; Adhémar 278; Adriani 251;
Wittrock 245.
1911 edition. See No. 243.

The only portrait that can possibly be
identified on this sheet is that of the
wrestler Ville, lower right, whose profile
had already been drawn in 1896 on a sheet
of sketches not listed by Dortu (Adriani,
Ill. p. 190).

248 PORTRAIT DE MONSIEUR X 1898
 Portrait of Mister X

Drypoint.
170 × 105 mm.
Monogram on the plate, lower left.
Delteil 8; Adhémar 276; Adriani 252;
Wittrock 246.
1911 and 1927 editions. See No. 245.

This may be a portrait of Arthur Meyer,
editor of the newspaper *Le Gaulois*.

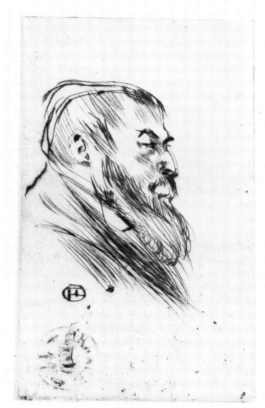

249 TRISTAN BERNARD 1898

Drypoint.
168 × 100 mm.
Monogram on the plate, lower left.
Hand-made paper.
Two impressions known, one bearing a
dedication 'à Spoke' and printed in black
(Bibliothèque d'Art Jacques Doucet,
Paris).
Delteil 9; Adhémar 282; Adriani 253;
Wittrock 240).
First edition (1920). 25 impressions in
black, red-brown, dark brown or olive
green on hand-made paper, one bearing
the dedication 'A Monsieur Loys Delteil/
très amical souvenir/Tristan Bernard'
(illustrated).
Second edition (1920). 445 impressions in
black or brown, of which 65 are on Japan
paper and 380 on vellum.
Third edition (1920). 200 on hand-made
paper for the de luxe edition of Théodore
Duret's *Lautrec*, Paris 1920, published by
Bernheim-Jeune.

The writer Tristan Bernard had given
Lautrec this zinc plate. Bernard later
offered it to Loys Delteil, to enable him to
make a new edition of 445 impressions for
his catalogue *Le Peintre-Graveur Illustré
X–XI, H. de Toulouse-Lautrec*, Paris 1920.

249 1920 edition

250–258 ALBUM 'YVETTE
GUILBERT' 1898
'Yvette Guilbert' Album

In March 1898 Lautrec was working on a
second portfolio of nine depictions of
Yvette Guilbert. It was to be published to
mark the London appearance in May of
the *diseuse*, who was now internationally
famous, and it became known as the *Série
Anglaise*; however, as Yvette informed
Lautrec on 6 May 1898, the engagement
had to be cancelled at short notice and
postponed until the following year
(Schimmel–Cate, p. 78). Nevertheless, the
London publishers Bliss and Sands
decided to go ahead with the portfolio,
and Lautrec's lithographs were published
with a text by Arthur Byl in a large
edition of 350, numbered on the imprint
page, which reads: 'Yvette Guilbert/
DRAWN BY/H. DE TOULOUSE-
LAUTREC/DESCRIBED BY/
ARTHUR BYL/TRANSLATED BY A.
TEXEIRA DE MATTOS/LONDON/
BLISS, SANDS & CO.
MDCCCXCVIII'.

The correspondence between Sands
and Lautrec, only recently published,
enables us to trace the evolution of the
portfolio. On 28 February 1898 Sands
asked Lautrec for drawings of Guilbert:
'. . . however, could you give me six
drawings of Yvette G. immediately, that
is, in two or three weeks. I think that
these drawings will be in great demand at
the beginning of May when she is here.
This would be something for both of us,
and also a little publicity – all the better –
for you, because . . . fashionable society
. . . will see them'. Clearly Lautrec agreed,
for he sent trial proofs to London
straightaway. 'You should have received
one more Yvette. That makes six. I will
do two more, as you request . . .; I will
have the stones for Yvette sent to you
tomorrow morning, Monday', as Lautrec
wrote on 20 March; and on 22 of the
month he wrote to Sands: 'Today I am
sending you Byl's text, and you must
have received the six stones. I have done
another one.' However, it was not until
1 April that the eight stones intended for
the portfolio were despatched to London,
with a bill from the printer Henri Stern,
who charged five francs a stone for
preparing the stones and the trial proofs
(Schimmel–Cate, pp. 45, 57, 59 and 64f.).

Finally, the title page and eight full-
page drawings of well-known numbers
from Yvette's repertoire were published
in a cardboard cover, printed in black on a
beige-tinted ground. While the portraits
were being pulled from the stones in
London, Lautrec wrote on 16 and 24
April that he and Yvette would write
their signatures for the cover and title
page on transfer paper, so that they could
easily be transferred to the appropriate
stones in London (Schimmel–Cate,
pp. 73f.). What distinguishes this series,
published at the end of April 1898, from
the series which had appeared four years
earlier (see Nos. 73–89), is the close-up
view adopted by Lautrec, which
concentrates on the face, taking far less
notice of the general scene; indeed, the
singer is hardly ever shown full-length.
Unlike his earlier use of the graphic
medium, with its bravura delight in
delicately sprayed detail, here the artist
relies on the interplay of the sweeping
chalk strokes and broad shading to
convey deep psychological penetration.

The litho stones for all nine illustrations
are now in the Musée d'Albi (see *Cat.
Toulouse-Lautrec*, Nos. P 12–20); they
were donated by the art-dealers Ernest
Brown & Phillips, Ltd, the Leicester
Galleries of London, who in 1930
published a new edition of the portfolio
printed by the Westminster Press,
London (82 copies, 75 of which were
signed and numbered by Yvette
Guilbert). The edition was published
under the title: 'Yvette Guilbert/A Series
of Nine Lithographs by H. de Toulouse-
Lautrec with a critical essay by Maurice
Joyant and a Reminiscence of Lautrec by
Mme Yvette Guilbert'. The Gerstenberg
Collection holds both the impression with
a dedication (first state) and one from the
edition.

250 FRONTISPICE POUR 'YVETTE
GUILBERT' 1898
*Frontispiece for the 'Yvette Guilbert'
Album*

Transfer lithograph, title page for the
Yvette Guilbert series.
Drawing in black; chalk, ink with brush.
295 × 245 mm.
Monogram on the stone, lower left;
signed by Yvette Guilbert and Lautrec,
upper left and lower right.
Hand-made paper.
Edition of 350.
Delteil 251; Adhémar 307; Adriani 256;
Wittrock 271.
New edition (1930). Without signatures.
Drawing in violet; chalk.
Imitation Japan paper.
82 impressions, with Lautrec's red
monogram stamp (Lugt 1338), lower left,
and the blind stamp of the Leicester
Galleries, London.

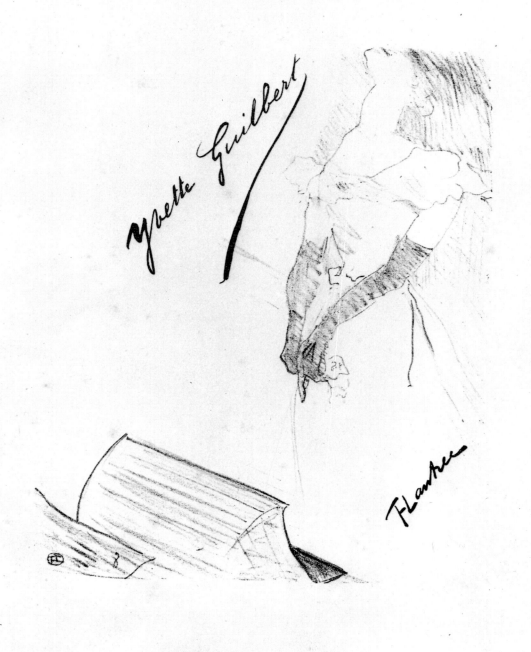

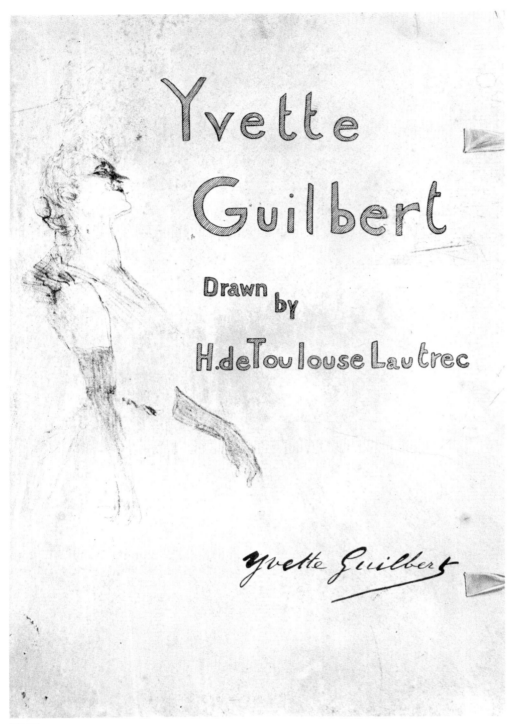

251·III

251 Yvette Guilbert, sur la Scène –
'Yvette Guilbert',
Couverture 1898
*Yvette Guilbert on Stage – Cover for
the 'Yvette Guilbert' Album*

Lithograph, cover and first sheet in the
Yvette Guilbert series.
First state. No tint stone.
Drawing in black; chalk, worked with the
scraper.
298 × 242 mm.
Monogram on the stone, upper left.
Vellum.
One impression dedicated 'à Stern'
known (illustrated).
Delteil 252 (state not described);
Adhémar 308 (state not described);
Adriani 257 I; Wittrock 272.
Second state. With beige tint stone.
Hand-made paper.
Edition of 350.
Delteil 252; Adhémar 308; Adriani 257 II;
Wittrock 272.
New edition (1930). Drawing in red-
brown, see No. 250.
Third state. No tint stone; the image
transferred to a new stone and now
showing only the figure of the singer;
used in this form as the cover for the
portfolio, with lettering not designed by
Lautrec: 'Yvette/Guilbert/Drawn/by/H.
de Toulouse Lautrec', with Yvette
Guilbert's signature.
227 × 165 mm.
Blue-grey hand-made paper.
Edition of 350.
Delteil 250; Adhémar 306; Adriani 255;
Wittrock 272.

a steps
Lautrec

252 YVETTE GUILBERT, 'DANS LA
 GLU' 1898

Lithograph, second sheet in the *Yvette Guilbert* series.
First state. No tint stone.
Drawing in black; chalk, worked with the scraper.
293 × 241 mm.
Monogram on the stone, upper left.
Vellum.
One impression dedicated 'à Stern' also known (illustrated).
Delteil 253 (state not described);
Adhémar 309 (state not described);
Adriani 258 I; Wittrock 273.
Second state. With beige tint stone.
Hand-made paper.
Edition of 350.
Delteil 253; Adhémar 309; Adriani 258 II; Wittrock 273.
New edition (1930). Drawing in red-brown, see No. 250.

The song *Dans la Glu* (Fallen for it) was based on a ballad by Jean Richepin.

253 YVETTE GUILBERT, 'PESSIMA' 1898

Lithograph, third sheet in the *Yvette Guilbert* series.
First state. No tint stone.
Drawing in black; chalk.
277 × 238 mm.
Monogram on the stone, lower left.
Vellum.
One impression dedicated 'à Stern' also known (illustrated).
Delteil 254 (state not described);
Adhémar 310 (state not described);
Adriani 259 I; Wittrock 274.
Second state. With beige tint stone.
Hand-made paper.
Edition of 350.
Delteil 254; Adhémar 310; Adriani 259 II; Wittrock 274.
New edition (1930). See No. 250.

Lautrec wrote to the publisher W. H. B. Sands in London on 8 March 1898: 'I am sending you two drawings of Yvette Guilbert in *Pessima* – and in the role of the *old grandmother* [No. 255]' (Schimmel-Cate, p. 51).

254 YVETTE GUILBERT, 'A
 MÉNILMONTANT', DE
 BRUANT 1898
 *Yvette Guilbert, 'A Ménilmontant',
 by Bruant*

Lithograph, fourth sheet in the *Yvette Guilbert* series.
First state. No tint stone.
Drawing in black; chalk.
294 × 240 mm.
Monogram on the stone, upper left.
Vellum.
One impression dedicated 'à Stern' also known (illustrated).
Delteil 255 (state not described);
Adhémar 311 (state not described);
Adriani 260 I; Wittrock 275.
Second state. With beige tint plate.
Hand-made paper.
Edition of 350.
Delteil 255; Adhémar 311; Adriani 260 II; Wittrock 275.
New edition (1930). Drawing in red-brown, see No. 250.
New edition (1964). Published by the Société des Amis du Musée Toulouse-Lautrec, Albi, to mark the artist's hundredth birthday.
Drawing in black.
295 × 235 mm.
Vellum.
250 impressions.

Yvette Guilbert is shown here singing a song by Aristide Bruant.

idem
Lautrec

253·I

a Stern
Hautrec

254·I

255 YVETTE GUILBERT,
'CHANSON ANCIENNE' 1898

Lithograph, fifth sheet in the *Yvette Guilbert* series.
First state. No tint stone.
Drawing in black; chalk.
293 × 236 mm.
Monogram on the stone, lower right.
Vellum.
One impression dedicated 'à Stern' also known (illustrated).
Delteil 257 (state not described);
Adhémar 313 (state not described);
Adriani 261 I; Wittrock 276.
Second state. With beige tint stone.
Hand-made paper.
Edition of 350.
Delteil 257; Adhémar 313; Adriani 261 II; Wittrock 276.
New edition (1930). Drawing in green; see No. 250.

See also No. 259.

256 YVETTE GUILBERT,
'SOÛLARDE' 1898

Lithograph, sixth sheet in the *Yvette Guilbert* series.
First state. No tint stone.
Drawing in black; chalk.
289 × 210 mm.
Monogram on the stone, upper right.
Vellum.
One impression dedicated 'à Stern' also known (illustrated).
Delteil 258 (state not described);
Adhémar 314 (state not described);
Adriani 262 I; Wittrock 277.
Second state. With beige tint stone.
Hand-made paper.
Edition of 350.
Delteil 258; Adhémar 314; Adriani 262 II; Wittrock 277.
New edition (1930). Drawing in green; see No. 250.

The number *Soûlarde* (The Drinker) by Jules Jouy was one of Yvette Guilbert's most exciting interpretations.

257 YVETTE GUILBERT,
'LINGER, LONGER, LOO' 1898

Lithograph, seventh in the *Yvette Guilbert* series.
First state. No tint stone.
Drawing in black; chalk.
297 × 234 mm.
Monogram on the stone, lower right.
Vellum.
One impression dedicated 'à Stern' also known (illustrated).
Delteil 259 (state not described);
Adhémar 315 (state not described);
Adriani 263 I; Wittrock 278.
Second state. With beige tint stone.
Hand-made paper.
Edition of 350.
Delteil 259; Adhémar 315; Adriani 263 II; Wittrock 278.
New edition (1930). See No. 250.

Yvette Guilbert had already been portrayed singing *Linger, longer, loo* in a similar pose in *Le Rire*, No. 7, 22 December 1894, though there she was shown full-length; see Dortu P.522, A.215; see also the rapid portrait sketches Dortu D.3599 and D.3633–3635.

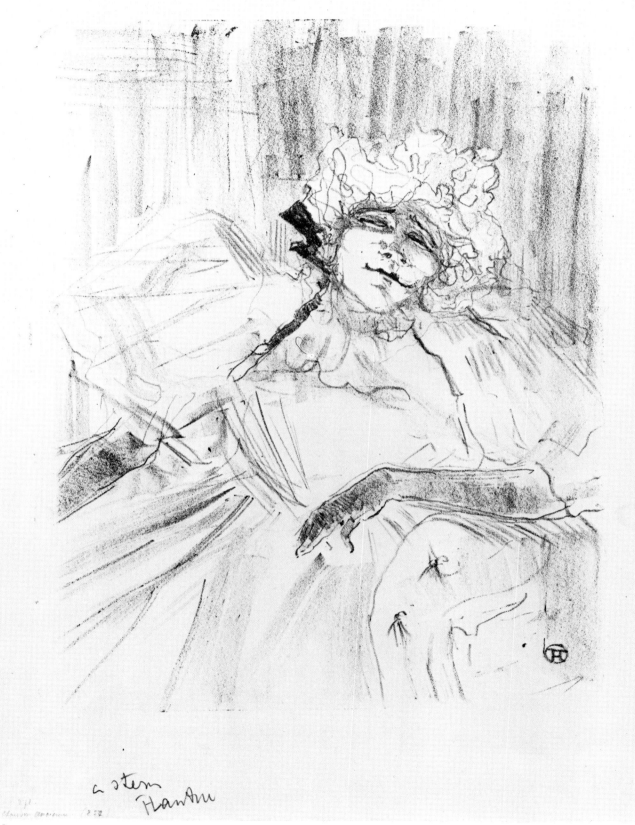

a stern
Hautru

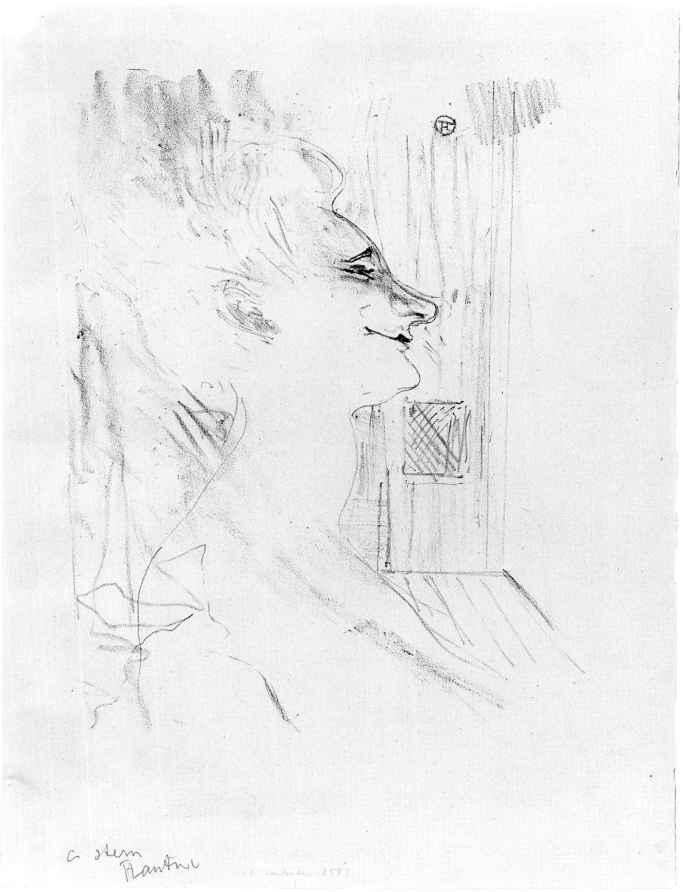

256·I

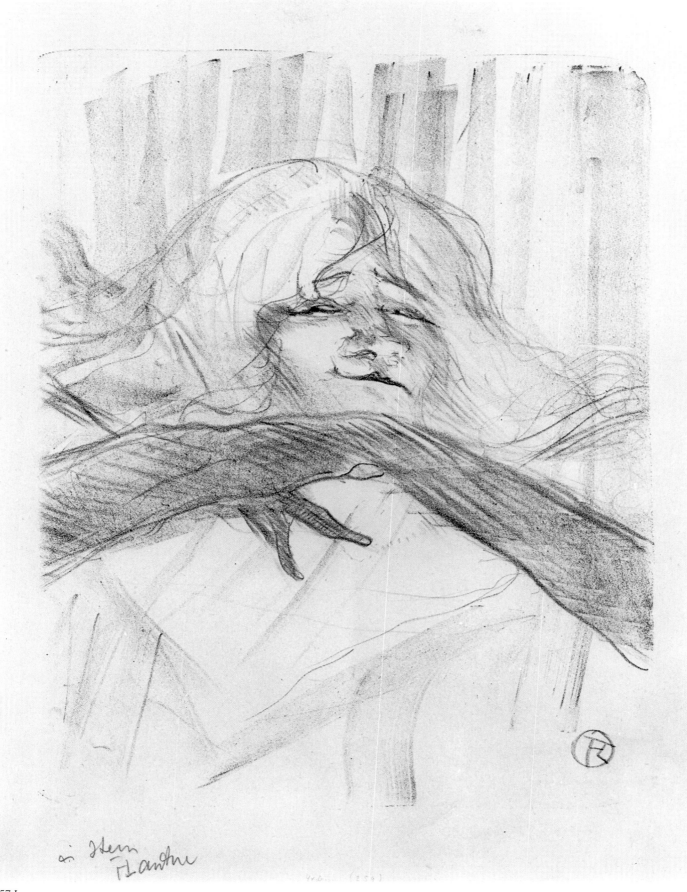

à Herr
FLanshu

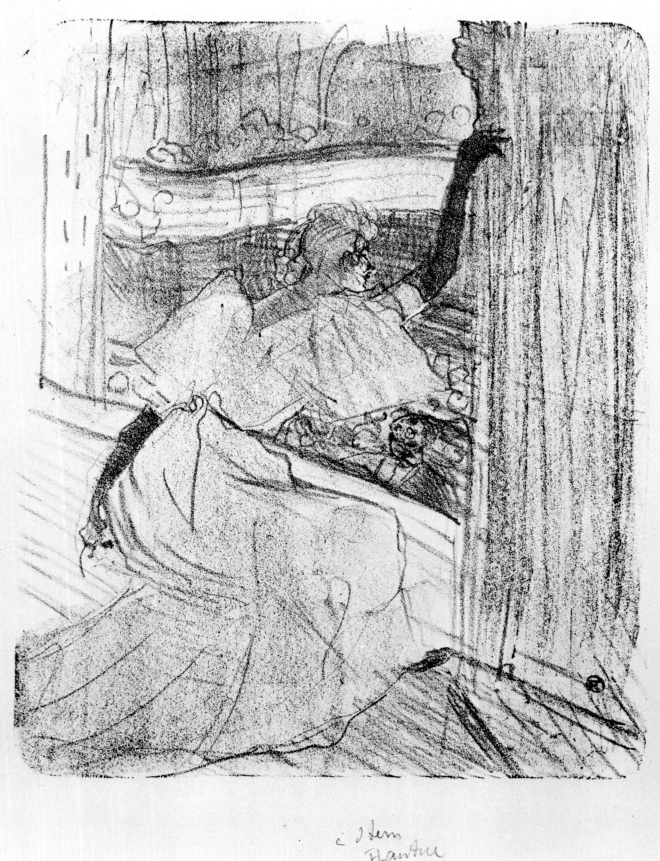

i'Item
Plantin

258·I

258 YVETTE GUILBERT,
 SALUANT LE PUBLIC 1898
 Yvette Guilbert, Taking a Bow

Lithograph, eighth in the *Yvette Guilbert*
series.
First state. No tint stone.
Drawing in black; chalk, worked with the
scraper.
294 × 238 mm.
Monogram on the stone, upper right.
Vellum.
One impression dedicated 'à Stern' also
known (illustrated).
Delteil 260 (state not described);
Adhémar 316 (state not described);
Adriani 264 I; Wittrock 279.
Second state. With beige tint stone.
Hand-made paper.
Edition of 350.
Delteil 260; Adhémar 316; Adriani 264 II;
Wittrock 279.
New edition (1930). Drawing in green; see
No. 250.

259 YVETTE GUILBERT,
 'CHANSON ANCIENNE' 1898

Lithograph.
Drawing in black; chalk.
293 × 234 mm.
Monogram on the stone, upper left.
Vellum.
One impression dedicated 'à Stern' also
known (Bibliothèque d'Art Jacques
Doucet, Paris).
Delteil 256; Adhémar 312; Adriani 265;
Wittrock 280.

Only a few proofs were made by Stern of
this lithograph, which was the first idea
for the fifth sheet in the *Yvette Guilbert*
portfolio. The artist rejected it and
replaced it with No. 255, so this
fascinating portrait, with its intense and
feverish handling of line, was sadly never
published.

259

260–272 PORTRAITS D'ACTEURS ET
D'ACTRICES, TREIZE
LITHOGRAPHIES 1898
*Portraits of Actors and Actresses,
Thirteen Lithographs*

The trend towards the close-up portrait that is so striking in the *Yvette Guilbert* portfolio, above, is confirmed in a series of portraits of stage stars. Delteil and Adhémar date this to 1895/1896, but it is clear from the correspondence between Lautrec and the London publisher W. H. B. Sands that most of the prints were commissioned by Sands, and made at the beginning of 1898.

Lautrec had mentioned a book he was planning in a letter to Sands at the beginning of July 1896, and the idea for a series of portraits of actors and actresses had taken on more concrete form by 2 June 1897, when Lautrec wrote to the publisher: 'I am thinking a great deal of our book to be done. However, I do not think that I will be ready before Christmas . . . I would have the best writers for that: Geffroy, Descaves, Tristan Bernard etc. We could do an English edition and a French edition' (Schimmel-Cate, pp. 39f.). During the year Lautrec decided on Arthur Byl as author, and asked him to write short texts to accompany each of the portraits; the number of drawings was also reduced from the envisaged 30 to between 20 and 25, largely because the artist was asking a relatively high price of 100 francs per drawing. On Christmas Day 1897 he wrote to Sands, confirming that he had received twelve pounds (as advance payment?) and was thinking about the book (Schimmel-Cate, p. 41).

His thoughts now returned to the people whom he had not drawn for years, but they had remained so firmly rooted in his memory that he had no difficulty in sketching them directly onto the stone from memory or photos, without using preliminary studies. On 25 February 1898 he mentions that he had drawn portraits of Sarah Bernhardt, Yvette Guilbert, Polaire, Anna Held, Polin, May Belfort, Emilienne d'Alençon and Jeanne Granier straight onto the stone; three days later Sands replied: 'I now think you will have the 25 drawings ready to print towards the end of March' (Schimmel-Cate, pp. 44f.). It is evident from a letter from Sands on 1 March that he considered the fee Byl had requested for the texts rather high, and would have liked to economize here, and to spend more on the quality of the paper and printing: '. . . You understand that it is you and your

drawings which are important;' he told Lautrec, 'the text is not very necessary – and the less that we spend on the text, the more we will be able to put into the drawings' (Schimmel-Cate, p. 47). Lautrec accepted the list of 20 names which Sands sent him on 28 March 1898; he merely answered on 1 April that he had done 'Cléo de Mérode instead of Ackté' (Schimmel-Cate, pp. 63f.). Lautrec enquired again on 30 May: 'I would be very obliged if you could tell me whether you have received all of the stones (15) and the last 4 proofs'. Sands confirmed the following day that he had received four stones to date; however, he could not use the portrait of Louise Balthy, and he was returning that particular stone to the printer Stern in Paris (Schimmel-Cate, pp. 81f.).

Unfortunately, the project which had started so promisingly, as an English edition of 250 copies and a French edition of 100, did not materialize – at least, not in the original form with 20 portraits and texts by Arthur Byl. Perhaps Sands thought there was not enough prospect of sales, following the negative press response to Lautrec's exhibition of 78 works at the Goupil Gallery in London in May 1898. According to the Paris print-dealer Edmond Sagot, Sands sold his rights in the portfolio to a 'Société des Amateurs indépendants', and the society may possibly have published thirteen of the portraits (Nos. 260–272) after 1901 under the title 'TREIZE LITHOGRAPHIES/par/H. De Toulouse-Lautrec'; they were printed in two series, one on vellum and one on China paper, and placed in a card cover with no text or publisher's name. According to Adhémar, the Paris publisher Gustave Pellet was selling 300 of the portfolios with the portrait series in May 1906. Another special edition, limited to 20 portfolios, is subtitled: 'TIRAGE SPECIAL/pour/Les XX'; this edition, which also contains two copies of each of the 13 prints on white and on beige vellum, was printed for the 'Société des XX', a society of bibliophiles founded by Pierre Dauze in 1897, and limited to a membership of 20. Each of the two series had one of the prints as a title page – a different one in each portfolio – with the lettering, not designed by Lautrec, in green below: 'TREIZE LITHOGRAPHIES/par/H. de Toulouse-Lautrec.'

260 SARAH BERNHARDT 1898

Lithograph, from the series *Treize Lithographies*.
Drawing in black or dark grey; chalk.
295 × 242 mm.
Monogram on the stone, lower left.
Beige or white vellum, China paper.
Edition after 1901 of about 400, 40 of which were for 'Les XX'; the picture was also used as a title page, when it bears the lettering below, not designed by Lautrec, in green: 'TREIZE LITHOGRAPHIES/par/H. de Toulouse-Lautrec'.
Delteil 150; Adhémar 166; Adriani 266; Wittrock 249.

Sarah Bernhardt is probably shown here in the play *Les Mauvais Bergers* (The Wicked Shepherds), that had opened in Paris on 15 December 1897. The drawing on the stone was made at the beginning of January 1898, for Lautrec wrote to Sands on the 14th of that month that he was going to send him 'a Sarah Bernhardt with the text' (Schimmel-Cate, p. 43; see also pp. 44 and 49).

261 SYBIL SANDERSON 1898

Lithograph, sheet from the series *Treize Lithographies*.
Drawing in black or dark grey; chalk. 278 × 244 mm.
Monogram on the stone, upper left.
Beige or white vellum, China paper.
Edition after 1901 of about 400 impressions, 40 of which were for 'Les XX'; the image was also used as a title page, when it has the lettering, not designed by Lautrec, below, in green: 'TREIZE LITHOGRAPHIES/par/H. de Toulouse-Lautrec'.
Delteil 151; Adhémar 167; Adriani 267; Wittrock 257.

This is a portrait of the opera singer Sybil Sanderson, born in Sacramento in 1865, wearing a costume of antique inspiration. On 27 March 1898 Lautrec asked Sands whether he would prefer a portrait of her or of Ackté, and at the beginning of April he sent a trial proof of the portrait of Sybil Sanderson to London (Schimmel-Cate, pp. 61, 64 and 66).

262 CLÉO DE MÉRODE 1898

Lithograph, sheet from the series *Treize Lithographies*.
Drawing in black or dark grey; chalk, worked with the scraper.
293 × 240 mm.
Monogram on the stone, lower left.
Beige or white vellum, China paper.
Edition after 1901 of about 400 impressions, 40 of which were for 'Les XX'; the image was also used as title page, when it has the lettering, not designed by Lautrec, below in green: 'TREIZE LITHOGRAPHIES/par/H. de Toulouse-Lautrec'.
Delteil 152; Adhémar 174; Adriani 268; Wittrock 258.

The Belgian singer and dancer Cléo de Mérode (1875–1966) was famed for her elegance and beauty. On 1 April Lautrec wrote to tell Sands that he had drawn Cléo de Mérode instead of Ackté, because she was more appealing, and on 4 April he sent a trial proof of the drawing to London (Schimmel-Cate, pp. 64 and 66).

263 COQUELIN AÎNÉ 1898
Coquelin the Elder

Lithograph, sheet from the series *Treize Lithographies*.
Drawing in black or dark grey; chalk. 290 × 242 mm.
Monogram on the stone, lower right.
Beige or white vellum, China paper.
Edition after 1901 of about 400 impressions, 40 of which were for 'Les XX'; the image was also used as title page, when it has the lettering, not designed by Lautrec, below in green: 'TREIZE LITHOGRAPHIES/par/H. de Toulouse-Lautrec'.
Delteil 153; Adhémar 169; Adriani 269; Wittrock 254.

Edmond Rostand wrote his verse drama *Cyrano de Bergerac* for the actor Benoît-Constant Coquelin (1841–1909), and its première was held on 28 December 1897 at the Théâtre de la Porte-Saint-Martin. On 1 March 1898 Lautrec sent a trial proof of this picture of Coquelin as Cyrano de Bergerac to Sands in London (Schimmel-Cate, p. 48; see also p. 57).

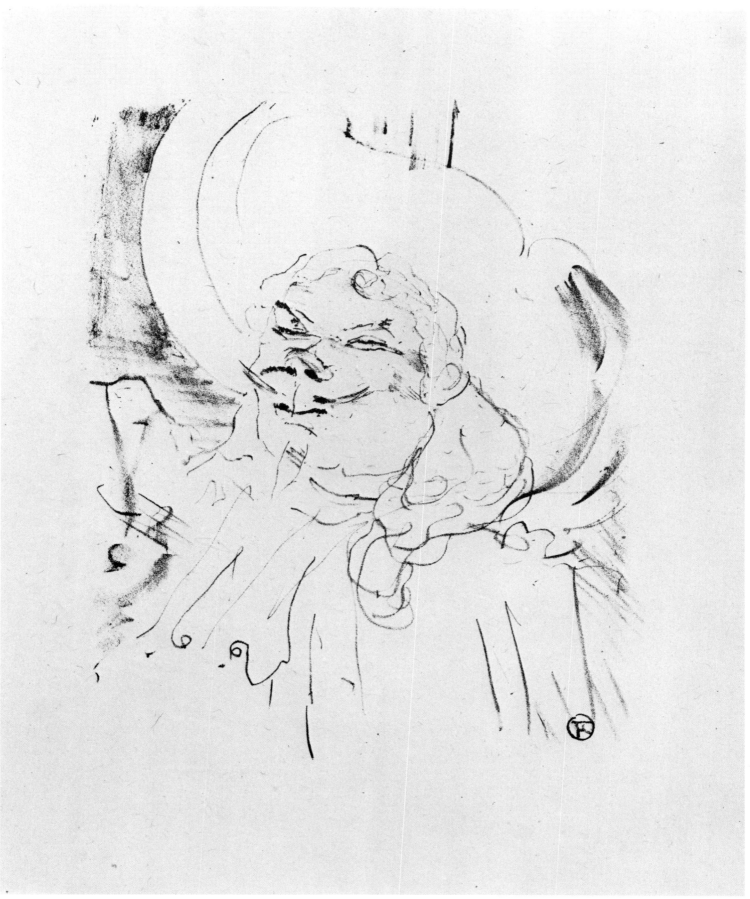

Lithograph, sheet from the series *Treize Lithographies*.
Drawing in black or dark grey; chalk, worked with the scraper.
293 × 240 mm.
Monogram on the stone, lower left.
Beige or white vellum or China paper.
Two impressions known, one dedicated 'à Stern' on hand-made paper (Kunstmuseum Winterthur).
Edition after 1901 of about 400 impressions, 40 of which were for 'Les XX'; the image was also used as title page, when it has the lettering, not designed by Lautrec, below in green: 'TREIZE LITHOGRAPHIES/par/H. de Toulouse-Lautrec'.
Delteil 154; Adhémar 178; Adriani 270; Wittrock 250.

The operetta star Jeanne Granier (1852–1939) may be shown here in the play *Le Nouveau Jeu* (The New Game) which opened on 8 February 1898. Lautrec mentions a drawing of her in a letter to the London publisher Sands on 5 March 1898, but he adds a question mark and goes on to say: 'I shall do a better one' (Schimmel-Cate, p. 49; see also p. 44). This portrait is probably the final version, while Nos. 276 and 277 were rejected by the artist as unsuitable for an edition.

Lithograph, sheet from the series *Treize Lithographies*.
Drawing in black or dark grey; chalk.
296 × 244 mm.
Monogram on the stone, lower left.
Beige or white vellum, China paper.
Edition after 1901 of about 400 impressions, 40 of which were for 'Les XX'; the image was also used as title page, when it has the lettering, not designed by Lautrec, below in green: 'TREIZE LITHOGRAPHIES/par/H. de Toulouse-Lautrec'.
Delteil 155; Adhémar 177; Adriani 271; Wittrock 259.

The actor Lucien Germain Guitry (1860–1925) enjoyed his main successes at Sarah Bernhardt's Théâtre de la Renaissance.

Lithograph, sheet from the series *Treize Lithographies*.
Drawing in black or dark grey; chalk, worked with the scraper.
292 × 243 mm.
Monogram on the stone, upper right.
Beige or white vellum, China paper.
Edition after 1901 of about 400 impressions, 40 of which were for 'Les XX'; the image was also used as title page, when it has the lettering, not designed by Lautrec, below in green: 'TREIZE LITHOGRAPHIES/par/H. de Toulouse-Lautrec'.
Delteil 156; Adhémar 173; Adriani 272; Wittrock 251.

The woman in this portrait has only recently been identified as Anna Held (see Schimmel-Cate, pp. 104f.). Lautrec sent a trial proof of the drawing to Sands in London on 25 February 1898 (Schimmel-Cate, p. 44; see also p. 49). He had drawn a full-length portrait of the singer four years before (No. 103).

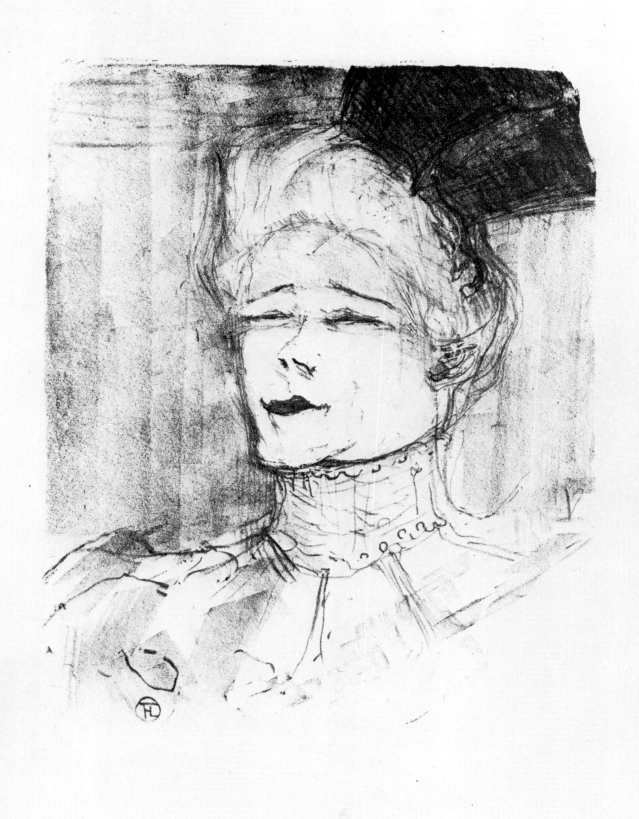

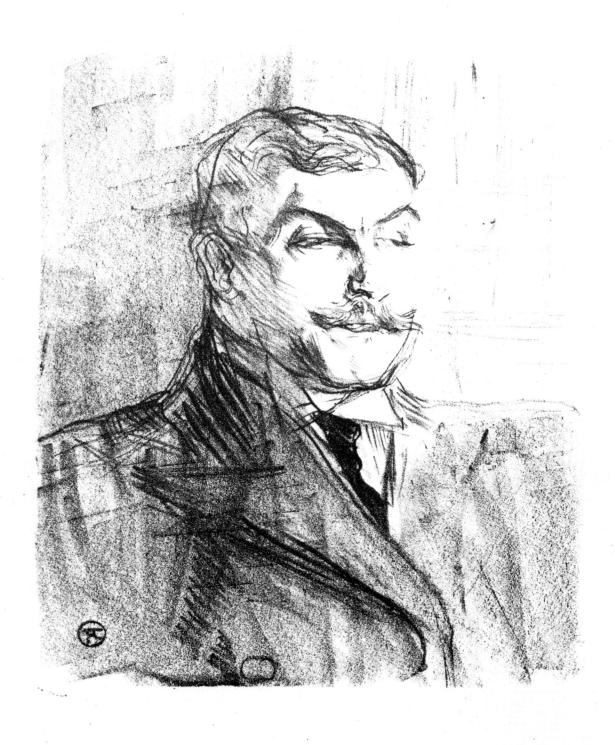

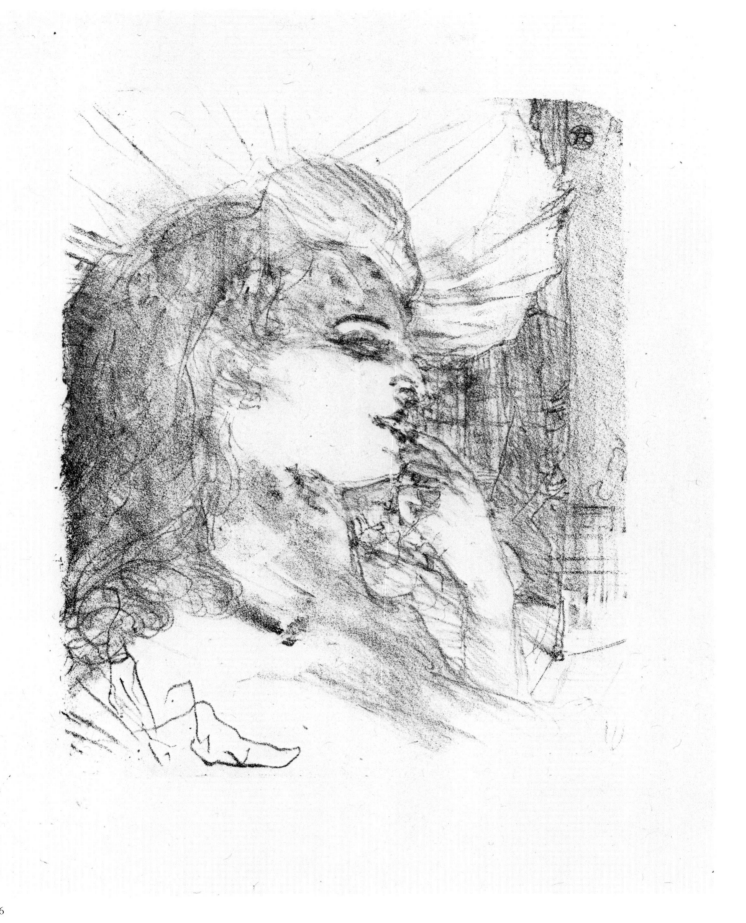

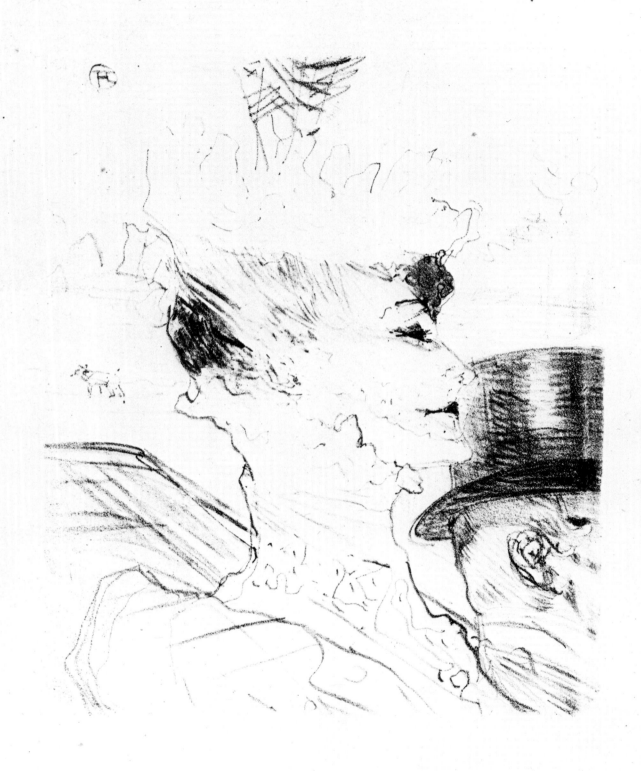

267 LOUISE BALTHY 1898

Lithograph, sheet from the series *Treize Lithographies*.
Drawing in black or dark grey; chalk, worked with the scraper.
295 × 244 mm.
Monogram on the stone, upper left.
Beige or white vellum, China paper.
Edition after 1901 of about 400 impressions, 40 of which were for 'Les XX'; the image was also used as title page, when it has the lettering, not designed by Lautrec, below in green: 'TREIZE LITHOGRAPHIES/par/H. de Toulouse-Lautrec'.
Delteil 157; Adhémar 171; Adriani 273; Wittrock 256.

On 23 March 1898 Lautrec suggested to Sands in London that he should draw Balthy, rather than Delna (Schimmel-Cate, p. 61; see also pp. 82f.). Louise Balthy, born in Bayonne in 1867, appeared at the Eldorado, the Scala and the Palais Royal.

268 MARIE-LOUISE MARSY 1898

Lithograph, sheet from the series *Treize Lithographies*.
Drawing in black or dark grey; chalk, worked with the scraper.
294 × 243 mm.
Monogram on the stone, upper right.
Beige or white vellum, China paper.
Edition after 1901 of about 400 impressions, 40 of which were for 'Les XX'; the image was also used as title page, when it has the lettering, not designed by Lautrec, below in green: 'TREIZE LITHOGRAPHIES/par/H. de Toulouse-Lautrec'.
Delteil 158; Adhémar 172; Adriani 274; Wittrock 260.

The actress Marie-Louise Marsy appeared at the Comédie Française in the eighteen-nineties, but she was mainly known for her liaison with Max Lebaudy, the heir to a vast fortune.

269 POLIN 1898

Lithograph, sheet from the series *Treize Lithographies*.
Drawing in black or dark grey; chalk.
292 × 237 mm.
Monogram on the stone, lower left.
Beige or white vellum, China paper.
Edition after 1901 of about 400 impressions, 40 of which were for 'Les XX'; the image was also used as title page, when it has the lettering, not designed by Lautrec, below in green: 'TREIZE LITHOGRAPHIES/par/H. de Toulouse-Lautrec'.
Delteil 159; Adhémar 176; Adriani 275; Wittrock 261.

See No. 25, where the buffoonish comedian Marsalès, known as Polin, can also be seen on stage. Polin appeared at the Alcazar d'Eté and La Scala, achieving great success with his caricatures of the French military. Lautrec sent a trial proof of the drawing to Sands in London on 25 February 1898 (Schimmel-Cate, p. 44; see also pp. 49 and 57).

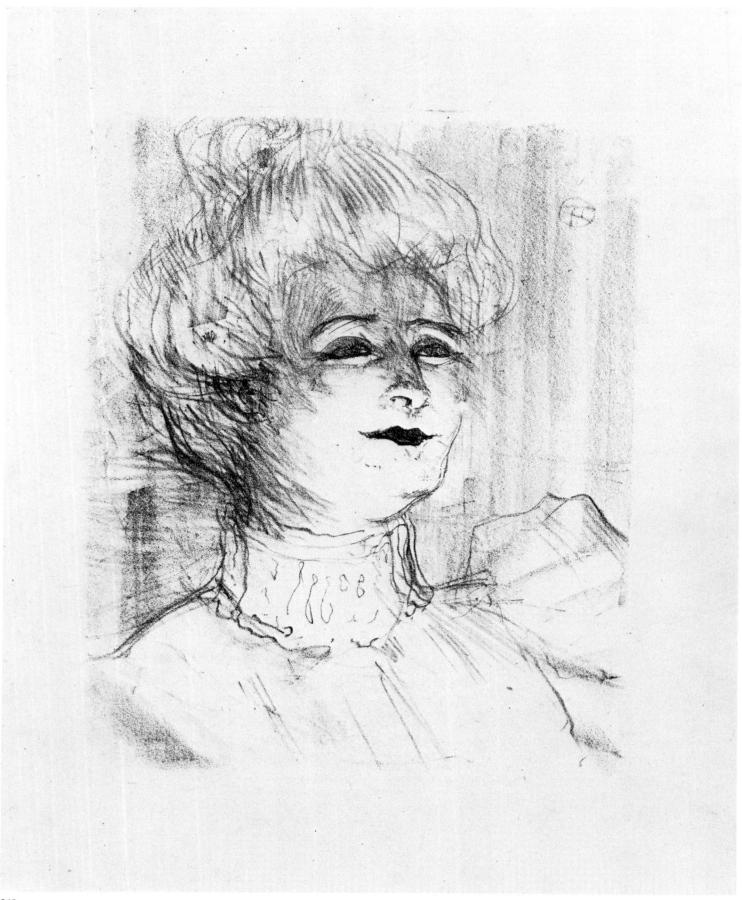

268

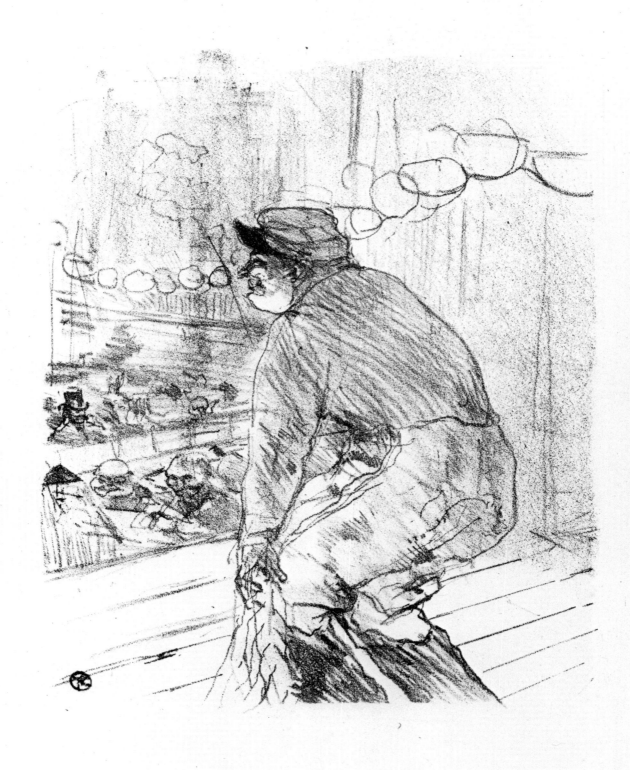

270 MAY BELFORT 1898

Lithograph, sheet from the series *Treize Lithographies*.
Drawing in black or dark grey; chalk.
295 × 242 mm.
Monogram on the stone, lower right.
Beige or white vellum, China paper.
Edition after 1901 of about 400 impressions, 40 of which were for 'Les XX'; the image was also used as title page, when it has the lettering, not designed by Lautrec, below in green: 'TREIZE LITHOGRAPHIES/par/H. de Toulouse-Lautrec'.
Delteil 160; Adhémar 175; Adriani 276; Wittrock 252.

Lautrec sent a trial proof of this drawing of May Belfort to Sands in London on 25 February 1898 (Schimmel–Cate, p. 44; see also p. 49).

271 EMILIENNE D'ALENÇON 1898

Lithograph, sheet from the series *Treize Lithographies*.
Drawing in black or dark grey; chalk.
295 × 242 mm.
Monogram on the stone, lower right.
Beige or white vellum, China paper.
Edition after 1901 of about 400 impressions, 40 of which were for 'Les XX'; the image was also used as title page, when it has the lettering, not designed by Lautrec, below in green: 'TREIZE LITHOGRAPHIES/par/H. de Toulouse-Lautrec'.
Delteil 161; Adhémar 170; Adriani 277; Wittrock 253.

Lautrec sent a trial proof of the drawing to Sands in London on 25 February 1898 (Schimmel–Cate, p. 44; see also pp. 49 and 57).

272 JANE HADING 1898

Lithograph, sheet from the series *Treize Lithographies*.
Drawing in black or dark grey; chalk.
286 × 242 mm.
Monogram on the stone, upper left.
Beige or white vellum, China paper.
Edition after 1901 of about 400 impressions, 40 of which were for 'Les XX'; the image was also used as title page, when it has the lettering, not designed by Lautrec, below in green: 'TREIZE LITHOGRAPHIES/par/H. de Toulouse-Lautrec'.
Delteil 162; Adhémar 168; Adriani 278; Wittrock 255.

Lautrec wrote to Sands in London on 20 March 1898 that he had already finished the drawing of Jane Hading (Schimmel–Cate, p. 57). The actress, whose real name was Jeanette Hadingue, was born in 1861 in Marseilles; she also appeared at the Comédie Française.

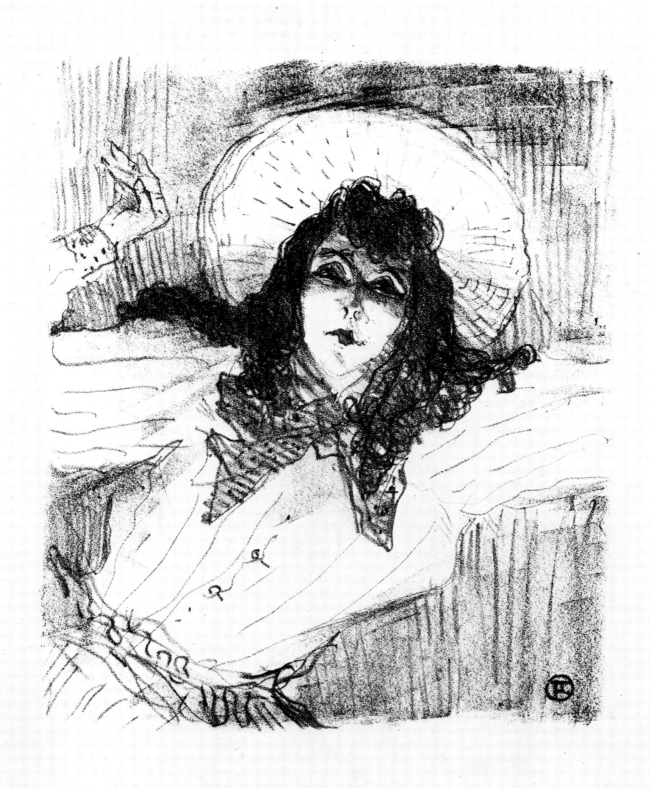

Jane Hading 1892

274

273 JANE HADING 1898

Lithograph.
Drawing in black; chalk.
292 × 232 mm.
Monogram on the stone, upper right.
Vellum.
Two impressions known, one dedicated 'à Stern' (Kunsthalle, Bremen).
Delteil 262; Adhémar 181; Adriani 280; Wittrock 262.

The following portraits of actresses (Nos. 273–277) are closely related in style and content to the series *Treize Lithographies*, above, and they are of the same dimensions. They were probably also drawn for the London publisher Sands in the spring of 1898, but only a few trial proofs were made and they remained unpublished.

274 JANE HADING 1898

Lithograph.
Drawing in black; chalk, worked with the scraper.
293 × 240 mm.
Monogram on the stone, upper left.
Vellum.
Two impressions known, one dedicated 'à Stern' (Bibliothèque d'Art Jacques Doucet, Paris).
Delteil 263; Adhémar 182; Adriani 281; Wittrock 263.

See No. 273.

275 MADAME RÉJANE 1898

Lithograph.
Drawing in black; chalk, worked with the scraper.
294 × 226 mm.
Monogram on the stone, lower left.
Vellum.
Two impressions known.
Delteil 266; Adhémar 57; Adriani 285; Wittrock 266.
New edition (1936). Published by the Leicester Galleries, London.
Drawing in dark olive green or black.
293 × 240 mm.
Hand-made Japan paper.
75 impressions.
New edition (1951). Published by La Société des Amis du Musée d'Albi to mark the fiftieth anniversary of the artist's death.
Drawing in black.
Vellum.
100 impressions.

To recall her appearances at the Théâtre des Variétés in *Madame Sans-Gêne* (see No. 61), Lautrec has portrayed Gabrielle Réjane in a similar costume to the one she wore then. As the litho stone with the drawing was presented to the Musée d'Albi by the London art-dealers Ernest Brown & Phillips Ltd, together with the stones for the *Yvette Guilbert* portfolio (Nos. 250–258), it may be assumed that Lautrec originally sent the stone to Sands in London with the portrait of Gabrielle Réjane, to have an edition printed there; however, this does not appear to have been done (see No. 273).

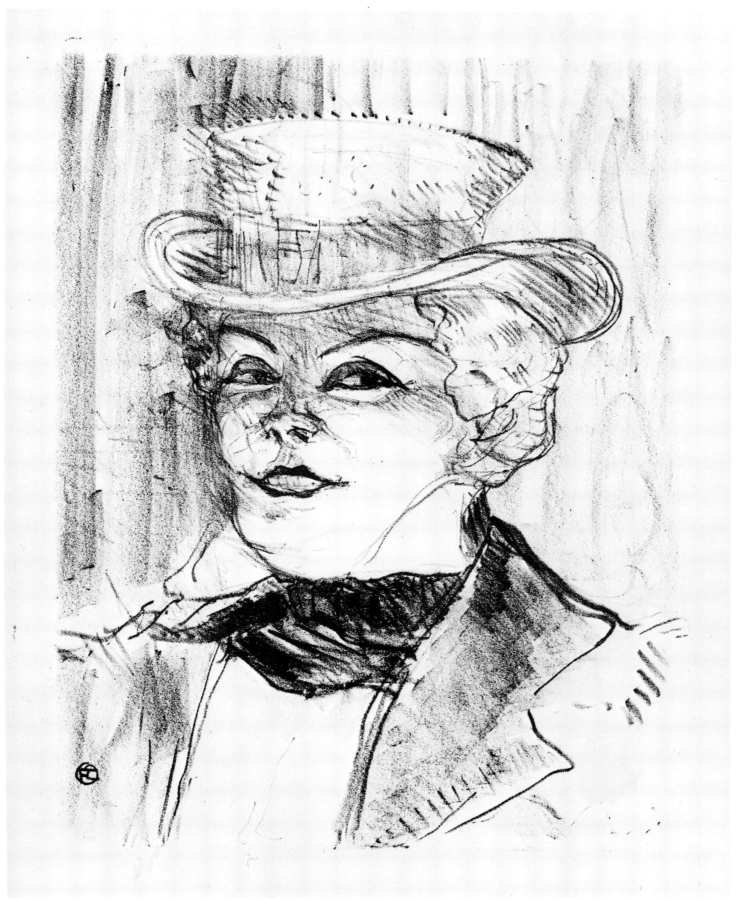

275

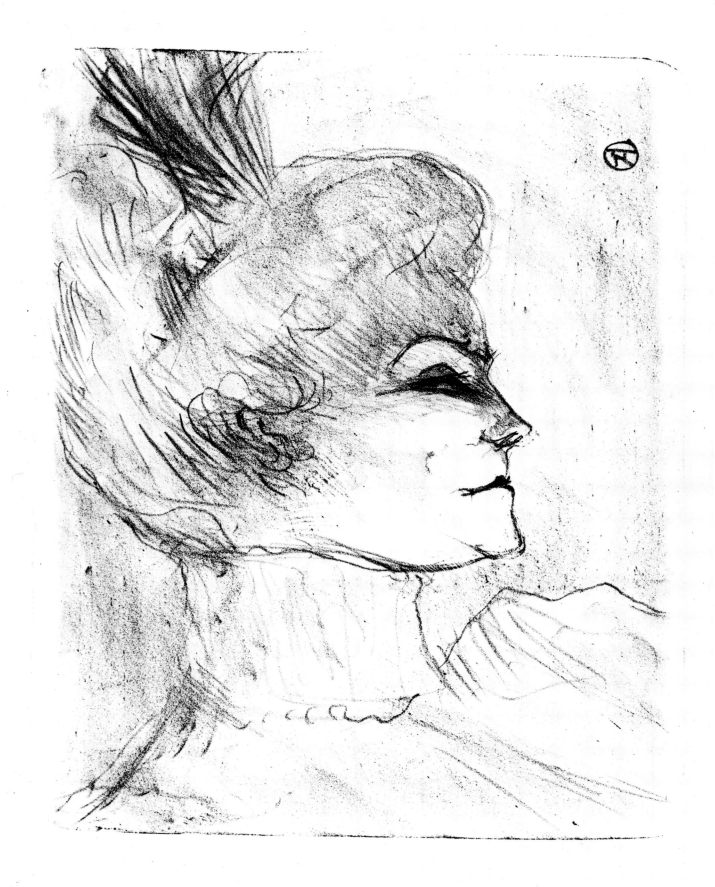

276

276 JEANNE GRANIER,
 DE PROFIL À DROITE 1898
 Jeanne Granier, Right Profile

Lithograph.
Drawing in black; chalk.
297 × 238 mm.
Monogram on the stone, upper right.
Vellum.
One impression known.
Delteil 265; Adhémar 179; Adriani 284;
Wittrock 265.

See Nos. 264, 273.

277 JEANNE GRANIER,
 DE PROFIL À GAUCHE 1898
 Jeanne Granier, Left Profile

Lithograph.
Drawing in black; chalk.
286 × 237 mm.
Monogram on the stone, lower right.
Vellum.
One impression known (Bibliothèque
d'Art Jacques Doucet, Paris).
Delteil 264; Adhémar 180; Adriani 283;
Wittrock 264.

See Nos. 264 and 273.

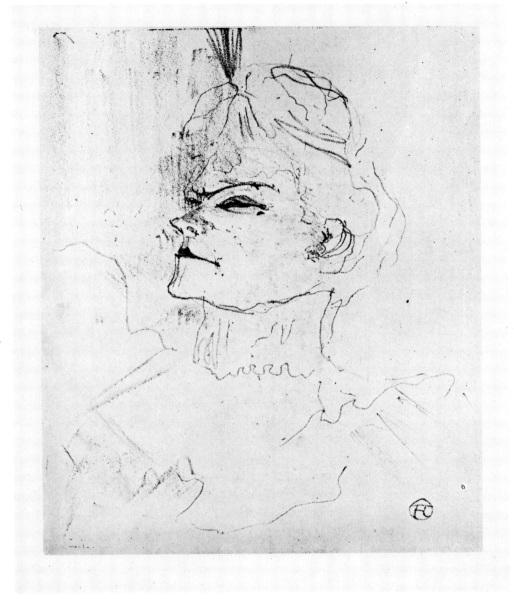

277

278

279

278 BICYCLISTES 1898
Cyclists

Lithograph.
Drawing in black; chalk, worked with the scraper.
254 × 222 mm.
Monogram on the stone, lower left.
Japan paper.
Two impressions known, one dedicated 'à Sands' (illustrated) and the other 'à Malfeyt 98'; both have Lautrec's red monogram stamp (Lugt 1338), lower right.
Delteil 267; Adhémar 318; Adriani 161; Wittrock 287.

This picture may also be a sketch for a song title, though no edition was printed. The impression shown here, which is dedicated to the London publisher W. H. B. Sands, is from Maurice Joyant's collection.

279 INVITATION À UNE
EXPOSITION 1898
Invitation to an Exhibition

Lithograph, invitation card, with text written by Lautrec: 'Henri de Toulouse-Lautrec vous prie/de lui faire l'honneur de visiter/le avril ses tableaux partant/pour Londres de 1 h. à 5 heures/14 Avenue Frochot'.
Drawing in black; chalk, pen and ink.
217 × 137 mm.
Monogram on the stone, upper left.
Vellum.
Eleven impressions known, one dedicated 'à Stern' (illustrated).
Delteil 232; Adhémar 283; Adriani 254; Wittrock 281.

This amusing card was sent by Lautrec as an invitation to a private view on 19 April 1898 at 14 (?), Avenue Frochot at which he showed the 78 paintings he was sending to an exhibition in London. The exhibition, which was arranged by Joyant, opened on 2 May in the presence of the artist at the London branch of Goupil, 5 Regent Street, where Vincent van Gogh had tried in vain to establish himself as an art-dealer twenty-five years before. However, Lautrec's work met with destructive criticism from the English press.

280 EDMOND CALMÈSE 1898

Lithograph.
Drawing in black; chalk.
297 × 238 mm.
Monogram on the stone, lower right.
Vellum.
Three impression known, one dedicated 'à Malfeyt' (illustrated), who printed a few impressions of the lithograph.
Delteil 291; Adhémar 285; Adriani 286; Wittrock 267.

Joyant became increasingly concerned with his friend's condition and tried to keep him occupied, commissioning five of the finest graphics Lautrec produced in 1898 for himself and his business partner Manzi (Nos. 302–306). But despite his efforts, Lautrec came more and more under the influence of street girls and drinking companions, chief among whom were the fat Gabrielle and the cab-hirer, Edmond Calmèse. The printer and paper-dealer E. Malfeyt had his business at 8 Rue Fontaine, next door to Calmèse's stables, and at No. 10, where he went every day to be driven to the Bois de Boulogne, the artist found two rather less dangerous companions in the pony Philibert and a nameless little terrier, now immortalized as a sign of special quality on numerous lithographs of this period. The two animals are visible in the background here.

T. Lautrec.

à Malfeyt

281

282

281 FEUILLE DE CROQUIS 1898
Sheet of Sketches

Transfer lithograph, with notes by
Lautrec: 'Olympia l'unique/aimie –
Edmond Calmèse/Ecuyer Troncheur [?]/
10 rue Fontaine'.
Drawing in black; pen and ink.
258 × 208 mm.
Monograms on the stone, upper left and
lower right, and a monogram in the shape
of a little elephant, above.
Hand-made paper.
Three impressions known.
Delteil 336; Adhémar 284; Adriani 287;
Wittrock 298.

This sheet of rapid sketches contains a
portrait with a North African motif in the
background and a caricature of 'Olympia
l'unique aimie', Victorine Meurent, now
grown old and living in the Rue de
Douai. Lautrec introduced her
respectfully to his friends as the model for
Manet's 'Olympia', painted in 1863.
 Calmèse's address and the drawing of
his little dog (see No. 280) suggest that the
sheet was drawn in 1898, when Lautrec
was in close contact with Calmèse, and
not, as Delteil suggested, in 1901.

282 LE PETIT PONEY DE CALMÈSE 1898
Calmèse's Little Pony

Lithograph.
Drawing in black or dark brown; chalk.
243 × 295 mm.
Monogram on the stone, lower left.
Vellum.
Edition of 15 numbered impressions,
some signed by the artist in pencil, lower
right; some also have Lautrec's red
monogram stamp (Lugt 1338), lower
right.
Delteil 287; Adhémar 286; Adriani 291;
Wittrock 304.

Paul Leclercq remembered Lautrec's
friendship with the pony Philibert at
Calmèse's stables (see No. 280): 'A pony,
which he called Philibert, once played a
large part in Lautrec's life for a few
months. Philibert belonged to a cab-hirer
in the neighbourhood. He was a very
small pony, round as a fat sausage, with
four spindly legs and a piercing gaze. For
Lautrec Philibert had become a person.
He insisted that I should meet him,
speaking of him as a personal friend. The
pony's eager expression amused Lautrec,
and not a day passed without his taking
sugar to the stable for the little horse.
Often Philibert, driven by his owner,

would take Lautrec for a morning run,
and off they would trot behind the fat
little pony up and down the Avenue des
Acacias; then Lautrec would go to
Armenonville to drink his drop; on such
days he only went out for Philibert's sake'
(Paul Leclerq [sic], *Henri de Toulouse-
Lautrec*, Zurich 1958, p. 51).

283

284

283 LE CHEVAL ET LE CHIEN 1898
 The Horse and the Dog

Lithograph.
Drawing in black; chalk.
149 × 243 mm.
Monogram on the stone, lower left.
Vellum, imitation Japan paper, Japan
paper.
Eight impressions known.
Delteil 288; Adhémar 287; Adriani 292;
Wittrock 322.

This lithograph, like No. 282, shows the
pony Philibert and Calmèse's dog.

284 LE CHEVAL ET LE CHIEN À LA
 PIPE 1898
 The Horse and the Dog with a Pipe

Lithograph.
Drawing in black; chalk.
114 × 183 mm.
Monogram on the stone, lower left (a
mouse).
Vellum.
Three impressions known, one dedicated
'à Viau' on imitation Japan paper
(Bibliothèque d'Art Jacques Doucet,
Paris).
Delteil 289; Adhémar 256; Adriani 293;
Wittrock 321.

The pony Philibert (see Nos. 280, 282 and
283) may be confronting Bouboule,
Madame Palmyre's bulldog (see
Nos. 209–211).

285 L'AMAZONE ET LE CHIEN 1898
 The Horsewoman and the Dog

Lithograph.
First state.
Drawing in black or grey; chalk, worked
with the scraper.
281 × 235 mm.
Monogram on the stone, lower right.
Hand-made paper.
Two impressions known, one with the
note 'passe' and dedicated 'à Malfeyt'
(illustrated), the printer who pulled the
impressions.
Delteil 285; Adhémar 289; Adriani 289 I;
Wittrock 302 I.
Second state. The horsewoman's dress
reworked and part of the skirt removed.
Two impressions known.
Delteil 285 (state not described);
Adhémar 289 (state not described);
Adriani 289 II; Wittrock 302 II.

a Maffeyt
pane
Houvta

285·I

286

286 Amazone et Tonneau 1898
Horsewoman and Cart

Lithograph.
Drawing in black; chalk.
237 × 293 mm.
Monogram on the stone, lower left.
Hand-made paper.
Edition of about 20 impressions, some
with Lautrec's red monogram stamp
(Lugt 1338), lower left; one impression
dedicated 'à Albert' and two on vellum
are also known.
Delteil 284; Adhémar 288; Adriani 290;
Wittrock 301.

On the right we again see the pony
Philibert with the two-wheeler cab, and
in the foreground Calmèse's little dog (see
No. 280).

287

287 L'Entraîneur 1898
 The Trainer

Lithograph.
Drawing in blue; chalk.
236 × 454 mm.
Reverse monogram on the stone, lower
left.
Vellum.
Edition of 40 impressions, some with
Lautrec's red monogram stamp
(Lugt 1338), lower left.
Delteil 172; Adhémar 361; Adriani 288;
Wittrock 313.

In the foreground we again have the pony
Philibert with the little dog (see No. 280),
so it is more likely that this sheet was
executed in 1898 than around 1896 or
1899–1900, as suggested by Delteil and
Adhémar.

289

288 L'AMATEUR DE CHEVAUX 1898
The Horse Fancier

Lithograph.
Drawing in violet or dark brown; chalk.
238 × 244 mm.
Monogram on the stone, lower left.
Vellum.
Eight impressions known, one dated and
dedicated 'à Malfeyt' (illustrated).
Delteil 234; Adhémar 292; Adriani 295;
Wittrock 299.

The lithograph was printed by E. Malfeyt
(see No. 280). It shows Jules Aclocque, a
passionate admirer of fine horses, whom
Lautrec often saw in the Bois de
Boulogne (see No. 289).

289 AU CAFÉ 1898
In the Café

Lithograph.
Drawing in black; chalk.
238 × 296 mm.
Monogram on the stone, lower left.
Vellum.
Two impressions known.
Delteil 330; Adhémar 293; Adriani 294;
Wittrock 300.

Adhémar rightly related this sheet to
No. 288, for it also shows Jules Aclocque
with the little dog we have come to know
so well.

a malajeit

Tlautrec
98

290 L'AUTOMOBILISTE 1898
The Motorist

Lithograph.
Drawing in black; chalk.
375 × 268 mm.
Monogram on the stone, lower left.
Vellum.
Edition of 25, some with Lautrec's red
monogram stamp (Lugt 1338), lower left
or lower right.
Delteil 203; Adhémar 295; Adriani 296;
Wittrock 293.

The little dog, now so familiar, takes not
the slightest notice of the snorting,
smoke-spitting hellish machine rattling
past, with Gabriel Tapié de Céleyran in an
astonishing get-up clinging to the wheel.
He and Paul Guibert were among the first
motorists in Paris; see the portrait sketch
Dortu D.4102.

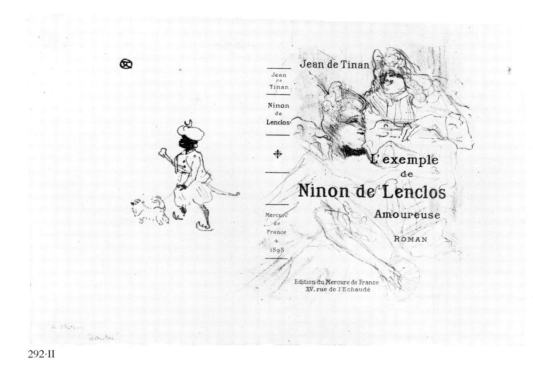

292·II

291 COUVERTURE POUR 'L'ETOILE
ROUGE' 1898
Cover for 'L'Etoile Rouge'

Lithograph, book cover.
First state. With lettering not designed by
Lautrec, above: 'PAUL LECLERCQ'.
Drawing in black; chalk.
225 × 244 mm.
Monogram on the stone, above.
Hand-made paper.
Three impressions known, two of which
are dedicated 'à Stern' and 'à Leclercq'.
Delteil 231 I; Adhémar 298 I;
Adriani 297 I; Wittrock 289.
Second state. With lettering added in red:
'L'Etoile Rouge'.
Vellum.
Edition of 30.
Delteil 231 II; Adhémar 298 II;
Adriani 297 II; Wittrock 289.

This print, which was published by the
Mercure de France, was used as cover for
Paul Leclercq's book *L'Etoile Rouge* (The
Red Star). The author (1871–1957) is
shown standing by the bed; see the
portrait sketch of the girl Dortu D.4412.

292 COUVERTURE POUR 'L'EXEMPLE DE
NINON DE LENCLOS
AMOUREUSE' 1898
*Cover for 'L'Exemple de Ninon de
Lenclos Amoureuse'*

Lithograph, book cover.
First state. No lettering.
Drawing in black or violet brown; chalk,
worked with the scraper.
191 × 248 mm.
Monogram on the stone, upper left.
Imitation Japan paper.
Edition of 25 numbered impressions; one
impression on vellum and two on hand-
made paper are also known, one
dedicated 'à Stern' (illustrated).
Delteil 230 I; Adhémar 273 I;
Adriani 298 I; Wittrock 288.
Second state. With lettering not designed
by Lautrec, in blue: 'Jean de Tinan/
L'exemple/de/Ninon de Lenclos/
Amoureuse/Roman/Edition du Mercure
de France/XV, rue de l'Echaudé . . .'.
Vellum.
Edition of 500, 50 of which were for a de
luxe edition (twelve on vellum, three on
Japan and 25 on China paper); one
impression on hand-made paper and
dedicated 'à Stern' is also known
(illustrated).
Delteil 230 II; Adhémar 273 II;
Adriani 298 II; Wittrock 288.

This lithograph was printed by Ancourt,
Paris, and used as cover for the novel
Ninon de Lenclos Amoureuse (Ninon de
Lenclos in Love) by Jean de Tinan,
published by the *Mercure de France*.

355

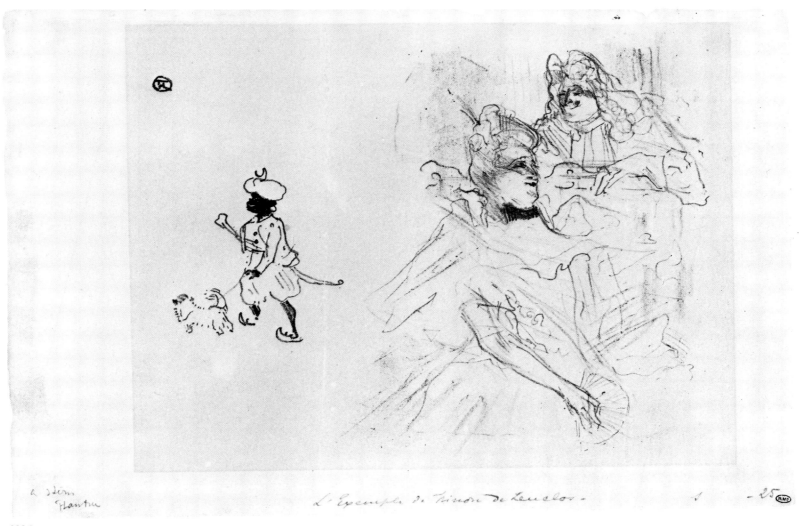

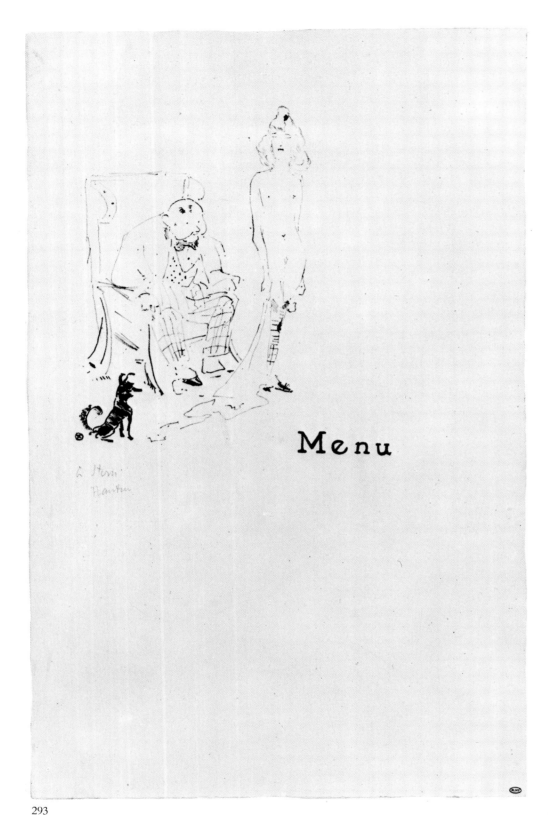

Menu

293

294 The remarque printed separately

293 LA FILLETTE NUE, MENU 1898
The Naked Young Girl, Menu Card

Lithograph, menu card, with lettering not
designed by Lautrec, below: 'Menu'.
Drawing in black; chalk.
205 × 140 mm.
Monogram on the stone, lower left.
Vellum.
Four impressions known, one of which is
dedicated 'à Stern' (illustrated).
Delteil 233; Adhémar 297; Adriani 299;
Wittrock 283.

294·I

294 DANS LE MONDE 1898
 In Society

Lithograph.
First state.
Drawing in black; chalk.
241 × 293 mm.
Writing in reverse on the stone, lower
right: 'Dans le monde'.
Vellum.
One impression known (illustrated).
Delteil 329 (state not described);
Adhémar 325 (state not described);
Adriani 301 II; Wittrock 316 I.
Second state. With remarque on another
stone.
Drawing in black; chalk, pen and ink.
Remarque now added on the stone, lower

left, in black: an imaginary animal
(mouse?).
Two impressions known.
Delteil 329; Adhémar 325; Adriani 301 I;
Wittrock 316 II.

The Gerstenberg Collection also has an
impression of the remarque printed
separately (38 × 75 mm, illustrated); see
the drawing of a rhinoceros Dortu
D.3614. The print of a little dog
(40 × 60 mm), which Adhémar (296) and
Wittrock (282) list as an independent
lithograph, is probably also a separate
print of an image intended as a remarque
(one impression dedicated 'à Stern' is in
the Kunsthalle, Bremen).

295 Au Lit 1898
 In Bed

Lithograph.
Drawing in dark violet; chalk.
311 × 257 mm.
Reverse monogram on the stone,
lower left.
Vellum.
Edition of 25.
Delteil 226; Adhémar 291; Adriani 302;
Wittrock 290.

296 LE LIT AU BALDAQUIN JAUNE 1898
The Bed with the Yellow Canopy

Colour lithograph.
Drawing in olive green with red, yellow
and black; chalk, ink with brush and
sprayed.
335 × 301 mm.
Monogram on the stone, lower right, and
the word 'Noir' in reverse on one
impression.
Vellum.
Two impressions known.
Not in Delteil; Adhémar 219;
Adriani 303; Wittrock 270.
Unlike the impression in the Kunsthalle,
Bremen, the print illustrated here has the
note 'Noir' below and the word
'programme' above it in pencil, with six
horizontal strokes.

Dortu dated the coloured sketch Dortu
P.676 for this lithograph, which was first
published by Adhémar and intended for
use as a programme, to around 1898, but a
corresponding drawing Dortu D.3323 to
around 1892!

297 DÉCLARATION 1898
Proposal

Lithograph.
Drawing in blue; chalk.
315 × 233 mm.
Monogram on the stone, lower right.
Vellum.
Three impressions known, one dedicated
'à Stern' (illustrated).
Delteil 328; Adhémar 299; Adriani 304;
Wittrock 306.

As on some of the preceding sheets, even
here, at the intimate moment of a
marriage proposal, Calmèse's little dog
(see No. 280) appears as a spectator (see
No. 298).

298 'DÉCLARATION' 1898

Lithograph, song title.
First state. No lettering.
Drawing in dark blue; chalk.
298 × 225 mm.
Monogram on the stone, lower right.
Vellum.
One impression dedicated 'à Stern'
known (illustrated by Delteil and
Adhémar).
Delteil 327; Adhémar 263; Adriani 305 I;
Wittrock 305.
Second state. The image transferred to a
new stone with the following text, not
designed by Lautrec: 'Répertoire Yvain/A
Madame AUGUEZ de MONTALANT/
Au Jardin de mon Cœur/. . ./Poésie de/
Jean Richepin/Musique de/Désiré Dihau
. . .' (with the address of the publisher
A. Quinzard & Cie.).
Drawing in brown or black.
263 × 225 mm.
Size of edition not known (several
hundred).
Delteil 327 (state not described);
Adhémar 263 (state not described);
Adriani 305 II; Wittrock 305 (Wittrock
also mentions new editions with changes
to the text, but gives no further details).
New editions (1923 and 1926). Lettering
removed, drawing in black.
Size of edition not known.

Unlike the previous lithograph, No. 297,
Calmèse's little dog, which appeared on
so many drawings in 1898, is here
replaced by the collie dog of Lautrec's
friend Robin Langlois; see No. 299.

298 New edition

à Mon
Blanche

299·II

299 Le Cheval et le Colley 1898
The Horse and the Collie Dog

Lithograph.
First state. The head and forequarters of a
dark horse to the right of a leaping dog.
Drawing in black; chalk.
328 × 250 mm.
Monogram on the stone, upper left.
Vellum.
Three impressions known.
Delteil 283 I; Adhémar 259 I;
Adriani 306 I; Wittrock 285 I.
Second state. The dark horse on the right
removed and replaced by the body of a
light horse, drawn on an additional stone,
now entering the picture from the left.
325 × 235 mm.
Monogram on the stone, above.
Four impressions known.
Delteil 283 II; Adhémar 259 II;
Adriani 306 II; Wittrock 285 II.
Third state. Without the dog, a separate
print of the stone with the light horse.
Two impressions known.
Delteil 283 (state not described);
Adhémar 259 (state not described);
Adriani 306 III; Wittrock 285 III.

In Lautrec's late works he gives expression
once again to his early interest in animals,
particularly in dogs and horses as the
embodiments of natural beauty, strength
and speed. On 11 May 1898 he wrote to
the English publisher Sands: 'I am sending
you two lithographs – Horse and Dog.
Could you show them to Mr. Brown
[Ernest Brown, a London art–dealer] and
ask him if with these proofs *hand-coloured*
or others in the same style it would be
possible to do something, and on what
terms. I would prefer a limited edition on
very beautiful paper, each proof between
two and four pounds – half and half, that
is, with 50% discount' (Schimmel-Cate,
p. 79). Unfortunately, we do not know
which sheet Lautrec had in mind and
whether an edition was ever made.

300

301

300 Le Chien et le Lapin 1898
The Dog and the Rabbit

Lithograph.
Drawing in black; chalk.
192 × 220 mm.
Monogram on the stone, lower left.
Vellum.
One impression known (Bibliothèque
Nationale, Paris).
Delteil 323; Adhémar 261; Adriani 307;
Wittrock 314.

Delteil wrongly entitled this motif *Le
Cochon* (The Pig), but, like the two
preceding works Nos. 298 and 299, it
probably shows the collie dog owned by
Lautrec's friend Robin Langlois; see
Nos. 228 and 229.

301 Le Poney Philibert 1898
Philibert the Pony

Lithograph.
Drawing in black; chalk.
356 × 254 mm.
Monogram on the stone, lower right.
Vellum.
Edition of 50, some with Lautrec's red
monogram stamp (Lugt 1338), lower left.
Delteil 224; Adhémar 300; Adriani 308;
Wittrock 284.
The impression show here has the note
'Philibert' on the verso.

Delteil mentions an impression dated
1898 and dedicated to Maurice Joyant.

302

302 JEANNE GRANIER EN BUSTE, DE TROIS
 QUARTS 1898
 *Jeanne Granier, Head and Shoulders,
 Three-quarter View*

Lithograph.
Drawing in red-brown; chalk.
282 × 229 mm.
Monogram on the stone, upper left.
Grey-blue hand-made paper, vellum.
Edition of 45 numbered impressions,
signed by the artist in pencil, lower left;
some also have Lautrec's red monogram
stamp (Lugt 1338), lower left, and the
blind stamp of the art-dealers Goupil &
Cie (Lugt 1090). One trial proof in black
and one with the note 'bon à tirer' are also
known.
Delteil 261; Adhémar 302; Adriani 279;
Wittrock 294.

Maurice Joyant and Michel Manzi, now
owner of the art-dealers Goupil & Cie,
were concerned for Lautrec's state of
health, and tried to keep him occupied.
To prevent his old friend from drinking
steadily, as far as was possible, Joyant
commissioned from him this lithograph
and four others (Nos. 303–306) in 1898.
 The woman depicted does not
resemble Marcelle Lender, as Delteil and
Adhémar suggested, so much as Jeanne
Granier (see Nos. 264, 276 and 277). A
copy of the lithograph was deposited at
the Bibliothèque Nationale, Paris, on
19 November 1898.

303 AU HANNETON 1898
 In the Hanneton

Lithograph.
Drawing in dark brown; chalk.
357 × 254 mm.
Monogram on the stone, lower right.
Vellum.
Edition of 100 numbered impressions,
signed by the artist in pencil, lower right;
they also have Lautrec's red monogram
stamp (Lugt 1338), lower right, and the
blind stamp of the art-dealers Goupil &
Cie (Lugt 1090) on the lower edge.
Delteil 272; Adhémar 290; Adriani 310;
Wittrock 296.

This picture may be of Madame Armande
Brazier – see the portrait sketches Dortu
D.4347, D.4387 (Statens Museum for
Kunst, Copenhagen) and D.4389 – at the
Brasserie Hanneton, on the Rue Pigalle,
which was a favourite haunt for lesbians.
Apparently, Calmèse's little dog was a
regular customer there too. As with sheets
Nos. 302 and 304–306, this lithograph was
commissioned by Maurice Joyant. One
impression was deposited at the
Bibliothèque Nationale, Paris, on 19
November 1898.

304 LE BON GRAVEUR,
 ADOLPHE ALBERT 1898
 The Master Engraver, Adolphe Albert

Lithograph.
First state. No monogram.
Drawing in black; chalk.
343 × 245 mm.
Hand-made Japan paper, vellum.
Two impressions known.
Delteil 273 I; Adhémar 301 I;
Adriani 312 I; Wittrock 297.
Second state. With monogram on the
stone, lower right.
Vellum.
Edition of 100 numbered impressions,
signed by the artist in pencil on the lower
left-hand edge of the sheet; some also
have Lautrec's red monogram stamp
(Lugt 1338) on the lower left edge and the
blind stamp of the art-dealers Goupil &
Cie (Lugt 1090).
Delteil 273 II; Adhémar 301 II;
Adriani 312 II; Wittrock 297.

This lithograph, commissioned by
Maurice Joyant (see Nos. 302, 303, 305
and 306), was deposited at the
Bibliothèque Nationale, Paris on 19
November 1898. It shows the engraver
Adolphe Albert (1865–1928), on whose
initiative Lautrec was able to exhibit with
the Indépendants after 1889 and at the
Salon des Peintres-Graveurs in 1893 (see
No. 13). In its compositional
arrangement, with the engraver seated at
a table in front of his litho stone, its strong
chiaroscuro effects and exactitude of
detail, all of which are unusual for
Lautrec, the portrait immediately calls to
mind Rembrandt's self-portrait of 1648
which shows the great master etching.

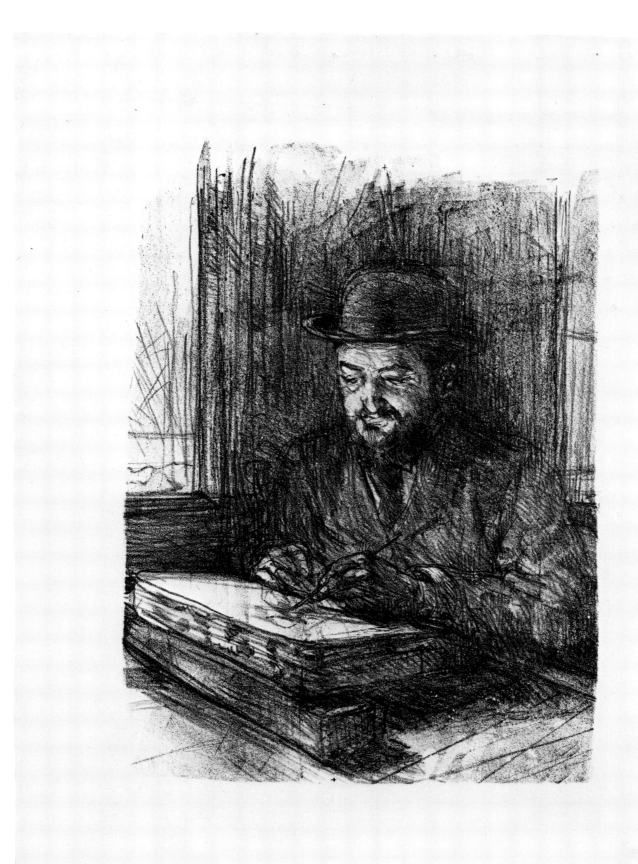

305 GUY ET MEALY,
DANS 'PARIS QUI MARCHE' 1898
Guy and Mealy in 'Paris qui marche'

Lithograph.
Drawing in violet; chalk, worked with
the scraper.
277 × 232 mm.
Monogram on the stone, upper left.
Imitation Japan paper.
Edition of 100 numbered impressions,
signed by the artist in pencil, lower left;
some also have Lautrec's red monogram
stamp (Lugt 1338), lower left, and the
blind stamp of the art-dealers Goupil &
Cie (Lugt 1090), below.
Delteil 270; Adhémar 304; Adriani 309;
Wittrock 295.

The première of the revue *Paris qui marche*
was held at the end of 1897 at the Théâtre
des Variétés, starring Georges Guillaume
Guy (1859–1917) and Juliette Samany,
known as Mealy (1867–1951). Like
Nos. 302–304 and 306, this lithograph was
commissioned by Maurice Joyant; it was
offered for sale at 20 francs, and deposited
at the Bibliothèque Nationale, Paris, on
19 November 1898.

306 DI TI FELLOW,
ANGLAISE AU CAFÉ CONCERT 1898
*Di Ti Fellow, English Singer in a
Café-Concert*

Lithograph.
Drawing in violet, chalk.
324 × 262 mm.
Monogram on the stone, lower right.
China paper.
Edition of 25 numbered impressions,
signed by the artist in pencil, lower left;
some also have the blind stamp of the art-
dealers Goupil & Cie (Lugt 1090), below.
Delteil 271; Adhémar 303; Adriani 311;
Wittrock 292.

The sheet was deposited at the
Bibliothèque Nationale, Paris, on 19
November 1898, and published by
Maurice Joyant (see Nos. 302–305) at the
price of 30 francs; see the portrait sketch
Dortu D.4427.

307 CHANTEUSE LÉGÈRE 1898
Cabaret Singer

Lithograph.
Drawing in black; chalk.
320 × 260 mm.
Monogram on the stone, lower right.
Vellum.
Edition of about 25, some with Lautrec's
red monogram stamp (Lugt 1338), lower
left; one impression in watercolour is also
known, Dortu A.257 (Charles Girard
Collection, Paris).
Delteil 269; Adhémar 359; Adriani 313;
Wittrock 291.

15

308

308 MADEMOISELLE LECONTE,
OU CHEZ LA GANTIÈRE 1898
*Mademoiselle Leconte, or At the Glove
Shop*

Lithograph.
Drawing in black; chalk.
294 × 238 mm.
Monogram on the stone, upper left.
Beige vellum.
Nine impressions known, including one
dedicated 'à Calmès' (Public Library,
Boston) and one 'à Stern' (illustrated).
Delteil 225; Adhémar 319; Adriani 314;
Wittrock 268.

309 PROMENOIR 1898
The Foyer

Lithograph.
Drawing in black; chalk.
460 × 355 mm.
Monogram on the stone, lower left.
Japan paper.
Edition of 100 numbered impressions,
some of which have Lautrec's red
monogram stamp (Lugt 1338), lower left,
and the blind stamp of the Edition de la
Maison moderne.
Delteil 290; Adhémar 324; Adriani 315;
Wittrock 307.

For the last time we see here the foyer of
the Moulin Rouge, with Gabriel Tapié de
Céleyran and the photographer Sescau in
the background on the left, in a final
reminiscence of its performers and of
Lautrec's many visits to the establishment.
This work was made at the end of 1898
for the *Album Germinal* ('album de XX
estampes originales, édition de la Maison
moderne'), published in 1899 by Julius
Meier-Graefe with a text, 'Au Bal Public',
by Geffroy; 100 impressions were made
for the publication.

310

310 CONVERSATION 1899

Lithograph.
Drawing in black; chalk.
273 × 232 mm.
Monogram on the stone, lower right.
Vellum.
One impression known.
Delteil 292; Adhémar 329; Adriani 213;
Wittrock 323.

This is probably a scene from the
Brasserie de la Souris (see Nos. 209 and
212), which Lautrec visited frequently at
the beginning of 1899. He had now
reached a state where his consumption of
alcohol resulted in neurotic fears, acute
paranoia, outbursts of violent rage and
depression. He was hardly capable of
working. To try to cut down his alcohol
consumption a little, his family decided to
find a companion to keep an eye on him.
The futility of this plan is evident from
this letter from Berthe Sarrazin, Lautrec's
housekeeper, to Lautrec's mother in Albi
on 14 February 1899: 'I've had trouble
this morning. This man is as stupid as a
goose. I don't think he'll be able to keep
on looking after Monsieur. He lets him
drink, he doesn't know at all how to
handle him … They went to the
Brasserie de la Souris in the rue Bréda.
Monsieur told the proprietress of this
dirty dive to send for wine, I don't know
how many bottles' (Goldschmidt-
Schimmel, No. 269).

311 LE CHIEN ET LE PERROQUET 1899
The Dog and the Parrot

Lithograph.
First state. With date.
Drawing in black; chalk.
308 × 262 mm.
Monogram on the stone, lower left, in the
shape of an elephant and dated in reverse:
'8 Fevrier 1899'.
Vellum.
Two impressions known.
Delteil 277 I; Adhémar 328 I;
Adriani 316 I; Wittrock 312 I.
Second state. Date removed.
Five impressions known, including one
dedicated 'à Stern' (illustrated).
Delteil 277 II; Adhémar 328 II;
Adriani 316 II; Wittrock 312 II.

This sheet, showing a dog, and a parrot
smoking a pipe, was made on 8 February
1899. With its absurd subject it has often
been taken as evidence of the
hallucinatory state of the artist's mind at
this time, but it is more likely to be a
burlesque on a painting made about 15
years earlier – Dortu A.194 – dedicated in
this case to Henri Stern.

 The monogram deserves special
mention, for it is now surrounded by an
elephant-like shape facing to the right (see
the pencil sketches Dortu
D.4504–D.4507, D.4572); it appears in the
same form on other lithographs of this
period. In all these works, the
degeneration of a mind suffering the
symptoms of paralysis is increasingly
evident. We find the old familiar themes
– the clowns after a show (No. 313), the
couple at a café-concert (No. 314), and
the old man with a young girl (Nos. 315
and 316), but they are now abandoned to
an inadequate command of form and a
distressingly exaggerated handling of line;
this tendency culminates in the darkness
and confusion of the lithograph of a
scarecrow (No. 317).

311·II

312

312 CHIEN ET CHAT 1899
Dog and Cat

Lithograph
Drawing in black; chalk.
146 × 294 mm.
Monogram and signature on the stone,
lower right, reversed.
Vellum.
Two impressions known.
Delteil 278; Adhémar 327; Adriani 317;
Wittrock 320.

313 CLOWN ET CLOWNESSE APRÈS LE
SPECTACLE 1899
*Male and Female Clown, after the
Show*

Lithograph.
Drawing in black; chalk.
310 × 262 mm.
Monogram on the stone, lower left, in the
shape of an elephant.
Vellum.
Six impressions known.
Delteil 324; Adhémar 357; Adriani 318;
Wittrock 319.

According to Delteil this unpublished
sheet was made for the printer Henri
Stern; see No. 311.

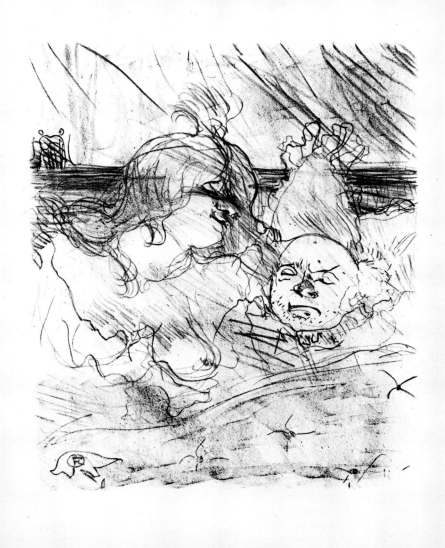

313

314

314 COUPLE AU CAFÉ CONCERT 1899
Couple at a Café-Concert

Lithograph.
Drawing in black; chalk.
260 × 314 mm.
Monogram on the stone, lower right, in
the shape of an elephant.
Vellum.
Six impressions known, one dedicated 'à
Stern' (illustrated) and another to
Lautrec's cousin Louis Pascal.
Delteil 331; Adhémar 356; Adriani 319;
Wittrock 327.

See No. 311.

315 FANTAISIE 1899
Fantasy

Lithograph.
Drawing in black; chalk.
280 × 240 mm.
Monogram on the stone, upper right, in
the shape of an elephant.
Vellum.
Two impressions known, one dedicated 'à
Stern' (illustrated).
Delteil 332; Adhémar 326; Adriani 320;
Wittrock 315.

See No. 311.

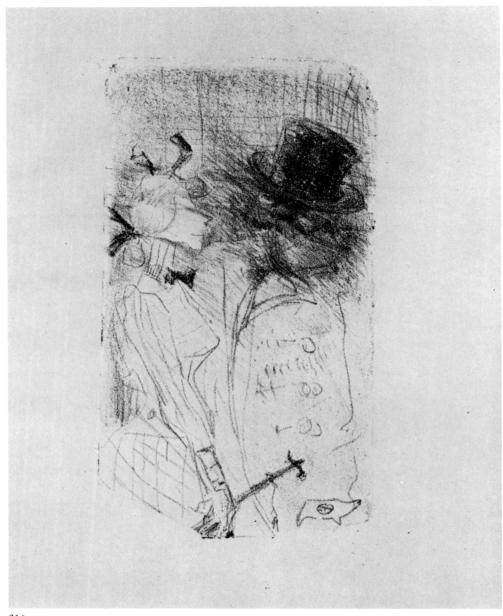

316

316 Vieux et Fillette 1899
Old Man and Young Girl

Lithograph.
Drawing in black; chalk.
243 × 133 mm.
Monogram on the stone, lower right, in
the shape of an elephant.
Imitation Japan paper, vellum.
Eight impressions known.
Delteil 229; Adhémar 265; Adriani 321;
Wittrock 318.

See No. 311.

317 L'Epouvantail 1899
The Scarecrow

Lithograph.
Drawing in black; chalk, worked with the
scraper.
285 × 190 mm.
Japan paper, vellum.
Three impressions known, one of which
is signed, lower right, in violet chalk
(illustrated).
Delteil 228; Adhémar 266; Adriani 322;
Wittrock 317.

According to Delteil this drawing of a
scarecrow and the head of a wooden horse
was made on the same day as No. 316; see
No. 311.

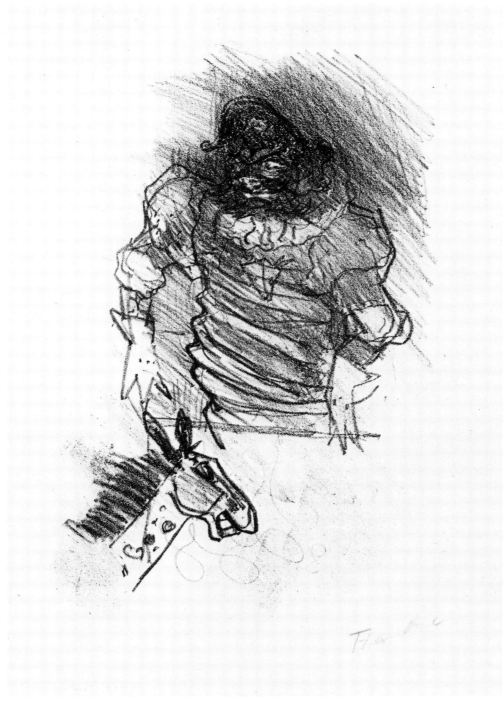

318 FOOTIT ET LE CHIEN SAVANT 1899
Footit and the Performing Dog

Lithograph.
Drawing in black; chalk.
267 × 405 mm.
Monogram on the stone, lower right, in reverse.
Vellum.
Three impressions known, one dedicated 'à Stern' (illustrated) and one in watercolour, not listed by Dortu, also dedicated 'à Stern' (illustrated).
Delteil 97; Adhémar 107; Adriani 323; Wittrock 328.

At the end of February 1899, after an acute attack of delirium tremens Lautrec was admitted to Dr Sémelaigne's psychiatric clinic in Neuilly, at 16 Avenue de Madrid. After radical 'drying-out' treatment the 'prisoner' had recovered sufficiently by mid-March to ask Joyant on the 17th of the month for litho stones, a watercolour box with sepia, a brush, some litho chalks, and good quality ink and paper (Joyant I, p. 216).

On his release in May the artist said to Joyant, not without pride, 'I bought my freedom with my drawings' (Joyant I, p. 222). The 'souvenirs de ma captivité' (dedicated to Arsène Alexandre) included 37 drawings in chalk, ink and coloured crayon drawn from memory on the subject of the circus – Dortu D.4522–D.4543, D.4546–D.4560.

Three lithographs that are related stylistically and thematically to the circus drawings (Nos. 318–320) could have been made at this time. They take up familiar motifs, and on this print, pulled by Stern, and the following one, we again find the clown Georges Footit with his performing dog at the Nouveau Cirque; see No. 104.

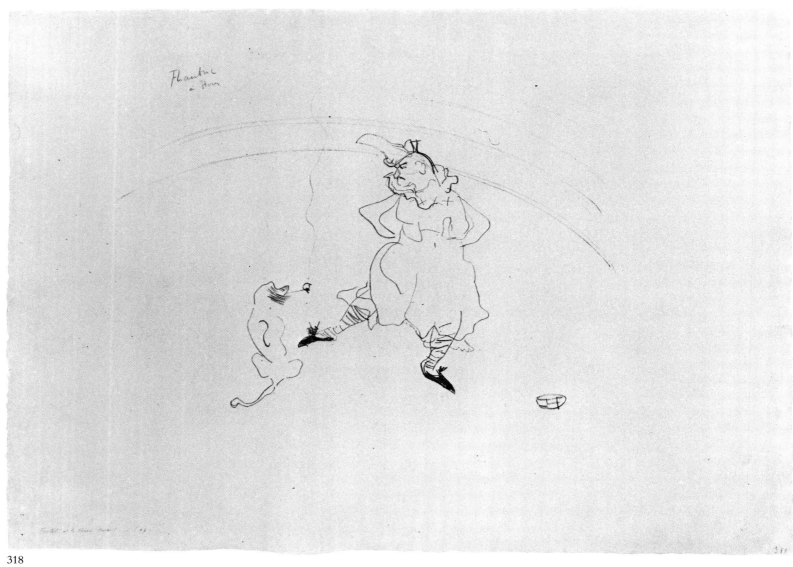

318

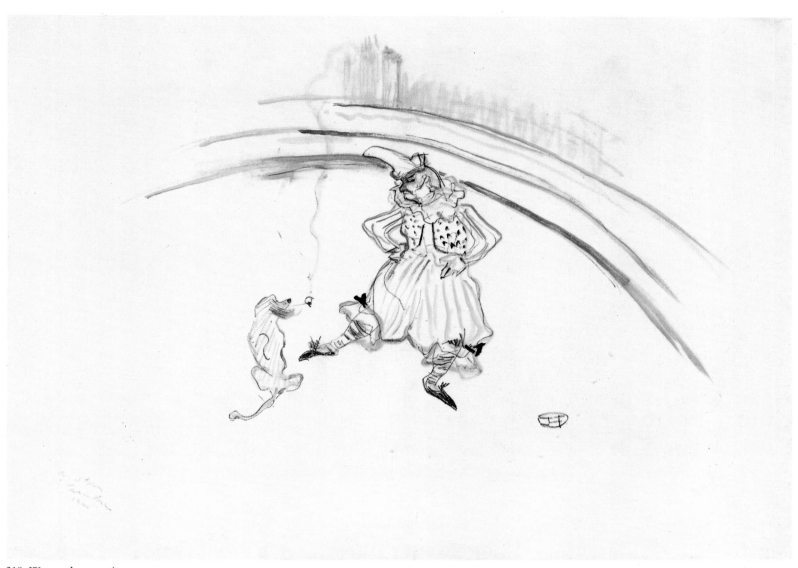

318 Watercolour version

319

320 La Goulue devant le
Tribunal 1899
La Goulue in Court

Lithograph.
Drawing in dark violet; chalk.
297 × 245 mm.
Reverse monogram on the stone, below.
Vellum.
Edition of 25, some numbered; one trial
proof with the note 'bon à tirer 25' also
known.
Delteil 148; Adhémar 146; Adriani 325;
Wittrock 329.

This last sheet devoted to La Goulue and
printed by Stern, Paris, takes up the
theme of an event long past. Stylistically,
it is close to the drawings in coloured
crayon which Lautrec made while he was
a patient at the clinic in Neuilly (see
No. 318). The print recalls the tragic
events of the summer of 1893. These
resulted in a rather comic finale, with the
court appearance of the erstwhile 'wild
cat', who, already tending to corpulence,
was beginning to work with performing
animals. On 9 February 1893 the second
art-students' ball, the *Bal des Quatr'z' Arts*,
was held on the initiative of Jules Roques
at the Moulin Rouge. But it had
distressing consequences, when the strict
moralist senator René Béranger and his
supporters brought charges against some
of the participants for 'indecent attire'.
The case was brought to court, and La
Goulue was summoned as a witness –
although, no doubt, she did not appear in
the garb in which Lautrec has portrayed
her here. The verdict led to protest
marches by the students through the
Quartier Latin on 1 July 1893, and when
the police intervened, barricades were
erected and street-fighting broke out, in
the course of which several people were
killed. It was 6 July before order could be
restored.

319 Menu du Dîner des
Tarnais 1899
Menu Card for the Dîner des Tarnais

Lithograph, menu card, with lettering not
designed by Lautrec: 'Dîner des Tarnais'.
Drawing in black; chalk.
188 × 187 mm.
Monogram on the stone, lower left.
Imitation Japan paper.
Two impressions known.

Delteil 197; Adhémar 221; Adriani 324;
Wittrock 172.

See Nos. 318 and 320, where the curl of
the whip also ends with the circle of the
monogram. This motif was sketched in a
similar form on a design for a fan, Dortu
D.3055 (E. W. Kornfeld Collection,
Berne); the fan was probably also made in
1899, and not in 1888, as Dortu assumed.

D148

11017

La goulue en dompteuse

Lautrec had met the well-known writer Jules Renard on 26 November 1894 at the home of the Natanson family, and at the end of 1895 told him he would like to do some illustrations for a book Renard was planning, called *Histoires Naturelles*. The two did not agree on the choice of illustrations or the design, however, and the project took a long while to materialize. Of the 23 transfer lithographs Lautrec produced for this project, which include an unpublished design for the cover (No. 344) and the drawing of a sparrow-hawk that he had made in 1897 (No. 206), only a few go beyond a skilful illustrative naturalism and retain anything of the exuberance that we find in the numerous small pencil sketches made on his many visits to the zoos at the Jardin des Plantes and the Jardin d'Acclimatation. While he was interned at the clinic in Neuilly, the artist had time and leisure to complete his series of illustrations; he commissioned Henri Stern to print them, and Jules Renard's book appeared in the summer of that year. One author's copy with a dedication is dated September 1899 (see the auction catalogue *Moderne Kunst des Neunzehnten und Zwanzigsten Jahrhunderts*, Galerie Kornfeld, Berne, 22–24 June 1983, No. 888). The book was published by Henri Floury with typography designed by Ch. Renaudin; it was offered for sale at 25 francs, and included a cover designed by Lautrec and 22 full-page 'lithographies tirées sur les presses à bras' (pulled on a hand-press). The edition was limited to 100 books, numbered on the imprint page. In 1959 a facsimile edition was published by Henri Floury.

321·II

322·II

321 COUVERTURE DES 'HISTOIRES NATURELLES' 1899
Cover for 'Histoires Naturelles'

Transfer lithograph, cover for the book *Histoires Naturelles*.
First state. With lettering designed by Lautrec: 'Histoires/Naturelles/édité par Floury'.
Drawing in black; ink with brush.
262 × 200 mm.
Monogram on the stone, upper left.
Vellum.
One impression known (Bibliothèque Nationale, Paris).
Delteil 297 I; Adhémar 333 (state not described); Adriani 326 I; Wittrock 202 I.
Second state. The line of lettering, upper left ('édité par Floury'), removed; used as the cover in this form.
Japan paper.
Edition of 100.
Delteil 297 II; Adhémar 333;
Adriani 326 II; Wittrock 202 II.

The motif of the fox chosen for the cover is a play on the name of the author, Renard; see No. 344.

322 COQS 1899
Cocks

Transfer lithograph, first sheet for *Histoires Naturelles*.
First state. No lettering.
Drawing in black; chalk, ink with brush.
230 × 196 mm.
Monogram on the stone, upper left.
Vellum.
Delteil mentions one impression.
Delteil 298 I; Adhémar 334 (state not described); Adriani 327 I; Wittrock 203.
Second state. With lettering not designed by Lautrec in olive grey: 'Coqs'.
Edition of 100.
Delteil 298 II; Adhémar 334;
Adriani 327 II; Wittrock 203.

323·II

324·II

325·II

323 LA PINTADE 1899
The Guinea-Fowl

Transfer lithograph, second sheet for
Histoires Naturelles.
First state. No lettering.
Drawing in black; chalk.
200 × 152 mm.
Monogram on the stone, lower left.
Vellum.
Two impressions known (Kunsthalle,
Bremen).
Delteil 299 I; Adhémar 335 (state not
described); Adriani 328 I; Wittrock 204.
Second state. With lettering not designed
by Lautrec, in olive grey: 'La Pintade'.
Edition of 100.
Delteil 299 II; Adhémar 335;
Adriani 328 II; Wittrock 204.

324 LA DINDE 1899
The Turkey

Transfer lithograph, third sheet for
Histoires Naturelles.
First state. No lettering.
Drawing in black; chalk.
208 × 132 mm.
Monogram on the stone, lower right.
Vellum.
One impression known (Kunsthalle,
Bremen).
Delteil 300 I; Adhémar 336 (state not
described); Adriani 329 I; Wittrock 205.
Second state. With lettering not designed
by Lautrec, in olive grey: 'La Dinde'.
Edition of 100.
Delteil 300 II; Adhémar 336;
Adriani 329 II; Wittrock 205.

See the pencil sketch Dortu D.4587.

325 LE PAON 1899
The Peacock

Transfer lithograph, fourth sheet for
Histoires Naturelles.
First state. No lettering.
Drawing in black; chalk.
230 × 198 mm.
Monogram on the stone, lower left.
Vellum.
One impression known (Kunsthalle,
Bremen).
Delteil 301 I; Adhémar 337 (state not
described); Adriani 330 I; Wittrock 206.
Second state. With lettering not designed
by Lautrec, in olive grey: 'Le/Paon'.
Edition of 100.
Delteil 301 II; Adhémar 337;
Adriani 330 II; Wittrock 206.

326·II

327·II

328·II

326 LE CYGNE 1899
The Swan

Transfer lithograph, fifth sheet for
Histoires Naturelles.
First state. No lettering.
Drawing in black; chalk.
205 × 205 mm.
Monogram on the stone, upper right.
Vellum.
Two impressions known (Kunsthalle,
Bremen).
Delteil 302 I; Adhémar 338 (state not
described); Adriani 331 I; Wittrock 207.
Second state. With lettering not designed
by Lautrec, in olive grey: 'Le/Cygne'.
Edition of 100.
Delteil 302 II; Adhémar 338;
Adriani 331 II; Wittrock 207.

327 CANARDS 1899
Ducks

Transfer lithograph, sixth sheet for
Histoires Naturelles.
First state. No lettering.
Drawing in black; chalk.
170 × 165 mm.
Monogram on the stone, lower right.
Vellum.
One impression known (Kunsthalle,
Bremen).
Delteil 303 I; Adhémar 339 (state not
described); Adriani 332 I; Wittrock 208.
Second state. With lettering not designed
by Lautrec, in olive grey: 'Canards'.
Edition of 100.
Delteil 303 II; Adhémar 339;
Adriani 332 II; Wittrock 208.

328 LES PIGEONS 1899
Pigeons

Transfer lithograph, seventh sheet for
Histoires Naturelles.
First state. No lettering.
Drawing in black; chalk.
233 × 194 mm.
Monogram on the stone, upper left,
reversed.
Vellum.
One impression known with the note
'bon' (Kunsthalle, Bremen).
Delteil 304 I; Adhémar 340 (state not
described); Adriani 333 I; Wittrock 209.
Second state. With lettering not designed
by Lautrec, in olive grey: 'Les Pigeons'.
233 × 168 mm.
Edition of 100.
Delteil 304 II; Adhémar 340;
Adriani 333 II; Wittrock 209.

L'Epervier

La Souris

L'Escargot

329·II

330·II

331·II

329 L'EPERVIER 1899
The Sparrow-Hawk

Transfer lithograph, eighth sheet for *Histoires Naturelles*.
First state. No lettering.
Drawing in black; chalk.
222 × 216 mm.
Monogram on the stone, upper left, in reverse.
Vellum.
One impression known with the note 'bon' (Kunsthalle, Bremen).
Delteil 305 I; Adhémar 341 (state not described); Adriani 334 I; Wittrock 210.
Second state. With lettering not designed by Lautrec, in olive grey: 'L'Epervier'.
220 × 205 mm.
Edition of 100.
Delteil 305 II; Adhémar 341;
Adriani 334 II; Wittrock 210.

See No. 206.

330 LA SOURIS 1899
The Mouse

Transfer lithograph, ninth sheet for *Histoires Naturelles*.
First state. No lettering.
Drawing in black; chalk.
122 × 122 mm.
Monogram on the stone, lower left.
Vellum.
Delteil mentions impressions.
Delteil 306 I; Adhémar 342 (state not described); Adriani 335 I; Wittrock 211.
Second state. With lettering not designed by Lautrec, in olive grey: 'La Souris'.
Edition of 100.
Delteil 306 II; Adhémar 342;
Adriani 335 II; Wittrock 211.

See the sheet of sketches Dortu D.4460.

331 L'ESCARGOT 1899
The Snail

Transfer lithograph, tenth sheet for *Histoires Naturelles*.
First state. No lettering.
Drawing in black; chalk.
95 × 182 mm.
Monogram on the stone, lower left.
Vellum.
Two impressions known.
Delteil 307 I; Adhémar 343 (state not described); Adriani 336 I; Wittrock 212.
Second state. With lettering not designed by Lautrec, in olive grey: 'L'Escargot'.
Edition of 100.
Delteil 307 II; Adhémar 343;
Adriani 336 II; Wittrock 212.

See the sheet of sketches Dortu D.4460.

L'Araignée

332·II

Le Crapaud

333·II

Le Chien

334·II

332 L'ARAIGNÉE 1899
The Spider

Transfer lithograph, eleventh sheet for
Histoires Naturelles.
First state. No lettering.
Drawing in black; chalk.
178 × 160 mm.
Monogram on the stone, left, in reverse,
caught in a spider's web.
Vellum.
One impression known with the note
'bon' (Kunsthalle, Bremen).
Delteil 308 I; Adhémar 344 (state not
described); Adriani 337 I; Wittrock 213.
Second state. With lettering not designed
by Lautrec, in olive grey: 'L'Araignée'.
156 × 156 mm.
Edition of 100.
Delteil 308 II; Adhémar 344;
Adriani 337 II; Wittrock 213.

333 LE CRAPAUD 1898/1899
The Toad

Transfer lithograph, twelfth sheet for
Histoires Naturelles.
First state. No lettering.
Drawing in black; chalk.
60 × 96 mm.
Monogram on the stone, lower left.
Vellum.
Two impressions known, one dated '98'
and dedicated 'à Malfeyt' (Bibliothèque
Nationale, Paris).
Delteil 309 I; Adhémar 345 (state not
described); Adriani 338 I; Wittrock 214.
Second state. With lettering not designed
by Lautrec, in olive grey: 'Le Crapaud'.
Edition of 100.
Delteil 309 II; Adhémar 345;
Adriani 338 II; Wittrock 214.

334 LE CHIEN 1899
The Dog

Transfer lithograph, thirteenth sheet for
Histoires Naturelles.
First state. No lettering.
Drawing in black; chalk.
238 × 205 mm.
Monogram on the stone, upper left.
Vellum.
Two impressions known.
Delteil 310 I; Adhémar 346 (state not
described); Adriani 339 I; Wittrock 215.
Second state. With lettering not designed
by Lautrec, in olive grey: 'Le Chien'.
Edition of 100.
Delteil 310 II; Adhémar 346;
Adriani 339 II; Wittrock 215.

394

335·II

336·II

337·II

335 LES LAPINS 1899
The Rabbits

Transfer lithograph, fourteenth sheet for
Histoires Naturelles.
First state. No lettering.
Drawing in black; chalk.
225 × 202 mm.
Monogram on the stone, upper right.
Vellum.
Delteil mentions impressions.
Delteil 311 I; Adhémar 347 (state not
described); Adriani 340 I; Wittrock 216.
Second state. With lettering not designed
by Lautrec, in olive grey: 'Les/Lapins'.
Edition of 100.
Delteil 311 II; Adhémar 347;
Adriani 340 II; Wittrock 216.

336 LE BŒUF 1899
The Ox

Transfer lithograph, fifteenth sheet for
Histoires Naturelles.
First state. No lettering.
Drawing in black; chalk.
179 × 207 mm.
Monogram on the stone, upper right.
Vellum.
One impression known (Kunsthalle,
Bremen).
Delteil 312 I; Adhémar 348 (state not
described); Adriani 341 I; Wittrock 217.
Second state. With lettering not designed
by Lautrec, in olive grey: 'Le Bœuf'.
Edition of 100.
Delteil 312 II; Adhémar 348;
Adriani 341 II; Wittrock 217.

See the colour study and pencil sketch,
Dortu P.691 and D.4598.

337 L'ANE 1899
The Donkey

Transfer lithograph, sixteenth sheet for
Histoires Naturelles.
First state. No lettering.
Drawing in black; chalk.
155 × 178 mm.
Monogram on the stone, lower left.
Vellum.
Delteil mentions one impression.
Delteil 313 I; Adhémar 349 (state not
described); Adriani 342 I; Wittrock 218.
Second state. With lettering not designed
by Lautrec, in olive grey: 'L'Ane'.
Edition of 100.
Delteil 313 II; Adhémar 349;
Adriani 342 II; Wittrock 218.

See the pencil sketch Dortu D.4597.

338·II

339·II

340·II

338 LE CERF 1899
 The Stag

Lithograph, seventeenth sheet for
Histoires Naturelles.
First state. No lettering; large picture
surface.
Drawing in black; chalk, sprayed ink,
worked with the scraper.
330 × 253 mm.
Monogram on the stone, lower right.
Vellum.
One impression worked over in pencil
and marked 'passe' is also known
(Staatsgalerie, Stuttgart).
Delteil 314 I; Adhémar 350 (state not
described); Adriani 343 I; Wittrock 219 I.
Second state. No lettering; sprayed areas
top and bottom enlarged, drawing in the
stag revised.
350 × 256 mm.
One impression known, marked 'bon
tenir les jambes et derrière dans le . . .'
(Bibliothèque Nationale, Paris).
Delteil 314 II; Adhémar 350 (state not
described); Adriani 343 II;
Wittrock 219 II.
Third state. No lettering; picture surface
greatly reduced; stag's legs somewhat
shorter.
240 × 203 mm.
One impression known
(Kupferstichkabinett, Berlin).
Delteil 314 III; Adhémar 350 (state not

described); Adriani 343 III;
Wittrock 219 III.
Fourth state. With lettering not designed
by Lautrec, in olive grey: 'Le Cerf'.
Edition of 100.
Delteil 314 IV; Adhémar 350;
Adriani 343 IV; Wittrock 219 III.

339 LE BOUC 1899
 The Ram

Transfer lithograph, eighteenth sheet for
Histoires Naturelles.
First state. No lettering.
Drawing in black; chalk.
237 × 175 mm.
Monogram on the stone, lower left.
Vellum.
Delteil mentions impressions.
Delteil 315 I; Adhémar 351 (state not
described); Adriani 344 I; Wittrock 220.
Second state. With lettering not designed
by Lautrec, in olive grey: 'Le/Bouc'.
Edition of 100.
Delteil 315 II; Adhémar 351;
Adriani 344 II; Wittrock 220.

340 LES MOUTONS 1899
 The Sheep

Transfer lithograph, nineteenth sheet for
Histoires Naturelles.
First state. No lettering.
Drawing in black; chalk.
235 × 201 mm.
Monogram on the stone, upper left.
Vellum.
One impression known, marked 'bon'
(Kunsthalle, Bremen).
Delteil 316 I; Adhémar 352 (state not
described); Adriani 345 I; Wittrock 221.
Second state. With lettering not designed
by Lautrec, in olive grey: 'Les/Moutons'.
Edition of 100.
Delteil 316 II; Adhémar 352;
Adriani 354 II; Wittrock 221.

341·II

342·II

343·II

341 LE TAUREAU 1899
 The Bull

Transfer lithograph, twentieth sheet for
Histoires Naturelles.
First state. No lettering.
Drawing in black; chalk.
225 × 196 mm.
Monogram on the stone, lower right.
Vellum.
One impression known, marked 'bon'
(Kunsthalle, Bremen).
Delteil 317 I; Adhémar 353 (state not
described); Adriani 346 I;
Wittrock 222.
Second state. With lettering not designed
by Lautrec, in olive grey: 'Le Taureau'.
Edition of 100.
Delteil 317 II; Adhémar 353;
Adriani 346 II; Wittrock 222.

342 LE COCHON 1899
 The Pig

Transfer lithograph, sheet twenty-one for
Histoires Naturelles.
First state. No lettering.
Drawing in black; chalk.
98 × 180 mm.
Monogram on the stone, lower left.
Vellum.
Delteil mentions one impression.
Delteil 318 I; Adhémar 354 (state not
described); Adriani 347 I; Wittrock 223.
Second state. With lettering not designed
by Lautrec, in olive grey: 'Le Cochon'.
Edition of 100.
Delteil 318 II; Adhémar 354;
Adriani 347 II; Wittrock 223.

See the sheet of sketches Dortu D.4460.

343 LE CHEVAL 1899
 The Horse

Transfer lithograph, sheet twenty-two for
Histoires Naturelles.
First state. No lettering.
Drawing in black; ink with brush.
225 × 193 mm.
Monogram on the stone, upper right.
Vellum, China paper.
Five impressions known.
Delteil 319 I; Adhémar 355 (state not
described); Adriani 348 I; Wittrock 224.
Second state. With lettering not designed
by Lautrec, in olive grey: 'Le/Cheval'.
Edition of 100.
Delteil 319 II; Adhémar 355;
Adriani 348 II; Wittrock 224.

344

345·I

345　Le Jockey　1899
The Jockey

Colour lithograph.
First state.
Drawing in black; chalk.
513 × 360 mm.
Monogram on the stone, lower right, and
dated in reverse.
China paper.
Edition of about 100; three trial proofs on
vellum also known, two worked over in
colour – Dortu A.259.
Delteil 279; Adhémar 365; Adriani 356 I;
Wittrock 308 I.
Second state.
Drawing in black with green, carmine,
brown, beige and blue; chalk, ink with
brush and sprayed.
518 × 362 mm.
China paper, Japan paper.
Edition of 112, of which 12 are on Japan
paper; four trial proofs also known, one
worked over in colour (not in Dortu; see
auction catalogue *Henri de Toulouse-
Lautrec. Lithographs*, Sotheby Parke
Bernet & Co., London 1978, No. 136).
Delteil 279; Adhémar 365; Adriani 356 II;
Wittrock 308 II.
The trial proof illustrated here
(530 × 372 mm) is printed on vellum.

The publisher Pierrefort, who had visited
the artist in the clinic at Neuilly in
company with Stern on 17 May 1899,
suggested that a series showing scenes at
race meetings should be published,
entitled *Courses*. Although Lautrec made
altogether four prints on this theme
(Nos. 345–348), Pierrefort published only
this one, printed by Stern, as an edition in
two states. Only a few proofs were made
of the monochrome prints No. 346 (The
Paddock) and No. 347 (The Trainer and
his Jockey) and of No. 348 (The Jockey
going to the Post), which was to be
reproduced in colour.

344　Couverture Inédite des 'Histoires
Naturelles'　1899
*Unpublished Cover for 'Histoires
Naturelles'*

Lithograph, rejected cover for *Histoires
Naturelles*.
Drawing in black; chalk.
304 × 218 mm.
Monogram on the stone, lower right.
Vellum.
Two impressions known, one marked
'bon' (Staatsgalerie, Stuttgart;
Bibliothèque Nationale, Paris).
Delteil 321; Adhémar 262; Adriani 349;
Wittrock 225.

See the cover used instead of this design,
No. 321.

345·II Trial proof

347

346 LE PADDOCK 1899
The Paddock

Lithograph.
Drawing in black; chalk.
369 × 323 mm.
Monogram on the stone, lower left.
Vellum.
Five impressions known, two of which
are worked in colour (Bibliothèque
Nationale, Paris; Dortu A.258, Statens
Museum for Kunst, Kopenhagen).
Delteil 280; Adhémar 364; Adriani 357;
Wittrock 310.

See No. 345.

347 L'ENTRAÎNEUR ET SON
 JOCKEY 1899
 The Trainer and his Jockey

Lithograph.
Drawing in black; chalk.
303 × 258 mm.
Monogram on the stone, lower left, in the
shape of an elephant.
Vellum.
Two impressions known, one dedicated 'à
Stern' (illustrated).
Delteil 281; Adhémar 362; Adriani 358;
Wittrock 309.

See No. 345.

348·II

348·III

348 LE JOCKEY SE RENDANT AU
POTEAU 1899
The Jockey Going to the Post

Colour lithograph.
First state. Trousers on the figure in the
foreground partly drawn.
Drawing in black; chalk.
390 × 297 mm.
Monogram on the stone in reverse, lower
left.
Vellum.
One impression known (see auction
catalogue *Henri de Toulouse-Lautrec.
Lithographs*, Sotheby Parke Bernet & Co.,
London 1978, No. 137).
Delteil 282 (state not described);
Adhémar 363 (state not described);
Adriani 359 (state not described);
Wittrock 311 I.
Second state. Drawing slightly reduced left
and right.
398 × 283 mm.
Vellum.
Three impressions known, one painted in
colour Dortu A.264 (Museum of Fine
Arts, Boston).
Delteil 282 II; Adhémar 363 II;
Adriani 359 II; Wittrock 311 II.
Third state. Drawing on trousers of
foreground figure covered over.
396 × 280 mm.
Imitation Japan paper.
Seven impressions known.
Delteil 282 I; Adhémar 363 I;
Adriani 359 I; Wittrock 311 III.
Fourth state. The image now in colour and
the trousers once more indicated on the
foreground figure.
Drawing in black with grey-blue, brown,
ochre and reddish brown; chalk, ink with
brush and sprayed.
437 × 282 mm.
China paper.
Three impressions known.
Delteil 282 (state not described);
Adhémar 363 (state not described);
Adriani 359 (state not described);
Wittrock 311 IV.
Fifth state. The rider's hand no longer
overprinted in ochre; drawing on trousers
of foreground figure greatly extended.
446 × 285 mm.
China paper.
One impression known worked over
with red chalk (illustrated).
Delteil 282 III; Adhémar 363 (state not
described); Adriani 359 III;
Wittrock 311 V.

See No. 345.

348·V

349 AU BOIS 1899
In the Bois de Boulogne

Lithograph.
Drawing in black; chalk.
345 × 245 mm.
Monogram on the stone, lower left.
Vellum.
Edition of about 30, some with Lautrec's
red monogram stamp (Lugt 1338), lower
left.
Delteil 296; Adhémar 255; Adriani 355;
Wittrock 185.

To allow him to spend as much time as
possible in the open air, in 1899, as in the
previous year, Lautrec would regularly
have himself driven to the Bois de
Boulogne, and it is there that this
charming sketch of his cousin Aline de
Rivières was made. A similar watercolour
in the form of a fan, Dortu A.261, is dated
1899 and bears the dedication: 'A ma
cousine Aline de Rivières et à son papa';
see also the colour study Dortu P.692,
probably also intended as a design for a
fan.

350 AU STAR, LE HAVRE 1899
At the Star, Le Havre

Lithograph.
Drawing in black; chalk.
459 × 373 mm.
Monogram on the stone in reverse, on the
woman's belt.
Vellum, imitation Japan paper.
Edition of about 20, one worked over in
colour, Dortu P.693 (Museu de Arte, São
Paulo).
Delteil 275; Adhémar 358; Adriani 351;
Wittrock 325.

In July 1899 Lautrec was on holiday at Le
Crotoy on the Channel coast, and he also
spent some time at Le Havre, where he
found English entertainers performing a
rough, but original act in the sailor's pub
Le Star, on the Rue du Général Faidherbe;
see the two following prints, Nos. 351
and 352.

351 PETIT FILLE ANGLAISE, MISS DOLLY,
AU STAR 1899
*Young Englishwoman, Miss Dolly, at
the Star*

Lithograph.
Drawing in black; chalk.
220 × 177 mm.
Monogram on the stone, lower left.
Vellum.
Edition of about 20, some signed and with
Lautrec's red monogram stamp
(Lugt 1338), lower left or right; one is
dedicated 'à Malfeyt' (illustrated).
Delteil 274; Adhémar 367; Adriani 352;
Wittrock 324.

See No. 350. The lithograph was printed
by Malfeyt and it was made from the
painting Dortu P.679, which is almost
identical in its dimensions.

D₂₉₆

Au Bois (rare)

350

352 LA CHANSON DU MATELOT,
 AU STAR, LE HAVRE 1899
 *The Sailor's Song, at the Star, Le
 Havre*

Colour lithograph.
Drawing in violet or brown with yellow,
red and blue; chalk, ink with brush and
spraying technique.
345 × 270 mm.
Monogram on the stone, upper right.
Vellum.
Four impressions known; the impression
from the archives of the Chaix printing
firm is signed by the artist in pencil, lower
left, and bears the note 'bon à tirer'; it also
has a note in the artist's hand, upper right:
'Miss X in/the alabamah/coons' (see
auction catalogue *Nineteenth and
Twentieth Century Prints*, Sotheby's,
London, 5 December 1984, No. 299).
Delteil 276; Adhémar 360; Adriani 353;
Wittrock 326.

See No. 350. The drawing Dortu D.4451
(Boymans-van Beuningen Museum,
Rotterdam) may possibly show a partner
of this English singer, shown here in a
sailor suit, since she wears a similar
costume.

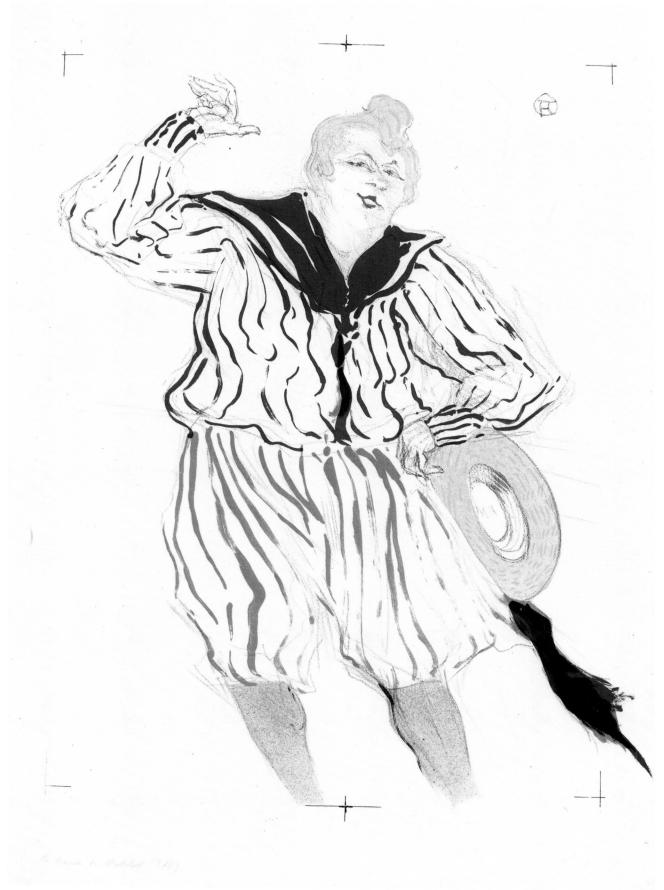

353

353 EN SCÈNE 1899
On Stage

Colour lithograph.
Drawing in grey with orange and red;
chalk, ink with brush and spraying
technique.
291 × 240 mm.
Vellum.
Five impressions known with the note
'passe' in the artist's hand in pencil, lower
left or right; one is coloured in
watercolour – Dortu A.256; two of the
impressions have the stamp of the printers
E. Malfeyt & Cie. on the verso.
Delteil 213; Adhémar 305; Adriani 354;
Wittrock 269.

354 JANE AVRIL 1899

Colour lithograph, poster.
First state. No lettering, only the name of
the printer.
Drawing in black; ink with brush.
555 × 344 mm.
Monogram on the stone, lower right,
with date; name of the printer: 'H. Stern
Paris' on right edge.
Vellum.
One impression in watercolour, signed by
the artist in pencil, lower left, and bearing
the following dedication: 'a stern/dans
l'emotion d'un/premier debut'; the print,
which once belonged to Maurice Loncle
(see auction catalogue *Collection M.L.*,
Galerie Charpentier, Paris 1959, No. 256),
is mentioned by Dortu (A.262), but
wrongly illustrated as its final poster state.
Delteil 367 (state not described);
Adhémar 323 (state not described);
Adriani 360 I; Wittrock P 29.
Second state. With lettering designed by
Lautrec: 'JANE/Avril' and remarque.
Drawing in black with red, yellow and
blue (yellow and blue printed from the
same stone).
Remarque added on the stone in black,
lower left: a little snake.
Edition of 25 impressions, some
numbered and signed by the artist in
pencil, lower left.
Delteil 367 I; Adhémar 323 I;
Adriani 360 II; Wittrock P 29 A.
Third state. Remarque removed.
Size of edition not known.
Delteil 367 II; Adhémar 323 II;
Adriani 360 III; Wittrock P 29 B.

One of Lautrec's most compelling colour
posters, this was commissioned at the
beginning of 1899 by Jane Avril, who
remained faithful to Lautrec to the last,
and printed by Stern in the course of that
year. For reasons no longer apparent,
however, it was never displayed. In the
treatment of the female silhouette, which
is almost full-length, it is related to the
following work, No. 355. For these last
two posters from lithographs, the artist
was able to use a process which enabled
different colours to be applied at one
printing, provided they were arranged in
the order of rotation of the machine, and
here only three printings were needed for
the four colours used.
 The design sketch Dortu S.D.29,
pencil, 55.8 × 37.6 cm, has the same
dimensions as the poster, and some notes
on the colours for the printer: 'Rouge/
bleu roi/noir' (Ill. p. 412).

Study for 354

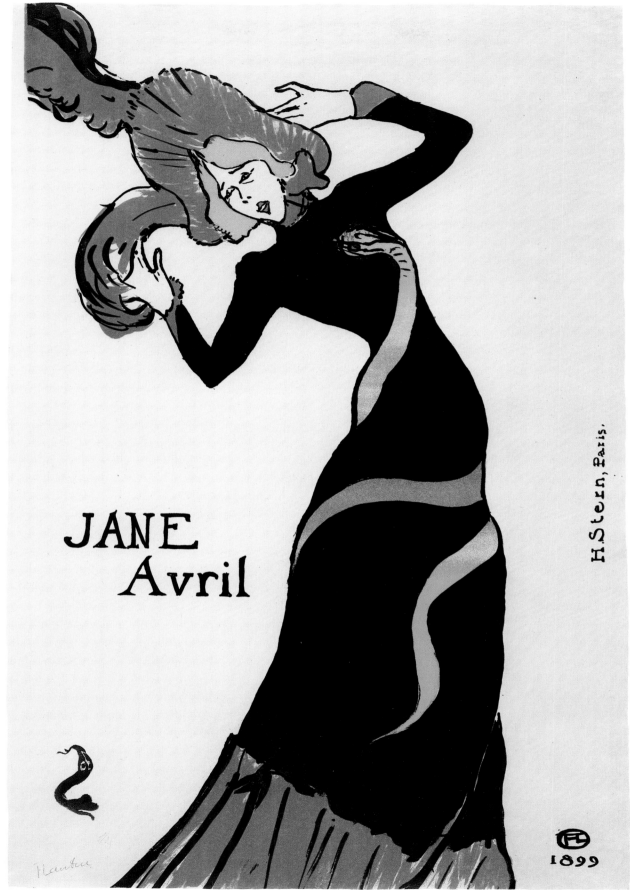

JANE
Avril

H.Stern, Paris.

1899

355 'LA GITANE' 1899/1900

Colour lithograph, poster, with lettering
designed by Lautrec in red and brown:
'Théâtre/Antoine/La Gitane/de/
Richepin'.
Drawing in black with olive-grey, blue,
red and brown (the red and brown of the
lettering and the coat on the figure in the
background were printed in one process).
Chalk, ink with brush and spraying
technique.
910 × 635 mm.
Monogram in black on each stone, lower
right, with the address of the printer in
red: 'Imp. EUGÈNE VERNEAU. 108,
Rue Folie Méricourt, PARIS'.
Vellum.
Delteil 368; Adhémar 366; Adriani 361;
Wittrock P 30.

The drama *La Gitane* (The Gypsy) by Jean
Richepin had its première on 22 January
1900 at the Théâtre Antoine. The leading
role was played by Marthe Mellot (shown
here), and her husband, Alfred Athis
Natanson, probably ordered the poster
from Lautrec, but an edition of it was
never printed; see the colour study Dortu
P.717 and the numerous sketches Dortu
D.4659–D.4663 and D.4672 (with a
dedication to the printer Verneau).

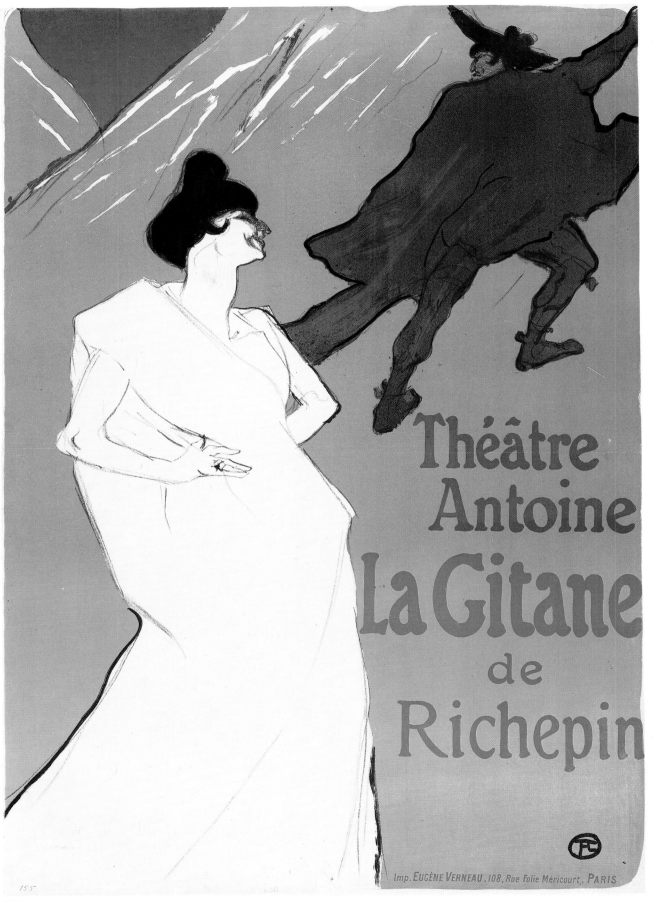

à M. Berni-Vert
les croqsimargous

356 MADAME LE MARGOIN, MODISTE 1900
Madame le Margoin, Milliner

Lithograph.
Drawing in black; chalk, worked with the scraper.
320 × 258 mm.
Monogram on the stone, upper left.
Vellum.
Edition of 40, some with Lautrec's red monogram stamp (Lugt 1338), lower right; two impressions dedicated 'au Margoin' and 'à Mme Renée Vert/les Croqsimargoins' (illustrated) and one impression with the note 'bon' are also known.
Delteil 325; Adhémar 370; Adriani 362; Wittrock 334.

This print shows the lover of Maurice Joyant, the eighteen-year-old Louise Blouet, who worked as a seamstress and model for Renée Vert. Lautrec nicknamed her 'Croqsimargoin', which in Parisian slang means 'the model who is nice to draw' or 'nice to nibble'. In Louise the artist found a woman he deeply respected; she showed him not pity, but deep sympathy and understanding, and their fondness for each other, which never interfered with her relation with his friend, bore fruit in April 1900 in one of Lautrec's loveliest portraits, printed by Stern. The intensity of the facial expression, the simple proportions and delicacy of the details, which only gradually reveal themselves as hat, curls and dress, represent the very essence of Lautrec's art for perhaps the last time; see the painting Dortu P.716 (Musée d'Albi).

357 DANS LA COULISSE 1900
In the Wings

Lithograph.
Drawing in black; chalk.
540 × 418 mm.
Monogram on the stone, lower right.
Vellum.
Two impressions known; Delteil mentions one impression worked over in colour.
Delteil 268; Adhémar 320; Adriani 363; Wittrock 330.

In the autumn of 1900 Lautrec decided to spend the winter in Bordeaux, rather than in Paris, and he took an apartment in the Rue de Caudéran and a studio in the Rue Porte-Digeaux. For a brief period his old productivity revived, as he attended the Grand Théâtre in December to see Jacques Offenbach's *La Belle Hélène* and Isidore de Lara's opera *Messalina*. The result was six paintings on the subject of *Messalina*, several drawings on both productions, and two lithographs which probably also belong to this series (Nos. 357 and 358). 'I am working hard ...', he wrote to Joyant on 6 December, 'we are all delighted with the production of *La Belle Hélène* at the theatre here, it is marvellous', and a few days later: 'Have you any photos, good or bad, of Lara's *Messalina*? I am working on the production and the more documentation I have, the better' (Joyant I, pp. 23f.).

358 DANS 'LA BELLE HÉLÈNE' 1900
Scene from 'La Belle Hélène'

Lithograph.
Drawing in black; chalk.
530 × 460 mm.
Monogram on the stone, upper left.
Vellum.
Edition of about 30 impressions, some numbered, some with Lautrec's red monogram stamp (Lugt 1338), lower left or lower right, and the blind stamp of the publisher Kleinmann (Lugt 1573).
Delteil 114; Adhémar 321; Adriani 364; Wittrock 331.

This print is dated 1895 by Delteil, and the style shows it to be one of Lautrec's late works; it was probably made in Bordeaux in the autumn of 1900, after the artist had seen the production there of Offenbach's operetta *La Belle Hélène*; see the previous print, No. 357. A chalk drawing not mentioned by Dortu (505 × 355 mm), was possibly made from this print; it is in the Boymans-van Beuningen Museum in Rotterdam (Inv. No. F II 33).

359·I

Four impressions known.
Delteil 333 II; Adhémar 368 (state not
described); Adriani 365 II; Wittrock 332.
Third state. With more lettering: 'Paul
Leclercq/JOUETS/DE/PARIS'; used in
this form as the cover.
Vellum.
Edition of 300.
Delteil 333 III; Adhémar 368 II;
Adriani 365 III; Wittrock 332.

At the end of April 1901 Lautrec left
Bordeaux and returned to Paris for the
last time. Now desperately ill, he
summoned his strength to design a cover
for his friend Paul Leclercq's novel *Jouets
de Paris* (Toys from Paris), which was to
be published by the Librairie de la
Madeleine, Paris. The cover was printed
by Stern.

360 'Zamboula-Polka' 1901

Lithograph, song title.
First state. No lettering.
Drawing in black; chalk, worked with the
scraper.
223 × 240 mm.
Monogram on the stone, lower left.
Vellum, imitation Japan paper.
Three impressions known, one dedicated
'à Stern' (illustrated).
Delteil 334 I; Adhémar 369 I;
Adriani 366 I; Wittrock 333.
Second state. The image transferred to a
new stone and with the following text,
not designed by Lautrec: 'Zamboula-
Polka/Chansonette comique . . .' (with the
address of the publisher Georges Ondet).
221 × 213 mm.
Vellum.
Size of edition not known (several
hundred).
Delteil 334 II; Adhémar 369 II;
Adriani 366 II; Wittrock 333.
New edition (after 1901). Without
lettering.
Drawing in black or olive green.
222 × 210 mm.
Imitation Japan paper.
About 50 numbered impressions.

Like the preceding lithograph, No. 359,
this print was made between the end of
April and 15 July 1901, during Lautrec's
last visit to Paris; it was printed by Crevel,
Paris. Désiré Dihau had asked his cousin
and friend, now fatally ill, for a title page
for this comic song to a text by P. Valfé,
to be published by Georges Ondet. The
litho stone is now in the Musée d'Albi.

359 'Jouets de Paris',
Couverture 1901
Cover for 'Jouets de Paris'

Lithograph, book cover.
First state. No lettering.
Drawing in black; chalk, worked with the
scraper.
208 × 100 mm.

Monogram on the stone, lower right.
Japan paper, imitation Japan paper,
vellum, hand-made paper.
Six impressions known.
Delteil 333 I; Adhémar 368 I;
Adriani 365 I; Wittrock 332.
Second state. With lettering not designed
by Lautrec, in black: 'JOUETS/DE/
PARIS/.

Biography

A more detailed biography can be found in: Götz Adriani, *Toulouse-Lautrec*, London 1987, pp. 281ff.

1864	Henri Marie Raymond de Toulouse-Lautrec-Monfa was born on 24 November 1864 in Albi, the son of Count Alphonse Charles Jean Marie (1838–1913) and his cousin, Countess Adèle Zoë Marie Marquette, *née* Tapié de Céleyran (1841–1930).
`1878–1879	A weakness of the bone tissue, probably due to the close kinship between his parents, prevented two breaks, of the thigh bone in each leg, from healing properly, leaving the fourteen-year-old Lautrec a cripple.
1880–1881	Henri now spent most of his time drawing and painting, in Albi and Paris, on holiday in Nice and on the country estates of his parents, at Céleyran and the Château du Bosc, near Albi. He received his first art lessons from his uncle, Charles de Toulouse-Lautrec, and the painter René Princeteau (1839–1914), a friend of his father through his great knowledge of horses.
1882	On Princeteau's recommendation Lautrec was accepted as a student at the studio of the celebrated Parisian society painter Léon Bonnat (1833–1922). But by the autumn of 1882, he had moved to the studio of the equally successful history painter Fernand Cormon (1854–1924), where in the next few years he befriended Louis Anquetin (1861–1932), Emile Bernard (1868–1941) and Vincent van Gogh (1853–1890).
1884	With his student friend René Grenier (1861–1917) Lautrec rented an apartment on Montmartre at 19a Rue Fontaine, in the immediate vicinity of Degas' studio. With his friends he frequented the Montmartre entertainments: the artists' cabaret, the Chat Noir, the Elysée Montmartre dance-hall and, after 1885 particularly, the cabaret Le Mirliton (Ill. p.12), newly opened by Aristide Bruant (1851–1925).
1886	From 1886 to 1897 Lautrec used a large studio on the fourth floor of 27 Rue Caulaincourt, on the corner of the Rue Tourlaque.
1889	The Moulin Rouge dance-hall opened on the Boulevard de Clichy (Ill. p.13). The most well-known poster designer of the time, Jules Chéret (1836–1932), was asked to produce a colour poster to advertise the Bal au Moulin Rouge.

Lautrec with friends in
the garden of the Moulin de la Galette
(Photo: Bibliothèque Nationale, Paris)

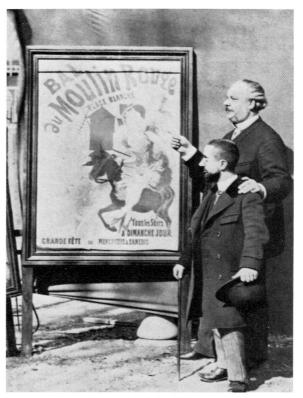

La Goulue and Valentin
le Désossé (?)
(Photo: Bibliothèque Nationale, Paris)

Lautrec with Charles Zidler (?) in front of the
Moulin Rouge poster designed by Jules Chéret, c.1891
(Photo: Bibliothèque Nationale, Paris)

Ball at the Moulin Rouge, c.1890
(Photo: Bibliothèque Nationale, Paris)

1891	As a regular visitor to the Moulin Rouge, Lautrec was commissioned in the summer of 1891 to design a poster for the start of its autumn season. This marked the beginning of his work in the field of lithography. It was a medium which he discovered relatively late, but which was now – at any rate, through his posters – to make him more widely known. At last the artist had the chance to work in a medium that must long have fascinated him – and with the added opportunity of competing with Jules Chéret, the acknowledged master of the *fresques du trottoir* (Arsène Alexandre), and using the same themes. Chéret had started the great vogue for posters in Paris in the 1860s, at a time when mechanical presses made it possible to produce large, good quality editions at a low cost. Chéret's fondness for the large format, his particular style in poster design and rational colour schemes in yellow, red and blue, which could easily be obtained using two or three stones, made this skilled lithographer the initiator of the picture poster drawn directly onto the stone. These came to replace the textual poster – usual up to this time – providing new focal points in the urban scene.

So here was a field which held out promise of success, and Lautrec made good use of the opportunity that was offered him. It certainly required courage to compete with Chéret's well-known works, with their bold, eye-catching colouring, that seemed so deeply rooted in eighteenth-century traditions. Indeed, this could only be done by introducing a completely new conception, and Lautrec's uncompromising directness made the leap straight from the evocation of the eighteenth into the twentieth century, making no concessions whatsoever to the intentions of the client, dealer or publisher. Drawing on a rich fount of graphic invention, Lautrec seems to have had no difficulty in capturing on paper the grandiose design of his first poster: MOULIN ROUGE, LA GOULUE (No. 1).

Major critics began to take notice of him, and some began to support him with enthusiasm. This sudden recognition encouraged Lautrec to continue working in graphics, and within the decade that remained to him, he produced a total of 351 lithographs and 9 drypoints that are among the finest graphic works ever produced.

1893	From 30 January to 11 February Maurice Joyant, director of the Galerie Boussod, Valadon et Cie., and an old friend of Lautrec, organized the first representative exhibition of his work, showing just 30 paintings together with the first lithographs.

One by one the great entertainers began to leave Montmartre, and the quarter began to lose its attraction for Lautrec as well. From autumn 1893 he was a much more frequent visitor to the places of entertainment in the city centre, on the Champs Elysées, and the *maisons closes* of the Rue d'Amboise, the Rue des Moulins and the Rue Joubert. Above all, however, it was the theatre life of Paris that claimed his attention, and his evenings were now spent at the Opéra or the Comédie Française, watching Molière's *Les Femmes Savantes* (No. 38) or Sophocles' *Antigone* (No. 44). Lautrec hardly missed a first night at the Théâtre Libre, the avant-garde Théâtre

de l'Œuvre or the Théâtre de la Renaissance, where
he could admire the divine art of Sarah Bernhardt (1844–1923)
(No. 52).

1894	Visits to Brussels and Holland and, in the summer, to London. In May, an exhibition of lithographs at the Galerie Durand-Ruel, Paris; in October, works in a poster exhibition at the Royal Aquarium in London.
1895	Trips to Brussels, London, Lisbon and Madrid. Works in the Paris exhibition, Centenaire de la Lithographie.
1896	In January Joyant organized the second exhibition of Lautrec's paintings and drawings in the new exhibition rooms at 9 Rue Forest, and he followed this with an exhibition of lithographs on 20 April. One of Lautrec's major works, the ELLES series (consisting of 10 sheets with a cover and title page), was published as the counterpart, in printed form, to the motifs from *maisons closes* found in the paintings of spring 1896 (Nos. 171–181). Works in the Exposition Internationale de l'Affiche in Rheims. Visits to Brussels, London, and in August to San Sebastian, Burgos, Madrid and Toledo.
1897	After years of intense productivity between 1892 and 1896, the tempo began to slacken. In May Lautrec moved from the Rue Caulaincourt to 15 Avenue Frochot, near the Place Pigalle. Visits to Brussels and London.
1898	Lautrec was now hardly capable of working without the intoxication of alcohol; he was seldom sober, and when he was, tended to be extremely irritable and restless. Exhibition of 78 paintings at the London branch of Goupil, 5 Regent Street.
1899	The artist's condition was worsening visibly. Neurotic fears, outbreaks of violent rage, deep depression and hallucinations were consuming his strength. After an acute attack of delirium tremens, his family decided at the end of February to place him in a private psychiatric clinic in Neuilly, at least for a short time. Released on 17 May, Lautrec spent the summer recuperating on the Atlantic coast.
1900	Lautrec had lost all will to live, and found it increasingly difficult to work. He spent brief periods of relaxation on the Atlantic coast. Contrary to his usual practice, he did not return to Paris in autumn 1900, but decided to spend the winter in Bordeaux, where he rented an apartment at 66 Rue de Caudéran and a studio in the Rue Porte-Digeaux.
1901	Lautrec experienced a pressing desire to return to Paris, where he arrived at the end of April with the works he had finished in Bordeaux, to tidy up his studio, complete works he had left unfinished, sort out the less important works, and sign those he considered important. When he left Paris on 15 July, he was never to return. There was no hope that his stays in Arcachon and Taussat would improve his health. A stroke in Taussat left him paralyzed down one side, and on 20 August he expressed the wish to be taken to his mother in Malromé. Here he died on 9 September 1901 at the age of 36, the last of the younger line of the counts of Toulouse-Lautrec-Monfa.

Lautrec with his mother in the garden of the Château de Malromé
(Photo: Bibliothèque Nationale, Paris)

Concordance

With the catalogue by Loys Delteil, *Le Peintre-Graveur Illustré X–XI, H. de Toulouse-Lautrec*, Paris 1920.

Adriani (1986)	Delteil (1920)	Adriani (1986)	Delteil (1920)	Adriani (1986)	Delteil (1920)	Adriani (1986)	Delteil (1920)	Adriani (1986)	Delteil (1920)	Adriani (1986)	Delteil (1920)
1	339	61	52	121	117	181	189	241	1	301	224
2	340	62	64	122	118	182	170	242	2	302	261
3	343	63	57	123	119	183	171	243	3	303	272
4	344	64	294	124	120	184	363	244	4	304	273
5	342	65	55	125	121	185	196	245	5	305	270
6	11	66	60	126	354	186	177	246	6	306	271
7	12	67	61	127	144	187	178	247	7	307	269
8	341	68	62	128	128	188	359	248	8	308	225
9	17	69	16	129	127	189	360	249	9	309	290
10	39	70	68	130	355	190	146	250	251	310	292
11	345	71	66	131	124	191	147	251	252	311	277
12	348	72	67	132	125	192	167	252	253	312	278
13	13	73	79	133	15	193	168	253	254	313	324
14	347	74	80	134	356	194	166	254	255	314	331
15	346	75	81	135	358	195	169	255	257	315	332
16	28	76	82	136	115	196	365	256	258	316	229
17	29	77	83	137	366	197	198	257	259	317	228
18	30	78	84	138	173	198	199	258	260	318	97
19	31	79	85	139	362	199	200	259	256	319	197
20	32	80	86	140	123	200	201	260	150	320	148
21	33	81	87	141	126	201	202	261	151	321	297
22	34	82	88	142	175	202	204	262	152	322	298
23	35	83	89	143	357	203	205	263	153	323	299
24	36	84	90	144	176	204	206	264	154	324	300
25	37	85	91	145	129	205	207	265	155	325	301
26	38	86	92	146	130	206	322	266	156	326	302
27	18	87	93	147	131	207	326	267	157	327	303
28	19	88	94	148	132	208	208	268	158	328	304
29	20	89	95	149	133	209	210	269	159	329	305
30	21	90	96	150	134	210	211	270	160	330	306
31	22	91	75	151	135	211	335	271	161	331	307
32	23	92	74	152	136	212	209	272	162	332	308
33	24	93	73	153	137	213	235	273	262	333	309
34	25	94	145	154	138	214	236	274	263	334	310
35	26	95	71	155	139	215	237	275	266	335	311
36	27	96	72	156	140	216	238	276	265	336	312
37	295	97	70	157	141	217	239	277	264	337	313
38	54	98	59	158	142	218	240	278	267	338	314
39	58	99	165	159	143	219	241	279	232	339	315
40	14	100	116	160	293	220	242	280	291	340	316
41	63	101	352	161	190	221	243	281	336	341	317
42	65	102	99	162	361	222	244	282	287	342	318
43	56	103	100	163	195	223	245	283	288	343	319
44	53	104	98	164	149	224	246	284	289	344	321
45	40	105	77	165	364	225	247	285	285	345	279
46	41	106	112	166	174	226	248	286	284	346	280
47	42	107	113	167	194	227	249	287	172	347	281
48	43	108	111	168	191	228	219	288	234	348	282
49	44	109	101	169	192	229	218	289	330	349	296
50	45	110	110	170	193	230	286	290	203	350	275
51	46	111	106	171	179	231	214	291	231	351	274
52	47	112	104	172	180	232	215	292	230	352	276
53	48	113	105	173	181	233	216	293	233	353	213
54	49	114	107	174	182	234	212	294	329	354	367
55	50	115	102	175	183	235	220	295	226	355	368
56	51	116	103	176	184	236	222	296	—	356	325
57	349	117	163	177	185	237	223	297	328	357	268
58	351	118	164	178	186	238	221	298	327	358	114
59	350	119	109	179	187	239	217	299	283	359	333
60	353	120	108	180	188	240	227	300	323	360	334

Delteil (1920)	Adriani (1986)	Delteil (1920)	Adriani (1986)	Delteil (1920)	Adriani (1986)	Delteil (1920)	Adriani (1986)	Delteil (1920)	Adriani (1986)	Delteil (1920)	Adriani (1986)
1	241	67	72	133	149	199	198	265	276	331	314
2	242	68	70	134	150	200	199	266	275	332	315
3	243	69	—	135	151	201	200	267	278	333	359
4	244	70	97	136	152	202	201	268	357	334	—
5	245	71	95	137	153	203	290	269	307	335	211
6	246	72	96	138	154	204	202	270	305	336	281
7	247	73	93	139	155	205	203	271	306	337	—
8	248	74	92	140	156	206	204	272	303	338	—
9	249	75	91	141	157	207	205	273	304	339	1
10	—	76	—	142	158	208	208	274	351	340	2
11	6	77	105	143	159	209	212	275	350	341	8
12	7	78	—	144	127	210	209	276	352	342	5
13	13	79	73	145	94	211	210	277	311	343	3
14	40	80	74	146	190	212	234	278	312	344	4
15	133	81	75	147	191	213	353	279	345	345	11
16	69	82	76	148	320	214	231	280	346	346	15
17	9	83	77	149	164	215	232	281	347	347	14
18	27	84	78	150	260	216	233	282	348	348	12
19	28	85	79	151	261	217	239	283	299	349	57
20	29	86	80	152	262	218	229	284	286	350	59
21	30	87	81	153	263	219	228	285	285	351	58
22	31	88	82	154	264	220	235	286	230	352	101
23	32	89	83	155	265	221	238	287	282	353	60
24	33	90	84	156	266	222	236	288	283	354	126
25	34	91	85	157	267	223	237	289	284	355	130
26	35	92	86	158	268	224	301	290	309	356	134
27	36	93	87	159	269	225	308	291	280	357	143
28	16	94	88	160	270	226	295	292	310	358	135
29	17	95	89	161	271	227	240	293	160	359	188
30	18	96	90	162	272	228	317	294	64	360	189
31	19	97	318	163	117	229	316	295	37	361	162
32	20	98	104	164	118	230	292	296	349	362	139
33	21	99	102	165	99	231	291	297	321	363	184
34	22	100	103	166	194	232	279	298	322	364	165
35	23	101	109	167	192	233	293	299	323	365	196
36	24	102	115	168	193	234	288	300	324	366	137
37	25	103	116	169	195	235	213	301	325	367	354
38	26	104	112	170	182	236	214	302	326	368	355
39	10	105	113	171	183	237	215	303	327	—	296
40	45	106	111	172	287	238	216	304	328		
41	46	107	114	173	138	239	217	305	329		
42	47	108	120	174	166	240	218	306	330		
43	48	109	119	175	142	241	219	307	331		
44	49	110	110	176	144	242	220	308	332		
45	50	111	108	177	186	243	221	309	333		
46	51	112	106	178	187	244	222	310	334		
47	52	113	107	179	171	245	223	311	335		
48	53	114	358	180	172	246	224	312	336		
49	54	115	136	181	173	247	225	313	337		
50	55	116	100	182	174	248	226	314	338		
51	56	117	121	183	175	249	227	315	339		
52	61	118	122	184	176	250	251	316	340		
53	44	119	123	185	177	251	250	317	341		
54	38	120	124	186	178	252	251	318	342		
55	65	121	125	187	179	253	252	319	343		
56	43	122	—	188	180	254	253	320	—		
57	63	123	140	189	181	255	254	321	344		
58	39	124	131	190	161	256	259	322	206		
59	98	125	132	191	168	257	255	323	300		
60	66	126	141	192	169	258	256	324	313		
61	67	127	129	193	170	259	257	325	356		
62	68	128	128	194	167	260	258	326	207		
63	41	129	145	195	163	261	302	327	298		
64	62	130	146	196	185	262	273	328	297		
65	42	131	147	197	319	263	274	329	294		
66	71	132	148	198	197	264	277	330	289		

Key to the abbreviated bibliographical references

A more detailed bibliography can be found in: Götz Adriani, *Toulouse-Lautrec*, London 1987, pp. 327ff.

Adhémar: Jean Adhémar, *Toulouse-Lautrec. Lithographies-Pointes sèches*, Paris 1965

Adriani: Götz Adriani, *Toulouse-Lautrec. Das Gesamte Graphische Werk*, Cologne 1976

Cat. Toulouse-Lautrec: Catalogue *Musée Toulouse-Lautrec*, Albi 1985

Delteil: Loys Delteil, *Le Peintre-Graveur Illustré X–XI, H. de Toulouse-Lautrec*, Paris 1920

Dortu: M. G. Dortu, *Toulouse-Lautrec et son Œuvre*, I–VI, New York 1971

Goldschmidt–Schimmel: Lucien Goldschmidt–Herbert Schimmel (eds.), *Unpublished Correspondence of Henri de Toulouse-Lautrec*, London 1969

Joyant: Maurice Joyant, *Henri de Toulouse-Lautrec 1864–1901. Peintre*, I, and *Henri de Toulouse-Lautrec 1864–1901. Dessins, Estampes, Affiches*, II, Paris 1926, 1927

Lugt: Frits Lugt, *Les Marques de Collections de Dessins & d'Estampes*, Amsterdam 1921; Supplément, Le Haye 1956

Schimmel–Cate: Herbert D. Schimmel–Phillip Dennis Cate, *The Henri de Toulouse-Lautrec W. H. B. Sands Correspondence*, New York 1983

Wittrock: Wolfgang Wittrock, *Toulouse-Lautrec. The complete prints*, I–II, London 1985

Index of Persons

The authors of the catalogues – Loys Delteil, Jean Adhémar, Götz Adriani and Wolfgang Wittrock – are mentioned under each catalogue entry and are therefore only listed here where their names occur outside the concordance.